full of grace

a journey through the history of childhood

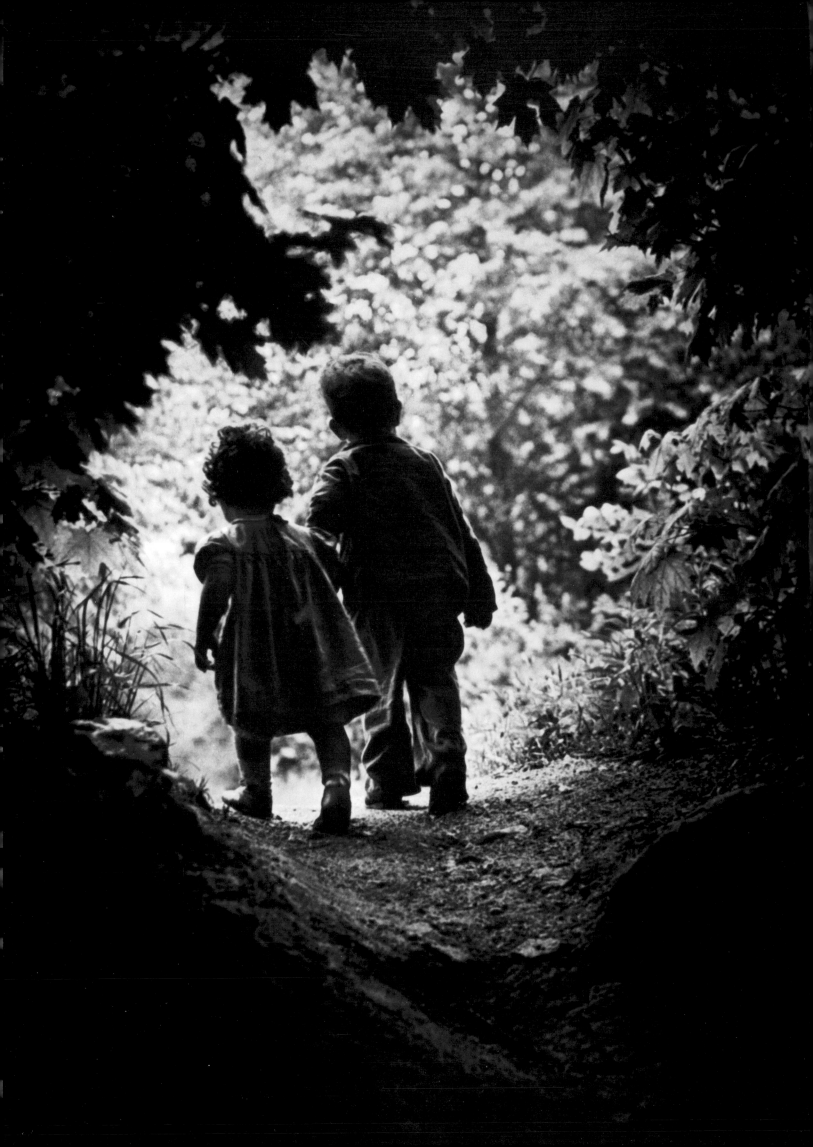

full of grace

a journey through the history of childhood

ray merritt

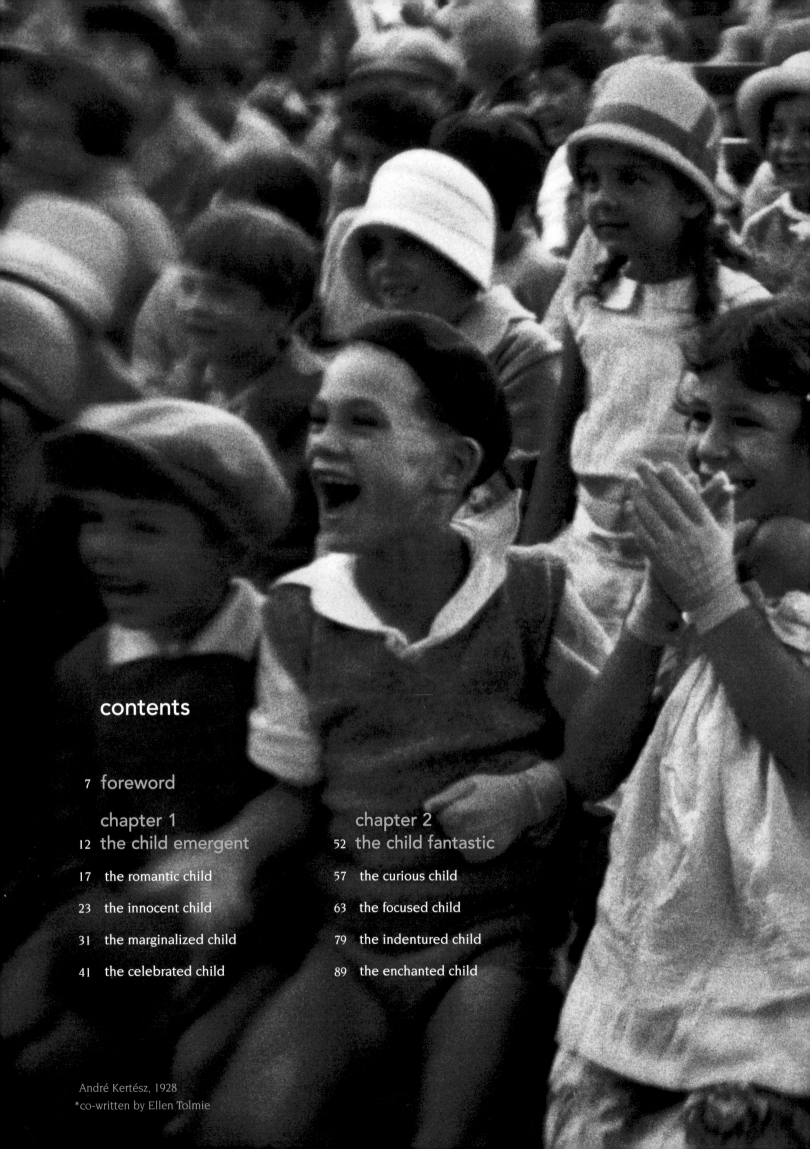

contents

André Kertész, 1928
*co-written by Ellen Tolmie

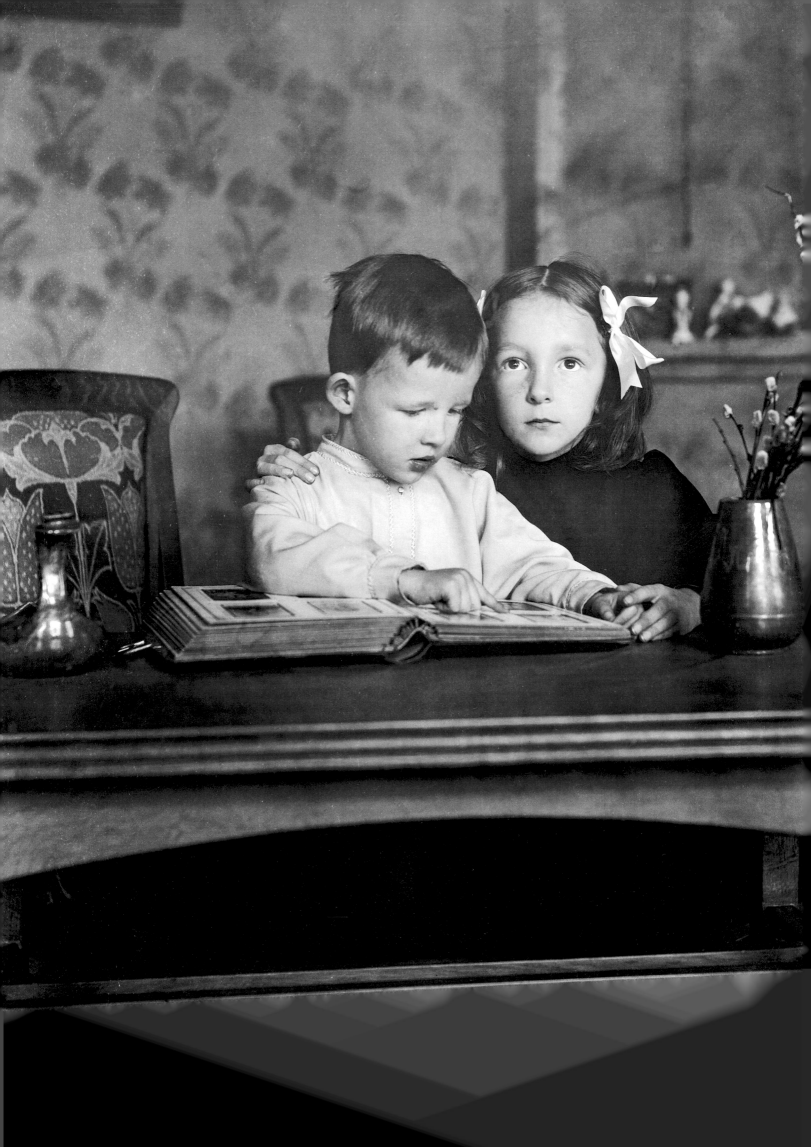

BOOK OF BEGINNINGS,
STORY WITHOUT END.

H.W. LONGFELLOW

Victor Hugo once said that he had discovered childhood. What he meant was that he had discovered its essence -- that special quality found in abundance only in the young. Children bring laughter to life. They are humanity's most precious possession. Even during their most distressed moments, an inner smile prevails. As Robert Coles said, they "present us with possibilities and postures, stirring us to thought and deed and prodding us, mind and heart, to respond." Children represent the less complicated beings we once were and a future we will never see. They reflect our past, they herald our successes and they carry our legacy. This book explores the modern construct of childhood from the middle of the nineteenth century to the present as reflected in the arts of photography and children's literature.

By the mid-nineteenth century, children in the industrialized countries were beginning to find their own place in our world. They were provided with schools, age-appropriate clothing and a more defined and honored role within the social order. Literature written for them had moved beyond the strictly instructional. Society was more empathetic and tender toward its young as the joys of childhood began to be viewed as a birthright.

The birth of photography coincided with these advances. Although prefigured by the use of the "camera obscura," the modern camera did not exist until pioneers like William Henry Fox Talbot, Louis Jacques Daguerre and Joseph Nicephore Niépce conceived of ways to fix visual images on solid surfaces. That tangible product gave the camera its special status as an instrument that reproduced what appeared to be unmediated truth. And so the camera was used to capture every object visible to the naked eye and many that were not. Yet children were always among its most endearing and enduring subjects.

Prior to photography, the child was depicted in painting, sculpture and illustration, but the mythological cupids and celestial cherubs of Western art were not so much children as stylized symbols. Even the Christ Child was a miniaturized representation of God incarnate. It was not until the eighteenth century that children became a prevalent subject for portrait painters. As society abandoned the concept that children were faulty, immature humans born into sin, they would be recharacterized as innocents, and many adults felt obligated to preserve that innocence. Artists sought to portray the young only in an idealized state, as hardy, healthy and scholarly

and, above all, as exuding the absence of want. Photography then took the process one step further, rendering the innocent child convincingly real and natural. The demand for photographs of the young was insatiable. Photographers were ubiquitous and their product was affordable. Childhood has held an abiding fascination for photographers ever since.

Photographic images of children are the most common, the most sacred and at times the most controversial images of our times. They are, like all photographs, paradoxical objects -- concrete yet abstract, specific yet symbolic. They can be both banal and profound; they can narrow perceptions by reinforcing clichés or broaden perspectives by kindling the

imagination. They have the power to communicate, to affect our feelings and our behavior and to shape our values.

Photographing children, however, continues to be challenging. Children's photographs serve as iconic representations of qualities as diverse as innocence, sensuality, suffering, unfettered joy, abundance and want. It is therefore no wonder that children are irresistible subjects for art photographers, photojournalists and advertisers, and, perhaps more than all the former, for their immediate families. Images of children are also assumed by many to be sacrosanct -- making any deviation from the unspoken norms problematic.

For all of these reasons I proceeded with caution in the selection of the images for this book. I sought photographs that were exceptional and relevant and that would resonate like magnetic fields, drawing out both the child that each of us used to be and the children that surround us now. This approach is not without personal and professional risk. Some may say there is too much whimsy, others will see too much nudity, and still others will see too much pain. I hope, however, that most viewers will be energized and enticed to think more deeply about the ideas and ideals of childhood that we all have but seldom examine.

In the course of creating this book, I have often been asked to describe that one radiant quality that draws us to photographs of children. The answer, of course, varies. For this writer, it is best captured by the word "grace." It is in childhood that one experiences one's first joys, sorrows and disappointments -- it

is a place where and a time when there is little need for deception or compromise. It is those very essential emotions that artists seek to depict. The very young are visceral in the sense that they are constantly being transformed by new sensations. They have no innately formed beliefs, they lack bias, they know no prejudice, they are brutally honest and they are incapable of hiding their emotions. They exhibit pride without vanity and are inclusive to a fault. Challenged children and those in danger often exhibit other aspects of grace -- the ability to adapt, to endure and to forgive. Hence the title of this book, *Full of Grace*, a term borrowed from a century-old nursery rhyme.

No matter whether a child is born in the corn fields of Kansas, the rice fields of Japan, the poppy fields of Afghanistan or the barren fields of Sudan, he or she is born full of grace. That is not to say that the presence of grace will guarantee a good life, for childhood has never been -- nor will it ever be -- a safe haven for all. Many children suffer the ravages of inherited disabilities and of war, pestilence, hunger, disease and abuse. Yet all children, at least for some period, possess that elusive attribute called grace.

The written word, like a photograph, informs and excites us -- and makes us dream. With that in mind, *Full of Grace* also looks to the classics of children's literature. The great writers of juvenile books tell us by the artistry of stories, in words and in illustrations, a great deal about the child of their times. The works chosen are not simply literarily excellent, but also culturally important. They are not just informative or instructive but in some way definitive -- works that have generational longevity. From Huck to Holden to Harry, from Alice to Dorothy to Nancy, into a hole, up the river, down the yellow brick road or through the wardrobe, they take us on imaginary journeys.

Words and images help us mediate the truth in different ways. The camera captures reality in a permanently etched manner while books allow us to abstract that reality into a world of our own. Both give form to our longings, whether by bringing back those we have repressed or by giving birth to some we never had before.

Each of us has been affected by the dominant photographic imagery of our time. For my

parents' generation, it was a flag over Iwo Jima, a mushroom cloud above Nagasaki and a nurse and a sailor embracing in Times Square. For my generation, it was water hoses in Selma, a little boy saluting a president's casket, a naked girl in Vietnam, a kneeling teenager at Kent State and a fireman at the Oklahoma City bombing holding a small dying child. The most intense images are usually the most tragic, yet those that continue to resonate in our memories are often the snapshots of our own youth and of our progeny.

This book is structured as a journey, one of the best metaphorical ways to explore modern childhood. The trip is difficult at times because advances in the welfare of children are often beset with natural and manmade obstacles. Along the way, one may reencounter the spontaneity and wonder of one's own early years as the images rekindle past emotions. Understand that the path we take here is largely the result of my personal experiences, preferences and passions. If your guide were Chinese, Japanese, African, South American, Middle Eastern or Italian, the journey would be different. Yet the quest would be the same -- the realization of children's basic rights.

I confess that your guide on this journey is not an authority on the young, nor particularly well versed in children's literature, nor an expert on photography. His credentials on childhood are limited to having been a child, having raised two children and having close encounters with five grandchildren. As for photography, his knowledge comes in large part from a long exposure to and a keen admiration of the medium.

When I began this project five years ago, I wondered if the subject was perhaps too complex, too simple, too esoteric or too exploitive. Notwithstanding my concerns, creating a visual and written ode to childhood turned out to be a richly joyful though daunting, and to some degree burdensome, undertaking -- not unlike parenting. What I came to better realize is that this is a most vital subject, for it is through our collective view of childhood that we shape society's view about the future. In the end, one cannot help but embrace the UNICEF mission to ensure that all children enjoy the requisite health, education, equality and protection to allow them to participate fully in the family of men and women.

We cannot be all things, but the one thing we all have been is a child. Our own passage from that state gives us the right to our impressions as we look upon images of the young. As each generation looks back, it is almost always with a nostalgia that induces a smile as well as with a sense of relief that one's personal passage occurred in what always seem to have been less complex times. Images of childhood, whether photographic or literary, serve not only as mirrors of the past and present, but also as windows into the future. They are about ideas, aspirations and hope.

With that in mind, I set off to make this book, not only for my progeny but for myself.

Abelardo Morell, Alice in Wonderland, 1998

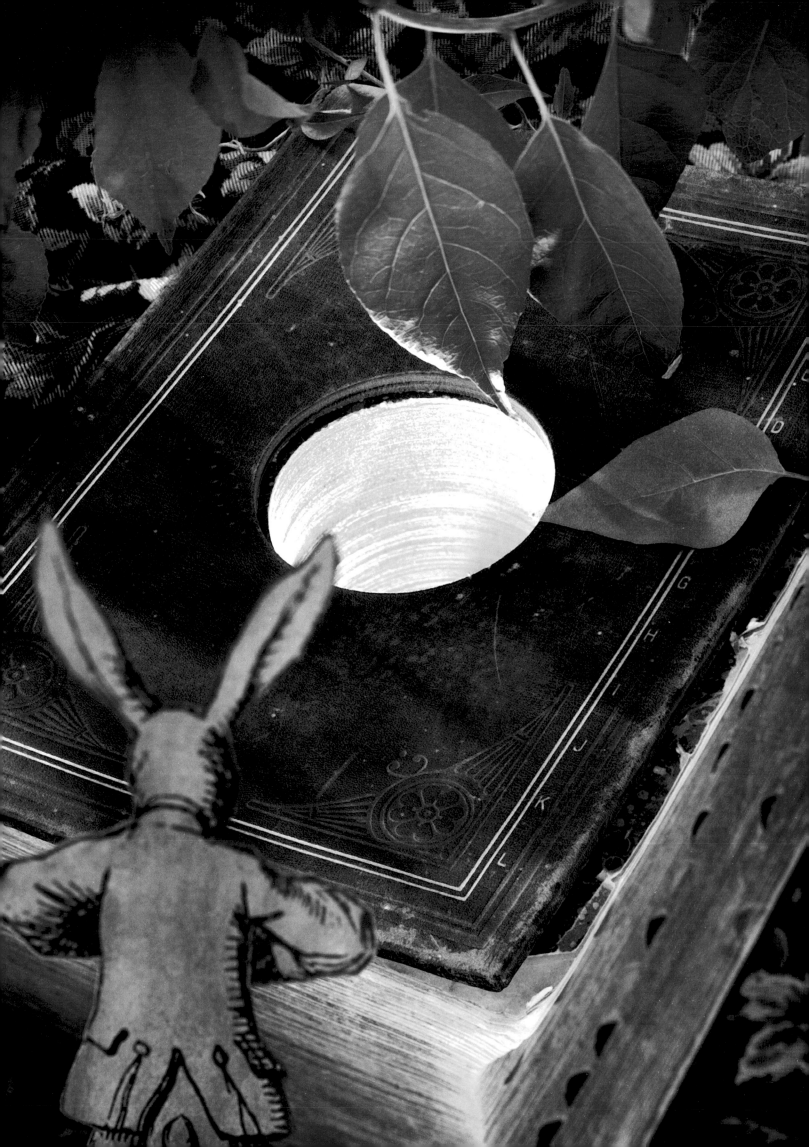

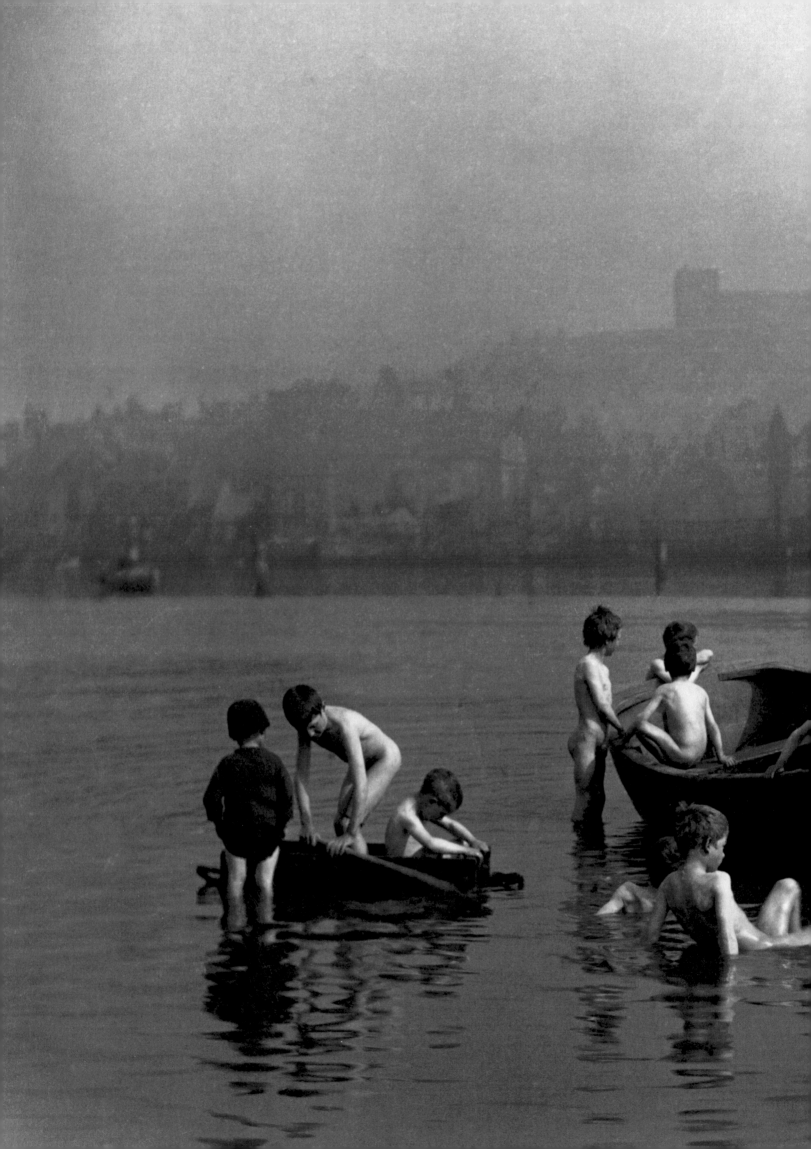

the child emerging
1845 – 1900

Frank Meadow Sutcliffe,
Yorkshire, England, c.1870

ANGELS AND ARCHANGELS MAY HAVE GATHERED THERE,

CHERUBIM AND SERAPHIM THRONGED THE AIR;

BUT ONLY HIS MOTHER IN HER MAIDEN BLISS

WORSHIPPED THE BELOVED WITH A KISS.

CHRISTINA ROSSETTI

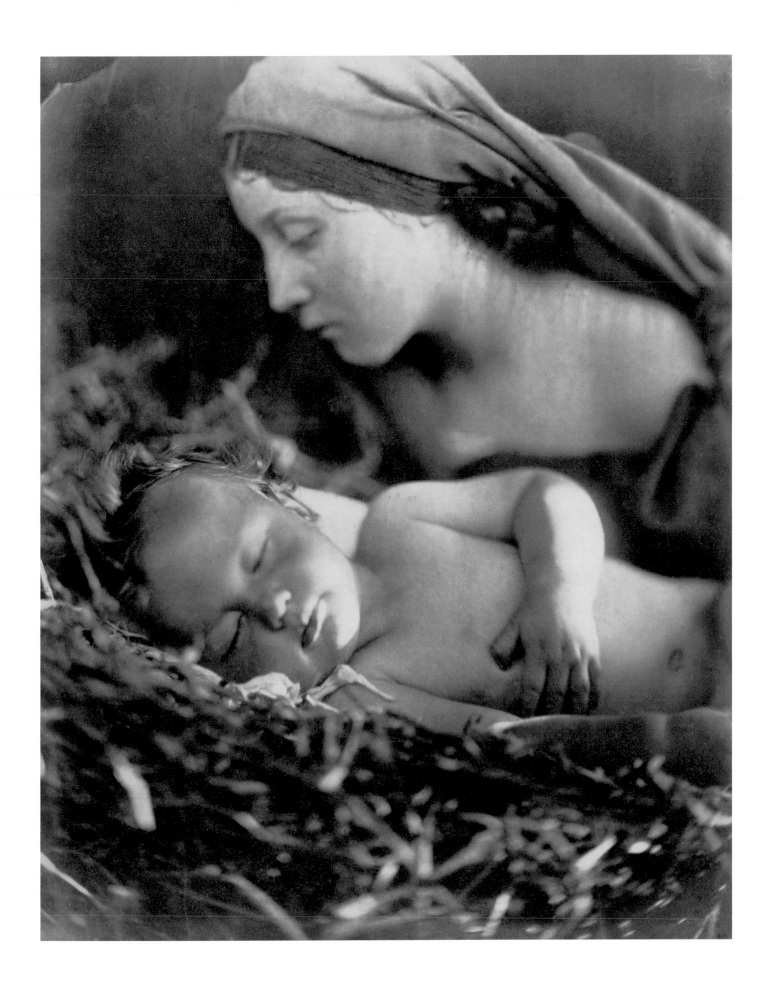

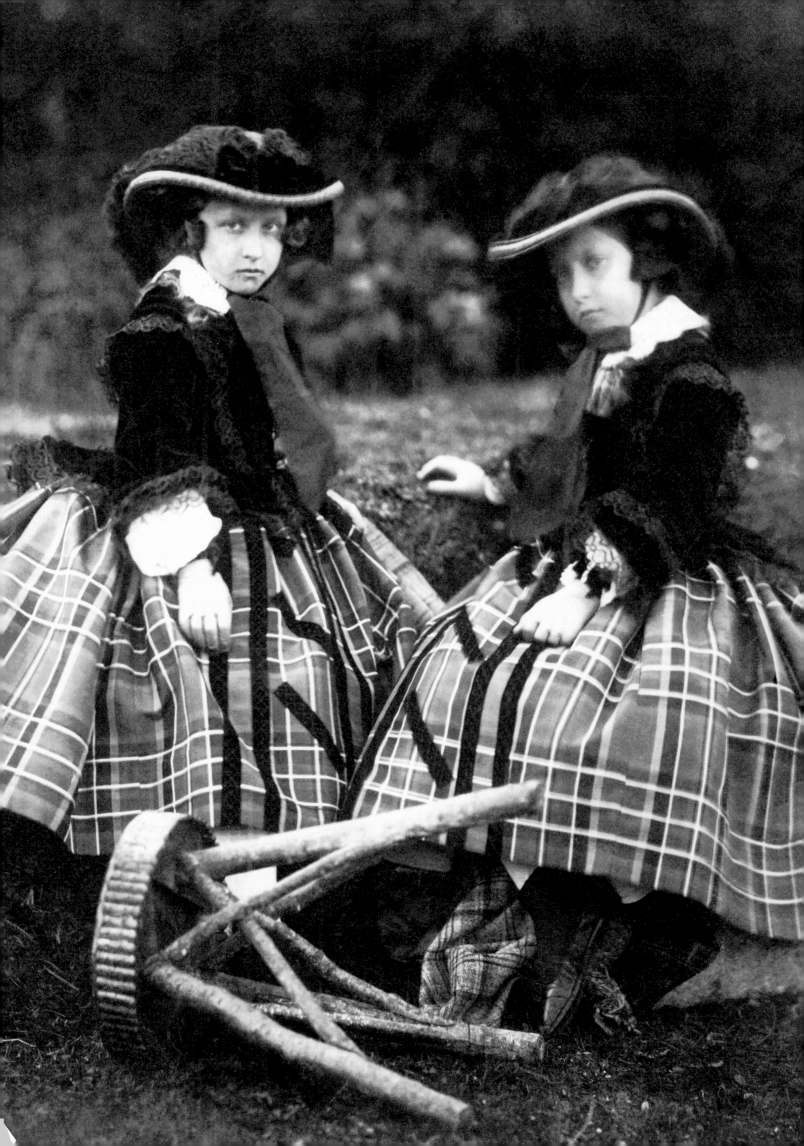

the romantic child

HOW BEAUTIFUL IS YOUTH! HOW BRIGHT IT
GLEAMS, WITH ITS ILLUSIONS,
ASPIRATIONS, DREAMS!

H.W. LONGFELLOW

The concept of concerned parenting is, in the grand order of things, a modern invention. If you search hard enough, however, you can find early harbingers. Johann Amos Comenius, a seventeenth-century educator, felt that children should have their spirits stoked by "kisses and embraces," arguing that affection and play were integral to child development. Obvious today; radical if not heretical then. In those times most children worked hard and died young. It took several centuries before other profound thinkers like Jean-Jacques Rousseau, John Locke, Victor Hugo and Johann Pestalozzi refined Comenius's concepts and firmed up the belief that children are not innately imperfect but are, in fact, born good. This concept that the child is a complex being whose development should be nurtured, guided and protected did not begin to gain currency with the mainstream of society until the latter half of the nineteenth century during the height of Queen Victoria's reign.

As is so often the case, art followed the times. The first significant artistic depiction of childhood's romantic innocence is found in the works of eighteenth-century master painters Thomas Gainsborough and Joshua Reynolds. They set a standard against which all child-related imagery would be judged for the next century. By the middle of the nineteenth century, the Victorian upper class embraced the belief that the material world could be transformed through the power of one's individual temperament. When it came to children, it was believed that they are in fact born devoid of adult fault, social evil or sexual urgings -- a romantic (in the sense of pure) state from which adults fall. The Child Romantics, as these children came to be called, were innocent, without evident want and, above all, brimming with grace.

This artistic genre, with imagery often filtered through a gauze of sentimentality, proved wildly successful. Painters, illustrators and photographers were kept busy meeting the demand. A fact conveniently ignored was that underprivileged children throughout the world, including those in Queen Victoria's enlightened industrialized empire, were often starved, exploited and compromised.

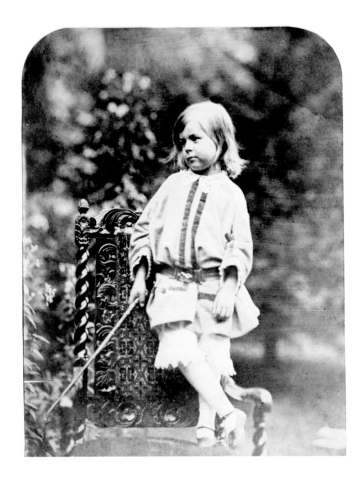

Lewis Carroll, Hallam (Lord Tennyson's son), England, 1857
Roger Fenton, Princesses Helena & Louise, England, 1865 (left)

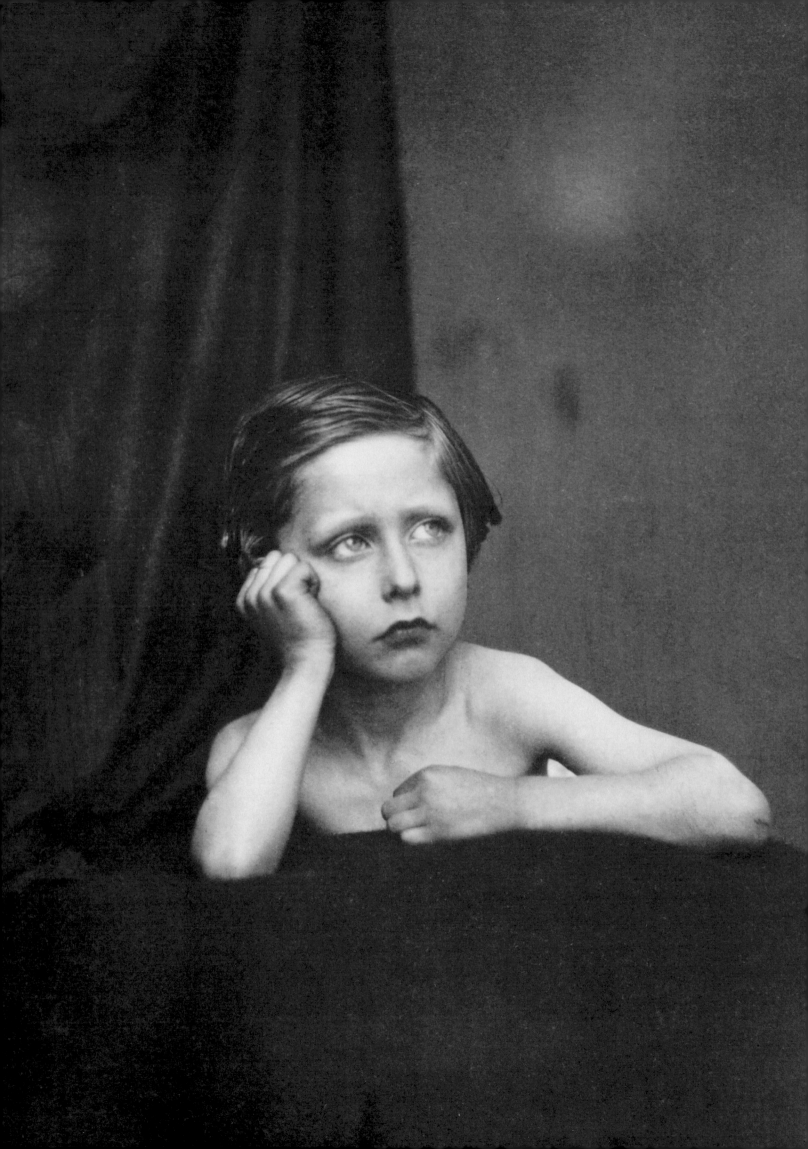

It was at this point in history that the science of photography became sufficiently perfected to permit, in the industrialized countries, universal access to photographic imagery. Suddenly, everyone wanted to have his or her picture taken. Within the first two decades after photography's birth in 1845, it is estimated that over ten million images were caught by the camera, and a preponderance of those were of family and children.

For many, photography was truly black magic. It sprang to life in the dark, conjured up by powerful and toxic chemicals -- the mysterious potions of the early practitioners. And from these dark rituals of science and craft came the heretofore impossible -- a seemingly uninterpreted rendition of the physical world. Photography's power lay in that very ability. Photographs immediately convinced the viewer that what the camera captured was in fact true -- something that other artistic media could never quite do. This process of making permanent that which previously could only be captured by pencil, quill, brush and memory was made possible by men of science.

Photography's initial purpose was to record a place and a moment in time. Since it was based on the sciences of optics and

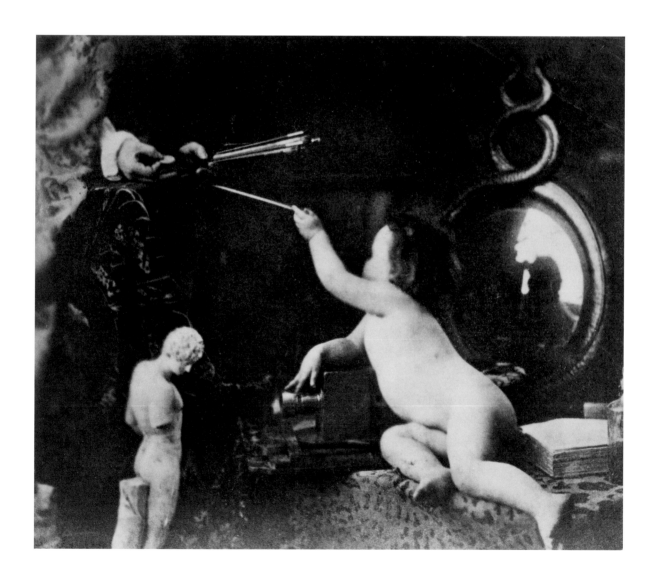

chemistry, it was considered, at best, mechanical art. Yet it captivated the industrialized world, for it soon gave everyone the ability to memorialize themselves and their loved ones -- an option formerly available only to the rich and the royals. Additionally, it permitted ordinary people to visualize the world and to draw their own conclusions, no longer reliant on the gloss and subjectivity of writers and painters.

The early practitioners, daguerreotypists and scientists, would serve only as the midwives of photography. Soon after its birth, photography was whisked away by artists eager to wean the infant medium away from mediocrity and mechanics and nurture it in the traditions of fine art. It was not surprising that to do so they used the child, as painters had done before them, as the icon to celebrate this new art. Imagery of children proved to have a powerful narrative and connotative capacity because it was perceived as timeless and linguistically neutral -- a natural double for photography itself.

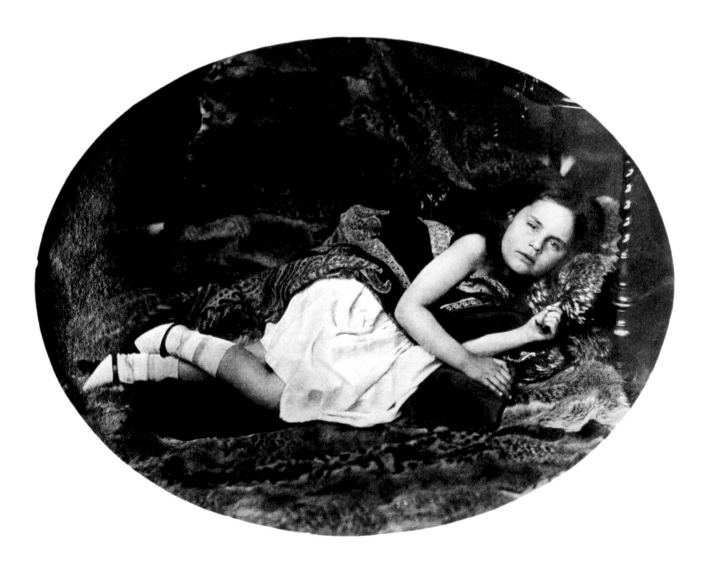

Lewis Carroll, 1863

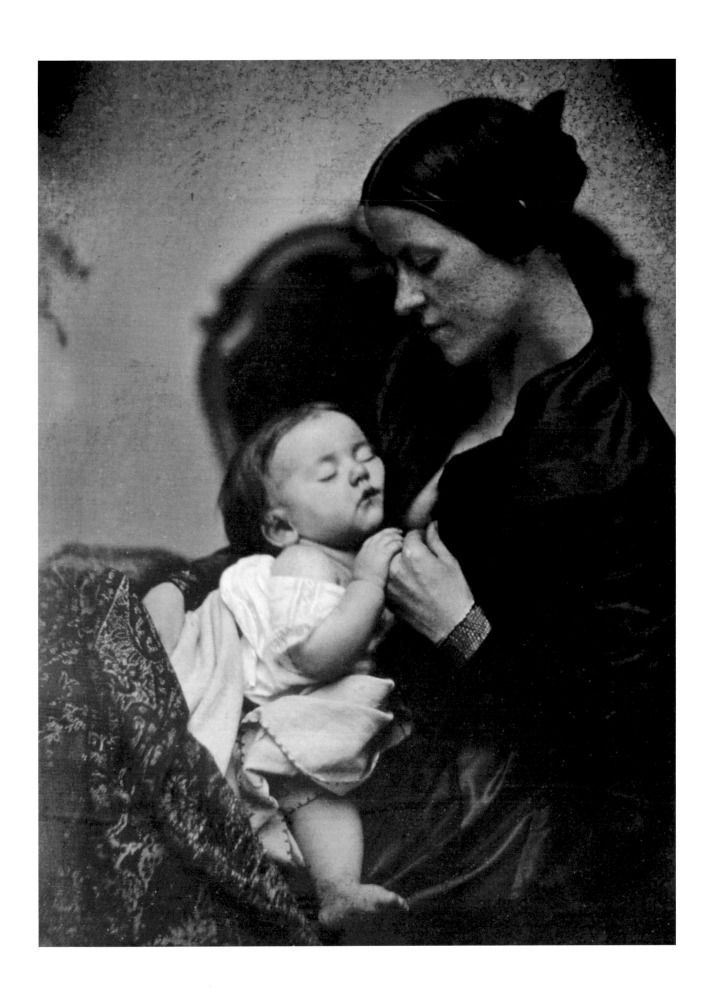

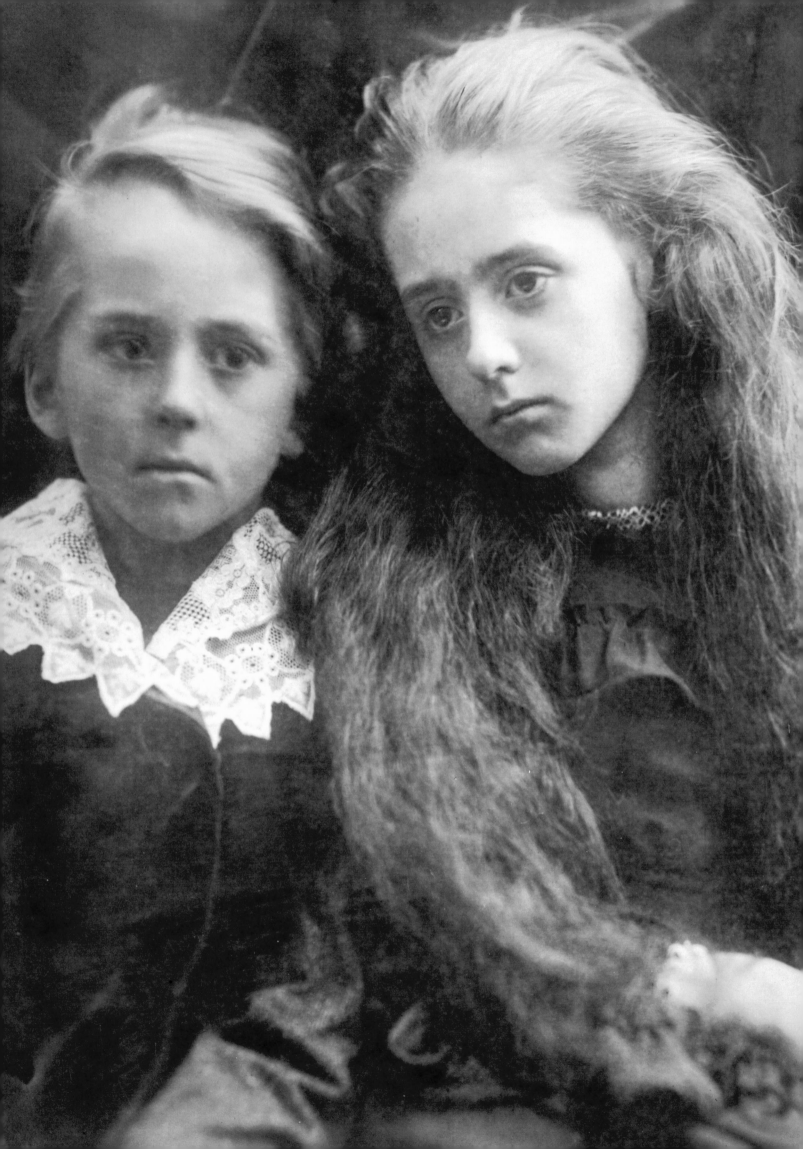

the innocent child

GIVE ME THE COMPANY OF A CHILD OF PURE
UNCLOUDED BROW AND DREAMING EYES OF
WONDER. HER LOVING SMILE WILL SURELY HAIL
THE LOVE-GIFT OF A FAIRY TALE.

LEWIS CARROLL

After the advent of the camera, it took a quarter of a century of experimentation for photography to take hold as an art form. Although many European and American photographers like Hill & Adamson, John Thomson, Southworth & Hawes, Felix Nadar, Gustave Le Gray, Roger Fenton and Oscar Rejlander became professionally as well as artistically proficient, three amateur artists -- Julia Margaret Cameron, Charles Lutwidge Dodgson (better known by his literary name, Lewis Carroll) and Clementina, Lady Hawarden -- set the medium on a path from which it would never retreat. The shared interests and extraordinary artistry of these three photographers, aided by the personal sponsorship of Queen Victoria, bound them together in history as preeminent among Victorian photographers.

Queen Victoria was a monarch like no other. Her empire reached virtually all corners of the globe, and her personal enthusiasm for and sponsorship of both photography and child welfare gave sustaining impetus to both. With an empire to run and nine children to care for, she still found time to indulge her hobby, photography, and, in doing so, made it her business to acquaint herself with its leading practitioners. Among those she would come to know were Cameron, Carroll and Hawarden.

It would be fair to describe the first of these, Julia Margaret Cameron, as a true Victorian eccentric. A lover of children (her sister called her "baby crazy"), she gave birth to six, adopted five and came to enjoy the company of twelve grandchildren. She first learned of photography from the renowned astronomer Sir John Herschel. She was fortunate during her life to have an extraordinary group of friends that included, in addition to the Queen and Herschel, Alfred, Lord Tennyson, Charles Darwin, Henry Wadsworth Longfellow and Thomas Carlyle. Steeping herself in literature, philosophy and religion, she became an avid disciple of Jeremy Bentham's Utilitarianism and believed that actions should be weighed on a scale of how much good they produce. That greater good, she hoped, could be achieved through her art.

Early attempts at painting having failed, Cameron took up photography and used the camera to create Pre-Raphaelitic imagery. The Pre-Raphaelites, then very much in vogue, were a movement that saw poetry, painting and photography as different means of expressing the same emotions. Cameron used popular symbolic images of that era -- Madonnas, May queens, virgins, cherubs and seraphim -- as tropes, not merely to record what she saw but to visually imagine.

Cameron's models were most often house-hold staff or neighborhood children whom she virtually coerced into posing for long periods. Her moody images evoked an aura of transcendental lyricism that she hoped

would express her feelings and beliefs. Using available light and often abandoning any effort to focus, Cameron blended the reality of photography with her personal vision -- the real with the ideal -- sacrificing, in her own words, "nothing of Truth with all possible devotion to Poetry and Beauty." She cared not for perfect recordation; blurs, smudges and cracks were all acceptable in her images. Her work was not so much about her models as it was about the allegorical themes she was attempting to capture. Yet it was children who would serve as her Cupid and Psyche. Cameron's work has withstood the rigors of time and criticism and she is now considered one of photography's greatest artists.

Lewis Carroll was a devoted and admired friend of the Queen. A self-effacing professor of mathematics with an extraordinary passion and genius for photography and writing, his photographs are very different from those of Cameron. Disdainful of Cameron's manipulation of her subjects, Carroll strove to capture the essence of youthful innocence, particularly in very young girls. It was a natural quality that he felt only the camera could record. For him, young girls were both the physical and the metaphoric precursors of adulthood --

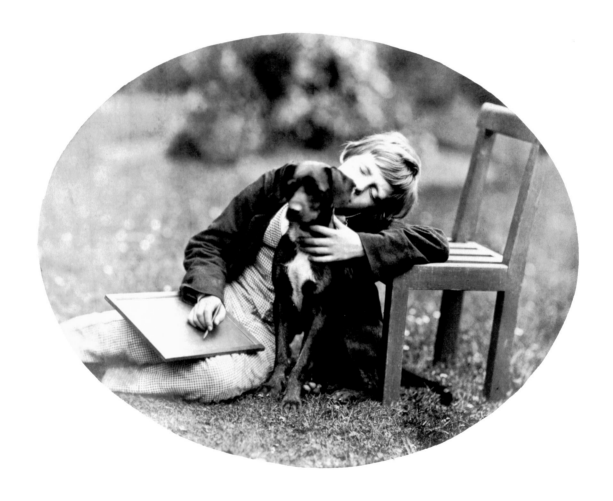

Lewis Carroll, brother Edwin, 1857

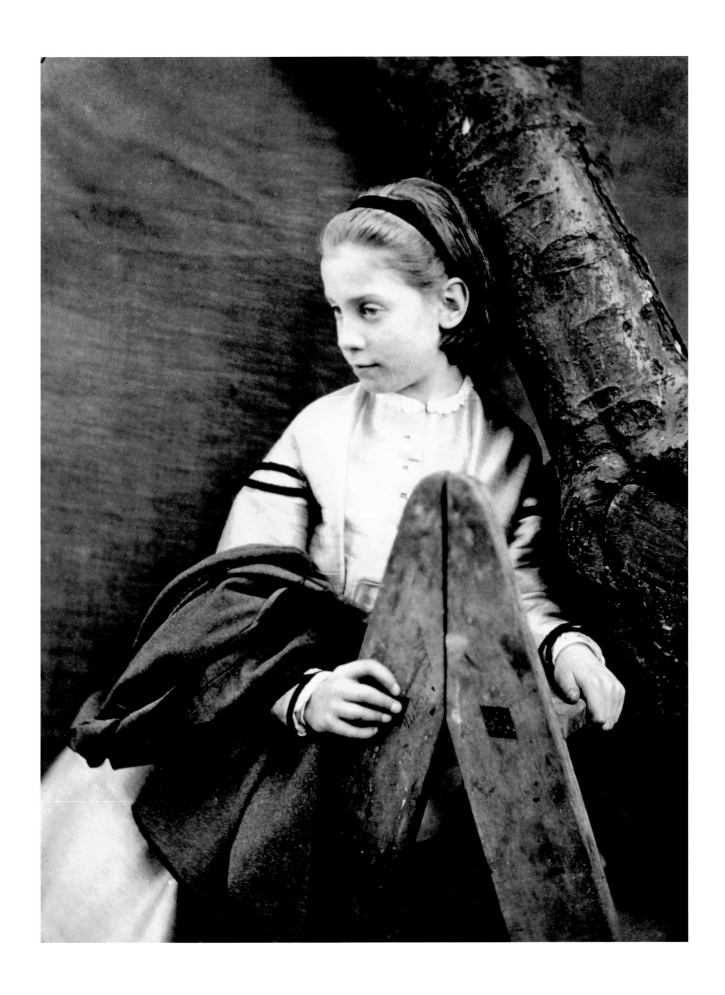

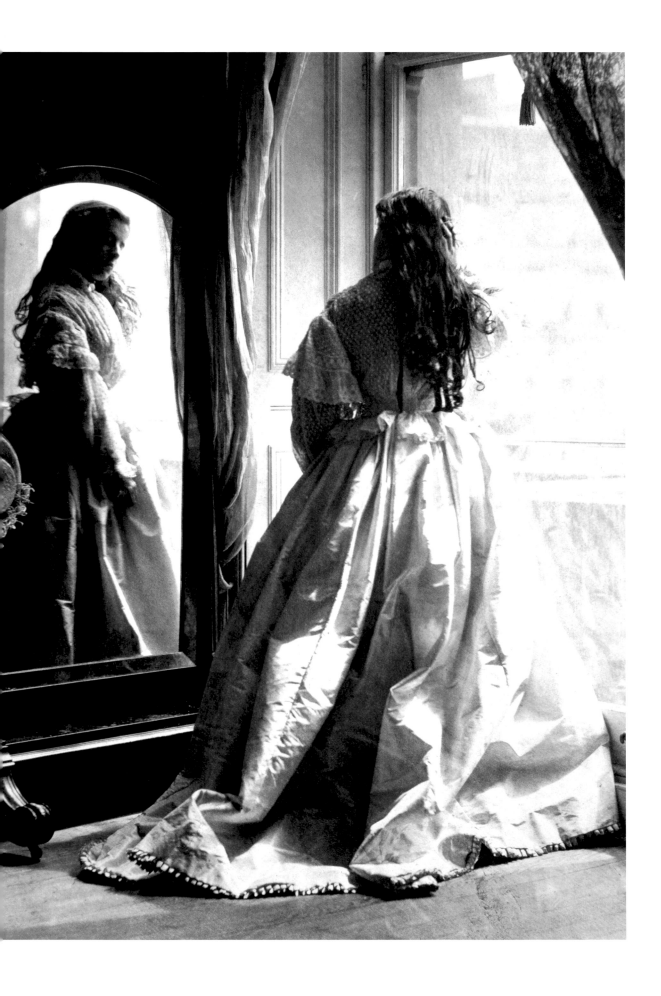

Clementina, Lady Hawarden, c.1860

a view consistent with the focus on naturalism prevailing during that period. The child had early on come to represent photography itself. For Carroll there was no other subject. His obsession has generated speculation by modern critics who detect in his imagery traces of pedophilia.

To be fair to Carroll, his work must be considered in relation to the times. Prior to 1885, it was a felony to have sex with a child under ten; above ten, it was only a misdemeanor, and thirteen was deemed the age of consent. Controversy based on unconfirmed suspicions notwithstanding, Carroll's work is remarkable for its structure, craftsmanship and substance, justifying Brassai's claim that Carroll was "the most remarkable photographer of children in the nineteenth century." Carroll truly believed in the absolute innocence of the child and set out to prove that through his photography. Carroll's "little girl" images sparkle in their naturalism -- the polar opposite of Cameron's dark shimmering subjectivity.

The third photographer of this trinity of gifted and dedicated amateurs, Clementina, Lady Hawarden, was distinctly different in background, temperament and approach from Cameron and Carroll. The daughter of a renowned Scottish admiral and an exotic

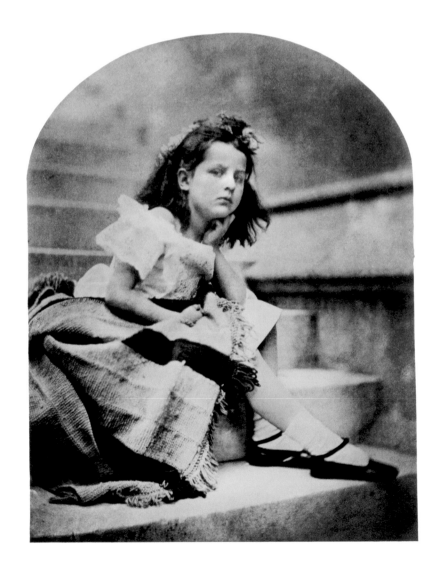

Lewis Carroll, 1864

Spanish beauty, Lady Hawarden was in every sense aristocratic and, in true Victorian fashion, she bore her husband ten children in ten years, dying at the age of forty-two. Lady Hawarden took up photography as a pastime. Working almost exclusively within the cloistered corners of her stately Victorian London home or her Irish country castle, she used eight of her children as her models and muses.

During a period that lasted less than a decade, Lady Hawarden produced a body of work that includes some of the most resonating photographic images to have been made to that date. Her subjects were often older than many of Cameron's and Carroll's, in the twilight of their juvenescent innocence -- thoughtful, mysterious, melancholy, yet in all Victorian respects very proper.

Lady Hawarden employed her camera to create unique allegorical imagery without the artifice and device of Cameron or the spontaneity of Carroll. Formal poses in the elegant settings of her homes became Hawarden's métier. The use of natural light and mirrors, and the careful positioning of her subjects, combined with her extraordinary technical proficiency, produced undeniably piquant images.

Lady Hawarden's work was a triumph of insight into the bliss of adolescence. There was clearly substance beyond the surface image. Through composition, shadows and tonality, she was able to make her images resonate on a theme popular at that time -- the emotion-laden withdrawal from the world that was imposed on young women of means by the strictures of Victorian sensibilities.

Her images laced romanticism with the spice of ambiguous but undeniable sensuality. She was able to sublimate desire by making desire sublime.

Lady Hawarden could well be considered the first photographic master of chiaroscuro, for she sought to capture not only the shadows of nature but the shadows in her subjects' souls as well. Her work was clearly different from Carroll's. Hawarden's pictures mourned the twilight of adolescent innocence, while Carroll's rejoiced in the beauty of pure prepubescent guiltlessness. Perhaps it could be said that Hawarden went where Cameron could not go and Carroll did not want to be.

While other photographers rushed to record faraway places and exotic edifices, these three artists stayed home and used the child as their principal subject. What binds them together is their uniform sensibilities in the rendering of the child. Their children seem so full of grace -- an attribute of child-related photography that recurs to this day.

These three artists were successful in photographically visualizing the difference between child and adult, making childhood *sui generis*. Their images made their mark at a critical moment in the history of modern childhood and charted the shift in the construct of childhood as a distinct epistemological and aesthetic state. They did so by originating a pictorial vocabulary for the depiction of children that is still used today.

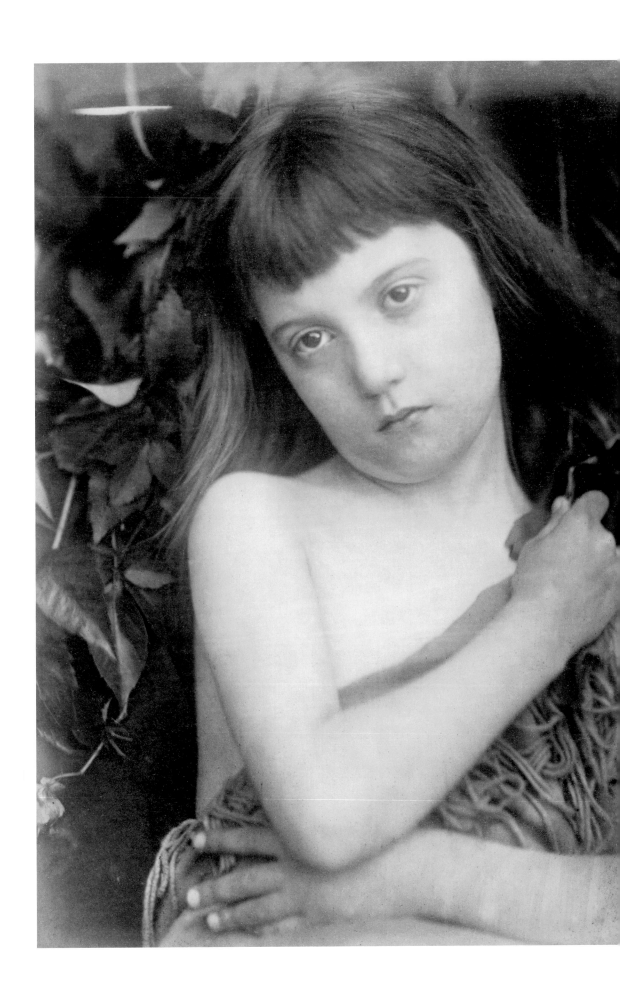

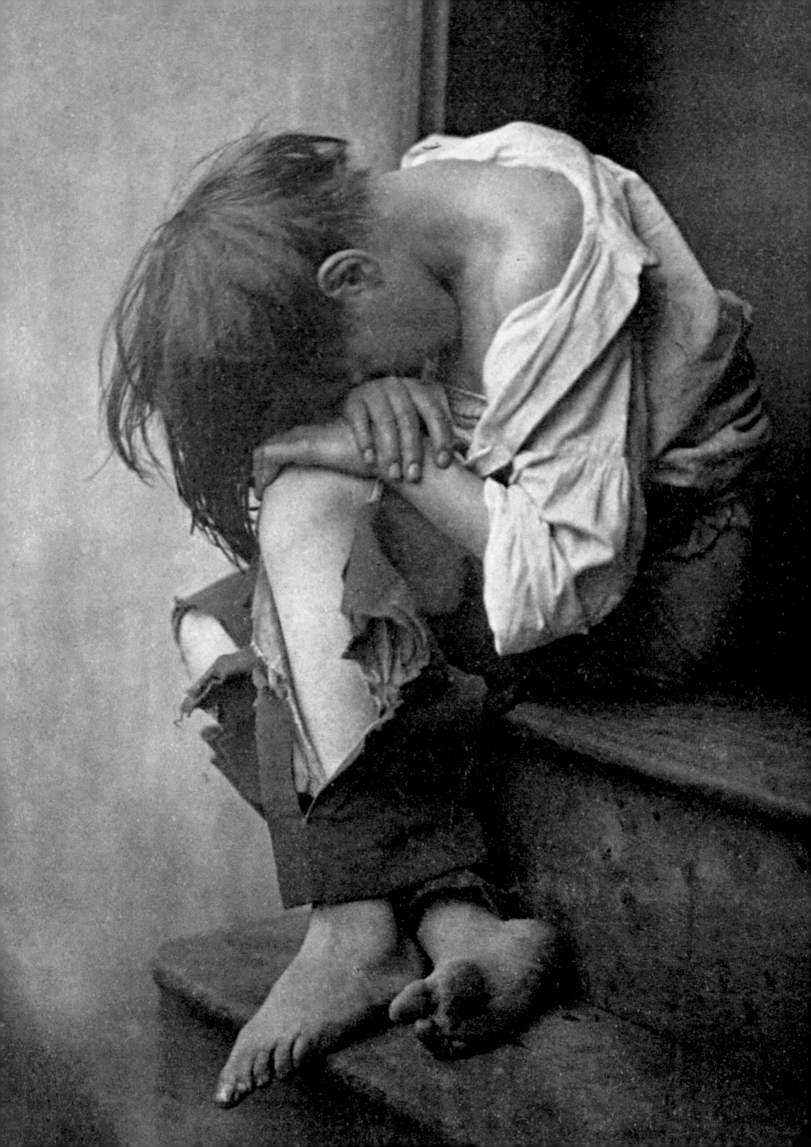

the marginalized child

When home is a hovel, and dull we
grovel, forgetting the world is fair.

Jack London

Not all the industrial, much less the agrarian,
world of the late nineteenth century was pop-
ulated by the prepubescent muses or coiffed
adolescents who graced early photographic
imagery. In fact, economic depressions in
England and America wrought dour condi-
tions that led to severe hardship, sustained
food shortages and often the absence of
simple necessities like proper clothing and
shelter. For the children of the poor, life
was anything but innocent and romantic.
Their constant companions were not hovering
governesses but the ever-present specters of
poverty, disease and exploitation.

Population shifts triggered by the Industrial
Revolution led to the overcrowding of major
urban centers. The newly arrived could often
find neither work nor shelter and were forced
to live on life's margins. Compounding the
problem was the prevailing Victorian view
that poverty was a moral judgment imposed
by God on the wicked rather than a social
condition. Alms, when given, were meted
out with a dose of righteous correction.
Such intolerance compounded these condi-
tions and proved particularly debilitating for
children. There was also rampant disease.
In most poor communities, one out of every
four children died before the age of one and
two out of five did not live to be six. Measles,
scarlet fever, whooping cough, yet unnamed
pneumonias and diarrhea plagued the very
young, while diphtheria and smallpox thinned
the adolescent ranks.

Those lucky and sturdy enough to survive were
viewed as members of a desirable pool of
young and malleable workers. Poor families
needed all the income they could get, and
young bodies were needed to stoke the
engines of commerce. Again, rationalizing
a Victorian tenet that children (particularly
those of the poor) should never be idle, trade
unions in England proudly proclaimed that
"every child over the age of nine should be
an active worker." In practice, it was not age
but ability that determined when one worked.
Four- and five-year-old boys were drafted to
be chimney sweeps, often prodded to work
faster by literally "lighting a fire under them."
By 1852 in England, seventy-six percent of
all fourteen-year-old girls and sixty percent
of fourteen-year-old boys were employed
full time, often up to twelve hours a day.
In America's eastern states, children consti-
tuted over fifty percent of the workforce in
most factories, mills and mines, holding
jobs with no future other than the physical
and emotional scars they wrought.

Governments were slow to come to the aid
of the young. It was not until 1874 that the
English enacted laws prohibiting the employ-
ment of children under ten, laws that were at
first ignored or lightly enforced. In America,
during and after the Civil War, the government
countenanced the enlistment of children in
the armed services. Over eight hundred
thousand children under the age of sixteen
were conscripted, some serving as the
"tongues of war" -- drummers, fifers, bugle
boys and standard bearers -- while others
served as powder monkeys (ammunition
carriers) or ponies (messengers) or, even

CHILDREN SWEETEN LABOURS; BUT THEY MAKE
MISFORTUNES BITTER. THEY INCREASE THE CARE OF LIFE; BUT THEY
MITIGATE THE REMEMBRANCE OF DEATH.

SIR FRANCIS BACON

Alphonse Le Blondel, Post-mortem print, c.1850
John Thomson, Begging for tea, 1865 (right)

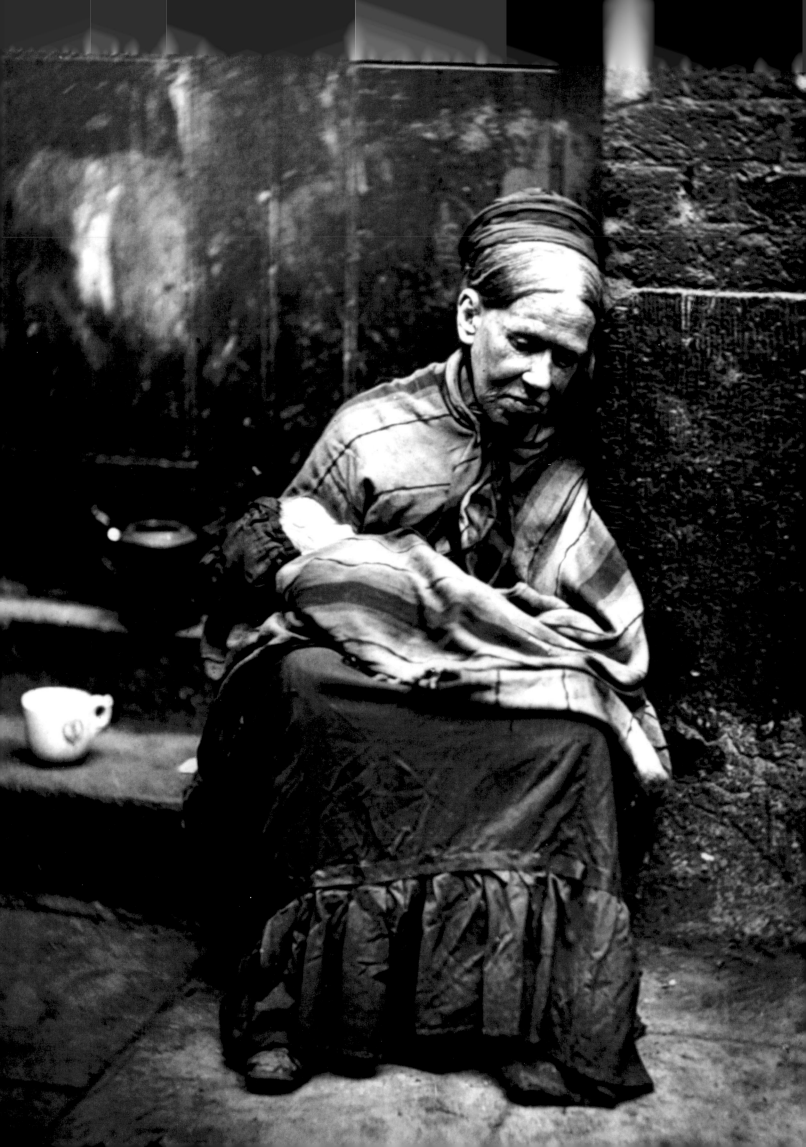

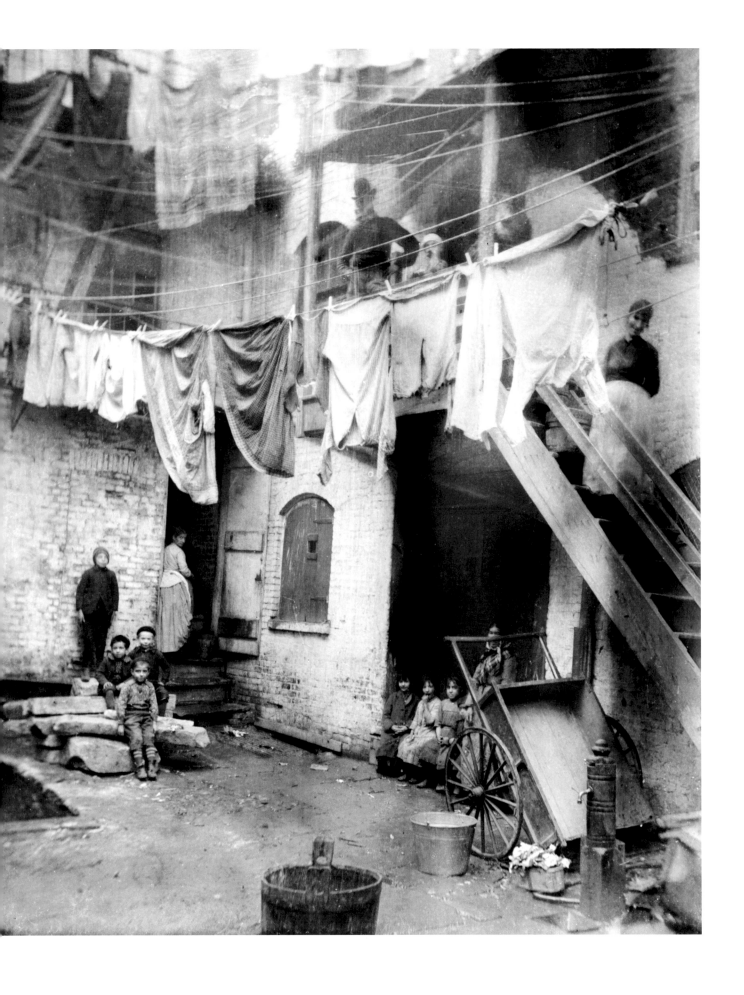

Jacob Riis, c.1890

worse, as foot soldiers. Less than four hundred thousand survived unscathed.

As a result of these conditions, some children simply revolted -- deserting the military, quitting their jobs, escaping abusive family life -- to join with other youths in lawless, self-sufficient cabals. The youth "chain gangs" of late nineteenth-century New York -- so called because they were linked by their universal disdain for the law -- were particularly notorious. Known by their colorful names, the Dead Rabbits, the Bowery Boys and the Pug Uglies, these gangs became potent and malevolent forces in society.

The collective effect of these tribulations on the children who survived these times was varied. Some, like comedian Harpo Marx, a child of the tenements of New York, survived and flourished. In his memoirs, he wrote that "[w]hen I was a kid, there really was no future. Struggling through one twenty-four-hour span was rough enough without brooding about the next one. You could laugh about the past, because you'd been lucky enough to survive it. Mainly there was only a present to worry about. But poverty never made us depressed or angry. My memories are pleasant, full of the sound of singing and laughing and full of people I loved." Other children were made old before their time.

It would turn out to be fortunate for the cause of social justice that photographic techniques had matured to such a level that photographers were able to document these inhuman conditions. By the 1870s, technological advances rendered the early, cumbersome cameras obsolete. The use of a dry-plate process, combined with the introduction of albumen-coated printing paper, simplified the craft. Further, the invention of the halftone printing process permitted photographs to be effectively reproduced in newspapers and magazines. For the first time, photographs could be transmitted to a large audience and used to entertain, record, educate and promote.

By the middle of the nineteenth century, photographers began covering political conflicts as well as social and economic inequities. Felice Beato, a British photographer, documented the uprisings in India and China in 1860. Roger Fenton, another English photographer, covered the Crimean War in the same year that Mathew Brady and George Barnard memorialized the American Civil War. Photographers such as Thomas Annan worked the slums of Glasgow, John Thomson recorded London's poor and Arnold Genthe documented the life of the Chinese in San Francisco. Ethnographic photography as well as geographic photography showed the wonders and perceived oddities of other people and cultures. As the populace became more literate, and newspapers and journals more popular, the demand for this kind of socially concerned photography grew and a new kind of cameraman, the photojournalist, was born.

Less interested than many of their peers in composition, focus and aesthetics, these photographers viewed the camera as a useful tool in reportage, advocacy and education, and often came to realize that their most arresting and endearing subjects were the children lost in society's margins. Their craft, as the term photojournalism connotes, often

required a partner -- the written word. As American photographer Walker Evans said, "[p]hotography [alone] is not photojournalism." Without contextualization, the meaning of an image can be misleading and its impact, particularly in sociopolitical reporting, can be lost. Documentary photography often needs words to help explain, confirm and reinforce its meaning.

Jacob A. Riis was a man who combined the synergistic talents of photographer and writer. A Danish immigrant, he was forced to live in poverty in the tenements of New York City until he found employment, eventually becoming a crime reporter and a crusader for social change. Riis's target was the horrors of the slums of New York. Finding that words and hand-drawn illustrations did not make the impact he sought, he began engaging photographers to help him expose the city's underbelly. Dissatisfied with their lack of vision, he armed himself with a camera and utilized the Blitzlicht-Pulver process (a precursor to the flashbulb) to visually dramatize the squalor of tenement life.

Riis's images captured a slum of more than one million people of diverse nationalities crowded into fewer than forty thousand apartments, and exposed the offal of human wretchedness generated by exploitation and neglect. His work often focused on the lives of children. An admitted muckraker in the best sense of the word, Riis became one of America's greatest writers on social reform and, in turn, its first photojournalist. His genius was not the quality of his prints

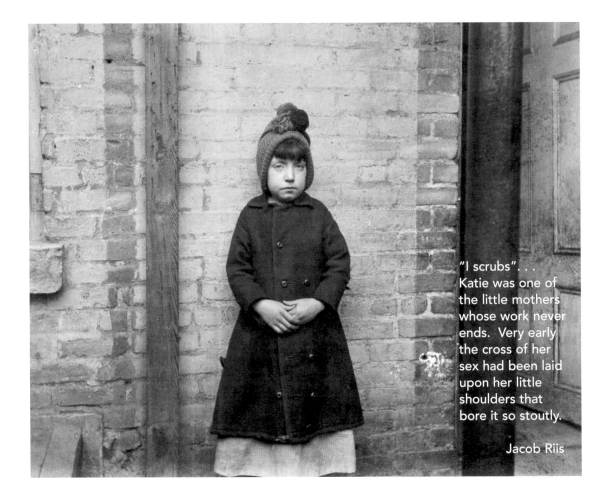

"I scrubs". . . Katie was one of the little mothers whose work never ends. Very early the cross of her sex had been laid upon her little shoulders that bore it so stoutly.

Jacob Riis

Jacob Riis, c.1890

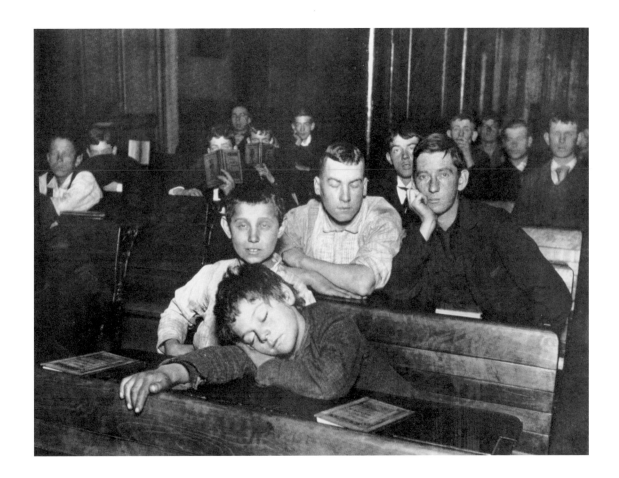

(which was often poor) but the power of his images. They established, as Henry Luce, the founder of *Life* magazine, later observed, that "the photograph |was| the most important instrument of journalism . . . since the printing press." Riis exposed man's dark capacity for cruelty. His technique was to break down the resistance of viewers and convert them to his cause. Riis's explosive joinder of words and images was ignited by the sparks of the zealous reformer that he was, and with his camera he created searing and indelible traces that may well have saved many lives.

Riis's books, *How the Other Half Lives* and *Child of the Tenements*, found instant success, and one reader who was most particularly moved was a then-obscure politician, Theodore Roosevelt. In 1894, when he became president of the New York City Police Board,

Roosevelt used Riis's work to help stamp out police indifference and brutality, one of the core problems in the slums. This action led to other reforms -- child labor restrictions, enhanced water purification and finally the actual razing of Mulberry Bend and Five Points (notorious New York City neighborhoods documented by Riis). Riis lived to see the fruits of his labor and fulfilled his personal pledge to the children of the slums, ensuring that "the light that shined in their eager eyes never |grew| cold." Alexander Allard, Riis's biographer and friend, observed that his photographs were "like children's drawings, spontaneous, uninhibited, honest." Their impact opened a new chapter in photography: the use of the camera, as Oliver Wendell Holmes noted, "as a mirror with a memory" -- in this case, a disturbing one.

IN THE LITTLE WORLD IN WHICH CHILDREN

HAVE THEIR EXISTENCE,

WHOSOEVER BRINGS THEM UP,

THERE IS NOTHING SO FINELY PERCEIVED

AND SO FINELY FELT AS INJUSTICE.

CHARLES DICKENS

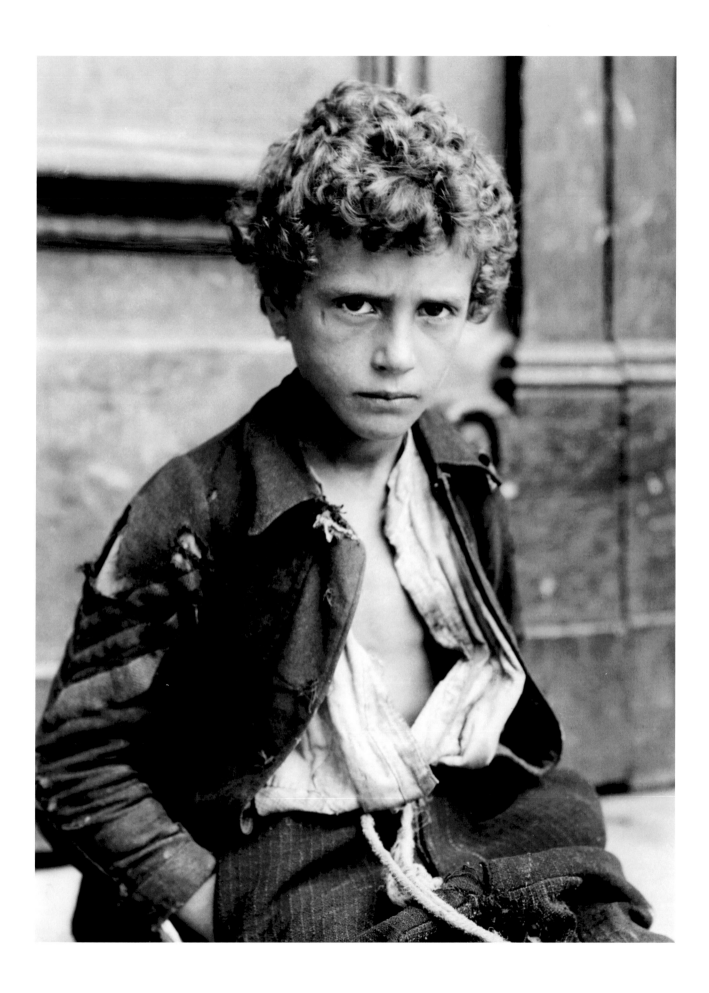

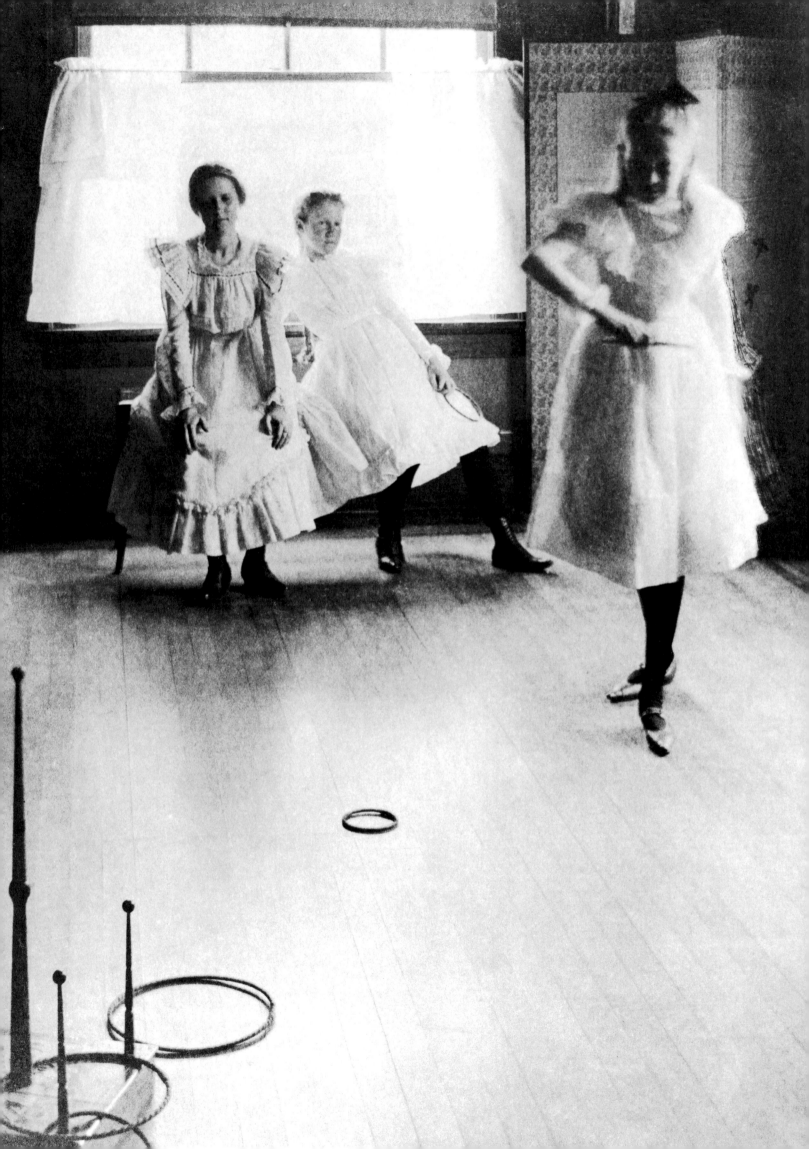

the celebrated child

HAPPY IS HE THAT IS HAPPY
IN HIS CHILDREN.

THOMAS FULLER

Many children during this period were neither the comfortable innocents of Cameron, Carroll and Hawarden nor the bitterly under-privileged youths championed by Riis. The Industrial Revolution spawned a large middle class in and around the great urban centers of England, France and America, and the fecundity of the heartlands permitted even those who toiled in the fields to live in rela-tive comfort, at least by nineteenth-century standards. That is not to say that life was easy. Most city dwellers lived in multistoried buildings fueled by a ton of coal each month that, along with chamber pots and prams, had to be hand-carried. Nevertheless, this sector of society became increasingly happy to have children, who came to be considered a valued part of the family -- a labor source for the less affluent, an asset in business and marriage for the more fortunate.

Yet a child's survival, even in this enhanced environment, continued to be precarious. Infancy remained a time of life when almost half of the population was likely to die. As health and hygiene improved, so did the survival rate. Children were amply fed, even though their rations consisted mostly of por-ridge with milk and bread, and an occasional dollop of jam. Victorian parents believed in strict discipline to ensure that, as their children grew, their spirits were appropriately curbed. Birching, caning and whipping were not uncommon. In order to maintain and perhaps extend the period of perceived inno-cence, great efforts were made to ensure that children avoided "sexual irritation." Girls rode side-saddle and were rarely permitted to wear trousers. There was a fixation about inappropriate self-touching, which was believed to lead to insanity. Cold bedtime baths, hand-tying, harnesses and braces were remedies for the recalcitrant.

On the more progressive side, education, heretofore primarily the domain of the mother, became less parent-dependent. Rudimentary child labor laws and technologi-cal advances somewhat reduced the need for child labor, especially for those under seven. With large numbers of the very young idled -- an undesirable state to a Victorian -- govern-ments turned to compulsory schooling as the answer. In Germany, as early as 1834, Friedrich Froebel developed the first kinder-garten, an institution that by 1856 had spread to England and America. In England, Victorian philanthropy created a system of "ragged schools" for the poor. Moral educa-tion, however, remained with the parents. Girls were taught duty and perseverance, while boys were given lessons in bravery, ambition and achievement.

In America and Europe, children of the middle class were for the most part well dressed and clean, and many had at least one dog as a pet. Boys wore dresses until they were old enough for britches. Girls' clothes followed the popular adult trends of bloused overshirts and plaid silk skirts with hoops and bustles. These sartorial adornments permitted those in the new middle class to flaunt their success by dressing their children as little adults.

The phenomenon of celebrating one's offspring did not end with clothing. Newly experienced leisure time for young children forged a demand for children's toys. Handmade rag dolls and wooden weapons gave way to a dazzling array of mass-produced items. Bisque dolls and lifelike wax dolls with glass eyes and human hair replaced the rag versions. Tin toys and lead soldiers became immensely popular. Board games were introduced. Tiddlywinks, scrapbooks, dissected (later known as jigsaw) puzzles, marbles and jacks were commonplace.

Children, at least Christian ones, found their special day -- Christmas. Clement Clark Moore's poem *The Night Before Christmas* reintroduced the intrepid patron saint of children, Saint Nicolas, as a full-bellied, pipe-smoking bearer of children's gifts. Contemporaneously, there developed a secular custom of decorating holiday fir trees with ornaments and children's presents. Children finally had their own holiday, honoring the birth of the Christ Child by celebrating the joy of all children.

Perhaps the most significant manifestation of society's focus on celebrating the child occurred in the literature of the latter half of the nineteenth century. For the first time, the child was considered worthy of being the principal protagonist in great literature. That is not to say that children's books were not popular before this. Over three hundred years earlier, starting with the publication of Comenius's *Orbis Sensualium Pictus* (1658), instructional catechisms became common and proved to be popular tools for parents to teach children all manner of things.

As the nineteenth century came to an end, enhanced literacy and increased leisure time gave rise to a veritable explosion of books

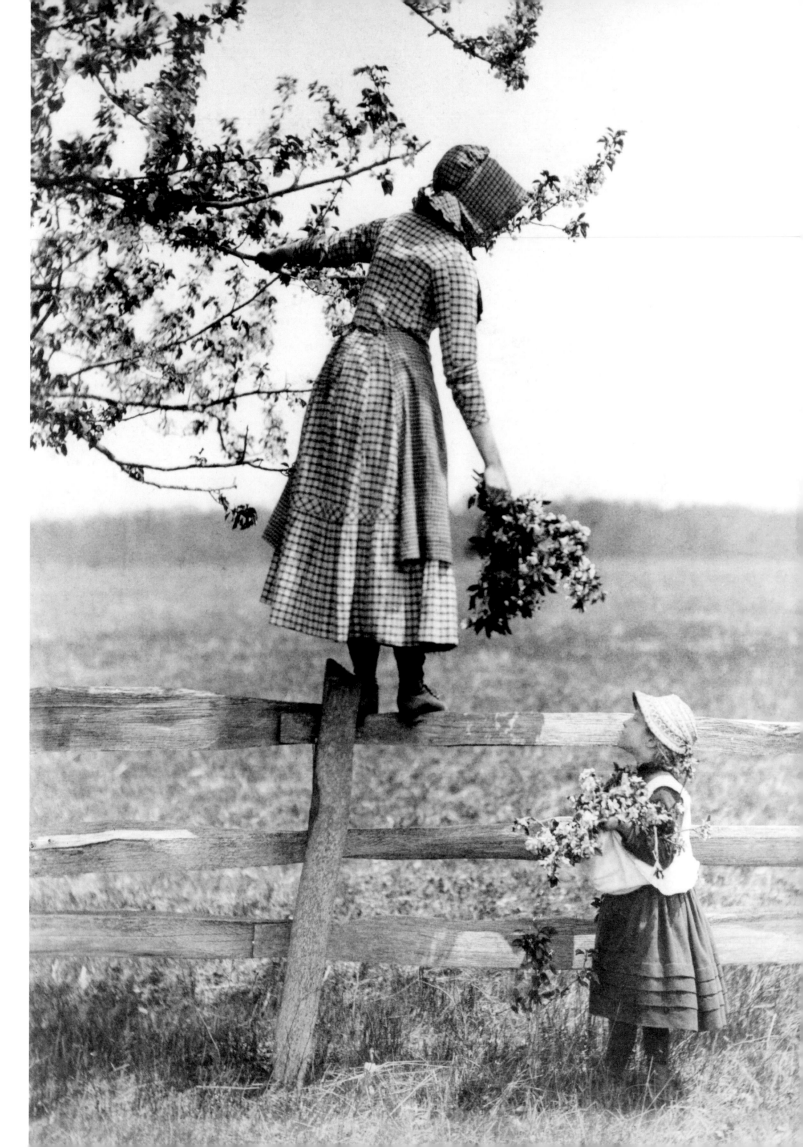

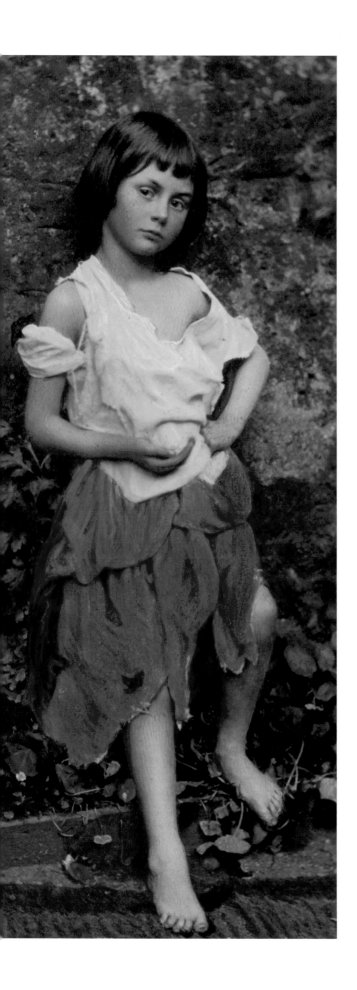

This version of Alice Liddell posing as a beggar girl is believed to be hand-colored by Lewis Carroll himself and given to Alice as a gift when she was seven and he was twenty-seven. Three years later, he wrote *Alice's Adventures in Wonderland*. The book's illustrator, John Tenniel, however, used the image of another Carroll child friend, Mary Babcock, as his model for Alice. This image was included in a number of items that Ms. Liddell sold in 1928 and it became part of the Henry W. and Albert A. Berg Collection, which was later gifted to the New York City Public Library. It is considered a unique version of Carroll's most famous image.

Lewis Carroll, Alice Liddell, 1859
John Tenniel, Illustration, c. 1857

relating to the young. Variety, quality and sheer bulk increased dramatically. Great writers were attracted to this genre. Robert Louis Stevenson, Rudyard Kipling and Captain Maryat put children in harm's way. Dickens introduced us to Tiny Tim, Pip, Twist and Copperfield, Harriet Beecher Stowe gave us the unforgettable Eva, Louisa May Alcott created the March girls and Frances Hodgson Burnett gave life to Little Lord Fauntleroy.

Three literary giants, Lewis Carroll, Mark Twain and Carlo Collodi, celebrated the joy of childhood by making children the central point of their work. In doing so, they created with words what illustrators and photographers had only attempted. They crafted endearing and enduring portraits of the nineteenth-century child that were more than surface deep, endowing them with deeply felt convictions and layered personalities.

The first of these works is Lewis Carroll's *Alice's Adventures in Wonderland* (1865) (and its companion book, *Through the Looking-Glass* (1872)). To protect his privacy, Charles Lutwidge Dodgson wrote under the pseudonym of Lewis Carroll, which he coined from variations of his first and middle names reversed. It is not hyperbole to say that Carroll created some of the most brilliant and complicated children's stories ever written. He was a genius who found his overarching inspiration in the grace of the young. Excelling at photography, poetry, painting, mathematics and virtually every endeavor he pursued, he is best remembered for the Alice books. We all know the story: Alice, a girl of eight (modeled after his young friend and photographic muse, Alice Liddell), sets off in her dreams on a fantastic journey down a rabbit hole and through

Photography quickly surpassed illustration as the preferred medium for visualization in all areas except one -- children's literature. In that instance, photography was unable to fully satisfy the imagination of either the writer or the reader. Great children's literature has often been made greater by the efforts of these artists. Respecting that contribution, there are included in this book some of the best examples of the illustrative arts. Sir John Tenniel imaginatively crafted the inhabitants of Wonderland, and Enrico Mazzanti deftly illustrated *Pinocchio*. It is appropriate that these and other illustrators be included in any book relating to the picturing of children.

John Tenniel, Illustration, 1865

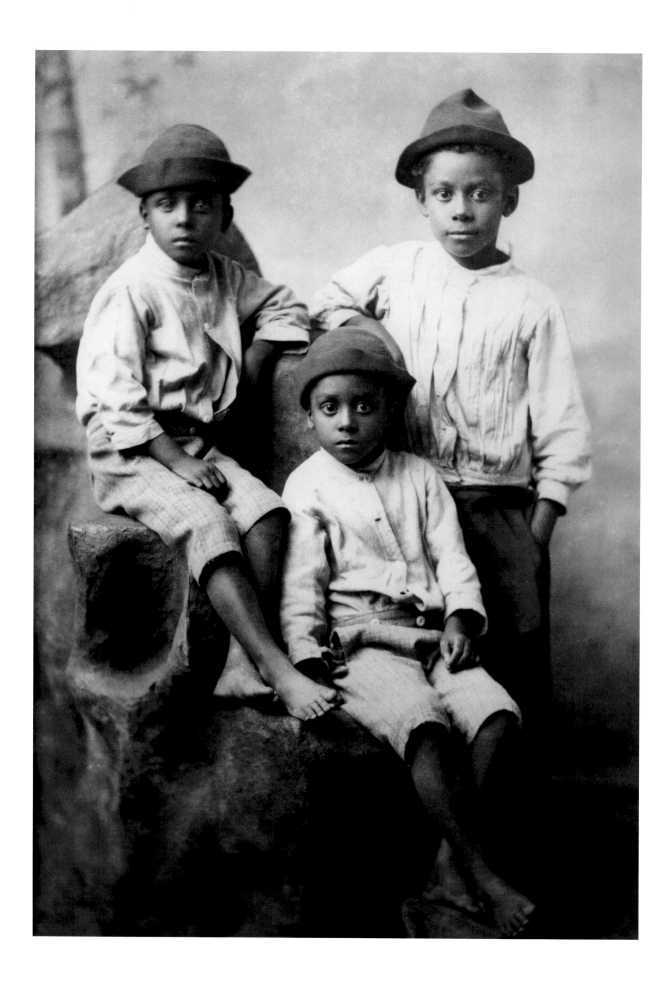

the reverse side of a mirror into a wonderland filled with whimsical and bizarre inhabitants.

Overflowing with rhymes, riddles, enigmas and contradictions, Carroll's books cleverly dissect Victorian life in a fashion coded for adults yet never condescending to children. Unlike most Victorian children's books, the Alice books do not patronize. In fact, they posit a world of wacky adults where Alice turns out to be the most sensible of all of its inhabitants. Alice's journey of the imagination takes her to a place where an eccentric Mad Hatter and an execution-prone Queen, not to mention giant puppies, sage caterpillars and precocious and confounding cats, hold court. There Alice realizes that she is capable of independent thought and action even when she discovers that there are things she does not and may never understand. If Carroll had a moral in all of this, perhaps it was that children must not rush or be rushed to maturity. The "stuff and nonsense" of adulthood can wait. He believed that adults should grant children their boredom and tolerate their silliness for from these would come the ability to imagine and relate to things unknown.

What does Carroll reveal to us of the nineteenth-century upper-class Victorian girl? If Alice is any indication, she will weather childhood well. For, as things got "curiouser and curiouser," Alice retained her innocence and poise, her sense of justice and her disdain for inequity. In the looking-glass world in which she found herself, she was able to make sense out of nonsense. She reaffirmed the Victorian view of girls as the most cherished of species and demonstrated that they had the survival mechanism to handle adulthood.

A little more than a decade after *Alice's Adventures in Wonderland* appeared, the American humorist Samuel Langhorne Clemens published what would be the first of his two classics. Clemens, like Carroll, wrote under a literary alias. In his case, it was derived from the riverboat vernacular, "by the mark, twain," a term that meant deep enough water for safe passage. He found his mark in writing and became, as H.L. Mencken observed, "the noblest literary artist to set pen to paper." It was fitting to call him an artist for, through his mastering of language and dialect, he painted deeply wrought portraits of the quintessential adolescent American boys of the nineteenth century. In *The Adventures of Tom Sawyer* (1876), he fashioned a middle-class boy, a bit long on imagination, with a good heart yet an often reticent conscience. Brimming with creativity and energy, Tom would, as Twain said, "be President, if he escaped hangin'." As Tom's character evolves, he begins to toe the line as he was taught. Conviction overcomes loyalty and superstition; unbounded energy gives

"Huck Finn and Tom Sawyer swears they will keep mum about this and they wish they may drop down dead in their tracks if they ever tell and Rot."

way to more cautious conduct. Eventually, he is drawn in by society's safety net even if he has to give up a fair measure of personal freedom. The whitewashing rogue who spied on his own funeral, the tomcat who nightly skulked out the window to indulge his superstitions, was on his way to manhood.

Compared to Tom, Huck Finn, the protagonist of Twain's second masterpiece, *The Adventures of Huckleberry Finn* (1884), was in many respects the reverse side of the mirror. A young roustabout from the wrong side of town turns out to be the savage civilizer. Huck had what Twain called "sand," referencing the base foundation of the river that would become his symbolic home. Muscular and lean, Huck moved with the grace of an alley cat. Like Odysseus, he was a waterborne wanderer and, as a literary hero, just as big -- the American mythical "good bad boy."

Twain showcased Huck's river smarts. Huck breaks with his community's perceived piety and finds within himself a moral compass that permits him to navigate freely without succumbing to inappropriate restraints. Huck goes West to avoid "sivilizing" in a society grounded in faulty logic and hypocritical religious prattlings. Perhaps only a child is clear-minded enough to take this journey, yet every reader at any age is left with a searing memory of a young boy and a black man floating downriver to a better place, not doing much but smiling.

Mark Twain, like Rousseau, saw childhood not as a temporal passage, but as a state of grace that should be enjoyed and celebrated. If the true measure of a book is its ability to take you out of your comfort zone, then

Hemingway was right when he said that "all modern literature stems from Twain's *Huckleberry Finn*." There was a bit of Tom and a lot of Huck in Twain himself. We know that he too was superstitious. Twain was born when Halley's comet passed over the earth and believed he would die when it returned. He did.

What Carroll did for England and Twain did for America, a fifty-seven-year-old political satirist did for Italy. Carlo Lorenzini, like Carroll and Twain, wrote under an alias. In his case, he took the name of Collodi, the little northern Italian village where he spent his youth. Many scholars consider his work *The Adventures of Pinocchio* (1883) to be the definitive masterpiece of all children's literature.

In the 1860s, Italy, like America, was in the throes of political, social and cultural change. The *Risorgimento* (the process of combining the Italian city-states) brought an uneasy unification. Sensing a need to educate the young, the infant country set upon a program to do so. Collodi turned out to be the right person in the right place at the right time. Asked by Italy's leading publisher to write a story of and for the new generation of Italian children, he created Pinocchio, his protagonist -- a dark, self-absorbed creature, naïve, impulsive, rude, selfish and capable of violence.

Rejecting the love and attention of his adopted father, Geppetto, Pinocchio's only interest lies in "eating, drinking, sleeping and having fun." A vagabond's life on the road is for him. Like Twain's Tom, he is seriously delinquent. Both boys in the end learn from their

mistakes, but Pinocchio's trek is far more daunting. Funland, to which he is drawn, proves much more dangerous than Tom Sawyer's Jackson's Island and the consequences of Pinocchio's escapades are more dire. Turned from a marionette into a dog and later a donkey, Pinocchio's journey to humanity is complete only when he realizes the importance of balance and the benefits of parental love.

Pinocchio is in essence a story of the journey of a self-absorbed child to adulthood. To literary critics, however, it is much more, for it also presents the vital issues of the times -- wealth versus poverty, hypocrisy versus candor, conformity versus individuality. The religiously inclined find meaning in the fact that the hero, the foster son of a carpenter, dies three times and is resurrected. Readers with Freudian inclinations fixate on his chronically protruding proboscis. But to most, a nose is a nose is a nose and *Pinocchio* is a rousing good story.

Philippe Aries, a historian of childhood, thought that in "every period of history, there is a corresponding privileged age," and for the nineteenth century, it was preadolescence. *Pinocchio* spoke of an age not unlike that of the new Italy, and Twain celebrated the ebullient juvenescence of boys, which mirrored America's youthful exuberance, while Carroll gloried in the Victorian golden age of prepubescent innocence.

One can glean a great deal about children of the nineteenth century from these classics. We see in all the protagonists an understandable reluctance to march to maturity. We see that children's games are often ploys to evade authority and avoid responsibility. Witches, ghosts and graveyards, not to mention advice-giving animals, are the mysteries of children's own religion, and superstitions serve as their gospel. We see beyond the pinafore and pumps of the upper-class Alice a person of spunk and sparkle. We see in Pinocchio and Tom bad boys made good, and in Huck the essence of innate goodness. What emerged during this period was a new and fundamentally different kind of fiction. The one-dimensional characters and moralistic plots found in earlier books for the young were replaced with richly developed characters whose adventures were intended to enhance children's imaginations rather than shape their characters.

Writer Graham Greene once said that "it is only in childhood that books have any deep influence on our lives." The profound effect of these books should not be underestimated, for it was the children who enjoyed these masterpieces who led society into the twentieth century. The journeys of Alice, Huck and Pinocchio, down the hole, down the river and down the road, seem to have been well worth taking. The images that these writers framed are of children who possess remarkable intelligence, who are intolerant of hypocrisy, bias and sham, and who are amply imbued with curiosity, charity and a clarity of vision.

WHEN ALL THE WORLD IS YOUNG, LAD,

AND ALL THE TREES ARE GREEN;

AND EVERY GOOSE A SWAN, LAD,

AND EVERY LASS A QUEEN;

THEN HEY, FOR BOOT AND HORSE, LAD,

AND ROUND THE WORLD AWAY;

YOUNG BLOOD MUST HAVE ITS COURSE, LAD,

AND EVERY DOG HIS DAY.

CHARLES KINGSLEY

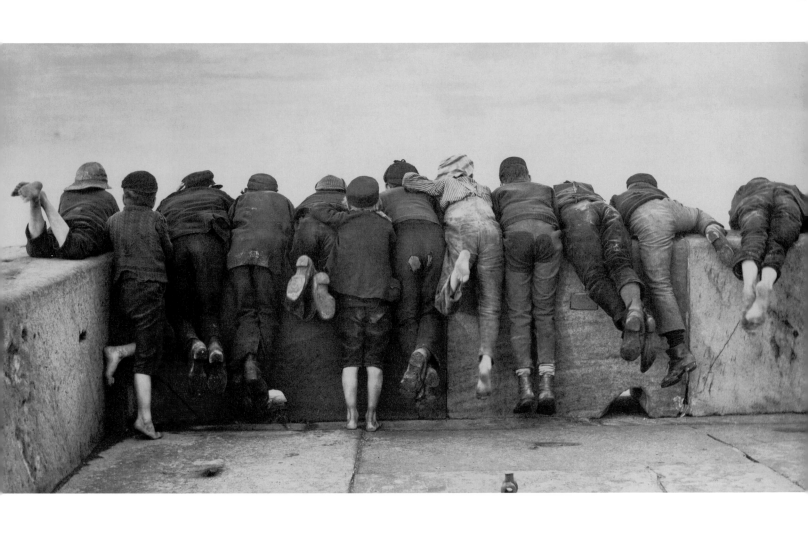

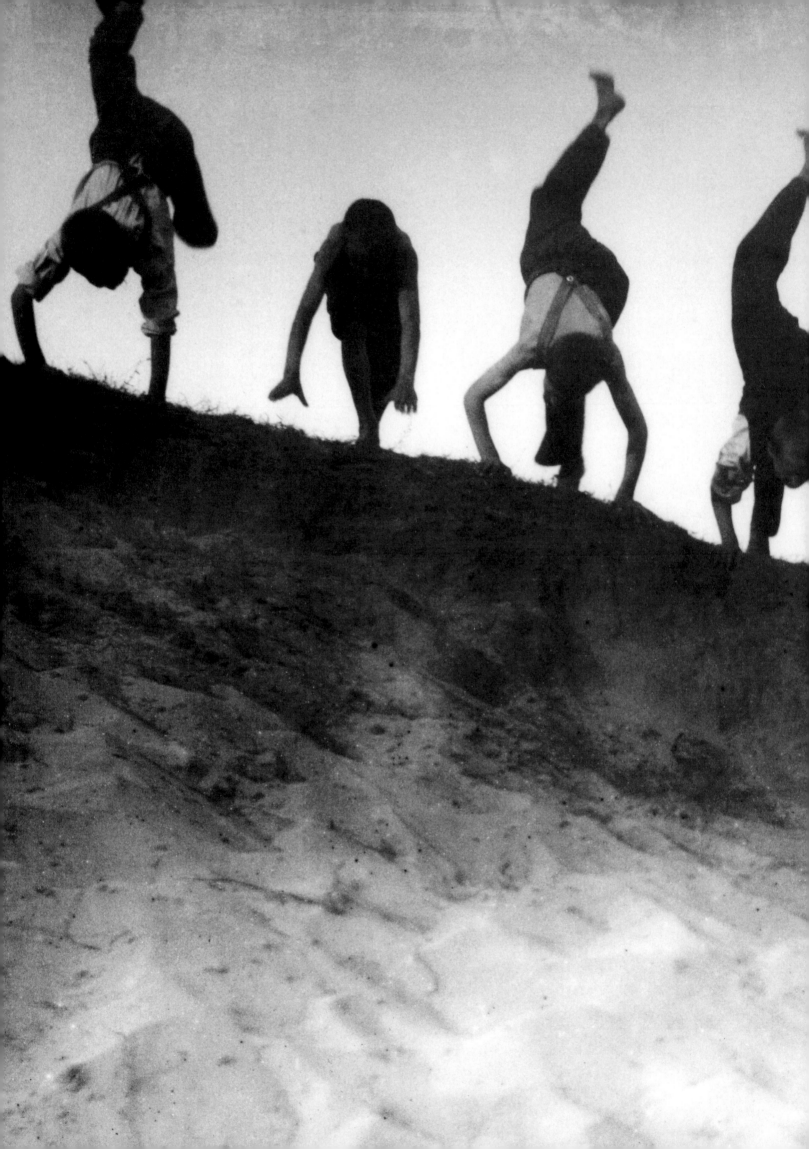

the child fantastic
1900 – 1930

Heinrich Zille, c.1900

A WORLD TO BE BORN

UNDER YOUR FOOTSTEPS.

SAINT-JOHN PERSE

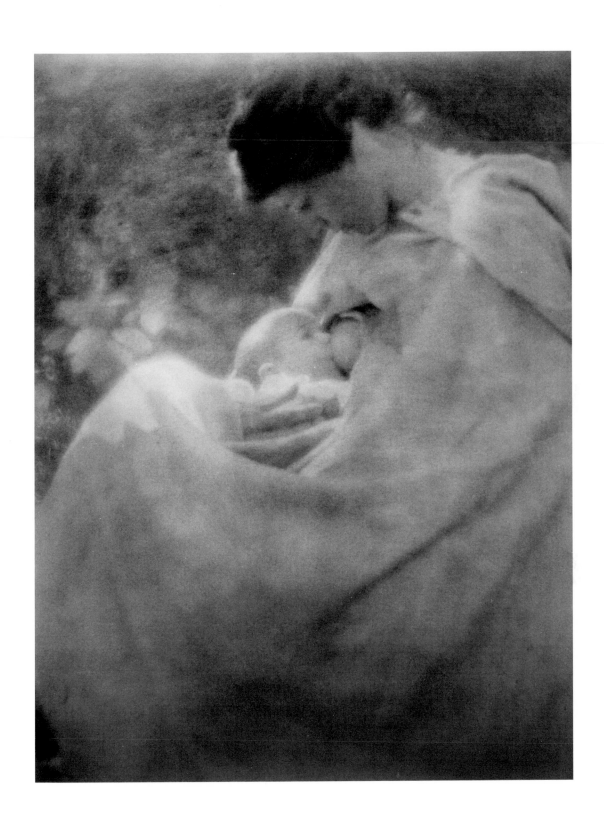

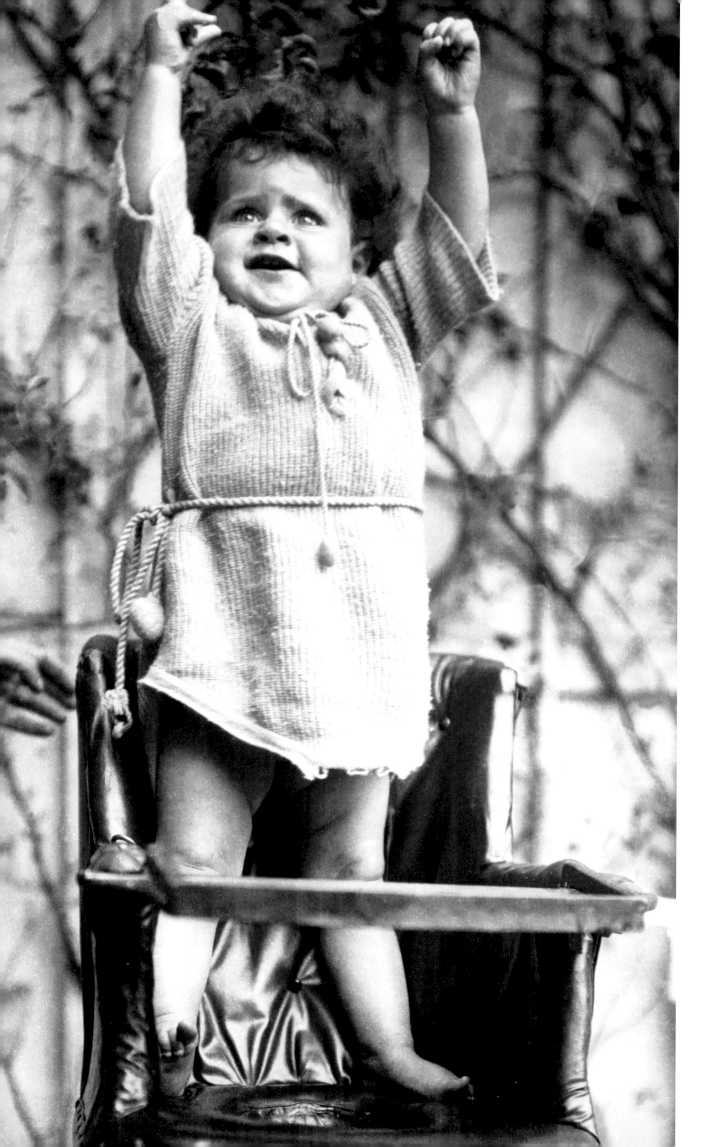

the curious child

As the new century began, Queen Victoria's long and defining reign ended with a royal whimper, followed by a populist roar. Her extended family -- czars, kaisers, kings and queens -- still held court throughout Europe, yet not one of them came forth to match her brilliance. This void was filled by the confidence, optimism and curiosity of the common man, in both Europe and America. It was done with dazzling verve and virtuosity. The Wright Brothers rose while the Titanic sank. Ziegfeld's girls shimmied while Ford's Model-Ts chugged. The Lone Eagle soared while the Bambino scored. Helen Keller inspired while Charlie Chaplin amused. Buildings reached to the sky; trains went underground. Alexander Calder made art move; Edward Hopper made life stand still. In its infancy, the twentieth century proved to be a bit colicky. Its new machinery whined and clattered. Even thought was cranky as radical ideas clashed with Victorian sensibilities.

For children, a new world was born. They would enjoy simple pleasures, vivid sensations and exciting discoveries. Most could have their own secret garden of delights. They were free to wander their neighborhoods, swim in lakes and streams, snatch eggs from a bird's nest or steal apples from an orchard without the risk of anything worse than a clip on the ear. Raggedy Ann and the Teddy Bear joined a gaggle of embraceable stuffed pets to allay the anxieties of children, who were then beginning to sleep in their own rooms. With Lincoln Logs and Erector Sets, children were invited to playfully participate in the growth of society's infrastructure. Children trembled at *The Perils of Pauline* and *The Hazards of Helen*. They read about the Bobbsey Twins' exploits and Tom Swift's gadgets. The first Miss America, in 1924, was only sixteen years old. Adolescent girls defiantly bobbed their hair and powdered their faces, and adolescent boys tapped their cigarettes to brandish their newly acquired sophistication. What in fact was occurring was the emergence of adolescence as a powerful cultural, consumer and behavioral force.

Unknown Photographer: Alice, Edith and Lillian Luhrs: 1907 (hand-painted photograph)
Erwin Blumenfeld: Lisette, 1923 (left)

Throughout all this tumult, the construct of childhood continued to flourish. It was nourished by many social factors -- the steady elevation of the status of the family, the state's acting as protector, steady progress in the removal of children from the workforce, the enhancement of children's education and the introduction of child psychology as a distinct field of study.

Family life changed radically in the early twentieth century. The middle-class family became more stable and more intimate. The decline in infant mortality meant that more children lived beyond their early years. Siblings were closer together in age without the gaps that had previously been caused by premature deaths. Parents had fewer children because the ones they did have were more likely to survive. As new laws gradually barred the very young from the workplace, children came to be viewed as having more of an emotional than an economic value. All of these factors generally strengthened the bonds between parents and children as well as those among siblings, and the family became a more cohesive and mobile unit.

The early twentieth century saw the beginning of government involvement in child welfare. It was no longer assumed that parents would or could always do the right thing with regard to their children. Industrialization and its resulting urbanization had created problems that the average citizen was not equipped to handle, and nations began to view the welfare of their children as critical to the future of the state itself. Rudimentary child labor laws were enacted; juvenile courts were created. In an effort to further decrease infant mortality, the state promoted health and hygiene for infants. Vaccines were developed to stem the ravages of diphtheria, tetanus and other serious diseases, and the pasteurization of milk became commonplace.

By 1930, every state in the United States and nearly all European countries had passed compulsory education laws. It was at this time that John Dewey, an American philosopher and educator, promoted the theory that education's essential purpose was to help a child reach the height of his or her potential. Unfortunately, most countries were slow to implement Dewey's goals, considering education more of a mechanism for determining rank. Since social order was believed to be dependent on hierarchy and deference, states geared their educational initiatives to reinforcing a sense of order.

Perhaps the most profound benefit for children during this period came from the recognition that they were a distinct and apt subject for psychological study. America was shocked when two youths with all of life's advantages sadistically bludgeoned to death a fourteen-year-old neighbor, just for the thrill of it. Nathan Leopold and Richard Loeb's crime sounded a warning bell. Educators and psychologists like L. Emmett Holt, G. Stanley Hall, Sigmund Freud and Carl Jung began confirming the correlation between childhood experiences and adult actions, and argued that those experiences form a complex mosaic that can lead to adult failings.

Freud led the way when he established that neuroses in adults often have their origins in childhood. He further postulated that children sense sexuality virtually from birth,

a decidedly un-Victorian view. Melanie Klein developed the concept of child psychoanalysis, believing that children represent in their play their own dreams, wishes and fears. By the twenties, the field of child psychology was firmly established.

It seemed clear that the renowned Swedish sociologist Ellen Key was right: democracy and science had unleashed a vibrantly new and positive approach toward children, ushering in what she called the "Century of the Child." The confidence engendered by the enthusiasm of the twentieth century was contagious. The richness of life in the first years of that century helped destine its children for greater things, and that era produced some of the world's greatest doers and dreamers, artists and writers, inventors and innovators. An eight-year-old Balthus was painting his cat. Miro and Cocteau were accomplished artists before they reached sixteen. Pearl Buck, Ayn Rand and Margaret Mead were experiencing a youth that would serve as the foundation for their future writing. Alfred Kinsey had a gleam in his eye while Helmut Newton was eyeing beauty. Walt Disney was watching ducks and chasing mice while Theodor Seuss Geisel dreamed and doodled.

Mark Twain may have been right when he said: "Better to be a young June bug than an old bird of paradise." The old order was over; the young were curious and confident and felt that it was now their time. They had witnessed unprecedented wonders -- planes flew, trains roared and electricity lit up the night. For them anything seemed possible, and maybe, with a little bit of pixie dust, they would figure out a way to make cows (or even men) fly over the moon.

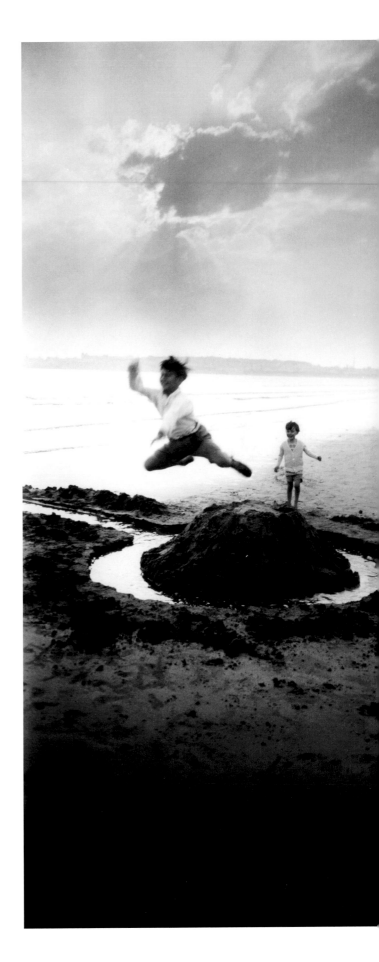

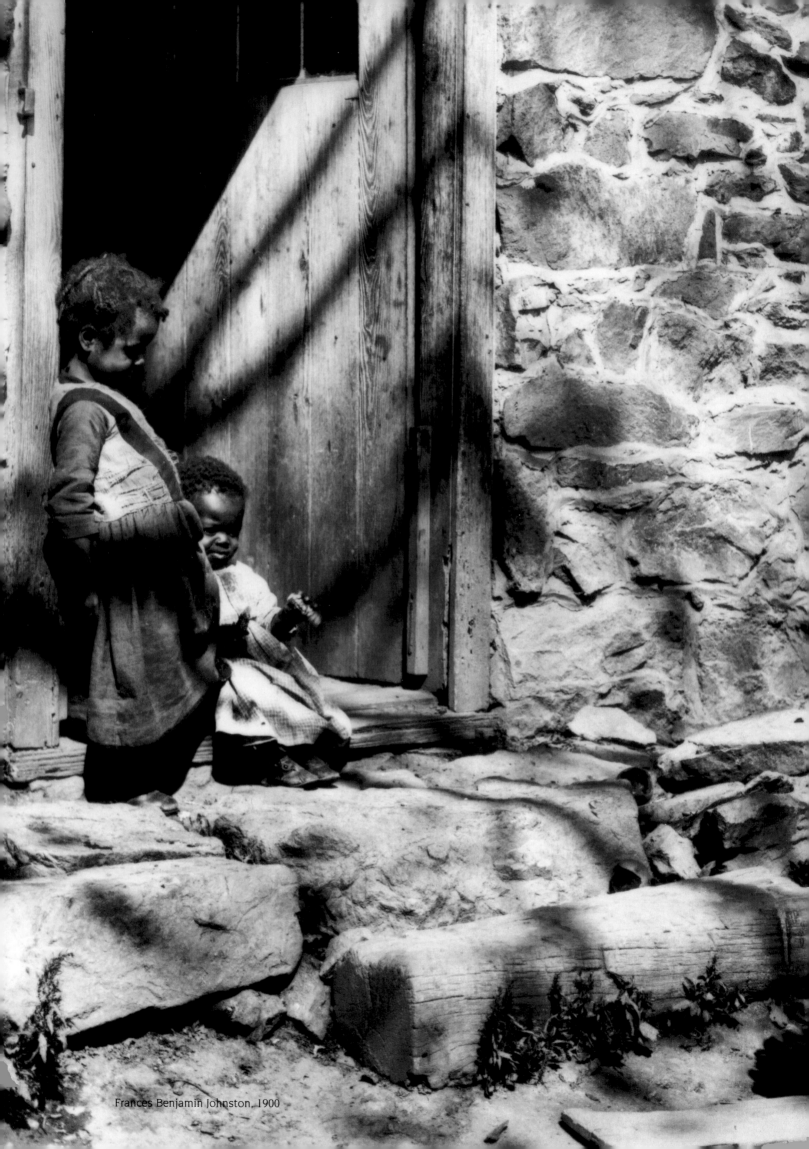

Frances Benjamin Johnston, 1900

KNOW YOU WHAT IT IS
TO BE A CHILD.
IT IS TO HAVE SPIRIT,
TO BELIEVE IN LOVE.
IT IS TO BE SO LITTLE
THAT ELVES CAN REACH OUT
AND WHISPER IN YOUR EAR.
IT IS TO TURN LOWNESS
INTO LOFTINESS AND
NOTHING INTO EVERYTHING.
FRANCIS THOMPSON

61

Emily and Lillian Selby, c.1900

the focused child

ART IS A FRUIT THAT GROWS IN MAN, LIKE . . .
A CHILD IN ITS MOTHER'S WOMB.

JEAN ARP

By the turn of the century photography had woven itself into the fabric of everyday life. Technological advances permitted photographs to preempt the visual component of newsprint, banishing engravers to other media. Photo-dominated publications proved vastly popular and advertisers were won over by photography's sales potential. The mass media grew at an astonishing pace. By 1920, Europe boasted of scores of daily newspapers as well as hundreds of illustrated magazines and journals, and its photography culture became known throughout the world for its vibrant experimentation.

It was, however, the introduction in America of an inexpensive little camera, made and marketed for children, that brought photography into the mainstream of everyday life. The Brownie (named after a then-popular children's story about elves) turned out to be popular not only with children but even more so with their parents. Its arrival heralded the advent of snapshot photography and its impact was thunderous. Amateur photography became a universal folk art, the most democratic form of visual expression the world had ever known. Photographs were everywhere. Photohistorian Peter Turner speculated that within a few years after the Brownie's introduction, more photographs existed than bricks. Photography was no longer the exclusive domain of the professional; everyone could give it a try.

For all of photography's popular success, many practitioners feared that it would never take its place in the world of fine art. That concern proved unnecessary, for the first third of the new century produced a corps of men and women who raised photography to an art form. Peter Henry Emerson and Henry Peach Robinson led the way. They, in turn, ceded the movement to Alfred Stieglitz, who would emerge as the prophet and pathfinder, and one of the first American photographers to be called a great artist. Stieglitz was followed by Edward Steichen, Gertrude Kasebier, Paul Strand, August Sander, Walker Evans, Martin Munkacsi, El Lissitzky, Alexandr Rodchencko, Brassai, André Kertész and, later, the great master Henri Cartier-Bresson. The work of these artists and countless others put to rest any lingering doubts about photography's place among the arts and, once again, children served as effective subjects.

The transition from the nineteenth century to the twentieth represented a movement from certainty to uncertainty. New ideas questioned the established order of things. Although artists enthusiastically embraced these concerns, there remained for many a nostalgia for a simpler past. Photography had a response to this dilemma. By printing on platinum paper, many sought the alchemy of the darkroom to create works that resembled drawings and prints more than photographs. These printing techniques allowed the art photographer to add a poetic gloss. This quality rather than clarity became the order of the day. It was this ability that many

critics thought separated the artist from the amateur photographer.

Artists wanted to do even more with the medium and there arose among some photographers a turn-of-the-century movement called Pictorialism. Employing the technique described above and utilizing subtle tones and soft focus with an emphasis on domestic imagery, landscapes and still life, practitioners such as Alice Boughton, Gertrude Kasebier, Alvin Langdon Coburn, F. Holland Day and Clarence White developed an emotive and intuitive style and created "inscapes" -- imagery that highlighted the inner consciousness rather than the surface reality. This style, they felt, would offer an idyllic interlude from the discordant frenzy of the modern world.

Women participated in the art of photography from its inception. Their presence was more pervasive than in traditional art media, perhaps because they could pursue photography without formal art training, which was often closed to their gender. Whatever the reason, they were in fact a force during this period, particularly in the Pictorial Movement. Kodak used a woman as its spokesperson. The Kodak girl -- fashionable and independent, yet feminine -- proved an effective marketeer.

While the conventional divisions of labor dictated that children belonged in the day-to-day world of women, many male photographers found inspiration in their children, often making them the subjects of their best work. Some of the most endearing images of Stieglitz, Steichen, Strand and Edward Weston are of children. Weston was particularly intrigued by the photographic possibilities he could explore with his son Neil.

Alice Boughton, 1929
Edward Weston, Neil, 1925 (right)

A completely different aesthetic came to be called "snapshot art." New camera technology made possible spontaneous, nondiscriminatory and nonjudgmental imagery. Snapshots were able to catch casual fragments of life's experiences. For many, they replaced diaries as amateur picture-makers used them to chronicle their lives. Roland Barthes, the French linguist, dubbed snapshots "clocks for seeing," for they froze moments for future revisiting. Recognizing that the hand-held camera granted the image-maker virtually unlimited freedom, photographers felt liberated from the conventions and confines of composition and subject matter. Images of children found a central place in this new aesthetic. Kertész, Brassai, Sander, Munkacsi and Cartier-Bresson, while utilizing a full array of subjects, often included children, whose unrepressed energy reflected the dynamism of the period.

The dean of the snapshot aesthetic was Jacques-Henri Lartigue. Astonishingly, Lartigue mastered the art of photography when he was a child. Born to a wealthy, eccentric family, Lartigue took his first picture when he was six. He later confessed that he used the camera to ensure that a moment in time that he loved would be recorded forever. Before he learned photography, he devised a little ritual to remember those moments. He would blink three times, open his eyes wide and do a somersault. The camera proved a better way. He photographed extensively in and around his home. The home for a child is often the site of his very personal fantasy, complete and secure. Proust called it a boundary against the loss of innocence. It was there that Lartigue worked his real magic.

For his whole life, Lartigue remained that youthful amateur in spirit. He was never burdened by ambition or the need to earn a living. It would be unfair, however, to credit his artistry merely to the fact that he was not corrupted by the pressure of professionalism. Hundreds of children with similar backgrounds were given cameras at the turn of the century but they never rivaled Lartigue. His secret was that he could capture the majesty and adventure of childhood leisure as only a child could see it. He made adult viewers aware of what they had lost.

The late Richard Avedon may have said it best: "I think Jacques-Henri Lartigue is the most deceptively simple and penetrating photographer in the history of that art. While his predecessors and contemporaries were creating and serving traditions, he did what no photographer has done before or since. He photographed his own life. It was as if he knew instinctively and from the very beginning that the real secrets lay in small things. And it was a kind of wisdom -- so much deeper than training and so often perverted by it -- that he never lost. The laughter he showed us with his images was the result of very personal moments, and he could relive them again and again -- even without somersaults."

From that point on, photography movements proliferated and kept pace with the times, and included Futurism, Dadaism, Constructivism, Precisionism and, finally, Surrealism. The child as muse was temporarily set aside, perhaps as a consequence of the senseless ferocity of the Great War, or because artists were exploring the formal,

modern possibilities of internalizing their art. For these movements, the child had to share center stage.

During this exhilarating time, to use André Kertész's words, "everything was a subject; every subject had its own rhythm." Art photography was now in its adolescence -- rambunctious, energetic, creative and enthusiastic. The "second child" of the arts -- as Avedon called photography -- had little more to prove. László Moholy-Nagy, the great Hungarian artist and Bauhaus instructor, saw the medium as essential for sensory understanding in modern times. He went so far as to predict that the "knowledge of photography |would eventually be| just as important as the knowledge of the alphabet." With industry and technology making life more abstract, photography would become, as he put it, the "new way of seeing." The "Recording Angel," as the Victorians called it, had come a very long way in a short time.

Jacques-Henri Lartigue, 1911

Martin Munkacsi, 1929

Jacques-Henri Lartigue, 1929

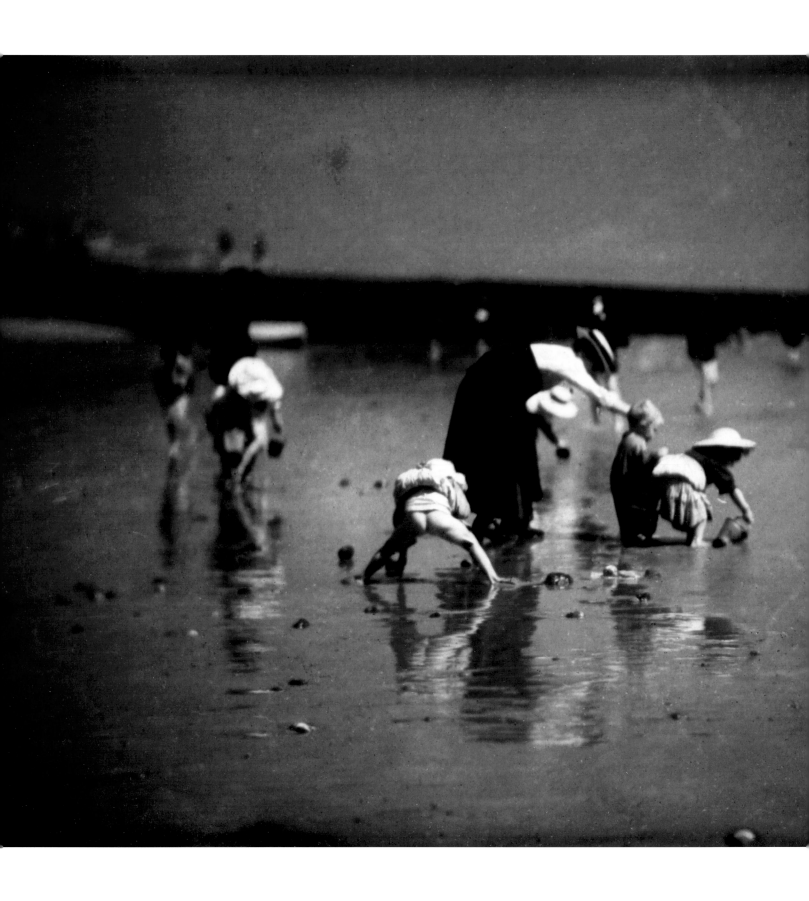

Otto Pfenninger, 1906

HEAVEN LIES ABOUT US IN OUR INFANCY!
WILLIAM WORDSWORTH

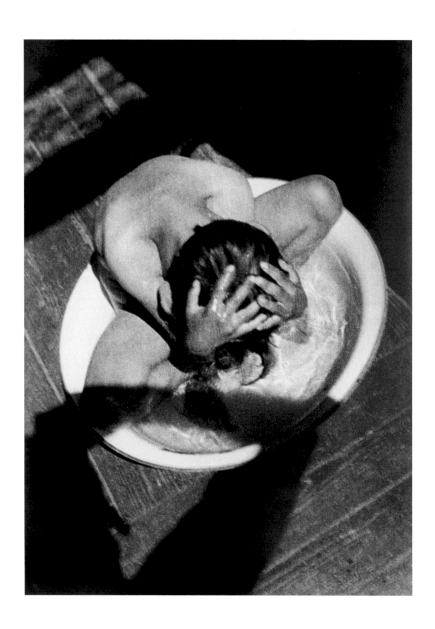

Alexandr Rodchenko, 1930

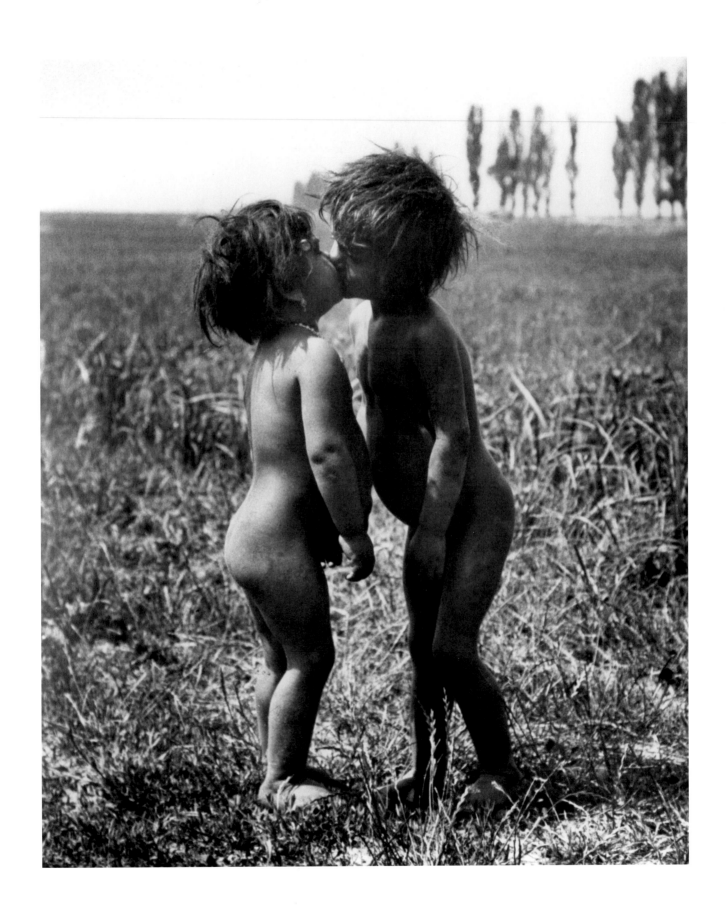

Andre Kertesz, c.1920

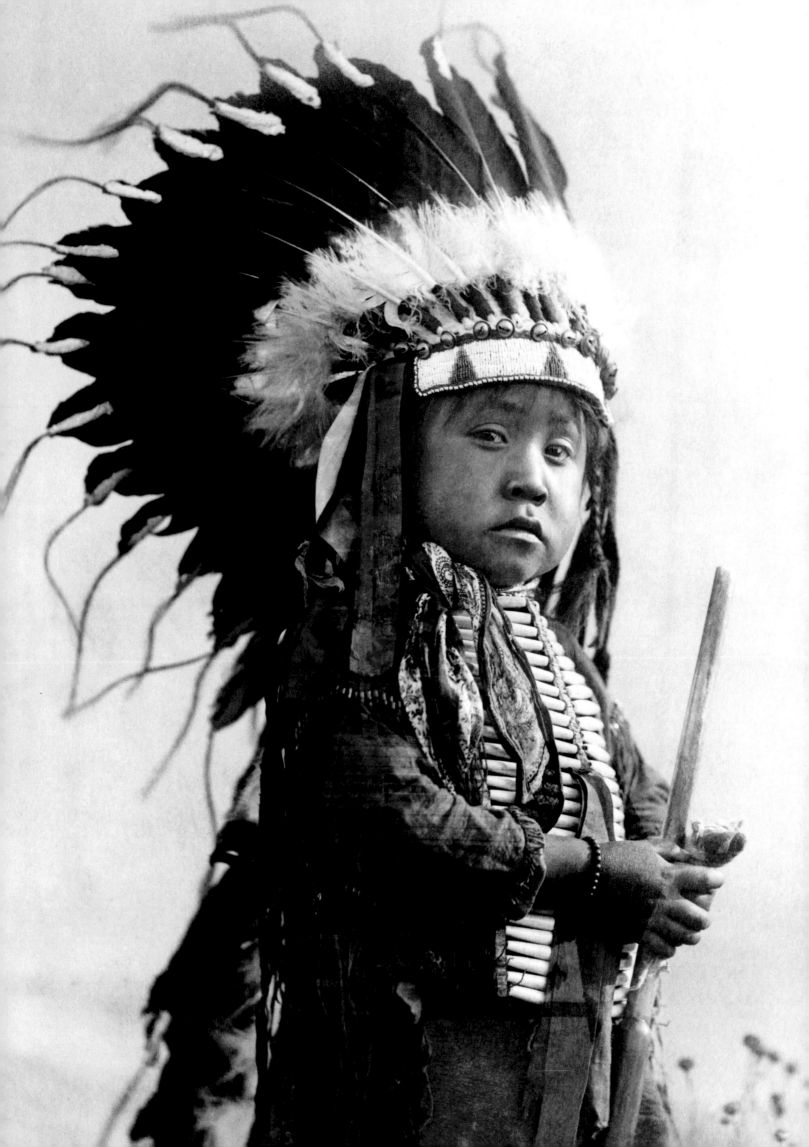

Two printing innovations
occurred during the early part of
the twentieth century, giving the
photographer more resources to
work with. The enhanced quality
of platinum paper permitted
greater black-gray variation,
and its use proved particularly
effective for art photographers
and anthropological pictorialists
such as Edward Curtis and
Richard Throssel. Platinum print-
ing helped them create visual
sympathy for a culture that was
vanishing. Unfortunately, they
often did so at the expense of
authenticity. In 1903, full-color
photography was invented in
France by the Lumière Brothers.
The process, called autochrome,
introduced an array of colors by
coating glass plates with dyed
starch grains. The process was
replaced in the thirties when
Kodachrome was introduced.

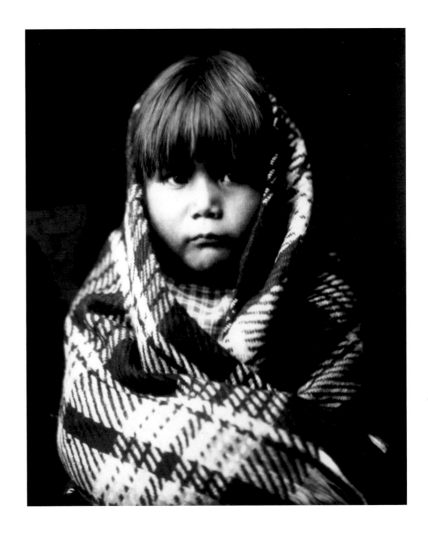

Edward Curtis, c.1904
Richard Throssel, c.1900 (left)

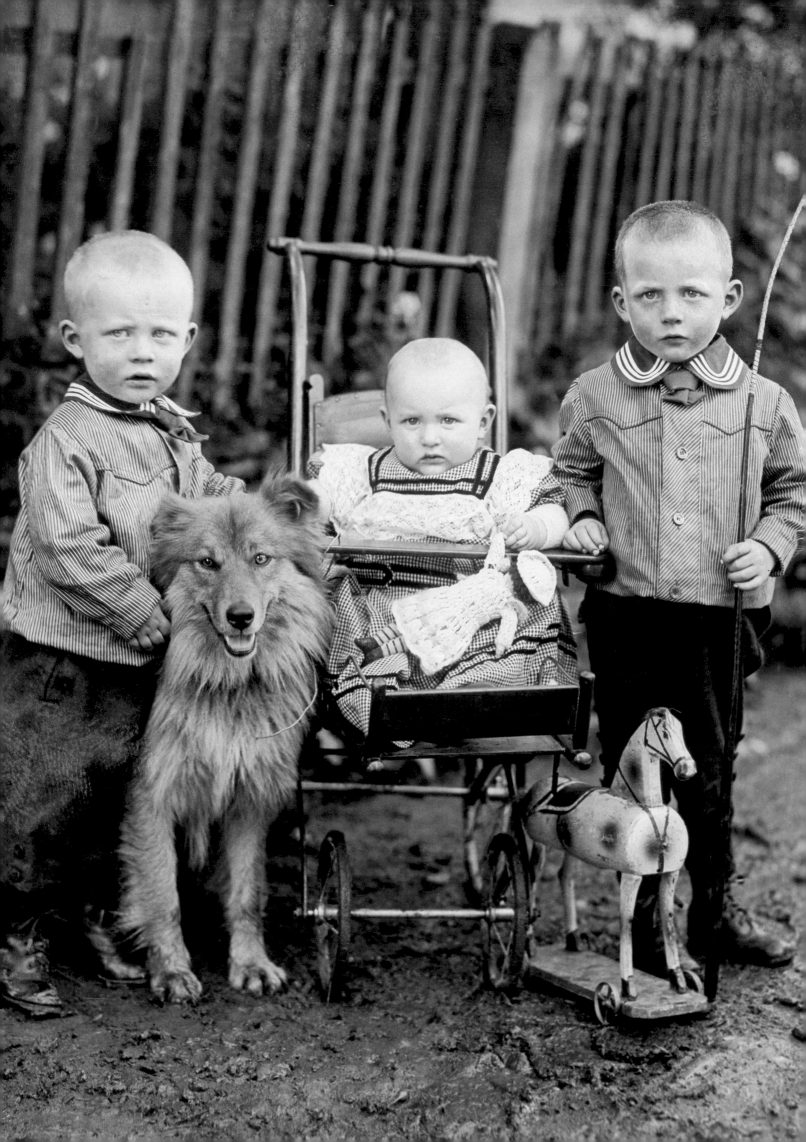

CHILDREN ARE REMARKABLE FOR THEIR INTELLIGENCE AND ARDOR,

FOR THEIR CURIOSITY, THEIR INTOLERANCE OF SHAMS,

THE CHARITY AND RUTHLESSNESS OF THEIR VISION.

ALDOUS HUXLEY

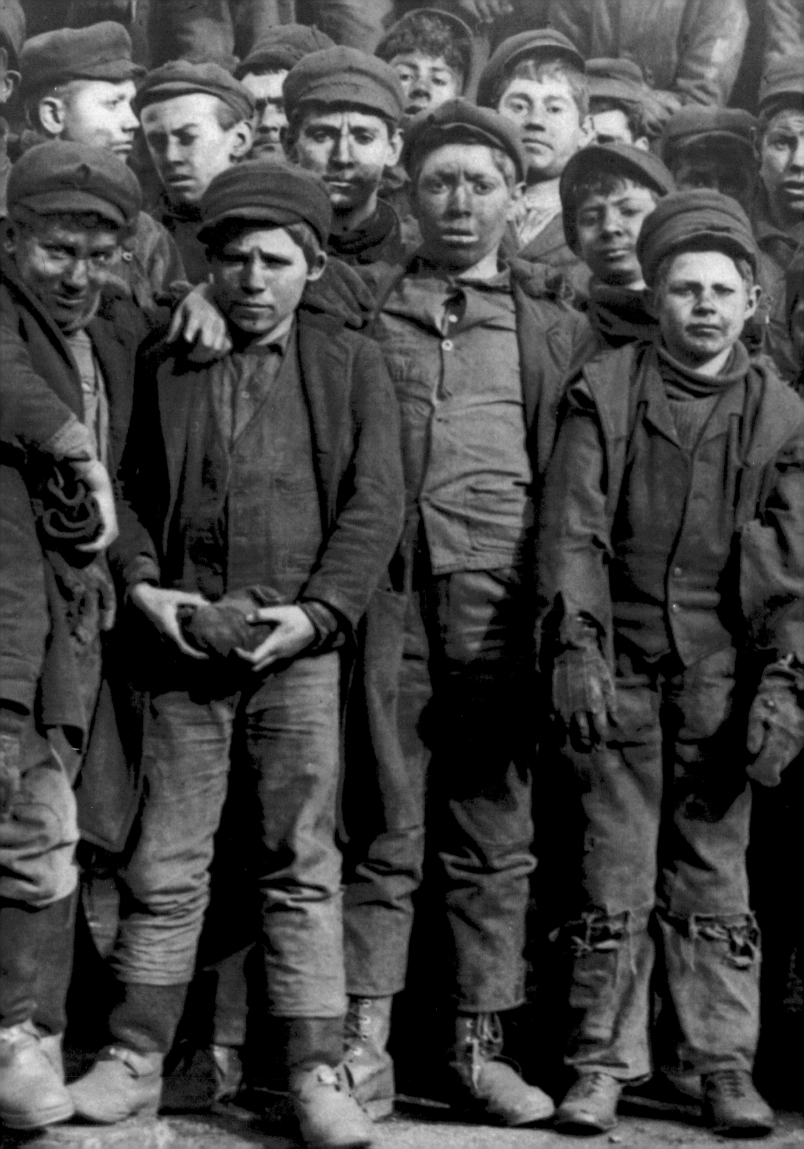

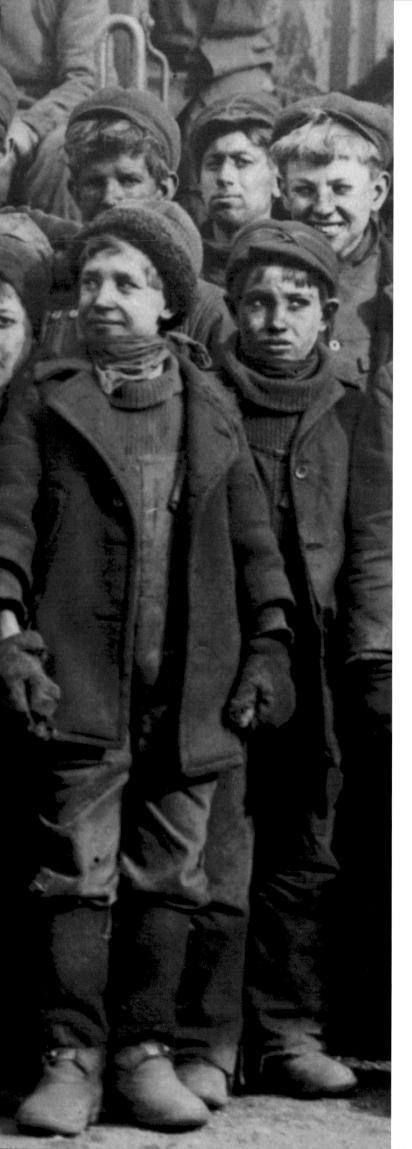

the indentured child

YOUTH, EVEN IN ITS SORROWS,
HAS A BRILLIANCE OF ITS OWN.

VICTOR HUGO

The excitement and enthusiasm of the new
century and the vibrancy of its children's
literature were not enjoyed by all children, for
no society has succeeded in embracing all of
its young. Poverty, exploitation and suffering
continued to be visited on the less fortunate.
In addition, the age of enlightenment, in both
Europe and America, conveniently ignored
working children. Although laws had been
enacted to prevent the employment of chil-
dren under seven, in excess of three million
children between seven and fifteen worked,
often for more than ten hours per day. These
children spent most of their waking hours
working the machines of progress or toiling
in the sun to harvest their nation's crops.

Between 1900 and 1930, life may no longer
have been a struggle for survival, but for
many it was still a long way from paradise.
In America, a house carpenter earned $3.25
per day, while a car cost $800 and Coca-Cola
four cents. The poverty level for a family in
the industrialized states was defined as an
annual income of $460 or less. In that context,
a child's wages, meager though they were,
could make a difference. From a governmental
vantage point, a nation's strength was rooted
in the skills and energy of its workers. The
government was slow to address the price
that society would pay in terms of the suffering
of its adolescents and the lost opportunities
of its young.

Lewis Hine, Breaker Boys, 1915

79

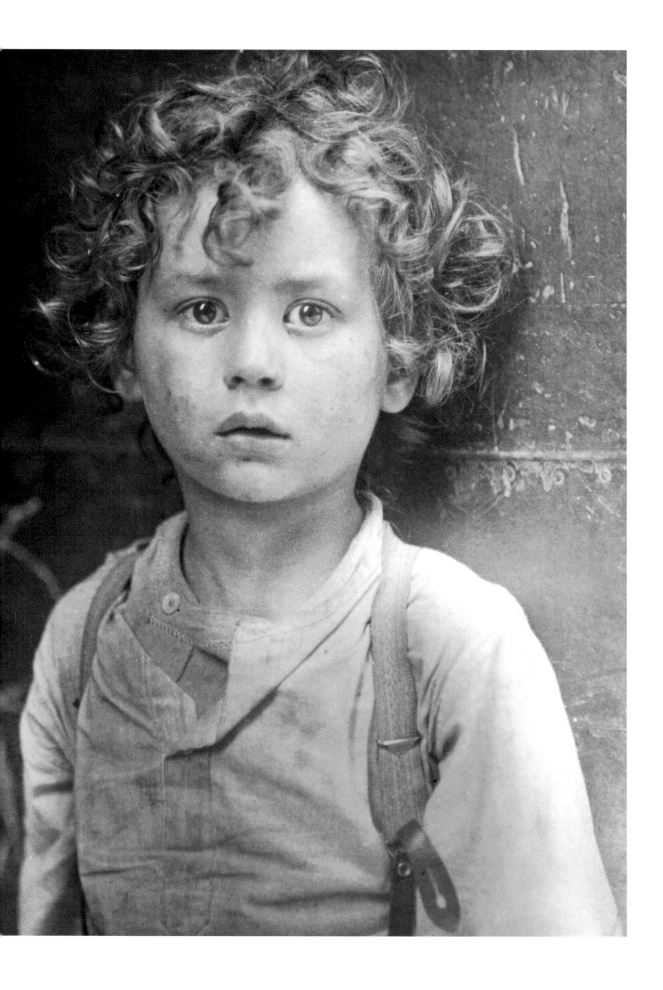

Lewis Hine, 1910

The demand for older children workers did not abate but, mercifully, laws and technology made the employment of the very young unnecessary in factories. This was not the case for agricultural workers, where even the very young were found useful. Employers in both factories and farms found adolescents to be ideal workers. They were quick, agile, and slow to tire. They had little difficulty with repetition and discipline and readily accepted the control of elders. These children were in a sense indentured to the machines that made life so liberating for others and to the harvests that satisfied the nation's appetite. For the working young, the magic of the new century was replaced by danger and drudgery.

New ideas about child development were in the air, evident in the institutions of progressive education and juvenile courts, and there was a heightened emotional investment in children. For the urban middle class, the labor of children was no longer an economic necessity. Not so for the working poor. It would take the genius of a photographer, Lewis Wickes Hine, to release these adolescents from their servitude. Hine's view was that there was no better way to address their plight than through photography. Documentation and detail would provide the basis for change.

Hine's photographic magic may well have been in the details -- bare feet, tattered clothing, hands old before their time. His images captured his subjects' inner qualities; the children he photographed were proud and alive. Although they often evinced traces of sadness, anger or resignation, they

nevertheless radiated that certain grace found in all great images of children.

Many scholars consider Hine the successor to Riis. Perhaps that is true, but the similarities end there. Riis was a journalist who used the camera to make his point. His images were highly subjective; they were intended to incite. Unrelentingly gloomy and sad, they resonate with misery. For the nineteenth-century viewer, this was novel and its visual shock worked. By the time Hine came along, images of poor children were commonplace. Social documentation photography was still in its formative period. While photographers such as Arnold Genthe, John Thomson and Paul Martin documented segments of society, they tended to emphasize the force of the subject matter rather than the quality of the imagery. Hine changed that approach. Considering himself an artist with sophisticated aesthetic sensibilities, he insisted that beauty be at the core of his imagery. He used his art for his cause -- the improvement of working conditions and the eventual removal of children from the workforce. In doing so, he created a new visual language for documentary photography.

Hine was aware of the trends in art photography and, to some extent, they presented challenges for him. Pictorialism seemed ill-suited to his purpose. Its sublime, soft-focus approach would not work. Hine wanted to make things clearer. He put the child in the center with the workplace as a backdrop. The machine was both a dynamo for change and a force that could dehumanize. Pictorialists used bucolic backgrounds to reinforce their humanism. Hine often used

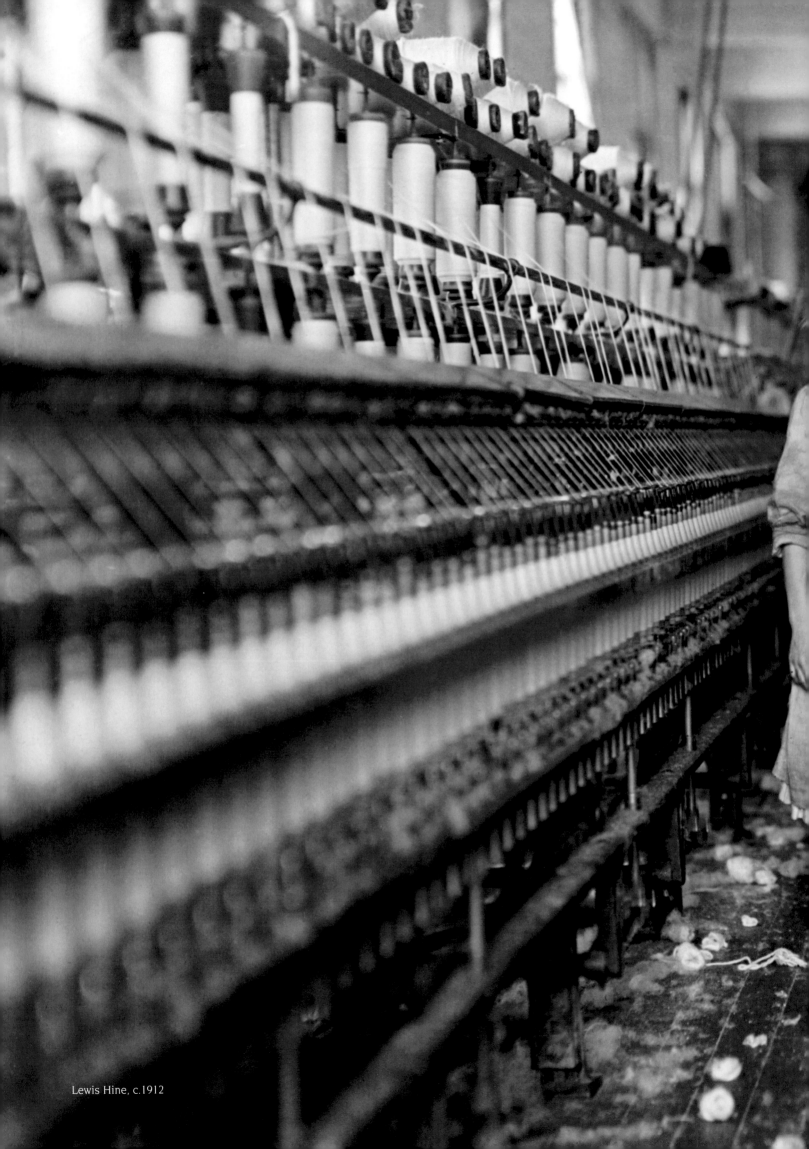

Lewis Hine, c.1912

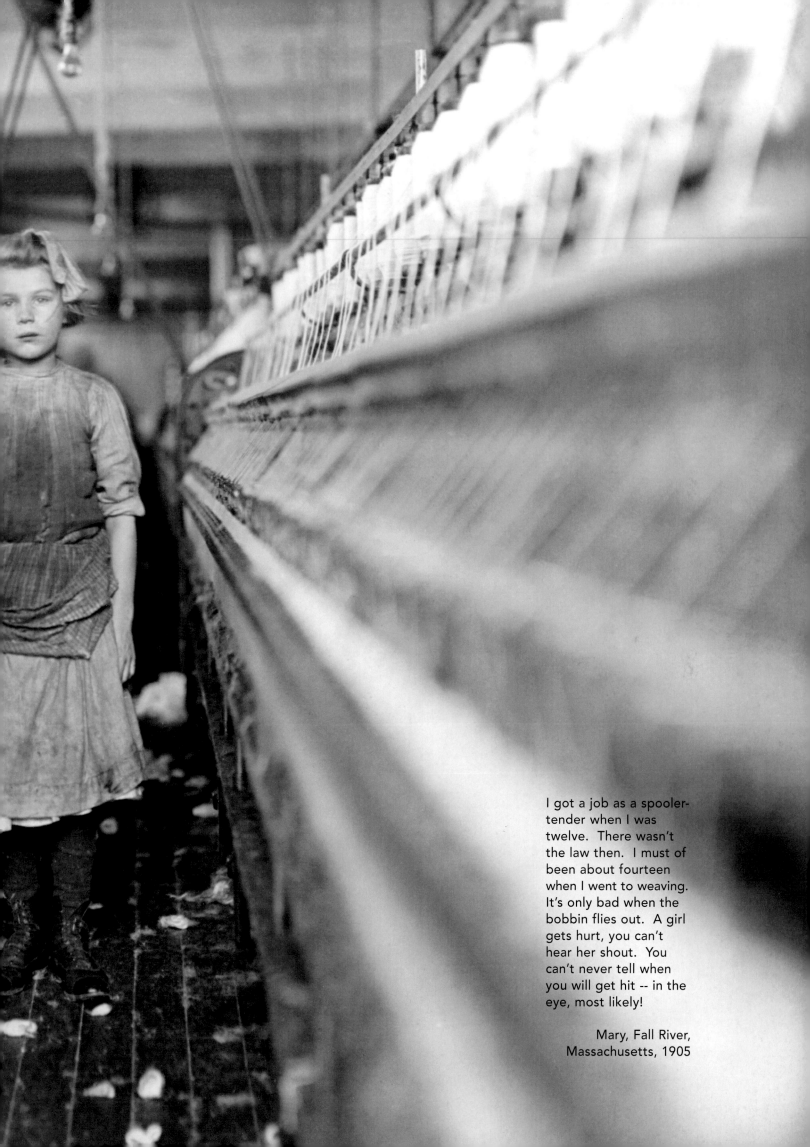

I got a job as a spooler-tender when I was twelve. There wasn't the law then. I must of been about fourteen when I went to weaving. It's only bad when the bobbin flies out. A girl gets hurt, you can't hear her shout. You can't never tell when you will get hit -- in the eye, most likely!

Mary, Fall River, Massachusetts, 1905

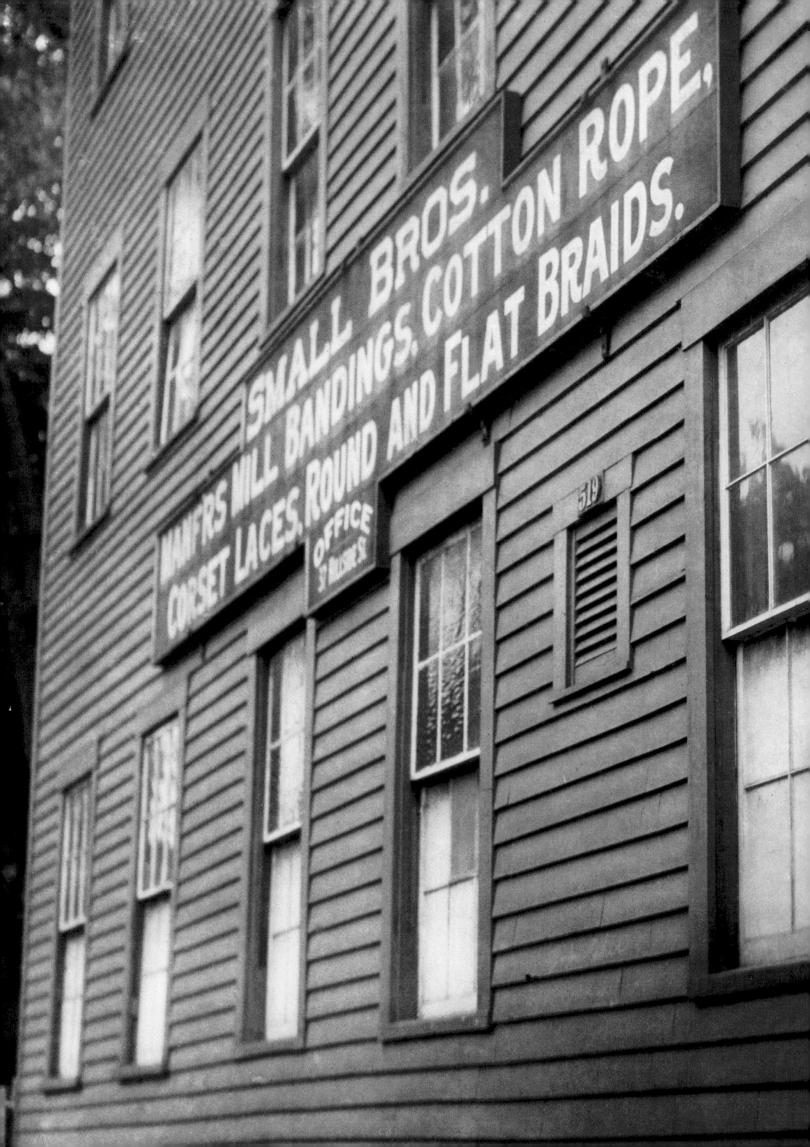

SMALL BROS. COTTON ROPE,
MANFRS MILL BANDINGS, CORSET LACES, ROUND AND FLAT BRAIDS.

OFFICE
37 BLOHRE ST.

519

backgrounds as contrast. Viewed against the symmetry of a myriad of sewing machine bobbins, the worn clothes, tousled hair and bare feet of the young stood out in vivid relief. Hine's children did not permit themselves to become accessories to the machine. Their humanity shone through. Their pride, their innate shyness and their juvenile bravado created a stark contrast to the machine's impersonality. Unfortunately, in most instances their fragility precluded their fulfilling the poses they struck. The shoes they did not have would not have fit.

Hine created a new and enduring approach to documenting the human condition. Some historians have named it "visual sociology." Building on what Riis and others had started, Hine took documentary photography to another level when he elevated his imagery to high art. He did this through the fusion of his personal concerns and his artistic genius. Unfortunately, the struggle he and other progressives waged to improve working conditions, if not to abolish child labor altogether, was to some degree compromised by a prevailing class condescension. It was not until well after World War I that meaningful child labor legislation was enacted and it occurred only after big business found an acceptable alternative to child labor in automation.

Walker Evans once noted that "[w]hat was good in the so-called documentary approach to photography is the addition of lyricism." Whether intentionally or accidentally, Hine's work resonates with a lyricism that is seductive and persuasive. His steadfast application of his artistry to his cause created what he wanted most -- "a Human Document to keep the present and the future in touch with the past."

PERHAPS YOU ARE WEARY OF CHILD LABOR PICTURES.

WELL, SO ARE THE REST OF US,

BUT WE PROPOSE TO MAKE YOU

AND THE WHOLE COUNTRY SO SICK AND TIRED OF THEM

THAT CHILD LABOR PICTURES WILL BE RECORDS OF THE PAST.

LEWIS HINE

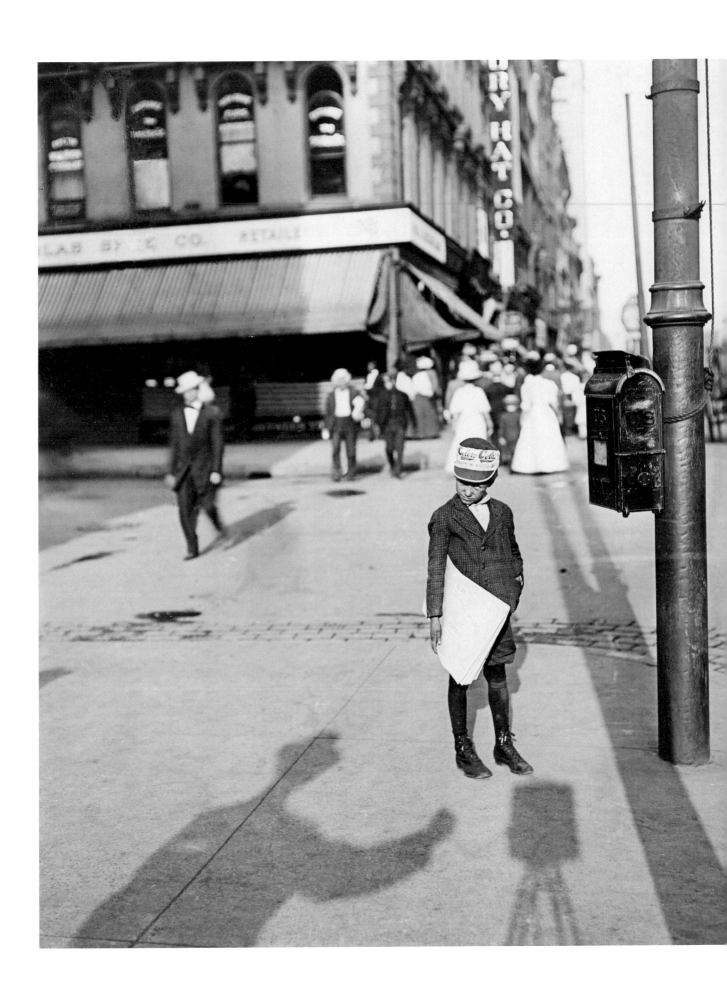

Lewis Hine, Photographer's shadow, 1908

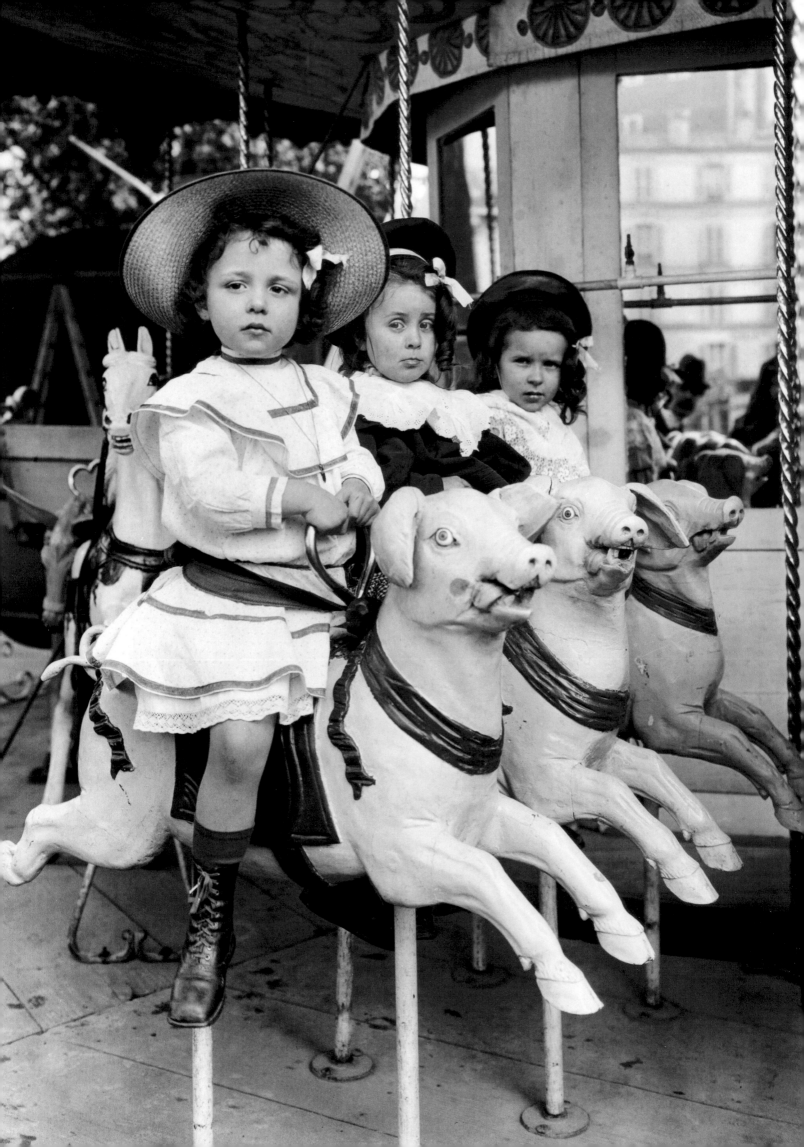

the enchanted child

CHILDREN, LIKE ANIMALS, USE ALL THEIR
SENSES TO DISCOVER THE WORLD. THEN
ARTISTS COME ALONG AND DISCOVER IT THE
SAME WAY ALL OVER AGAIN.

EUDORA WELTY

The new century wasted no time in creating a leisure culture for its children. Baseball, nickelodeons, arcades, movies and, above all, books filled their lives, particularly in the child-centered middle class. It could be said that children's literature went to the dogs -- or, more accurately, to the animals. By this time, virtually every young child shared a crib with a floppy-eared dog, a stuffed bear or a fuzzy rabbit, and household pets were common. Children have always had an affinity for animals, stuffed or real, especially those that are small and young, kindred in their dependency, innocence and curiosity.

In these exhilarating and tumultuous "modern" times, children's literature sought out a less complicated world. The islands, forests, woods and streams where animals lived, whether real or imagined, proved a comfortable place for literature to go. Dorothy left Kansas for Oz and Buck heard the call of the wild, while Wendy flew off to Neverland. Peter Rabbit ran to the fields looking for trouble while Pooh was content to stay in the confines of Hundred Acres. Moles and Rats messed about in boats, while a Toad and a Badger conversed in the wild woods of Kenneth Grahame's reveries. Ultimately, all would always end well. This genre was quite acceptable to the young, for in their innately egocentric ways, they believed that the sun and moon followed them when they walked,

that things that moved, like trains and planes, were alive, and that the stars twinkled just for them. Thus, a child would have no problem accepting that scarecrows and lions could talk, that rabbits and bears could express feelings, that the woods were always tranquil and that felicity would prevail at the end of the day. The stories in early-twentieth-century children's books were intended to allay fears while providing a vehicle for escape and empowerment, introducing children to adventures without real risk. The hero and heroine were often parentless. Without that authority or protection, their adventures were at once exhilarating and somewhat terrifying. As the world became more complex and daunting, adults welcomed sharing with their children stories of a simpler life.

Four classics, written in the early part of the new century, helped accomplish these goals. They virtually preempted the genre of happy fantasy, bequeathing to generations some of the most embraceable heroes of children's literature. L. Frank Baum and his friend and illustrator, William Denslow, collaborated to

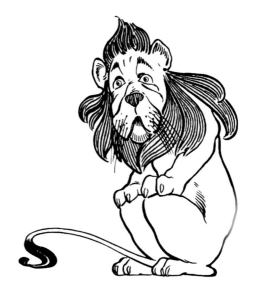

create a fable about a road trip in a land called Oz. Their book, *The Wonderful Wizard of Oz* (1900), tells the story of a feisty ten-year-old girl named Dorothy Gale who, along with her intrepid dog Toto, sets off with three challenged males in search of courage, intelligence and passion. Baum did not possess the eloquence of Lewis Carroll or the timbre of Mark Twain, but with simple dialogue he built Dorothy's character by her actions and reactions. The mood he sought was perfectly set by Denslow's images, which, while influenced by art nouveau, managed to capture Oz as more progressive than romantic.

Set in a land where all things are possible, Baum's story immortalized the American belief that if you keep your head up and plow along, you will find in your heart that personal compass to lead you back home. Baum's moral was simple. If you give children roots and wings, they may fly away but they will always have the sense and character to return. As a guide to life, this ode may now seem naïve. Yet, on Baum's yellow brick road, it seems enchanting and liberating, very much like the challenge and promise of the new century.

Dorothy had none of Alice's nineteenth-century upper-class elegance, beauty or concern with appearance and manners. In fact, she was a bit on the dowdy side -- a plain, pigtailed girl from America's heartland who overcame her challenges with gumption and good sense. Baum created a thoroughly modern *femme vitale*, a protagonist who combined rationality with kindness, assertiveness with compassion. Dorothy respected diversity; she sympathized with those who were challenged physically or emotionally. She

rejected intolerance and exhibited a healthy skepticism toward repressive rules. You knew from the start that Dorothy, like Huckleberry Finn before her, would take the right path no matter what life dealt her and you had no hesitation about joining in her quest.

Across the ocean, J.M. Barrie in his novel *Peter and Wendy* (1911) crafted a very different kind of new-century hero, more fitting to the European view of childhood. Queen Victoria was replaced by her carefree, pleasure-seeking son, Edward. No longer enamored of virtuous Victorian girls, the Edwardians transferred their affection to boys, particularly those more interested in good times than good deeds. Pan, the Greek god of nature -- half boy, half beast -- was the Edwardians' favorite deity. Barrie's young hero, Peter Pan, was the poster boy for an age that refused to grow up. Forget that Peter at his core was a selfish, flippant, rude misogynist; his engaging narcissism, fueled by constant pleasure-seeking, proved wildly addictive.

One could not conjure up two more polarized views of childhood than those exemplified by Dorothy and Peter. It is probably fair to say that the contrast is more a reflection on the state of affairs in America and Europe than on the nature of children. The United States was just beginning its ascendancy to world power -- unsophisticated but imbued with boundless energy and optimism. England was seeing the luster of decades of economic and colonial dominance tarnish. Yet both Dorothy and Peter had one essential quality in common -- youthful confidence. Dorothy believed that her grit would get her through. Peter's old-fashioned code of honor erased all his doubts. He, however, had a darker side.

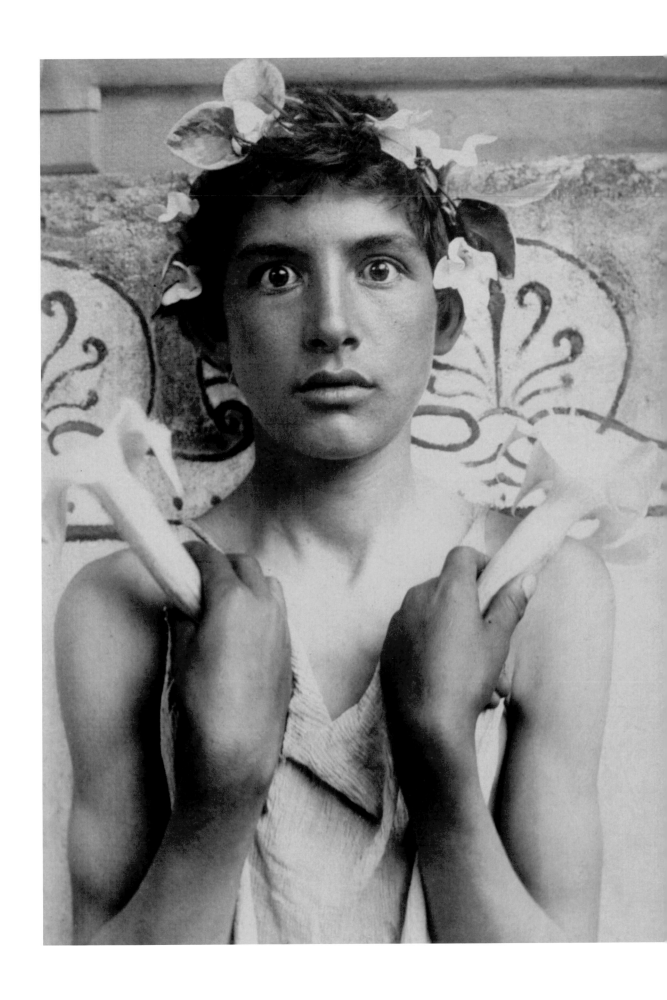

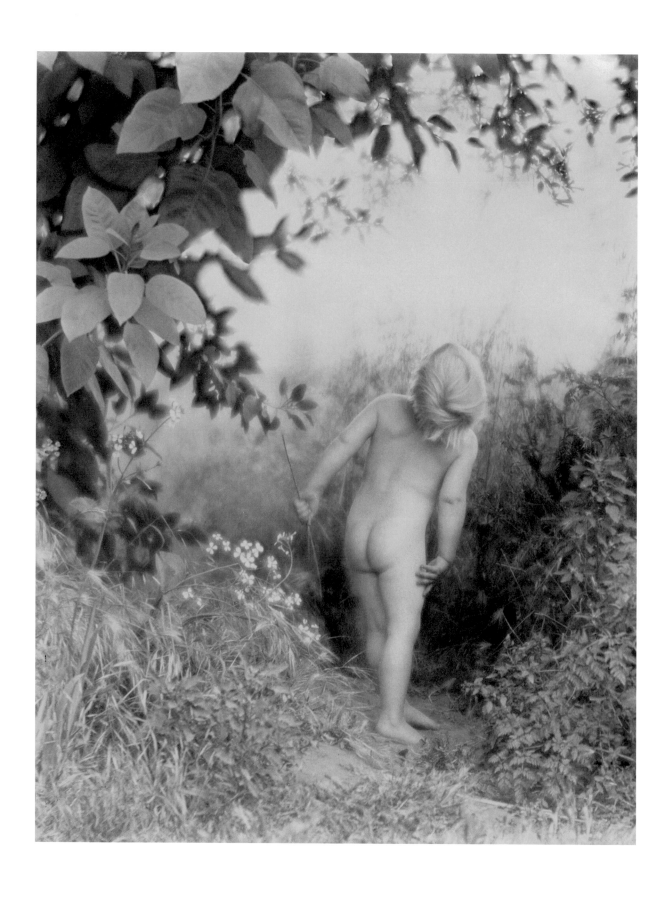

Edward Weston
I Do Believe in Fairies, 1913

BUT STILL I DREAM THAT SOMEWHERE THERE MUST BE THE SPIRIT

OF A CHILD THAT WAITS FOR ME.

BAYARD TAYLOR

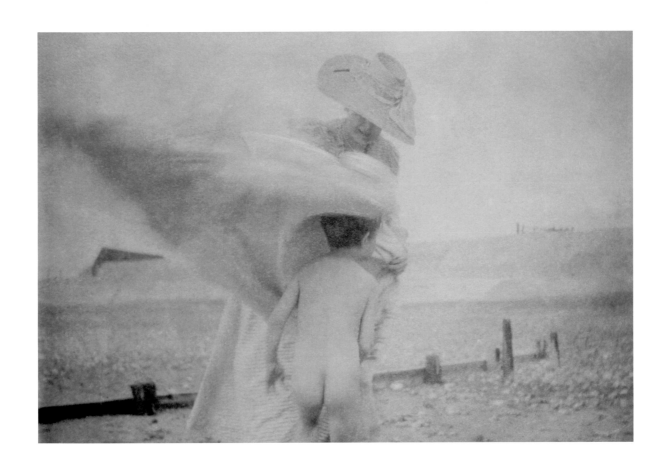

J.M. Barrie,
Llewelyn Davies's youngest child
(model for Peter Pan), c.1900

Peter and his Lost Boys are a metaphor for the rootlessness of a new society. Peter himself is the ultimate trickster, a warrior-child out to best Captain Hook and all other adult authority figures.

Unfortunately, the enchantment engendered by Dorothy and Peter was shattered by the guns of Somme. World War I quickly eroded confidence, and depression, economic and emotional, set in. Heroic adventure would soon pass from fantasy to reality. Writers stopped using children as surrogates for their lost innocence or as models for their own hedonism. It was at this juncture that children's literature gravitated to kinder and softer icons in the animal world. Anthropomorphizing animal characters made stories more accessible. Writers endowed animals with human qualities as a means of exploring children's fears, insecurities and aspirations. Some authors may have gravitated toward them due to a disdain for humans, at least in comparison with innocent animal alternatives. Beatrix Potter would clearly be in that group. Still others, like

A.A. Milne, found that it was easy to gain the confidence of children by using animals to teach by subtle example. Both produced work that was embraceable yet enchantingly profound.

Beatrix Potter possessed in abundance qualities necessary to relate to the young. Educated almost exclusively by a governess, and having absent parents and few childhood friends, she turned to animals and nature for her early life experiences. It was thus quite natural for her to communicate through stories about animals. In addition, she became an accomplished artist. (Her father was a proficient amateur photographer.) Combining her talents, Potter wrote and illustrated *The Tale of Peter Rabbit* (1902). It tells the story of a venture out from the security of home to a forbidden but romantic place -- a green world of vital growth where Potter's little hero moves toward the challenges and dangers that maturity brings. The story's charm lies in the fact that Peter knows nothing of this but the reader instinctively senses that Potter will ensure that all ends well.

Peter's trip to Mr. McGregor's garden may seem a bit daunting, but the tale is hardly cautionary. When Peter's mother buttons up a jacket that he obviously hates, she warns: "Now run along, and don't get into mischief. I am going out." Any child with an ounce of spunk would join Peter in accepting the challenge implicit in those words. As Peter loses his clothes, cries, comes home exhausted and is made to drink medicinal tea, child listeners empathize. Potter's insight about children, combined with her lack of condescension and sentimentality and a heavy dose of poetic inventiveness, makes her a quintessential children's communicator. With almost Chaucerian ease, she showcased the humanity in animals and the animal in humans long before modern science confirmed that affinity and she did so with a grace that transcends time and place.

Finally, we come to A.A. Milne's *Winnie-the-Pooh* (1926), where the fantasy in children's literature is perhaps finally tamed. Milne, ably assisted by E.H. Shepard's beguiling illustrations, crafted a story for his son and his bedtime friends. Christopher Robin, a sweet six-year-old who is just starting school and cannot yet spell, acts as a sort of big brother adviser to the stuffed animals of Hundred Acre Woods. He rules a roost populated by a fearful Piglet, a materialistic Rabbit, a single-minded Kanga, a morose Eeyore, a pretentious Owl and a beloved Pooh bear with a little brain and a big heart, who is quite content if only he has "a smackerel of something about eleven."

These animal characters, born not in the woods but on the shelves of Harrod's, are relocated by Milne just a few miles away. Hundred Acres serves as a sylvan model for a peaceful life where humans and animals exist in harmony with themselves, one another and nature, free from strife and materialistic woes, simply having "Grand Thoughts about Nothing." Milne's animals, so human and childlike in personality, provide metaphors for the daily life of the young. They make their fair share of mistakes, unkind cuts and bad judgments, just as every child does. Is there a child who would not empathize with Piglet's timidity and applaud him when he protests that it's "hard to be brave when you're only a Very Small Animal"?

Milne, to some degree, followed the Edwardian ethos of the friendship and loyalty that living in a verdant paradise inspires. Yet, in a more profound way, he took us in a new direction.

For Milne, the cult of the innocent and humble child was over. Christopher Robin and his stuffed toys had personality traits that were previously thought to be found only in adults -- neurosis, self-doubt, vanity, egotism and insensitivity. When Christopher proclaims, "Now I am six, I'm as clever as clever, so I think I'll be six now for ever and ever," he truly wishes that to be the case. Subconsciously, Christopher realizes that he must leave the forest and that the first gate of maturity will close behind him. His anxiety over change might well excuse his condescension toward Pooh, his ridicule of Eeyore and his dismissiveness of Kanga, yet the reader has to cheer when he puts the neo-fascist Rabbit in his place.

What Milne so cleverly did was to obliquely psychoanalyze the young throughout his story. He clearly felt empathy for what his young son was facing. Christopher Robin, top dog on the peak of one mountain, was losing his perch and would have to face climbing a new one, where the human inhabitants would not be so friendly and benign. Milne was able to teach this caution-ary lesson in the most felicitous of ways.

Regrettably, the clamor and carnage of the so-called Great War awakened everyone from Milne's reverie. Twenty-one million people -- combatants and civilians -- died in four years of war. Peter Pan's boast that "to die will be an awful big adventure" would prove to have a hollow ring. Barrie's pursuit of unrestrained boyhood pleasure quickly fell from fashion. Somber maturity became the order of the day. Psychoanalysis, with its recognition of childhood sexuality and emotional drives, showed that the premise of childhood's innocence and innate goodness was overly simplistic. In an increasingly complex world, childhood would change. At least for the next several decades, adults would have no time to yearn nostalgically for an enchanted youth. Mercifully, that time would pass, and the world would return to a point where one might well wish for a Tinkerbell on one's shoulder, be tempted to squeeze through Mr. McGregor's gate and believe again that there really is a place at the top of the forest where the little boy (in all of us) can be found playing.

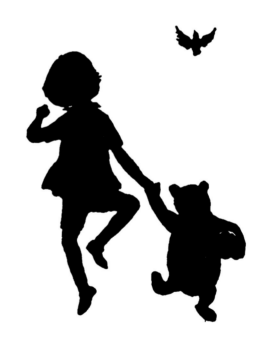

FANTASIES ARE MORE THAN SUBSTITUTES

FOR UNPLEASANT REALITIES.

THEY ARE ALSO DRESS REHEARSALS.

ALL ACTS PERFORMED IN THE WORLD BEGIN IN THE IMAGINATION.

BARBARA GRIZZUTI HARRISON

Russell Lee, Pie Town, New Mexico, 1940

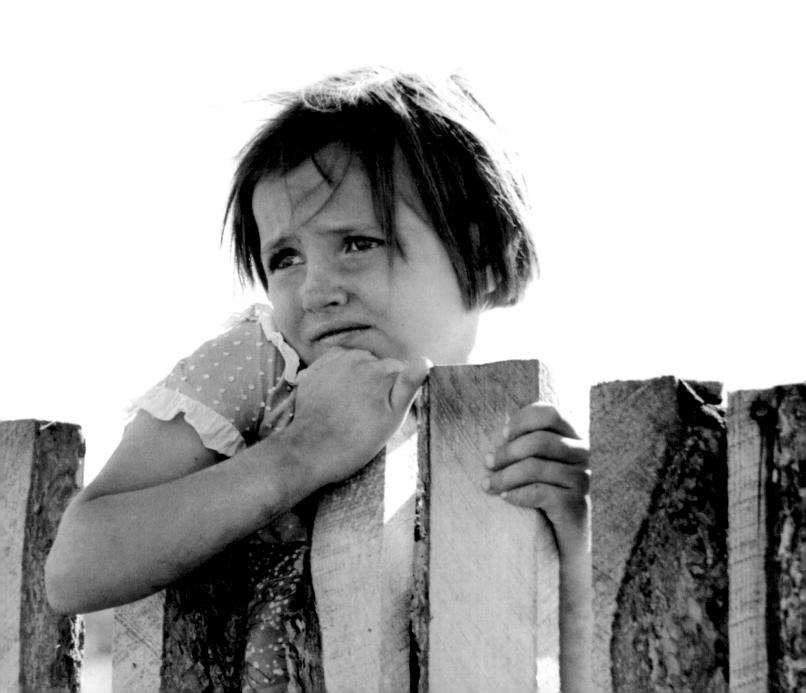

the child challenged
1930 – 1950

THEREFORE I WILL NOT REFRAIN MY MOUTH;

I WILL SPEAK IN THE ANGUISH OF MY SPIRIT;

I WILL COMPLAIN IN THE BITTERNESS OF MY SOUL.

THE BOOK OF JOB, 7:11-13

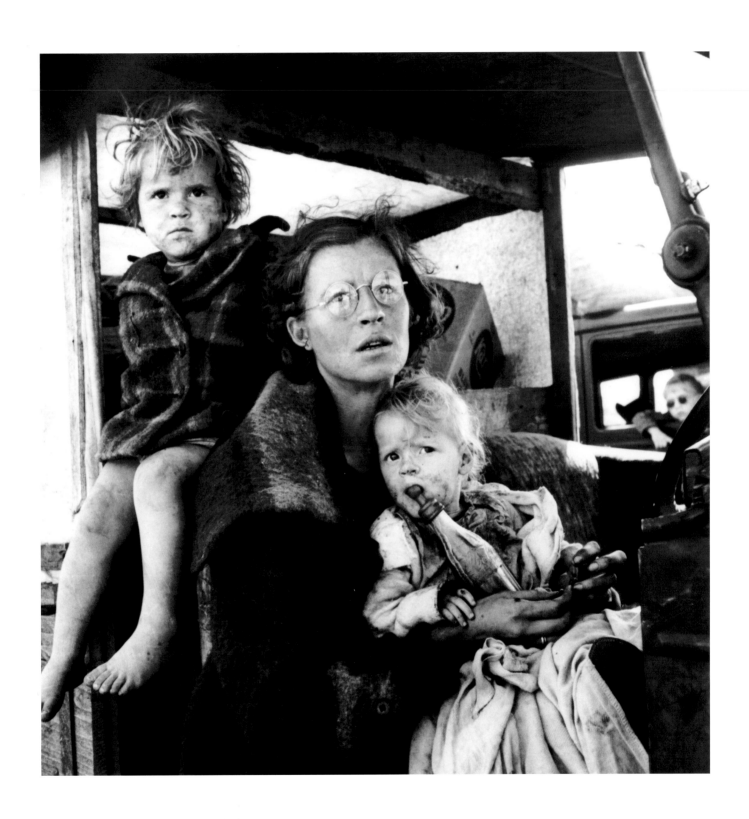

Dorothea Lange, 1939

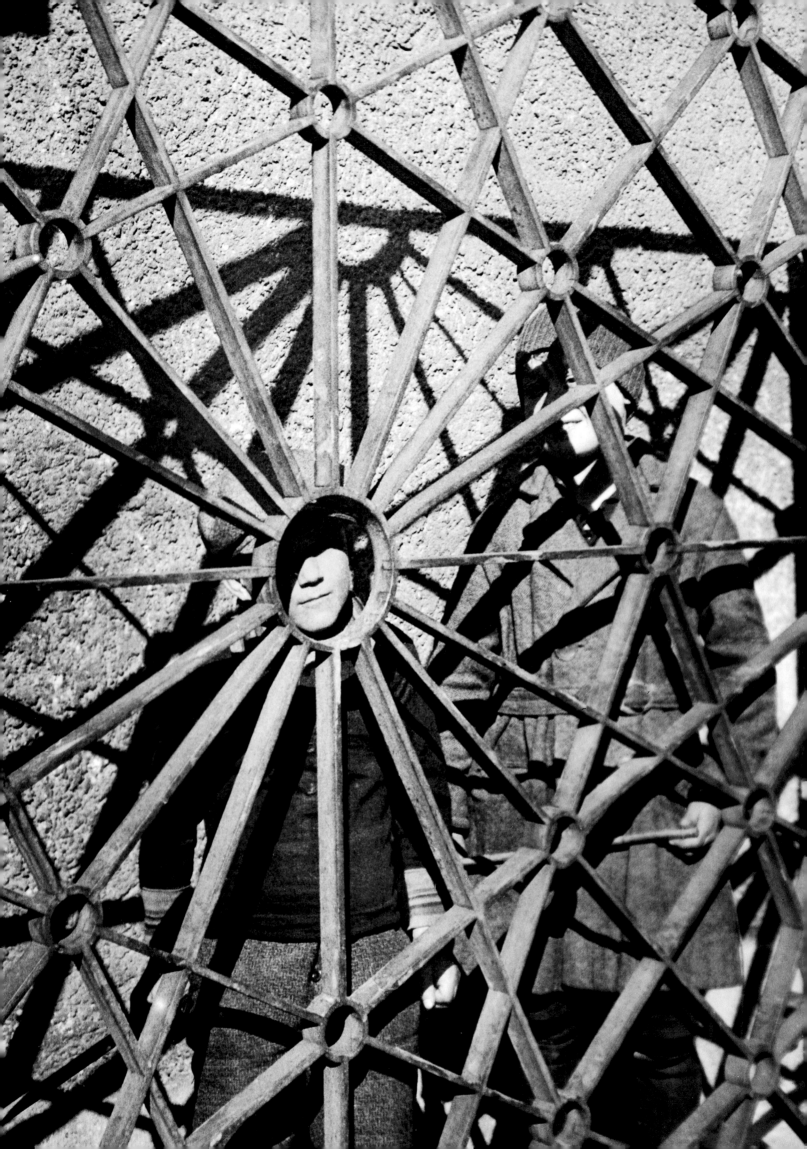

the child observed

THE CAMERA IS THE CENTRAL INSTRUMENT OF
OUR TIME [FOR THROUGH IT] ALL CONSCIOUSNESS
IS SHIFTED FROM THE IMAGINED . . . TO THE CRUEL
RADIANCE OF WHAT IS.

JAMES AGEE

It is difficult to summarize, much less synthesize, the period from 1930 to 1950. It was an era of cultural extremes: blacklists, white hoods, brown shirts; famine and feast; war and peace. The arts, including photography and literature, were forced to alter their modes of expression as well as their ideologies and iconographies as these events evolved. Despite all the turmoil, these two decades produced extraordinary photographic developments. Photographers and their patrons found forms and uses for photographs that infused them with extraordinary inventiveness, immediacy and relevance. Photography would command a preeminent place not only in the worlds of journalism, advertising and publicity but also within leading art movements.

The medium's vitality was evident throughout the world, particularly in Europe, Russia, Japan and North America. The Russians introduced the use of photography in revolutionary art, effectively utilizing unexpected vantage points and engendering a fresh rapport with the visible world. German photographers like August Sander and Albert Renger-Patzsch emphasized a more rigorous objectivity, one grounded in a close observation of detail. In the United States, Walker Evans, Margaret Bourke-White, Dorothea Lange and Carl Mydans imbued documentation with metaphor, showing that a suggestive appeal could often be more effective than

the explicit. The works of these artists broke down conventional modes of expression and firmly established photography as more than mere recordation.

Photography of children, in large part, no longer concentrated on capturing the idealized version of the happy, prosperous family and visualizing the wonders of industrialization and consumerism. The new emphasis focused on those beset by tragedy, particularly those caught in the Depression and, later, in World War II. Certainly that was the stated mission of the photographers hired by the U.S. government to record the plight of the American farmer. They were directed to show what was happening to rural America and why government intervention was necessary. To effectively do that, they often turned to children. Later, war photographers would do the same.

When it came to the picturing of children, there can be no question that this period ushered in a distinctly different aesthetic. The ready availability of quick-shutter cameras with rolled 35mm film gave photographers a new mobility that permitted them for the first time to effectively capture children in their reveries without being observed. Remarkably, this style of photography did not really have a name nor did it develop its own vocabulary, but its patriarch is undisputed -- Henri Cartier-Bresson. Considered by scholars to be one of the preeminent photographers of the twentieth century, Cartier-Bresson was raised in a bourgeois French family. In his formative years he trained to be a painter. In 1931, while recovering from a serious

illness, he saw the photograph that serves as the cover of this book. He was so inspired that he gave up painting and took up photography. What captivated him most about Martin Munkacsi's image of three African boys was the freedom, spontaneity and grace that it radiated. For him, that image captured a *joie de vivre* that none of his paintings ever had.

He and his followers borrowed freely from other movements. Their images were not pictorial, but neither did they pretend to be entirely objective. They did not require grandeur of their subjects to extract a lyrical grace. Using many of the elements of modernism -- reflections, closeups and unusual vantage points -- they were able to accomplish their objectives. Cartier-Bresson called it "shooting on the sly" or, in French, *"images à la sauvette."* He used the latter phrase as the title of his first book. When it was later printed in English, the title was changed to *The Decisive Moment*. The original seems more apt. He believed that his art was a matter of personal vision, for which no explanation was necessary. For him, the quest for the invisible was more exciting than the recording of facts. When it came to the imaging of children (who were not the principal subjects of his work), Cartier-Bresson's approach was most effective. He repeatedly captured the presence of joy -- that illusive natural quality that is most often absent in adults. It seemed to be most visible when children's play took them to their special place of make-believe.

Toward the end of the forties, this movement -- at least when it came to children -- found its matriarch. Helen Levitt, a New York based street photographer, had a vision similar to that of Cartier-Bresson. She called it "a way of seeing." Her imagery, like Cartier-Bresson's, was not primarily intended to be social documentation but rather a presentation of an aesthetic reality. She and other like-minded practitioners were able to capture the almost surreal qualities of children's dreams and, in turn, the mystery and wonder of their imagined worlds. In a real sense, they were able to remove in the young any hint of human pretension and capture them unstaged. This approach marked a significant departure in the picturing of children. No longer relying primarily on portraiture, their images took on a different kind of poetic quality as they captured the spontaneous movements of children. That permitted the viewer to see the child with greater texture and depth.

After experiencing the carnage of World War I, the Irish poet William Butler Yeats warned that nature had gone awry. In his despair, he wrote that "everywhere the ceremony of innocence is drowned." Fortunately, he was not correct, for the children of the world would not allow it. The role of ceremony or ritual is to keep us from forgetting. In this case, what was not to be forgotten was that the young reinvigorate life. Perhaps children should be thought of as the poets and true visionaries of this period. Images like those of Cartier-Bresson and Helen Levitt bear witness to the fact that children's play -- their ceremonies and rituals -- confirms the belief that innocence does not have to yield to evil.

James Agee's view of photography (as quoted in the beginning of this section) was only partially correct. Images of the Depression and the war did shift from the imagined to

the "cruel radiance" of what was. Indeed, during the Depression we saw children portrayed as resilient in the face of natural adversity and in war we often saw children as victims resigned to their lot. Additionally, we saw in both instances that the camera could defeat or misdirect our ability to be objective. In the works of Levitt and Cartier-Bresson, however, we find aspects of the essence of childhood truly reflected and recorded. In these instances, the "cruel radiance" was replaced with a warm luster of inner confidence. Sixty years later, it is those images -- of the child as a confident dreamer -- that are the most enduring. Children withstood bad times, were resplendent in good times and clearly persevered, in most instances, with their spirits intact. These disparate bodies of work -- the child as survivor, the child as victim, the child as witness and, most poignantly, the child as dreamer -- are visual testaments to a generation's children.

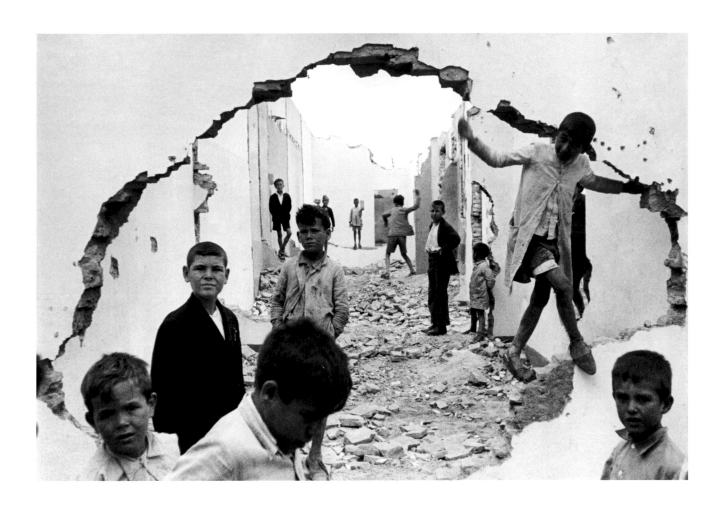

Henri Cartier-Bresson, Valencia, Spain, 1933

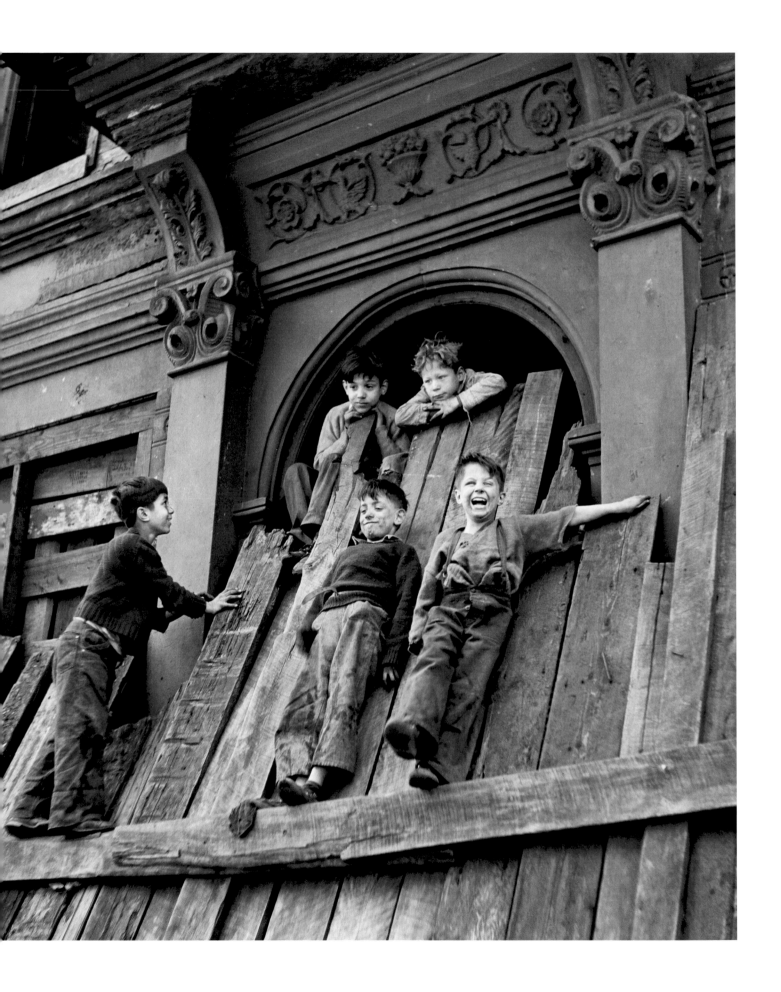

Jerome Liebling, New York, 1949

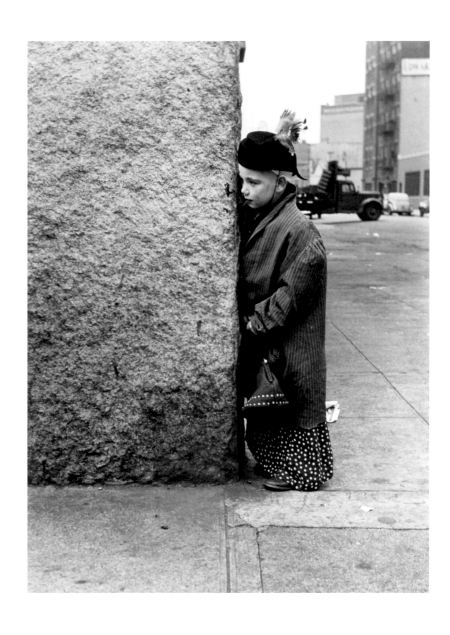

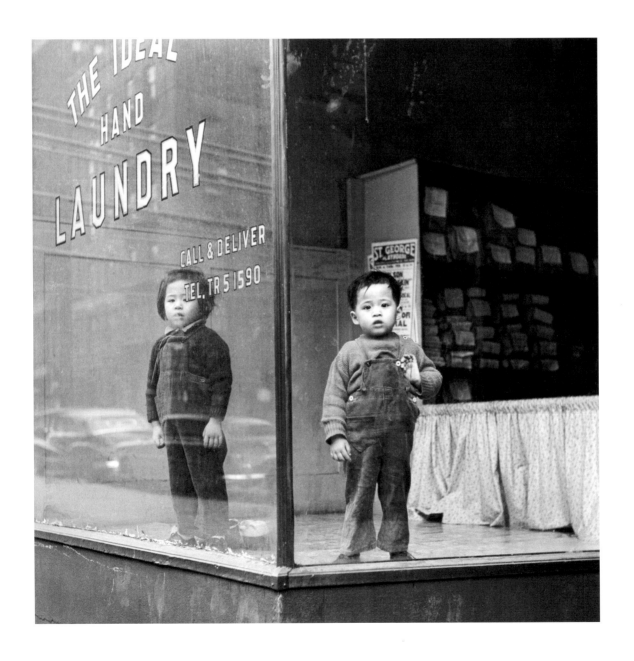

Arthur Leipzig, 1946

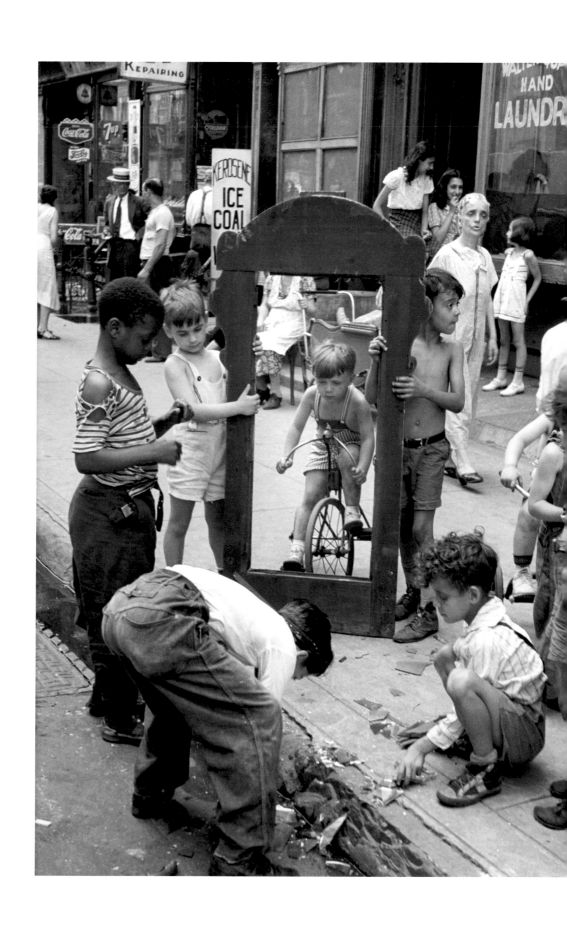

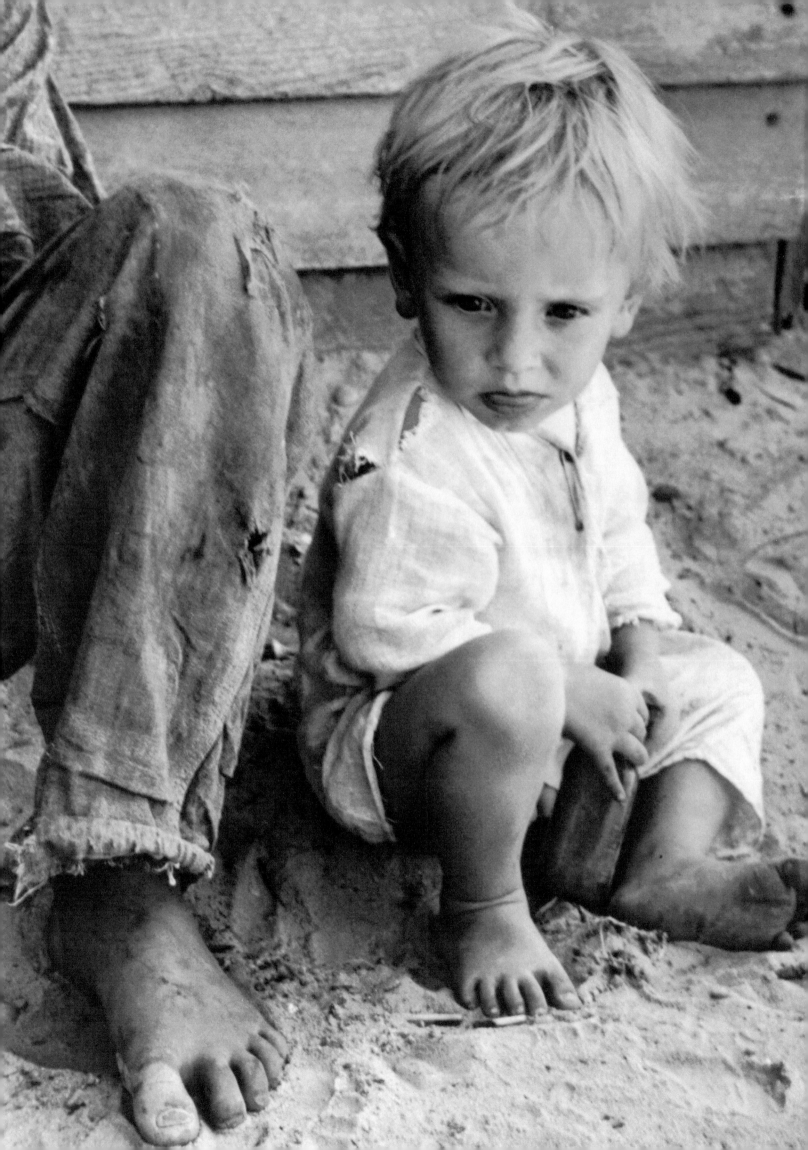

the child assailed

IT WAS THE WORST OF TIMES . . .
IT WAS THE EPOCH OF INCREDULITY . . .
IT WAS THE SEASON OF DARKNESS . . .
IT WAS THE WINTER OF DESPAIR . . .

CHARLES DICKENS

In many respects, no three decades could be more different than the twenties, the thirties and the forties. The twenties represented a period of growth, modernity and prosperity -- a time of amusement and excitement, when heroes like Babe Ruth and Charles Lindbergh kindled spirits and engendered optimism. That season of light quickly darkened and in the thirties, as opportunities dwindled or disappeared, those ebullient emotions were lost. For many, sacrifice replaced optimism and foreboding supplanted enthusiasm. The words Dickens penned in 1859 seem equally appropriate to capture the economic maelstrom that struck seventy years later, for the thirties would prove to be a nadir for many -- their winter of despair and discontent.

The Great Depression began in 1929 when national economies worldwide suffered a steep drop in production and, with it, an unprecedented rise in unemployment. Economic output in America dropped by half and unemployment rates rose to over 25%. The American stock market lost over 90% of its value in that one year alone. Bankruptcies forced millions of people to the margins of society. Virtually everyone was adversely affected. Without governmental safety nets, many became dependent on family and charity for basic subsistence.

For a distinct segment of Americans, the family farmer, the effects were cataclysmic.

Farmers in the central and northern Great Plains kept plowing and planting despite chronic droughts. Once the ground cover became depleted, winds whipped across the countryside, raising billowing clouds of dust. The black blizzards, as the storms were called, finally did these farmers in. Hundreds of thousands of families from Oklahoma and Arkansas, derisively labeled "Okies" and "Arkies," lost almost everything in the storms. Forced to leave the land they were born on, they undertook a motorized migration to California. Plains farmers and their families came to personify the grit that made America strong.

These events resonate in people's memories, etched there by the searing black, white and gray images of interminable soup lines filled with hopeless and helpless men. Yet it was the children, the Depression's most vulnerable victims, who would suffer the most long-term physical and emotional injury. For them, simple existence became a daunting challenge. Yesterday's givens -- medicine, proper food, decent shelter, adequate clothing and basic education -- suddenly were out of reach. Perhaps the greatest pain for these children was not enduring their own deprivation, but having to witness their parents' and grandparents' despair and shame.

There are those who say that the deprivation wrought by the Depression was in some respects good for the soul -- that families might have lost their homes but found their hearts -- as family members were forced to lean on one another for survival.

This roseate sentiment seems to gloss over the Depression's destructive impact. Fortunately, some salutary results emerged from those difficult times. The Depression put to rest any lingering notion that the welfare of children could be handled solely by family, private charity and local government. National governments would have to do the heavy lifting. In America, President Roosevelt made children a national priority, with specific policies and programs as opposed to mere platitudes.

Nevertheless, the Great Depression proved to be a resounding defeat for America. The American dream was based upon opportunity and hard work, and land ownership was the basis of family security. The farmers and their children found themselves vulnerable as these elements eroded. Those most affected were not well read; they probably had only two books -- the Bible and the *Farmers' Almanac*. They found no solace in the almanac. It would be from the Good Book that they would take their cue.

The Depression in America was visually recorded by a small federal agency, the Farm Security Administration. The FSA was able to enlist many of the very best American photographers working at that time. Its success in garnering that talent was based not on money or, for that matter, the promise of exposure, but on the majesty of its mission. A renowned economist, Rexford Tugwell, headed up the agency as it tackled the issues then facing the American farmer. He understood that photography had come to dominate public communication and that its utilization, with proper direction and selection, would be the most efficient and effective means of documenting the farmers' plight. His assistant, Roy Stryker, assembled a staff of thirteen photographers and assigned them to record the farmers and the environment in which they existed. These photographers included Arthur Rothstein, Jack Delano, Russell Lee, Ben Shahn and Carl Mydans. Walker Evans, already a well-regarded photographer, would soon become the group's star. Eight women completed the team, including Dorothea Lange and Esther Bubbley. Later, Marion Post Wolcott, John Vachon and Gordon Parks would join them. This corps of artists and photographers would turn out to be the most talented group of visual communicators ever assembled for a select project. Stryker had lofty objectives. He concurred with John Dewey's thesis that "artists have always been the purveyors of news" since they encapsulate events in a manner that heightens perception, enhances appreciation and elevates emotion. Stryker seized the opportunity to create a photographic self-examination of America. Through judicious editing (Stryker used his pencil to punch holes in images he found wanting), he was able to assemble a pictorial mosaic of the spirit of Americans in distress as manifested by the suffering American farmer.

Without diminishing the contribution of the other photographers, it is fair to say that the work of two members of the FSA corps -- Walker Evans and Dorothea Lange -- stood out. Walker Evans was raised in a patrician and puritanical home, attended preparatory schools, sojourned in Paris, settled in New York and became active in the artistic community. His primary subjects were normally architectural depictions in which any human

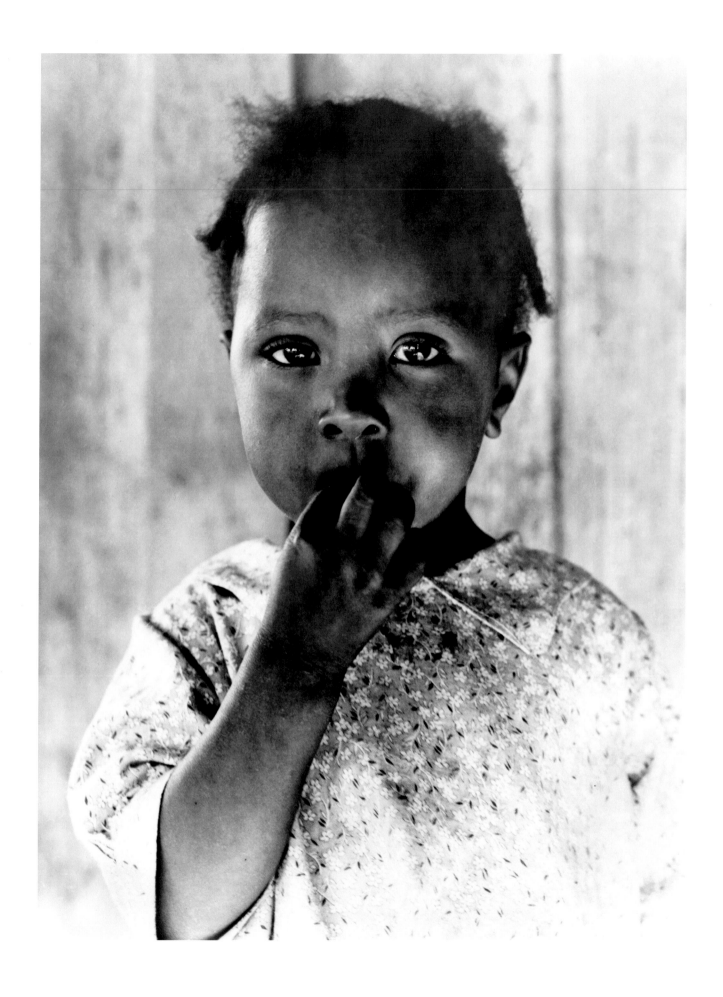

Dorothea Lange, 1937

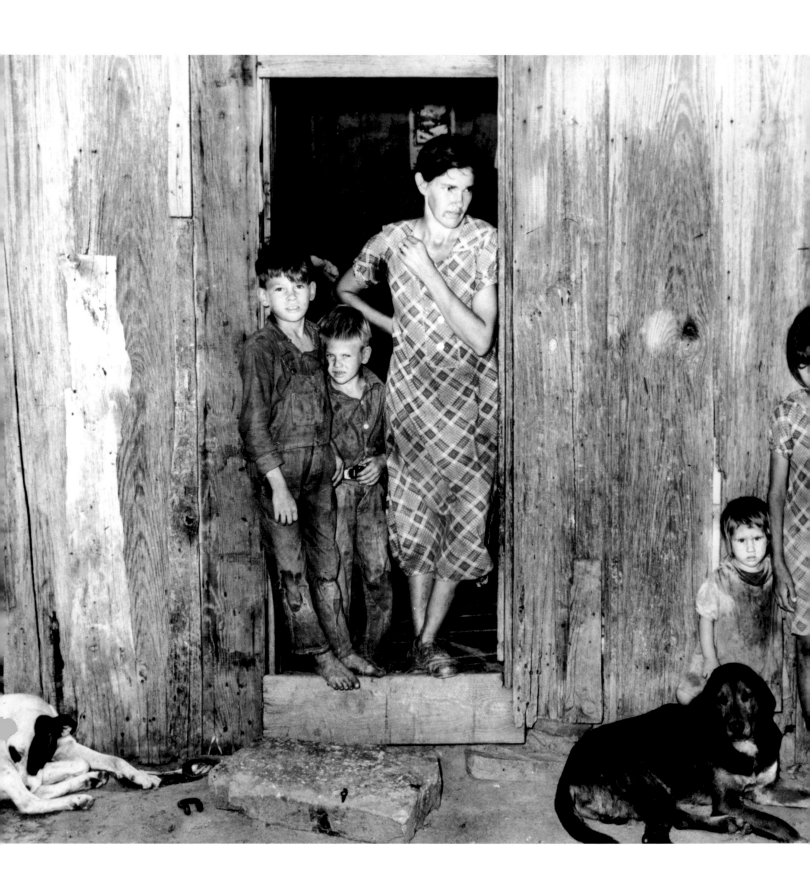

presence was most often accidental. Yet for the FSA project, several of his powerful images of the Depression included children. Evans once mused that "the photographer is a joyous sensualist for the simple reason that the eye traffics in feelings, not in thoughts."

In this way Evans was able to reveal grandeur in everyday life. He did so with a clarity and structure that highlighted that beauty. It is not possible to view his images of Depression children even today without being in awe of his subjects' courage and dignity. Evans had the ability to make his images seem alive. He would let his sitters arrange themselves and take their pictures only when they were finally at ease. His photographs were devoid of exaggeration or distortion. He avoided using images of squalor as propaganda and the result was searing imagery of timeless grace and beauty in the face of adversity.

The other artist who excelled at picturing the Depression child was Dorothea Lange. She was very different in temperament and background from Evans. Deserted by her father, she led a lonely and painful childhood made worse by a lifelong limp -- a legacy of polio. Her father's desertion and her disability caused her to be a self-described "lost child." Even though images of children have long been used as symbols of the suffering of the dispossessed, Lange had theretofore made little use of them. Yet it was the "lost" children of the Depression with whom she would bond. She was able to navigate between the shoals of sentiment and those of sentimentality. Later in life she would confess: "I think [my disability] was the most important

thing that ever happened to me. |It| formed me, instructed me, helped me and humiliated me." It seems to have given her an intuitive understanding of deprivation and the ability to identify with sadness and pain. Her work makes people deeply cognizant of their commonality with others and that gift may well have earned her the title of photography's supreme humanist.

One of the most intriguing stories of the Depression is the saga of Florence Owens Thompson, Dorothea Lange's most famous subject. The members of Mrs. Thompson's family were indeed immigrants in their own country. A full-blooded Cherokee Indian, Florence married her teenage love at seventeen and together they journeyed from Oklahoma to California. Unfortunately, her husband died young, and she and her seven children continued to support themselves as "harvest gypsies" -- California's crop-pickers. They journeyed by car from harvest to harvest but when the Depression came, finding work became difficult. The influx of thousands of needy people made employment scarce. Nevertheless, she held her family together.

One fateful day, a "fancy lady with a limp," as Florence later described her, asked for permission to photograph her. The woman did not inquire as to her name or history. Frustrated at her inability to move to the next crop (her car was in need of repair) and disappointed that no money was offered by the photographer, she nevertheless acquiesced when told that the pictures might help gain aid for transient camps. The next day her image appeared on the cover of the local newspaper. Florence would not know until later that the "fancy lady" was Dorothea

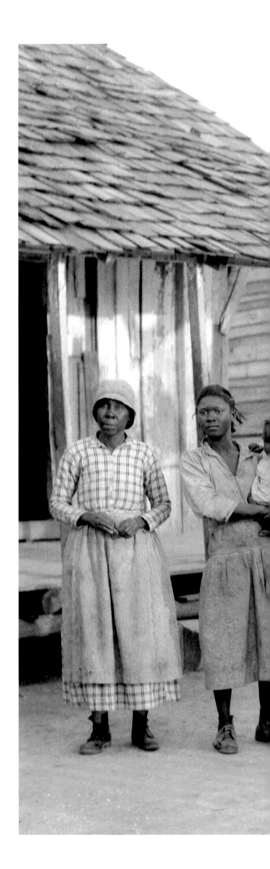

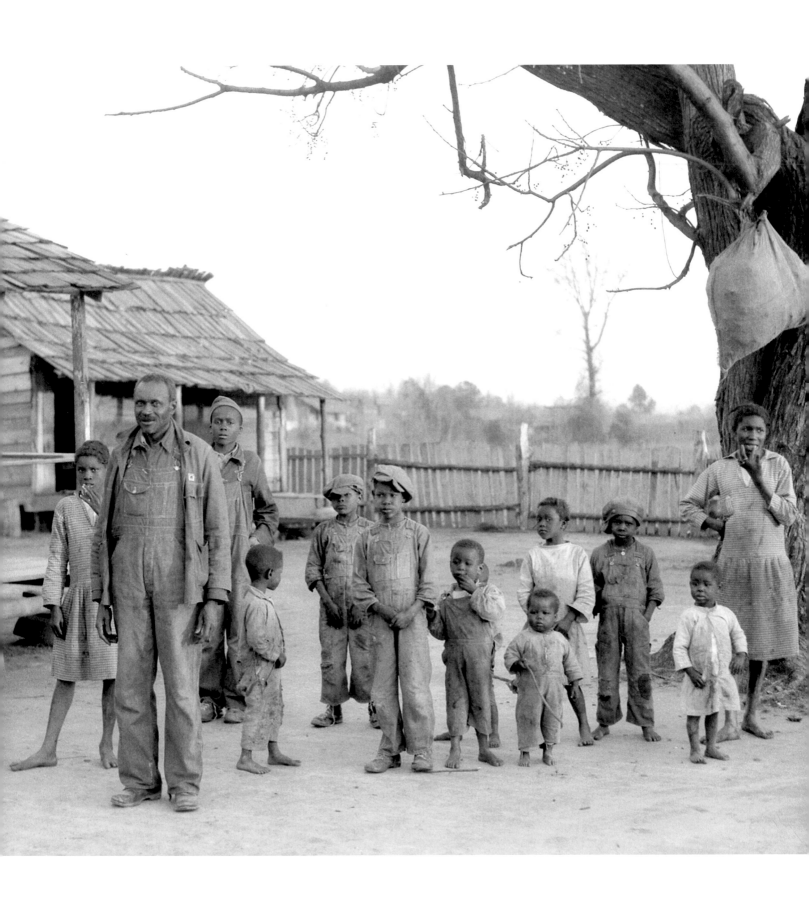

John Vachon, 1935

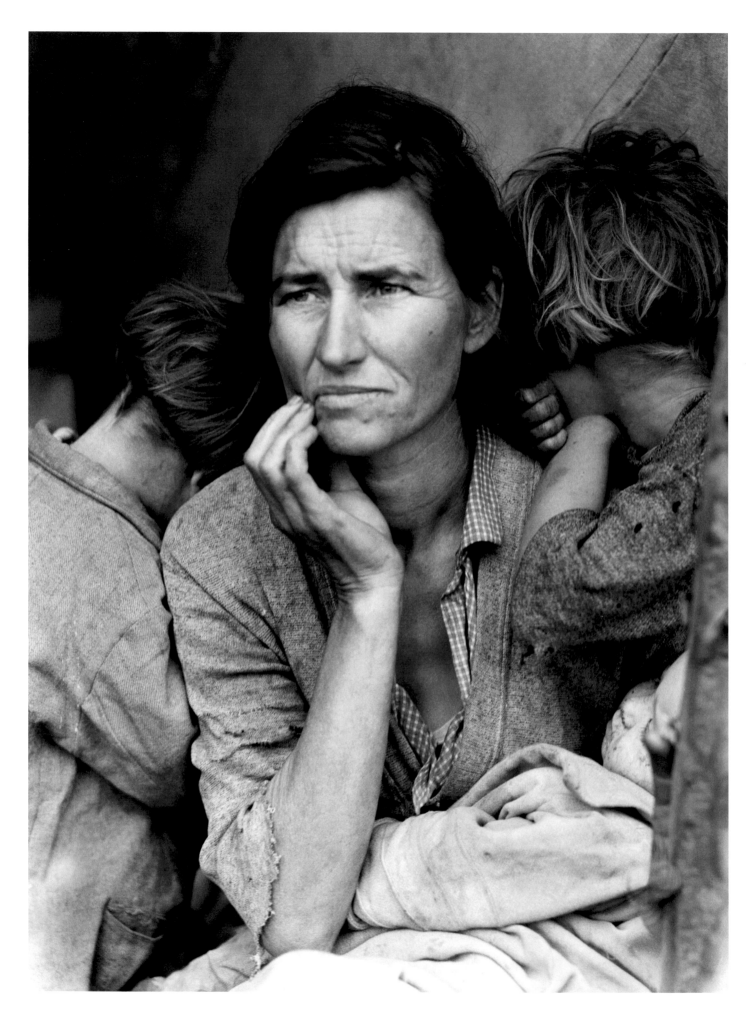

Lange, and that the picture taken that day would come to represent the best in photo-documentation. Although Florence lived a full life, content in the knowledge that her children went on to better ones, she always resented her image as the beatific "Migrant Mother." She was a survivor and did not want or need charity, perhaps evidencing a bit of her Cherokee independence.

Lange had captured Florence looking beyond the camera, her children clinging to her with their faces turned away. The image is profoundly enigmatic. Some see shame and despair, others see unhappiness and fatigue. Most, however, view it as the transcendent image of the Depression family. While registering hardship and pain, it clearly resonates with its subjects' inner strength. By removing the background detail, Lange created a tableau that was not about physical loss as much as it was about human suffering. Lange was able to etch in silver the entire Depression in that one photograph.

The image would over time take on nearly mythic proportions as the icon of that era. There was a reverence for tradition and religion during the Depression. Both were perceived as antidotes for bad times and Lange understood that. Her sorrowful Madonna clearly spoke of cleansing and rebirth. In this one image she captured everything about the times -- survival, anxiety, family unity, the destruction of old and cherished ways in the face of urbanization and the craving for reassurance that, through all of this, basic beliefs and traditions would prevail.

Evans and Lange, along with their confreres, each made major contributions to the photographic quilt that was crafted by the FSA. The Historical Section (as it later would be called) produced over 270,000 images. The alchemy among those photographers worked. Although their images of children are in black and white, they portray a full palette of emotions -- joy, misery, pride and even shame, but, above all, a certain grace. What comes through most vividly is the sense that humankind will survive and flourish and will do so largely because of the spirit of its children.

Unfortunately, the dry recital of statistics often makes them lose their impact and tends to numb reality, for mere numbers cannot project the pain or quantify the anger and humiliation that the Depression wrought. It is only in the images, voices and stories of those affected that one can

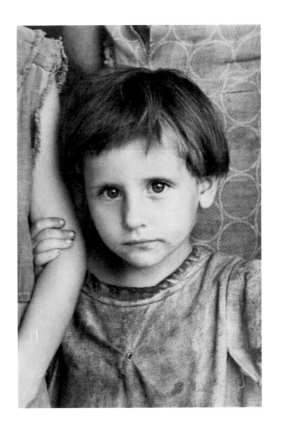

get a true sense of what had happened to the construct of childhood.

In America, the gloom that settled over the country found its emotional low on a cold, rainy night in March of 1932 when the young son of aviator Charles Lindbergh and writer Anne Morrow was kidnapped. He was found five miles from his home, dead from starvation and exposure. Lindbergh was then a widely respected American icon -- the first man to complete a solo flight across the Atlantic. The "Lone Eagle," as he was affectionately called by the press, had lost his eaglet. To a nation down on its luck, it seemed that even the rich and storied could not escape bad times.

Eugene Williams and Roy Wright, two thirteen-year-old black boys, were more fortunate.

They were members of a veritable army of over a quarter million youths who went "on the lam." Out of school, without family, these nomads "jumped the blinds" or "went by thumb" in search of a better life. The roads and rails only led them to a worse existence. This itinerant army became frighteningly evocative of the *bezprizorni*, hordes of homeless youths that plagued Russia after its revolution. Eugene and Roy, with seven of their friends, hopped a freight train passing through Alabama. Homeless children riding the rails had become a recurring and defining symbol of the Depression. North of the small town of Scottsboro, Eugene and Roy and their friends were arrested and falsely charged with the rape of two young white female hobos. Their lawyer, a local real-estate salesman turned public defender, pleaded them all guilty, despite their protestations of

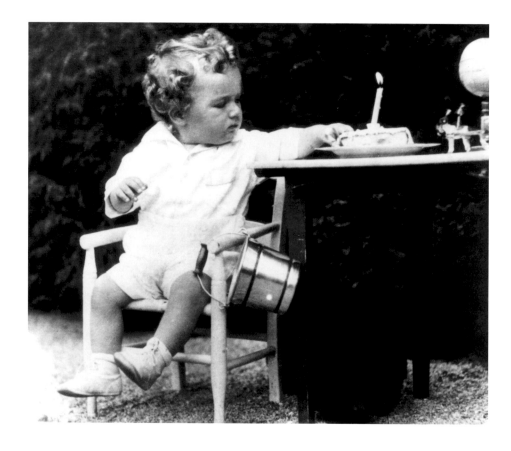

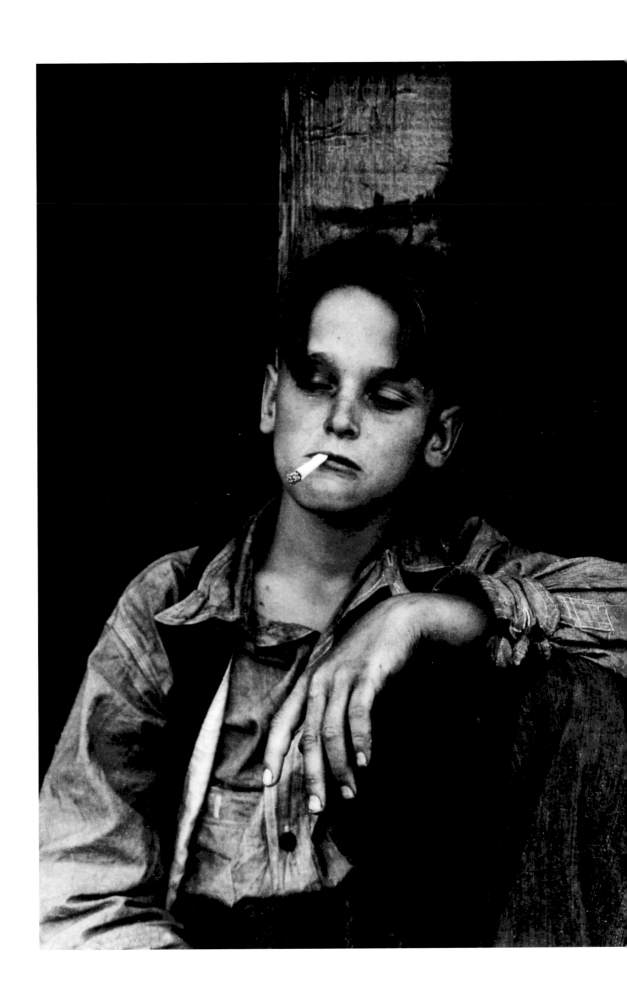

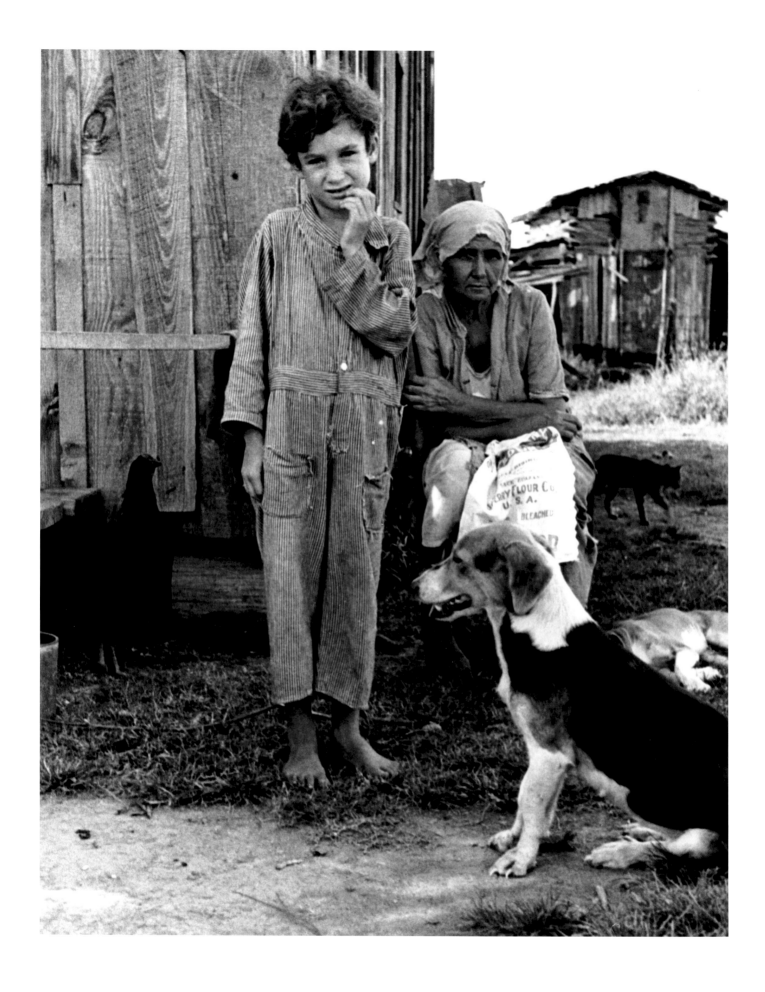

124

innocence. Eventually the girls recanted, admitting that they had conjured up their stories of assault to avoid being charged as vagrants. The defendants would spend between six and nineteen years in prison for a crime they did not commit. Their cause came to symbolize the continuing racial strife that was exacerbated by the Depression, further corroding American life.

Slim Pickens fared somewhat better. Oral histories tell the story of a white twelve-year-old from outside of Montgomery, Alabama, who recalled his life during the Depression with a curious sense of nostalgia. "We lived in a shed down the road; wasn't much. My pappy wouldn't let people plaster signs on it like the shacks [Negroes] lived in. He thought that set us apart. The big problem for us was food. I suppose there was plenty to eat somewhere, but we couldn't find it though the dog and cat somehow did. Seemed like I was always sickly. Pap said it was my seeds, and I wouldn't have been so bad off if my leg did not start to shrivel. Turns out I had rickets and what they called 4Ds -- pellagra. Was mighty fierce -- the Ds stood for diarrhea, dermatitis, dementia and death. Praise the Lord, I only had three of those symptoms. I kind of just sat around most of those years with my eyes closed in the company of my cat. He and the dog were my only friends."

Although Slim did not know it then, his maladies were not due to bad seeds (genes) but rather were the direct result of a bad diet -- the lack of sufficient vitamin D and niacin. One of the most salutary effects of the American New Deal policies with respect to children was the required addition of essential nutrients to children's foods. Iron and vitamins such as niacin, thiamin and riboflavin put an end to diseases like rickets and pellagra. It was too late to help Slim. All his life, he had a pronounced limp to remind him of his youth. He did, however, survive those years. He worked as a short-order cook for forty years before he retired. "I really liked to be around food," he explained; "made me feel secure."

Another story of survival is the odyssey of a boy called Blues. By the time he was sixteen, his life had already taken a bad turn. Raised in Kansas, one of fifteen children of a dirt farmer, he was sent to live with his aunt in Minneapolis after the death of his mother. There he was turned out by his aunt's boyfriend and forced to find his way alone -- poor, black, without a job and seemingly without a future. He recalled his foreboding. "The hawk had come, I could already feel its wings shadowing me." Indeed, for the youths of the inner cities, especially the blacks, the shadow of the hawk would spread far. It would have been easy for him to choose a life of crime but he wanted more. He played the piano in bordellos -- hence his nickname. Later, he found work as a busboy, a semiprofessional basketball player and a railroad worker. Throughout this time, he never stopped writing and reading. When business was slow, he would devour magazines and was moved by the photographs of those bitter years that came out of a government agency called the Farm Security Administration. Those images inspired Blues to take up the camera. "My father was a dirt farmer who mostly farmed dirt, but we had enough to eat. I know poverty and when I saw those photographs . . . I knew I could do it." Blues was able to

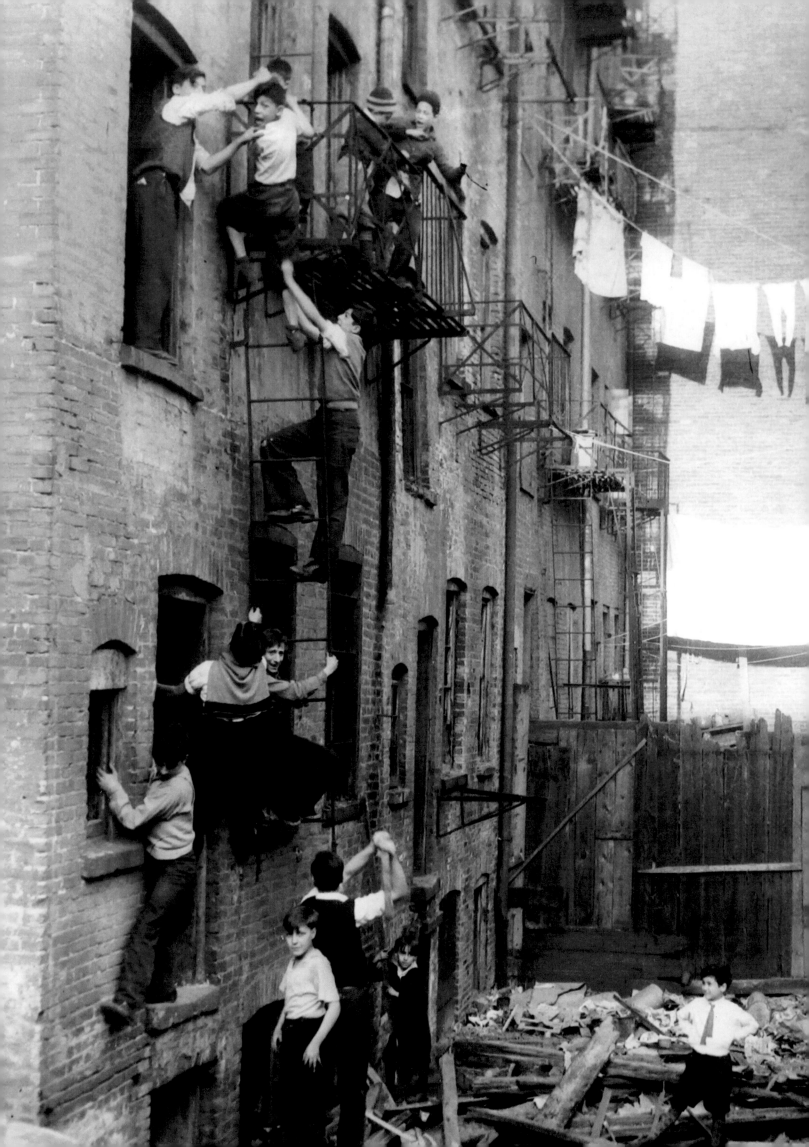

change his life, but not without a price. "My experience left me scared and angry at times, |yet| the hardship and disillusion served me well. Although poverty and bigotry would still be around, I could now fight them on even ground." Blues's choice of weapons turned out to be his eloquence with words and imagery. He became a writer, poet, novelist, composer and filmmaker. His most enduring success, however, was with his camera. He became one of the most respected photojournalists of the twentieth century. Blues's given name was Gordon Parks.

These are just a few of the thousands of Depression stories. The case of the Scottsboro boys exposed the hatred and inequities that lie so close to the surface of a society in distress. Slim Pickens's story exemplifies survival. Gordon Parks's life is a testimony to perseverance, ambition and desire. Florence Thompson's saga is grit and grace personified. Sadly, the young Lindbergh boy never lived long enough to have a story of his own.

For some, the Depression left a stain of disillusionment and bitterness, but children, in most instances, were able to eradicate that stain. The young would come to realize that there was commonality in their desire for a better life and that their collective search for it was deeper than color or blood. They would embrace the call of Depression troubadour Woody Guthrie's anthem, which he sang in every migrant camp he visited. It was in fact their world, no matter how hard it had run them down and rolled them over. As Guthrie exclaimed: "This land was made for you and me." The children of the Depression knew that he was singing to them.

Oh, no, the Depression was not a romantic time. It was a time of terrible suffering. The contradictions were so obvious that it didn't take a very bright person to realize something was terribly wrong.

Have you ever seen a child with rickets? Shaking as with palsy. No proteins, no milk. And the companies pouring milk into gutters. People with nothing to wear, and they were plowing up cotton. People with nothing to eat, and they killed the pigs. If that wasn't the craziest system in the world, could you imagine anything more idiotic? This was just insane.

And people blamed themselves, not the system. They felt they had been at fault. [T]he preachers would tell the people they suffered because of their sins. And the people believed it. God was punishing them. Their children were starving because of their sins.

People who were independent, who thought they were masters and mistresses of their lives, were all of a sudden dependent on others. People of pride went into shock and sanatoriums. My mother was one.

What I learned during the Depression changed all that. I saw a blinding light like Saul on the road to Damascus. It was the first time I had seen the other side of the tracks. I saw the world as it really was.

Virginia Durr
Wetumpka, Alabama

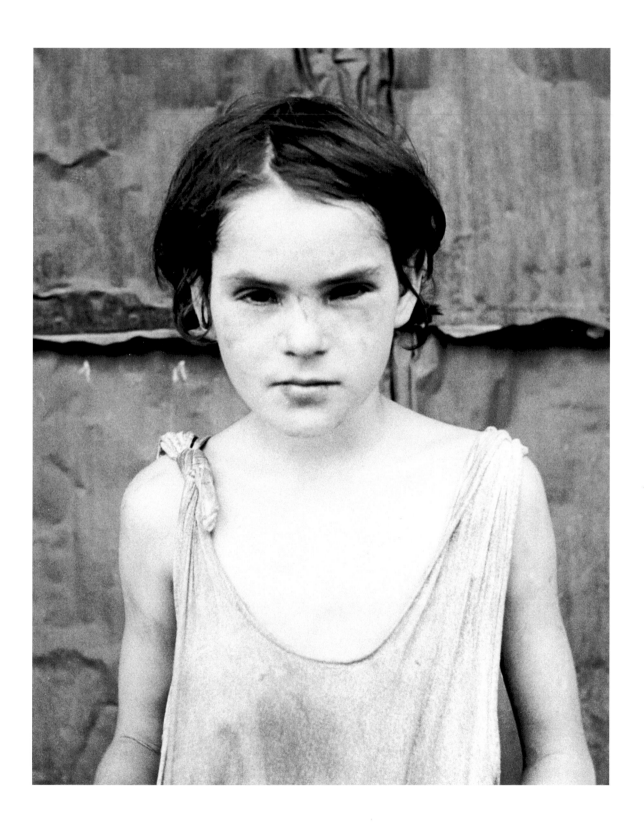

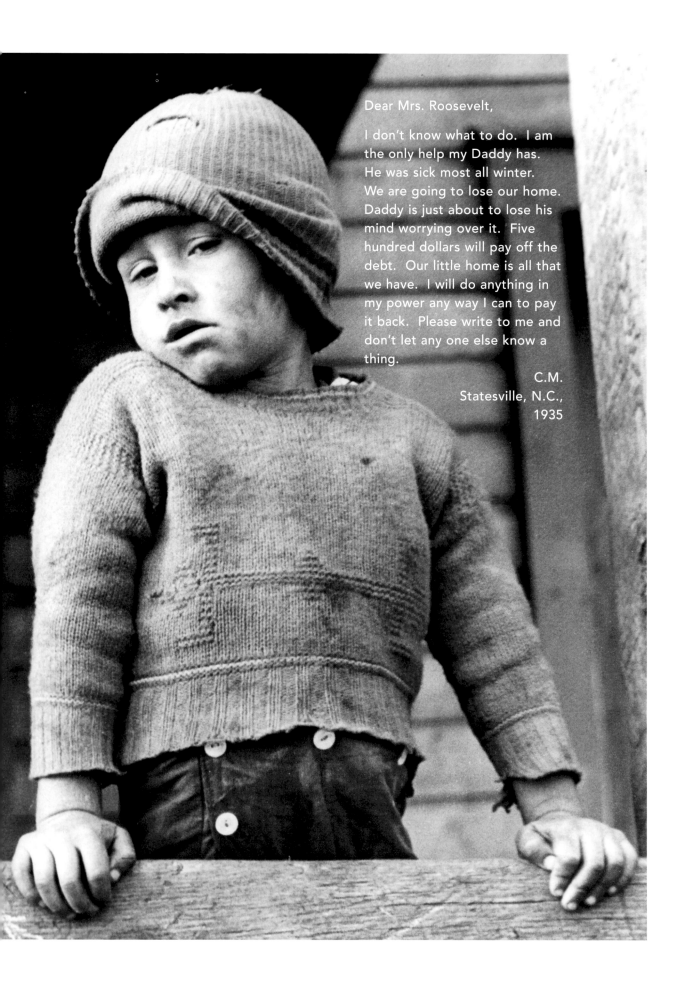

Dear Mrs. Roosevelt,

I don't know what to do. I am the only help my Daddy has. He was sick most all winter. We are going to lose our home. Daddy is just about to lose his mind worrying over it. Five hundred dollars will pay off the debt. Our little home is all that we have. I will do anything in my power any way I can to pay it back. Please write to me and don't let any one else know a thing.

C.M.
Statesville, N.C.,
1935

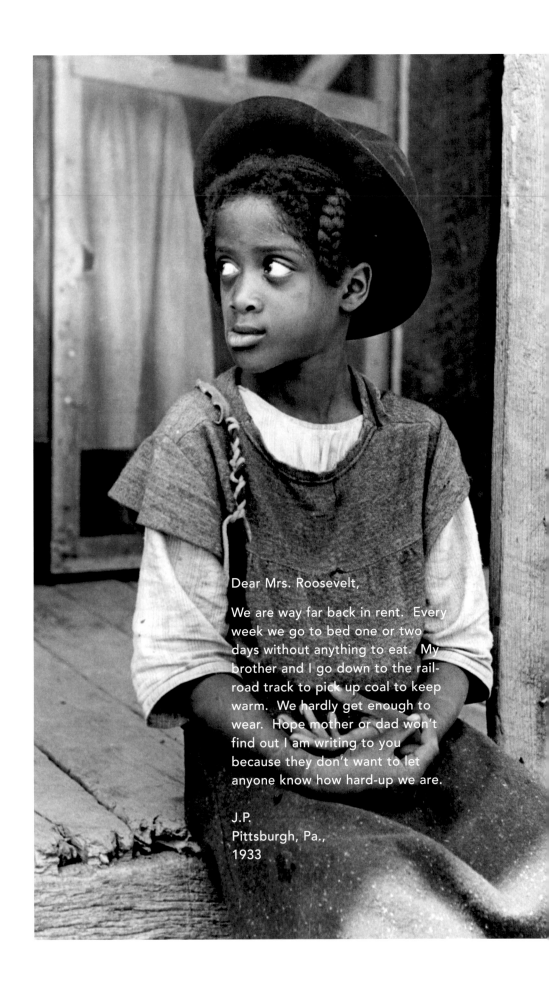

Dear Mrs. Roosevelt,

We are way far back in rent. Every week we go to bed one or two days without anything to eat. My brother and I go down to the railroad track to pick up coal to keep warm. We hardly get enough to wear. Hope mother or dad won't find out I am writing to you because they don't want to let anyone know how hard-up we are.

J.P.
Pittsburgh, Pa.,
1933

the child delights

THE MARVELOUS RICHNESS OF HUMAN EXPERIENCE
WOULD LOSE SOMETHING OF REWARDING JOY IF
THERE WERE NO LIMITATIONS TO OVERCOME.
THE HILLTOP HOUR WOULD NOT BE HALF SO
WONDERFUL IF THERE HAD BEEN NO DARK
VALLEYS TO TRAVERSE.

HELEN KELLER

Just as the depth of despair in the Depression years was popularly epitomized by the Lindbergh baby and the Scottsboro Nine, it could be said that six girls and a determined collie underscored the hope that Keller's hilltop hour would soon be here. Born in Canada, the Dionne quintuplets represented a miracle, a one-in-fifty-seven-million long shot. Canadians and Americans followed their development with rapt enthusiasm, for their multiple birth spoke of miracles.

In that same year (1934), another little girl and a big dog with an even bigger heart made people smile again. Shirley Temple, a five-year-old with an overabundance of personal charm and golden locks, sashayed into the hearts of moviegoers. To a needy public, she was everyone's perfect little girl -- dimpled and demure with a level head under her fifty-six blonde curls. She quickly became an American icon, always playing a down-and-out waif who, through pluck, ingenuity and hard work, survived and prospered. In the process, she boosted people's spirits and underscored a growing belief that it would be the children of the Depression who would lead America out of its woes.

Eric Knight's children's classic *Lassie Come-Home* (1938) gave the world the enduring story of an intrepid dog's struggle to survive. Bartered to avoid foreclosure of her family's

John Florea, Timmy and Lassie, 1942
Mike Disfarmer, c.1940 (left)

farm, Lassie was transported hundreds of miles away, only to escape and make her way back home. Lassie was the embodiment of courage, faithfulness and determination.

The fact was that there were large segments of society that were only brushed by the Depression. America and Western Europe quickly began to recover economically, ecologically and emotionally. Both were on their way to becoming lands of abundance and renewed opportunity. For the first time in many years, adults, including those scarred by the Depression, had hopes that their children would be able to share in the delights of their newfound bounty.

Two popular publications captured the new idealized essence of the young -- the Dick and Jane books and the comic book *Archie*. Dick and Jane were "born" in 1927 when educator Zerna Sharp came up with a better way to teach children to read, using a seductive and simple combination of colorful illustrations and familiar words. Dick and Jane, who had no last name, came to represent, for the white suburban community, Everyboy and Everygirl. The books featuring them became the virtually exclusive reading primers for the young. By the end of the forties, 80% of all first graders learning to read were doing so with stories about the world of Dick and Jane. The books embodied what many parents had dreamed of for years -- a place of safety and security. For Dick and Jane, it was a small world, from screen door to picket fence -- a water-colored environment where night never came, where calamities, large or small, were unknown, where parents never scolded and where the good times never stopped.

Eleanor Campbell, 1940

For American children of the early forties, these books served as a guide to the perfect world -- no Depression, no struggle and certainly no war. Dick, a confident six-year-old, was the big brother of two sisters, Jane and Sally, whom he loved with all his heart, except for that portion reserved for Spot, his devoted dog. A perfect child, he cared for his siblings, was respectful of his parents and was adored by his grandparents. The girls' color-coordinated ensembles were never soiled or wrinkled. No Medusa-like Shirley Temple curls or Orphan Annie locks for them! They led perfect lives, at least as parents would perceive it. Content to play second fiddle to their brother, they loved home, school and baking cookies.

The glue that kept this perfect family together was Spot. He, even more than the children's parents, taught them responsibility. He counted on them to care for him -- feed him, walk him, groom him -- and confide in him. In the world of Dick and Jane no one aged, but Spot at least changed his stripes. Originally a terrier, after six years he traded breeds to become a springer spaniel. Whatever breed he was, he was the young readers' favorite -- fun and street smart. Father was tall and handsome. Mother was cheerful, pretty and subservient. She never complained, preached, postulated or pouted.

The children's grandparents were the oldest people in their little world. Although always busy, they found time to teach the children about animals and to encourage them to try new things and take some risks. You could trust them; you had to respect them. Even Spot knew that.

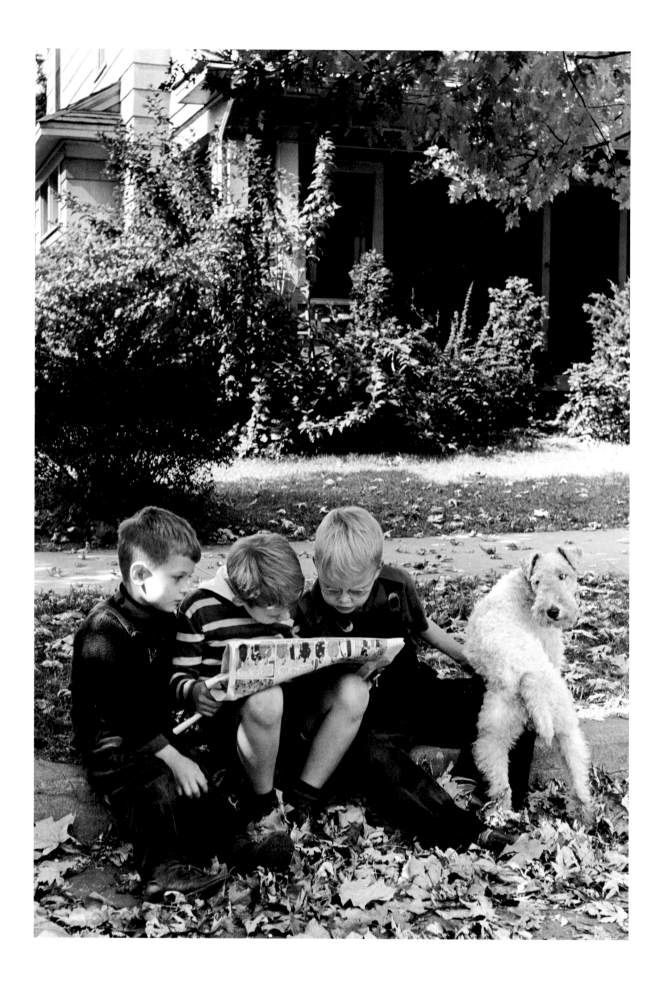

What Dick and Jane did for the very young, Archie and his merry gang would do for that era's adolescents. Archie Andrews, sweet Betty, sultry Veronica and the hapless Jughead celebrated the delights of the teenage years. Their lives were consumed with the harmless pursuit of immediate pleasure. Betty simply wanted Archie, who understandably lusted for Veronica, while Jughead longed only for his next hamburger. It would seem that life's worst fears were of having too few burgers and being alone on Saturday night. By 1941, when *Archie* made its debut, over 75% of those between the ages of thirteen and seventeen were high-school bound and over half of America's seventeen-year-olds would graduate. As the ideas and ideals of childhood evolved, laws, institutions, philosophies and psychological theories relating to children drew clearer perimeters around the view of the child. It was by then unquestionable that childhood was qualitatively different from adulthood. The joy of childhood was clearly recognized as a birthright that transcended social and economic class.

The culture of the young had paradoxically taken root parallel to the worst of the Depression. Its most vibrant manifestation was the "teenager." These older children began to separate from the family, subtly but profoundly. Hard times had bound the family together, often in suffocating ways. As families became more prosperous, older children began to go their own way.

Some experts viewed the widening gulf pragmatically, attributing it to three factors -- compulsory high-school attendance, the automobile and the end of Prohibition. High school gave teens peer solidarity, new role models and a great deal more time away from home. Cars gave them unprecedented freedom of movement and privacy. Liquor and cigarettes were available, and teenagers could now experiment with "adult" diversions with less fear of prying eyes.

Love took on a more temporary meaning. Petting and "pinning" were the order of the day. A new dating vocabulary was created. "Crush," "going out" and "going steady" paced the course of a relationship. At first, these youths shared the same popular culture as adults. While adults listened, their children jitterbugged to the music of Glenn Miller and Benny Goodman. Drummer Gene Krupa ignited their fire and trumpeter Harry James kept it burning. Eventually their enthusiasm began to worry adults. The Lindy Hop and the Suzie Q revealed too much nether limb for conservative adults and swooning for Sinatra cracked the mold of proper decorum.

Notwithstanding parental objection, teenagers continued to swoon and proudly created a proprietary jive vocabulary. They took their leisure seriously and, because they numbered more than ten million by 1940, so did merchants and advertisers who recognized and exploited the paradigmatic shift in teen buying demands. No longer content to emulate their elders, teenagers developed voracious appetites for their own fashion fads, entertainment, soft drinks and music. *Life* magazine saw adolescents as living in their own "jolly world of gangs, games, movies and music, |speaking| a curious lingo, adoring chocolate |and| wearing moccasins."

Society had literally tired of the travails of the Depression and was delighted to encourage a carefree and self-indulgent life for its young.

Many urban children had difficulty relating to the worlds of Dick, Jane and Archie, preferring "the streets" as their learning ground. Representing an ever-changing panorama of life, the streets were filled with colorful people and lively action. Pitching pennies, playing stickball and passing time at the arcades were ways in which urban children shaped their own notions of right, wrong and fair play. And *Life* and other picture magazines were determinedly capturing it all in pictures.

It would be inaccurate and unfair to suggest that America's youth cared only about arcades, malts and jitterbugging in a world without problems. Teenagers were having a positive impact on culture. They were beginning to reshape the way people spoke, the music people listened to and the clothes people wore. Many young people came to see themselves as members of a generation very different from the one that had preceded them. Magazines dedicated to the young, like *Seventeen*, encouraged them in their quest for their own identity.

Teenagers gained a voice in family affairs and they demanded and received some level of privacy in their personal lives. They took an interest in the world at large and changed for the better the way people responded to authority. They would question, not simply obey. As teenagers transformed themselves from frivolous youths into citizens-in-training, their perceived narcissism gave way to youthful idealism. "The only people who are too young . . . to have a political opinion are the truly infantile who can't read and the perpetually young who don't read," exclaimed *Seventeen* in 1944, exhorting the young to get active.

Teenagers knew that times were indeed good and that they would be coming of age in a world of expanding opportunities that could be theirs if they acted responsibly. But they also knew that things were a long way from perfect. For many youths, things were far from ideal. Evidence of intolerance was increasingly visible; Jews, Catholics, Poles, Chinese, Japanese, Italians and African-Americans were often suspect or disdained. It was a time when skin color, religion or national origin still affected how a child was educated, what kind of job that child would eventually hold and where and how well he or she could live. And there were international troubles as well. According to an editorial in *Seventeen*, "no group of adults who created a civilization which would be blackened by World War II could claim to have done a good job."

Life's adversities could not be kept from children. The halcyon interludes of Helen Keller's hilltop hour faded and waned. America's youth had peeked over Dick and Jane's fence and had seen that all was not well in the world. Hitler, Franco, Mussolini and Tojo were consolidating their power. By depicting the wanton destruction of women and children in the name of Fascism, Picasso's harrowing painting *Guernica* sounded a wake-up call, a warning that there would be even darker valleys to traverse before children could again enjoy the wonders of a hilltop hour.

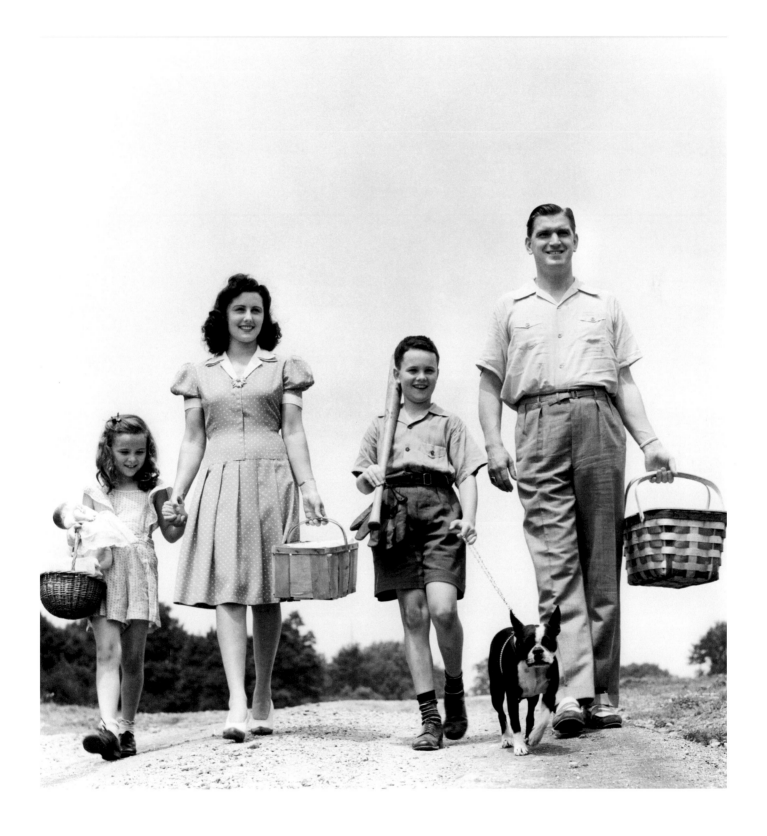

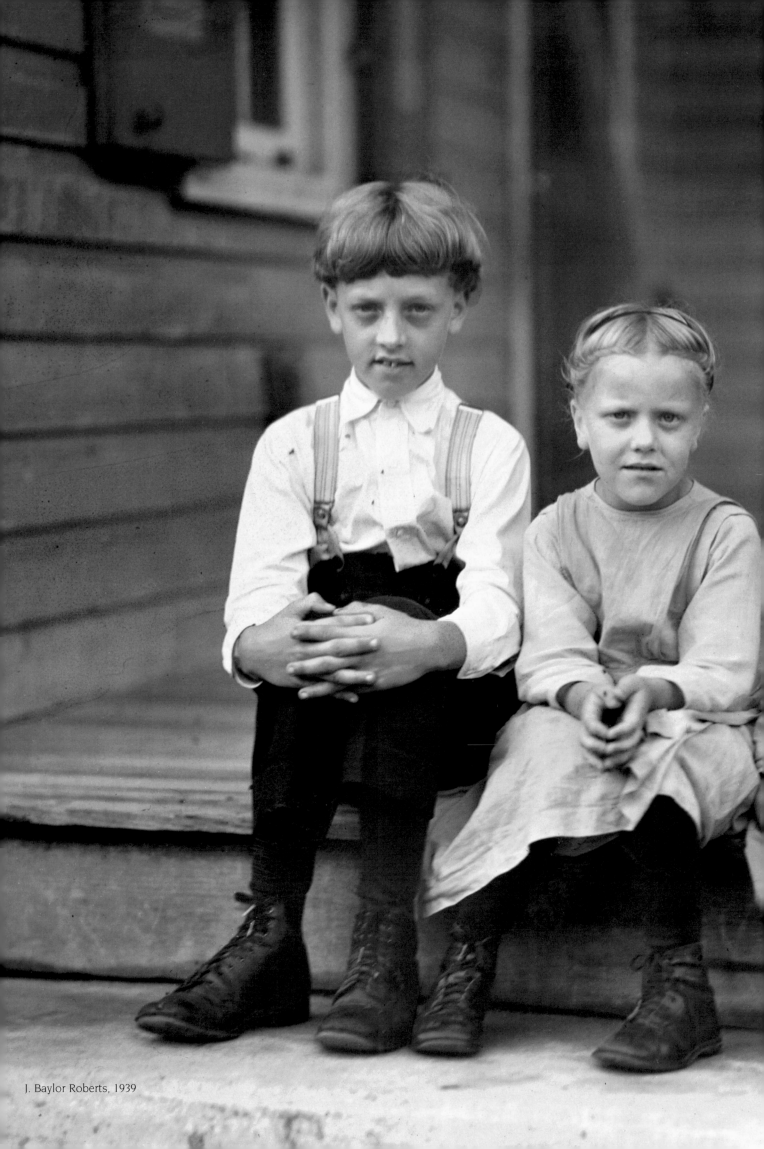

J. Baylor Roberts, 1939

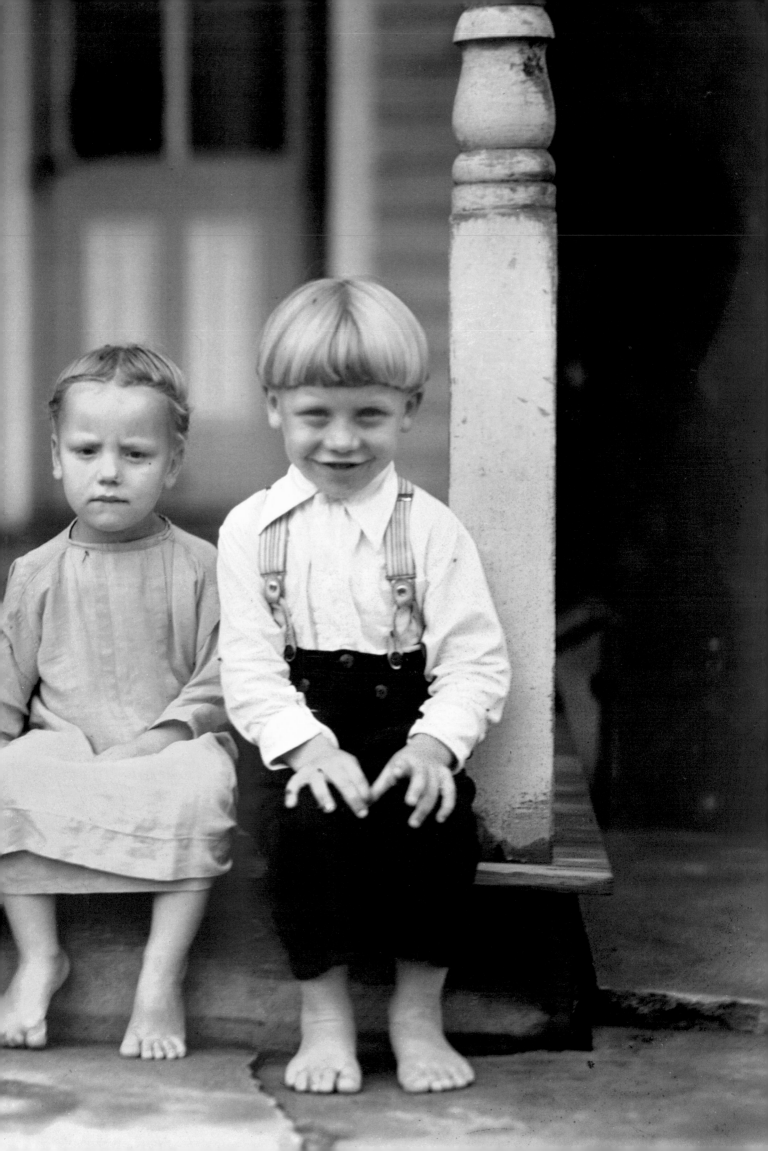

May Hanson, Ray, 1941

THERE'S A SOMEBODY I'M LONGING TO SEE

I HOPE THAT HE TURNS OUT TO BE

SOMEONE TO WATCH OVER ME

ALTHOUGH HE MAY NOT BE THE BOY SOME GIRLS

THINK OF AS HANDSOME,

TO MY HEART HE CARRIES THE KEY.

IRA GERSHWIN, 1942

Gordon Parks, 1942

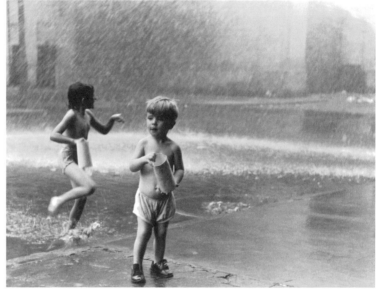

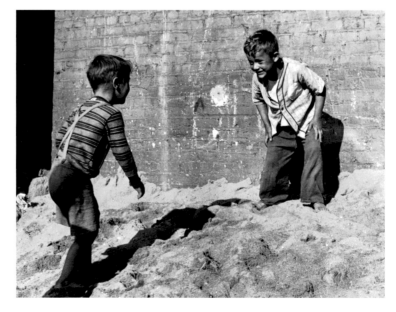

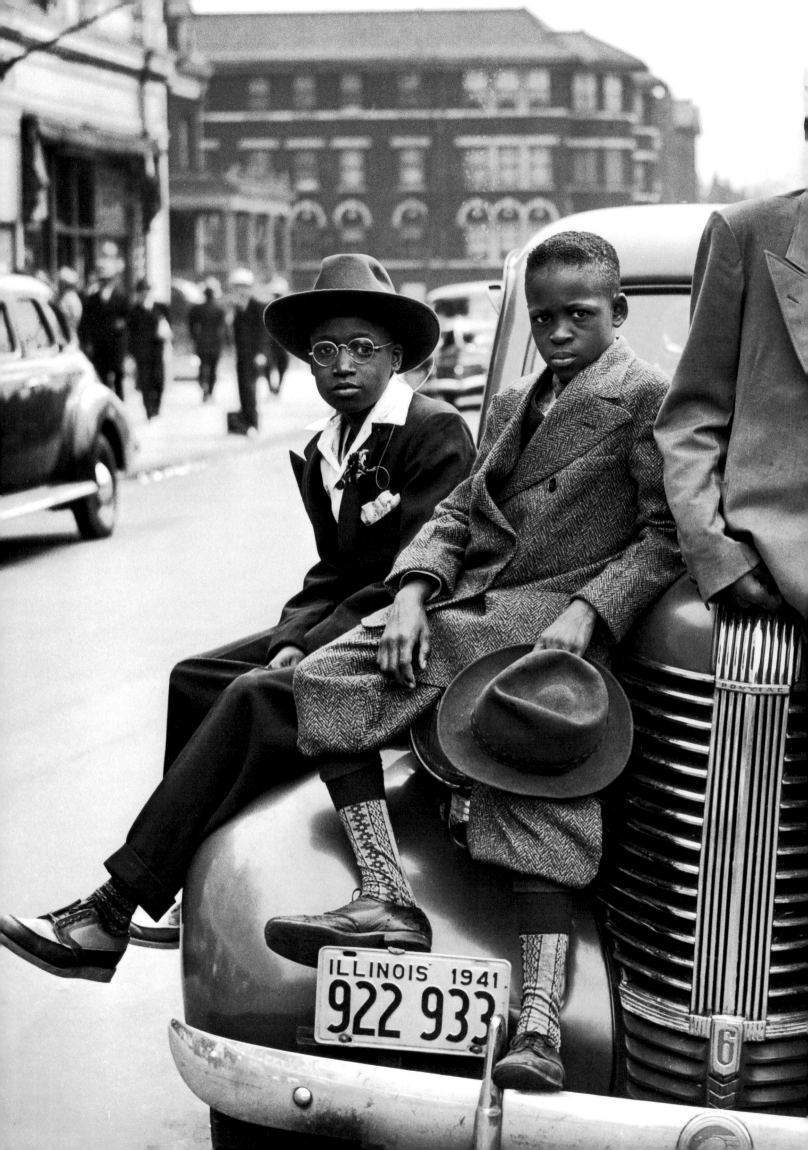

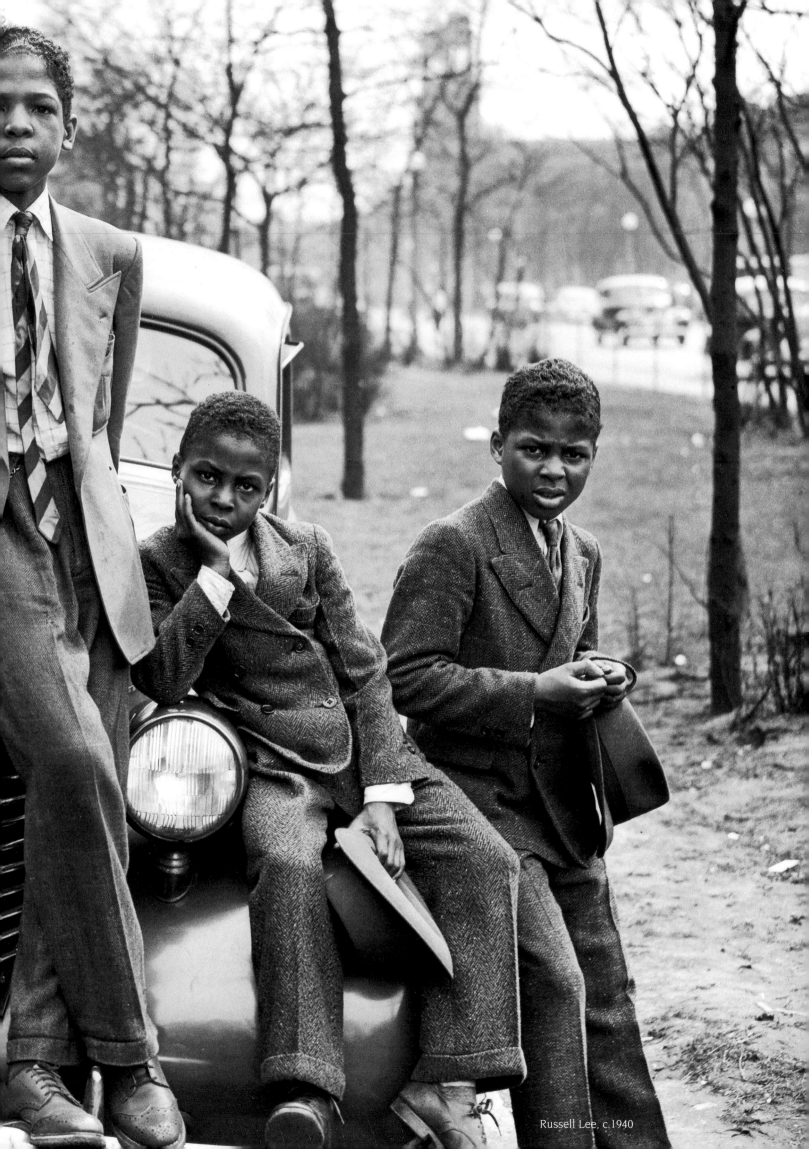

Russell Lee, c.1940

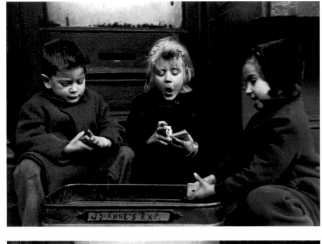
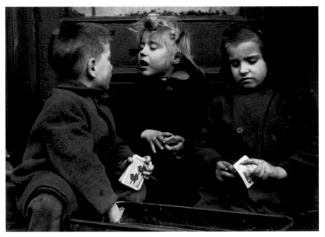
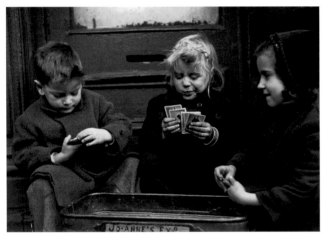
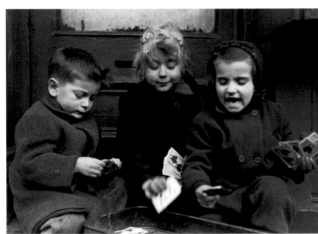
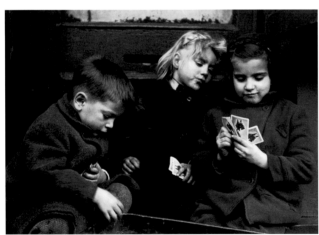
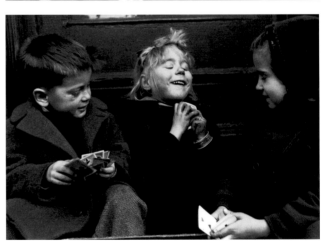

148

CHILD FACES OF BLOSSOM SMILES

OR MOUTHS OF HUNGER WORN BY LOVE,

PRAYER AND HOPE,

CAREFREE AS THISTLEDOWN

IN A LATE SUMMER WIND.

CARL SANDBURG

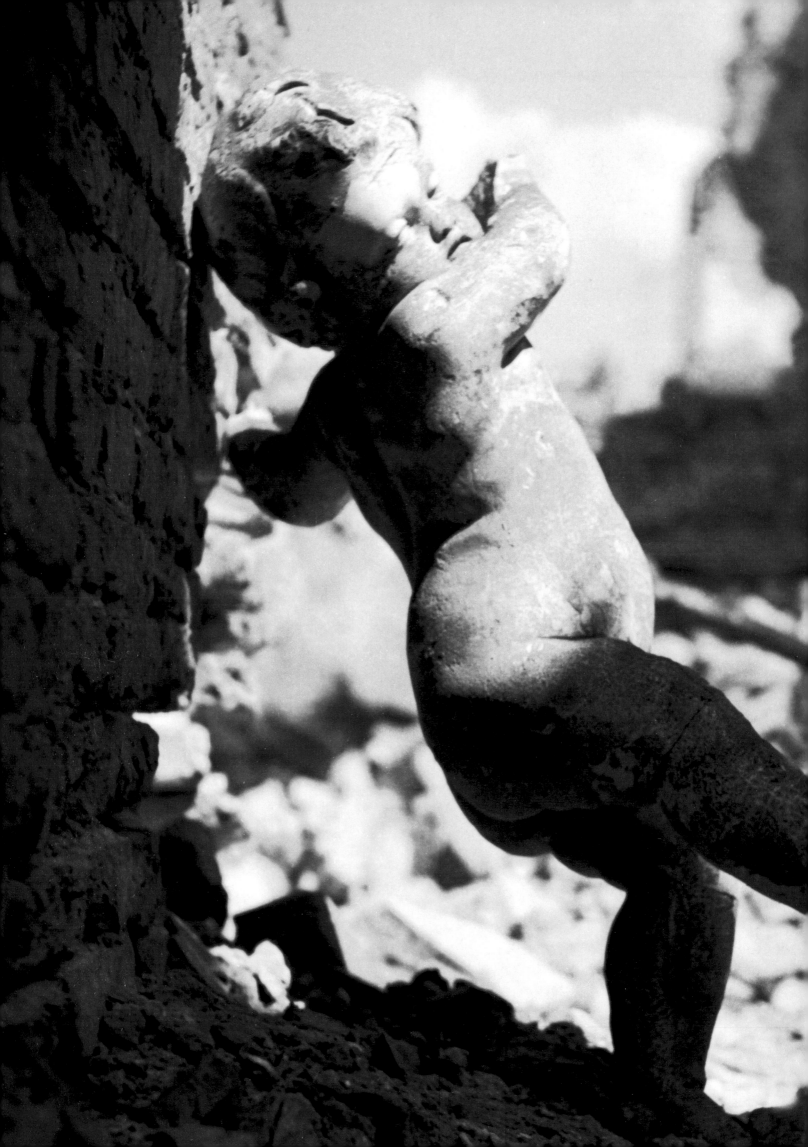

the child devastated

EVER SINCE CAMERAS WERE INVENTED,
PHOTOGRAPHY HAS KEPT COMPANY WITH DEATH.

SUSAN SONTAG

Photographers have been drawn to wars as close witnesses since the inception of the camera. Roger Fenton chronicled the Crimean War, Mathew Brady covered the American Civil War and, even earlier, Agustin Casasola photographed the Mexican Revolution. Their images were often filled with heroics and staged battle scenes, reinforcing the romance and righteousness of the cause. There are many reasons that war attracts photographers. The public demands visual information, and war (along with natural catastrophes) offers an opportunity to visually capture deep emotions.

War images are a form of history-as-spectacle, much the same as a Goya painting. Although World War I presented those opportunities, access was limited. Amateur photography was forbidden, and governments, particularly those in Germany and France, strictly limited photographers to recording acts of patriotism. Therein lies the enduring tension between the wagers of war and the visual recorders of war.

World War II profoundly tested the alliance between government and photographers. Both sides understood the importance of photography to their cause. The Allies enlisted some of the best photographers to join their ranks. The introduction of small quick-shuttered cameras such as the Ermanox and the Leica as well as the development of more light-sensitive paper permitted photographers to put themselves in the very midst of the

action. This ability made their work understandably attractive to publishers and readers.

By the end of the thirties, mass-circulation publications like *Life* magazine in America, the *Berliner Illustrierte Zeitung* in Germany and the *Picture Post* in England had nurtured an almost insatiable appetite for photographic imagery. Television had yet to supplant the photo-essay, and photography allowed people to experience the action almost as if they were there. Unfortunately, through the process of editing, the story told was most often the one sanctioned by military censors and tailored to the government's objectives.

Government control was most pervasive in Germany. Germany had been the epicenter of photography for decades, in the vanguard of experimentation and innovation. The Nazis found such freedom unacceptable. Realizing the power of photography to influence public opinion, they required all photographers to register with the Ministry of Propaganda. At the advent of the war, they went further and declared that there would be no independent media and that all able-bodied photographers were to be conscripted into the army. Photography would have only one mission in Germany -- to help choreograph Hitler's rise to power.

The fact is that war photography evolved as the war progressed. At first, the most popular images were those that captured the physical and emotional experiences of front-line soldiers. Photographers (and picture editors) reasoned that these images were self-validating, and that the suffering, sacrifice and determination of their subjects would prevail.

As the conflict intensified, photographers broadened their scope to show the effect of war on civilian populations. Among the most memorable images of World War II are the Omaha Beach landing by Robert Capa, MacArthur's arrival on the shores of the Philippines by Carl Mydans, raising the flag on Iwo Jima by Joe Rosenthal, the awesome aftermath of Hiroshima by Wayne Miller, Anne Frank's poignant photo booth image, the horrors of the Bergen-Belsen camp by George Rodger and the Times Square V-J Day embrace by Alfred Eisenstaedt. Only one of those featured a child and that was a mechanical self-portrait. Children were simply not singled out but considered part of the whole. As Gertrude Stein said, "during war . . . there are no children's lives and grownup lives, there are just lives."

Viewed with the benefit of hindsight, Stein's observation may have been an oversimplification. No other event in the twentieth century (with the possible exception of AIDS) had a more devastating effect on the well-being of the very young. Never before had so many young people been exposed to so much death. Never before had weapons of mass destruction been so persistently aimed at civilian populations composed primarily of children and women. Never before had so many children been so effectively corrupted by propaganda fundamentally alien to basic human dignity. It was not until photographers entered the concentration camps and surveyed the devastation of Nagasaki, Berlin and Dresden that they came to appreciate that the devastation of war could be captured more powerfully in the faces of children than in the blood of battle scenes.

Therese Bonney, c.1944

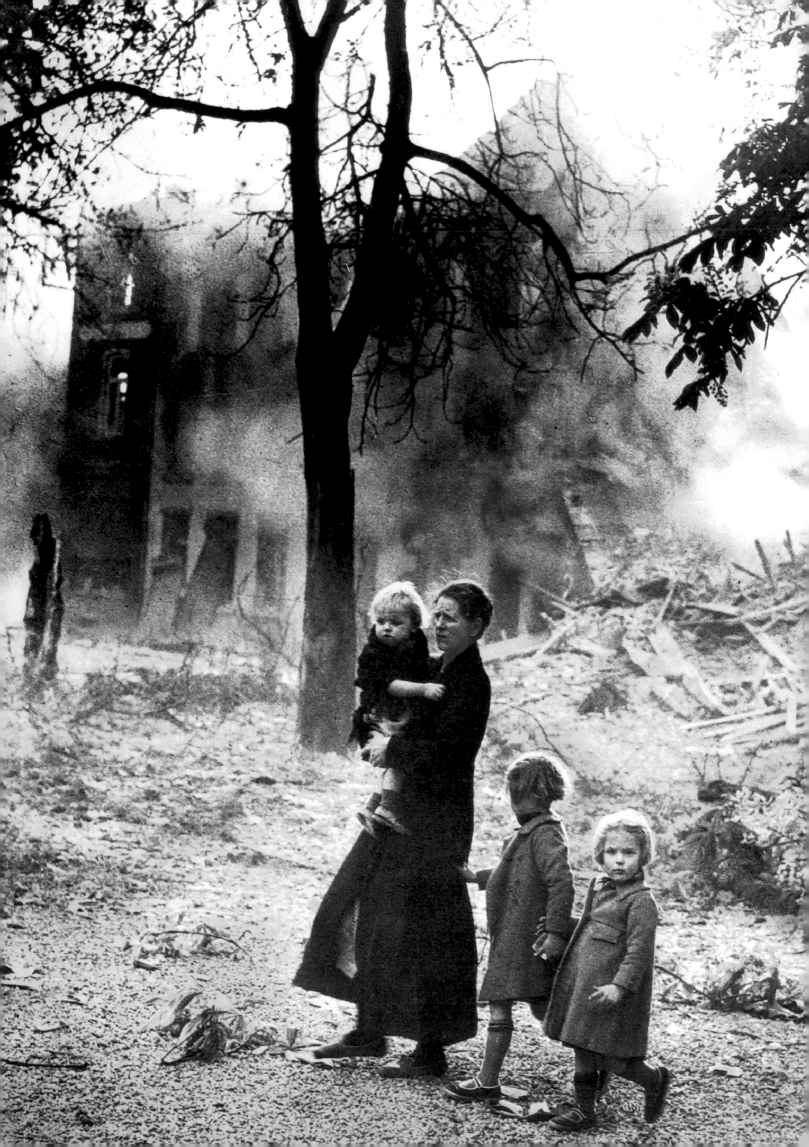

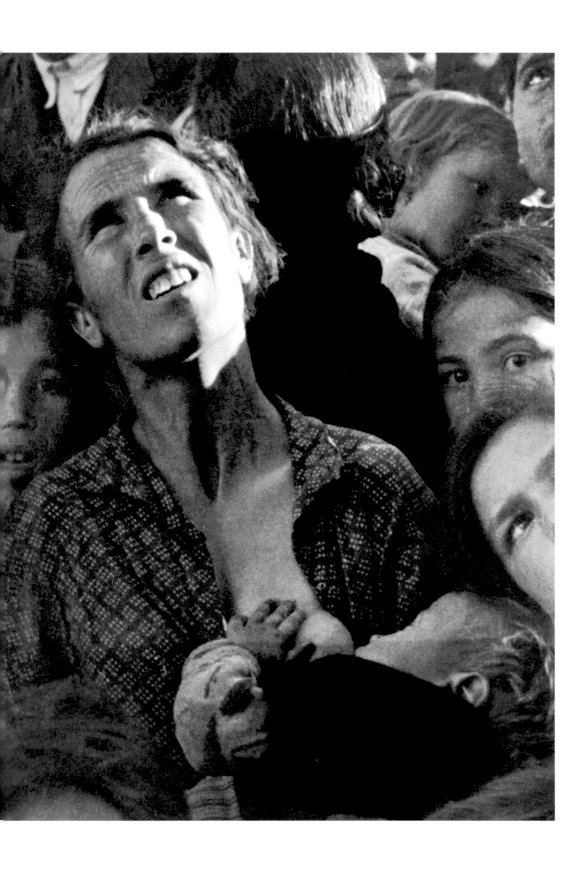

David Seymour (Chim): Air raid over Barcelona, 1936

It may be worthwhile to pause and consider what makes images, particularly those involving children, rise to the level of visual icons. Clearly, it is more than their reflection of reality. Conventional thinking characterizes photographs as "taken" and paintings as "made," implying that one is objective and the other interpreted. Photography's perceived objectivity is based upon the fact that it is fundamentally a trace of reality. Nevertheless, particularly in war, images are often manipulated to serve a cause, even in instances in which their "objectivity" may not have lent itself to that cause. War imagery had long before evolved from staged memorializations of the pageantry of the male warrior trade. The emphasis had shifted to the capturing of emotions. For images of combatants, photographers wanted to show grit, pain and courage. For war's unwilling witnesses, they sought to capture fear, anxiety and in some instances stoic endurance. For the victims and the vanquished, the focal points were defeat, resignation and, ultimately, death.

Many of the elements mentioned above are present in two iconic war images. Consider David Seymour's image of a woman holding her baby and looking up at the sky. She and the other witnesses seem helpless in what was viewed as proof of Nazi barbarism in its support of Franco in the Spanish Civil War. The woman's eyes seem to cry out in anguish, not so much for her, but for her child. In fact, the picture was taken four months before the war at a political rally on a particularly sunny day. Nevertheless, it remains an icon -- photography's *Guernica*.

The iconic war photograph is the so-called "Death Pit" image. Presented here is a fragment of that horrific photograph. The full image shows four naked men and one child. They are surrounded by seven clothed men; some are armed, the rest seem to be observers. In the foreground, a German officer appears to be directing the photographer to film a pit into which the victims will fall as they are executed. The caption reads: *"Tormenting Jews before their execution, 1943."*

In her classic books on photography, Susan Sontag observed that photographs do not "explain, they acknowledge" and, in order for them to truly educate, there must be some knowledge or information about the event so the image can be set in context. We know

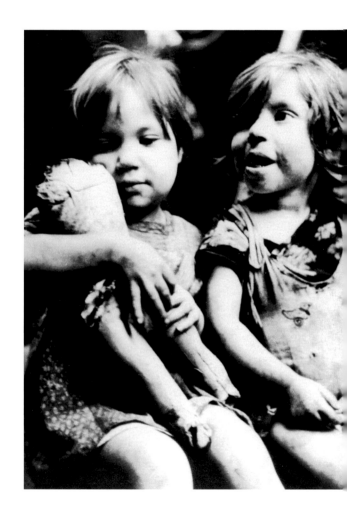

little about the "Death Pit" image -- who took it, who the victims and victimizers were or who its original audience was. Does it fit into a conventional photographic genre, such as social realism, documentation or photojournalism? Or should it be relegated to propaganda imagery at its pornographic worst? It may well belong to all of the above when viewed in different contexts, and therein lies another paradox of photography. Images can be used to harm as much as to comfort, to obfuscate as well as to explain.

Photographs like this one also serve as emotional flashpoints. Sontag recalls seeing Nazi atrocity images in 1945 when she was twelve. She recalled that "nothing I have ever seen -- in photographs or in real life -- ever cut me as sharply." She said that after seeing them, "something inside me went dead." She was not alone. The writer James Agee, who collaborated so effectively with Walker Evans in capturing America's Great Depression, refused to view atrocity images of the war. He feared that their power would overwhelm his passion for justice with a lust for vengeance. Others feared that by viewing them they would unwittingly collude with the perpetrators. Still others believed that these victims had already suffered enough and should be left alone. "Death Pit" has become a signature image of the Holocaust, just as Seymour's Spanish Civil War image is now viewed as iconically capturing the plight of the war's innocent victims.

As the effect of man's inhumanity to his own species became more apparent, photojournalists began to turn their cameras more frequently on children. They were among

photography's best -- Eugene Smith, Robert Capa, Roman Vishniac, Margaret Bourke-White, Theresa Bonney, David Seymour (Chim), George Rodger and William Vandivert. They viewed war as unacceptable, and each, in his or her own way, worked to convince others of its futility. Robert Capa said it best: "A war photographer's most fervent wish is to be unemployed."

To use President Jimmy Carter's words, "[w]ar may sometimes be a necessary evil, but no matter how necessary it is always evil." World War II killed and maimed more children than all previous wars combined. Those who survived witnessed or participated in the rise and fall of what was once unimaginable.

One of the best ways to understand the effect of World War II on children is to view the photographs of children caught in the conflict. Such images help illustrate the wider story and serve as a testament and homage to the thirteen million children who perished. These photographs can create an impression so searing that the imprint is virtually permanent. They are akin to what psychologists call "flashback memory," for they are the freeze-frames of exceptionally traumatic events. They give us a child's perspective on war that traditional histories often ignore or contort to fit their purposes. Collectively, they are important to give a necessary balance to history.

Unknown Photographer,
Tormenting Jews before their execution, Sniatyn, 1943

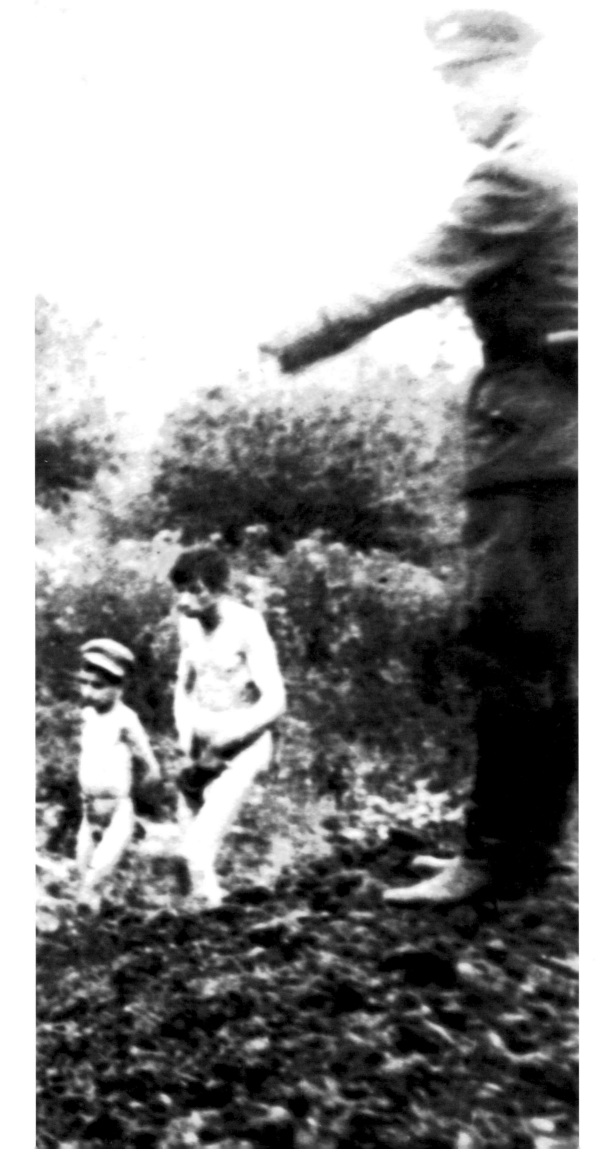

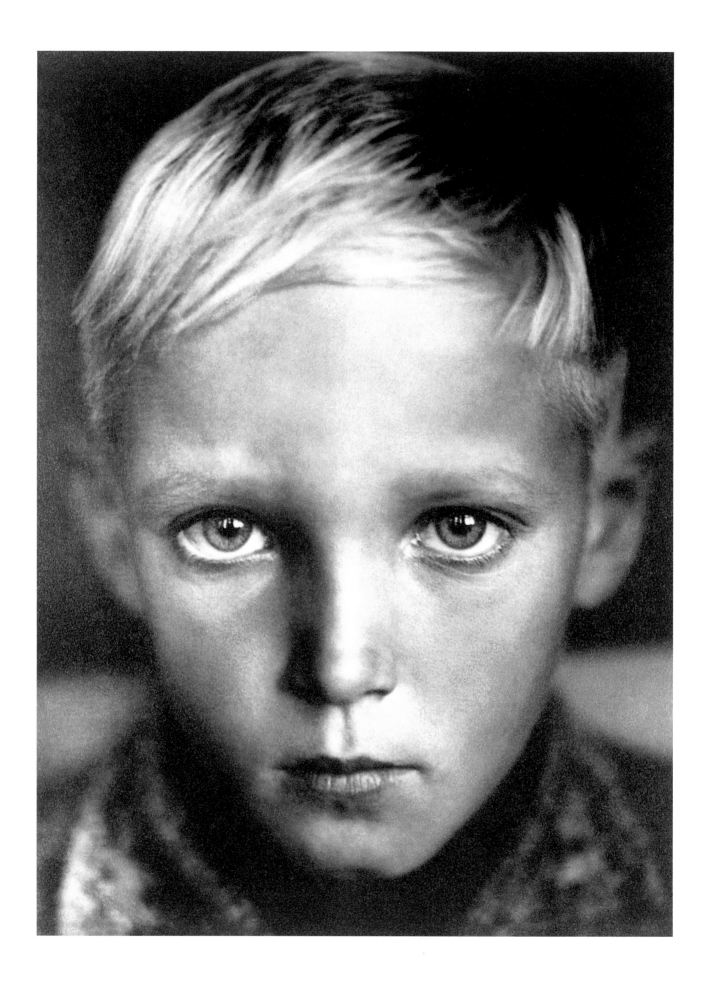

Erna Lendvai-Dichsen, 1932

WHAT WILL THE STORY BE OF MAN ACROSS
THE NEAR OR FAR FUTURE?
FOR THE ANSWERS READ IF YOU CAN
THE STRANGE BAFFLING EYES OF YOUTH.

CARL SANDBURG

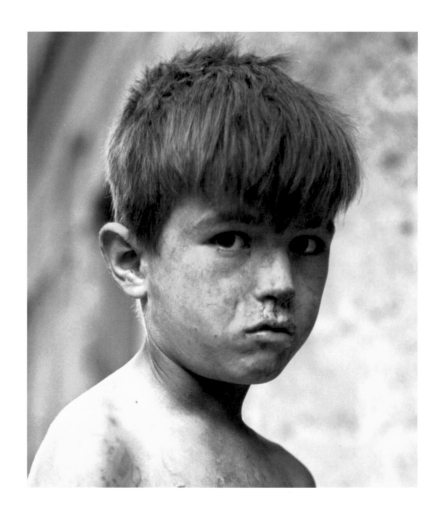

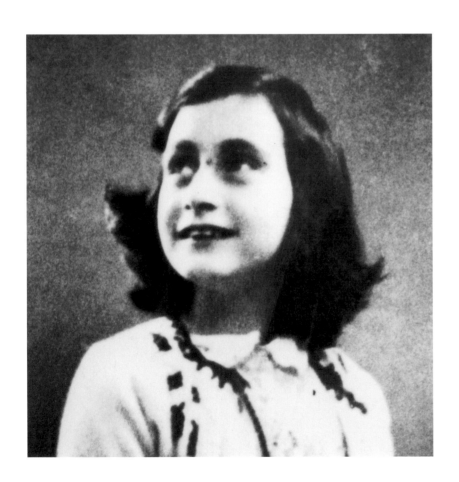

Anne Frank, Self-portrait, 1942

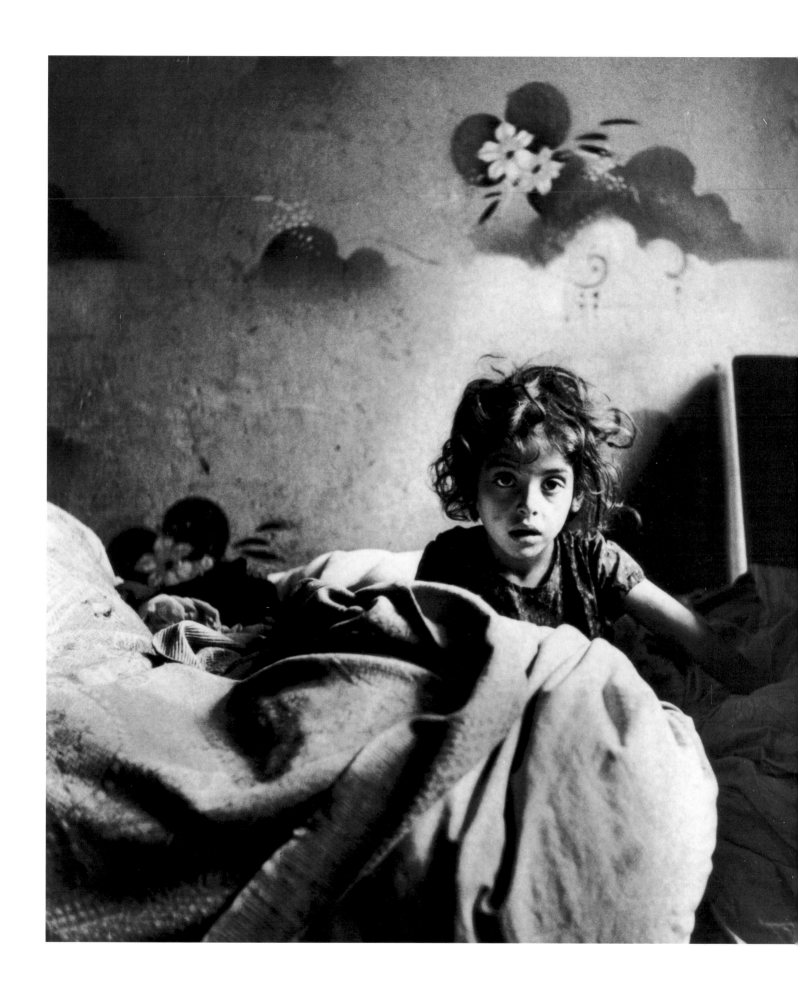

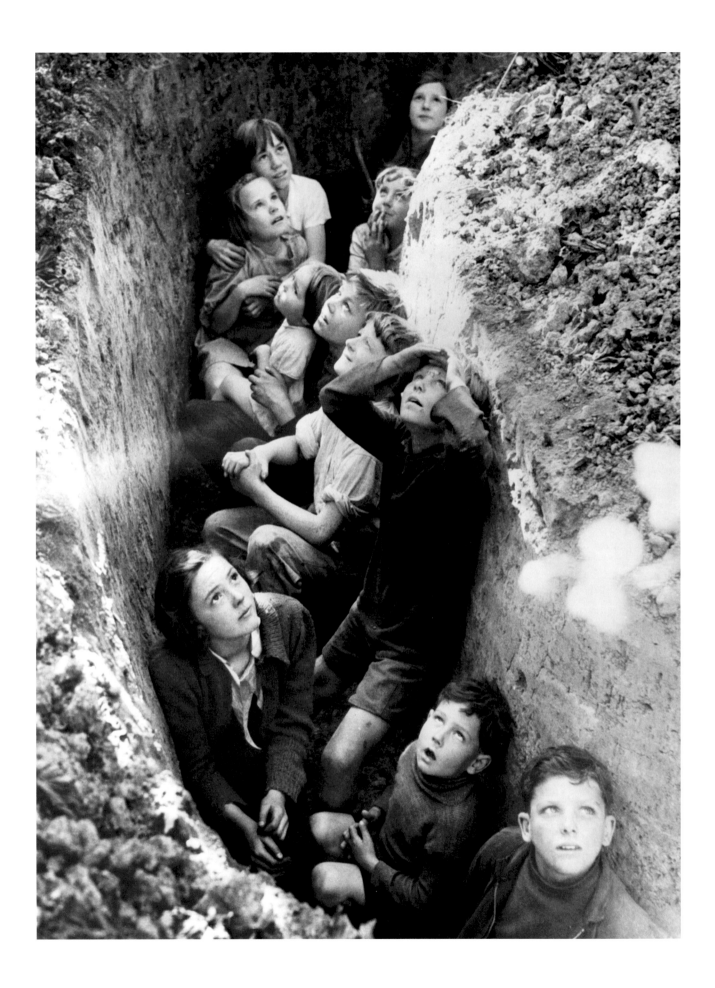

Unknown Photographer, English bomb shelter, 1942

ALL WARS, JUST OR UNJUST,

DISASTROUS OR VICTORIOUS,

ARE WAGED AGAINST THE CHILD.

EGLANTYNE JEBB

MY PROGRAM FOR EDUCATING YOUTH IS HARD.

WEAKNESS MUST BE HAMMERED AWAY.

I WANT A BRUTAL, DOMINEERING, FEARLESS, CRUEL YOUTH.

YOUTH MUST BE ALL THAT. IT MUST BEAR PAIN.

THERE MUST BE NOTHING WEAK AND GENTLE ABOUT IT.

THE FREE, SPLENDID BEAST OF PREY

MUST ONCE AGAIN FLASH FROM ITS EYES. . . .

THAT IS HOW I WILL CREATE THE NEW ORDER.

ADOLPH HITLER, 1933

I SEE THE WORLD SLOWLY TRANSFORMED INTO A WILDERNESS.

I HEAR THE APPROACHING THUNDER THAT, ONE DAY,

WILL DESTROY US TOO.

I FEEL THE SUFFERING OF MILLIONS.

AND YET WHEN I LOOK UP AT THE SKY,

I SOMEHOW FEEL THAT EVERYTHING WILL CHANGE FOR THE BETTER,

THAT THIS CRUELTY TOO SHALL END,

THAT PEACE AND TRANQUILITY WILL RETURN ONCE MORE.

ANNE FRANK, 1944

Unknown Photographer, c.1943

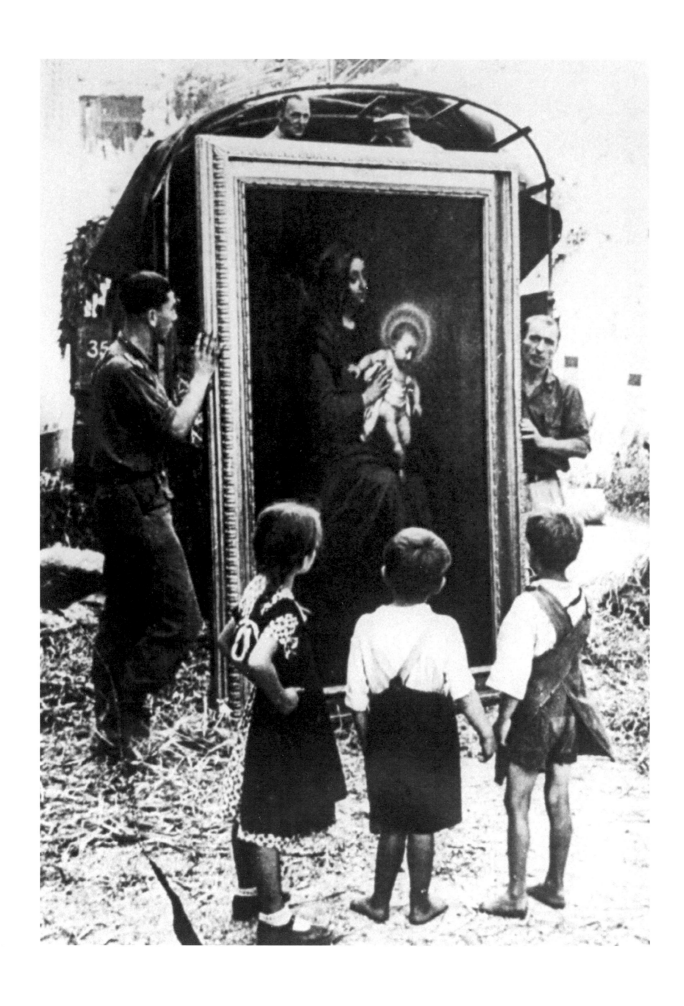

Marty Katz
Looting of the Uffizi Museum, 1944

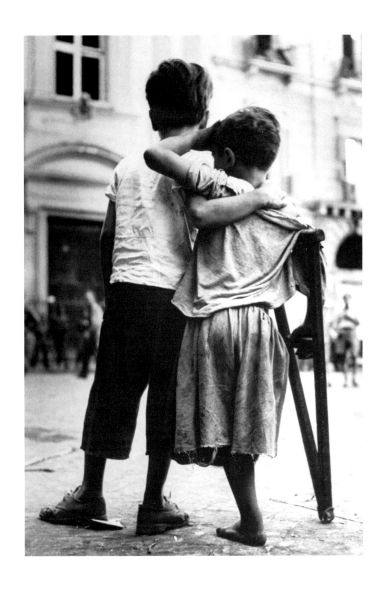

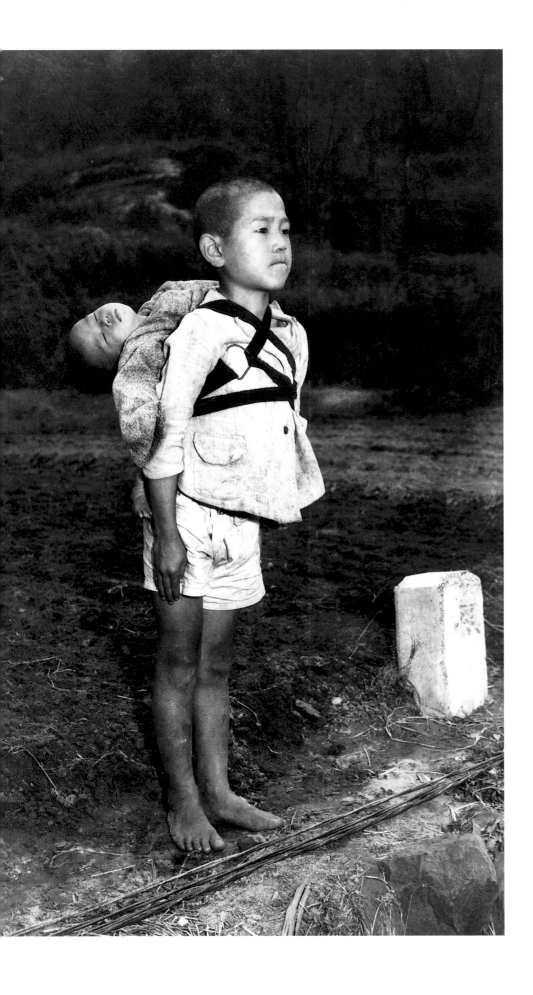

Joe O'Donnell,
Child brings dead brother to cremation site, Nagasaki, 1945

THE LIVING BLIND AND SEEING DEAD ·

TOGETHER LIE AS IF IN LOVE.

THERE WAS NO MORE HATING THEN,

AND NO MORE LOVE.

GONE IS THE HEART OF MAN.

EDITH SITWELL

Wars end in jubilant celebration; World War II was no exception. In all but one country in Europe, bells rang, sirens blared and horns honked. People gathered in villages and cities, singing and dancing, marching and weeping. There were winners, whose sacrifice and effort had toppled the most evil regime the world had ever endured, and there were losers.

For the children caught in the conflict, there were few winners. The statistics are numbing. This war killed, maimed or adversely affected over fifty million children. More than one million children died in the Holocaust; only eleven percent of the Jewish children living in Europe before the war survived. Seven million non-Jewish children under the age of sixteen were war combatants or casualties. Four hundred thousand children died in Leningrad alone. For Nagasaki and Hiroshima, child war fatalities remain virtually incalculable due to the lingering effects of radiation.

Even for the child survivors, many could not be considered winners. Poland was left with a million orphans. Over ten percent of all children in Greece lost both parents. Throughout Europe there were well over thirty million displaced persons, and at least thirteen million of those were children.

For the children of many of the victors, there was some comfort in knowing that their myths and heroes had prevailed; their hopes and expectations had been realized. They felt a part of the victory, no matter how small their contribution. For the children of the vanquished, the effects of the war were negative in almost every way. Mere survival

George Rodger, Germany, c.1945

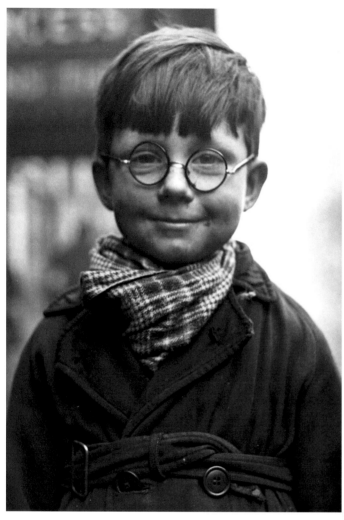

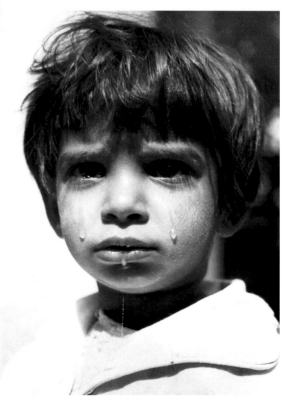

Haywood Magee, England, 1951
Werner Bischof, Hungary, 1947 (bottom)

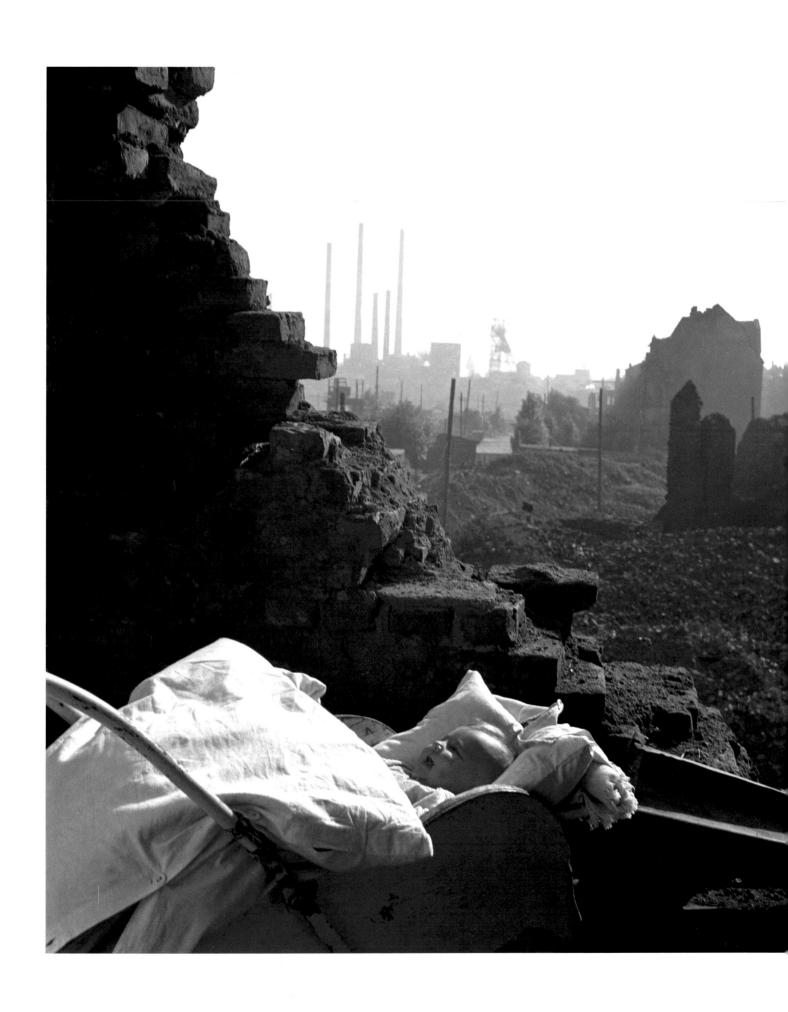

David Seymour (Chim).
Child fathered by occupation soldier, 1947

173

became their primary objective. Only after that challenge had been met could they attempt to come to terms with the destruction that had been visited on them, psychologically as well as physically. The culture and myths, heroes and ideologies of Germany's young were largely destroyed. Their parents often adopted a strategy of silence on issues they preferred to forget. The Holocaust and the Bomb were rarely discussed. Children would have to come to terms with those events themselves.

The most important legacy of the war was humanity's plea for peace. The war marginalized children's hopes and their plight served as a clear warning -- if war is not resisted as a response to national, regional and religious conflicts, the effect on future generations will be tragedy and suffering instead of peace and

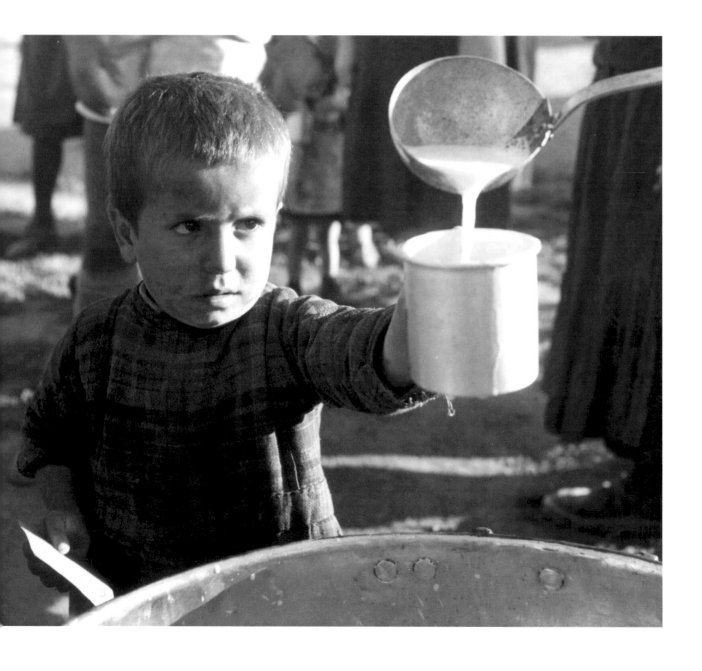

David Seymour (Chim)
UNICEF-provided milk, 1948

understanding. The second inheritance from the war, helped considerably by photography's recording of the plight of children in its aftermath, was an enhanced commitment to care for the children most affected by conflicts and the use of volunteerism among the citizens of the world to accomplish that goal.

The idea of an international mandate to rise above partisan politics to address the special needs of children in war had a precedent in World War I. Eglantyne Jebb, a remarkable English visionary, created an organization called "Save the Children" to raise resources to help children affected by conflict, whether friend or foe. She based her program on the tenet that there was no such thing as an "enemy child." Her continuing efforts inspired others to band together during and after World War II to ensure that the surviving children were cared for. The war had made it painfully clear that children's welfare was too precious to be entrusted solely to political and national self-interest.

On December 11, 1946, one year after the creation of the United Nations, world leaders established an organization dedicated to bringing relief to war-affected children, supporting those in vanquished and victorious countries equally. It was called the United Nations International Children's Emergency Fund (UNICEF). That organization would in time expand its mandate to include children around the world.

Although they have suffered frequent setbacks, these two legacies -- a desire for peace and an enhanced commitment to children's needs -- have survived. Whatever the hurdles, the desire for peace continues to live in the hearts of all humankind. UNICEF has become the world's premier children's welfare organization and, with its many partners, has made steady progress in advancing the well-being of children.

Indeed, if children were the decision-makers, Shel Silverstein's poem might be their reigning anthem:

I will not play at tug o' war
I'd rather play at hug o' war.
Where everyone hugs
Instead of tugs,
Where everyone giggles
And rolls on the rug,
Where everyone kisses,
And everyone grins,
And everyone cuddles,
And everyone wins.

Perhaps that is too much to hope for. Yet, this war gave new definition to the meaning of good and evil, rapture and tragedy, hate and love, humiliation and admiration. The Chinese have a proverb that says that a gem cannot be polished without friction or a child perfected without trials. The war gave children all the friction and trials they could handle. Hopefully, a new era, one more fit for children, was about to unfold.

WHAT A WASTE IT WOULD BE AFTER FOUR BILLION
YEARS OF EVOLUTION IF THE DOMINANT ORGANISM ON THE
PLANET CONTRIVED ITS OWN SELF-DESTRUCTION.

CARL SAGAN

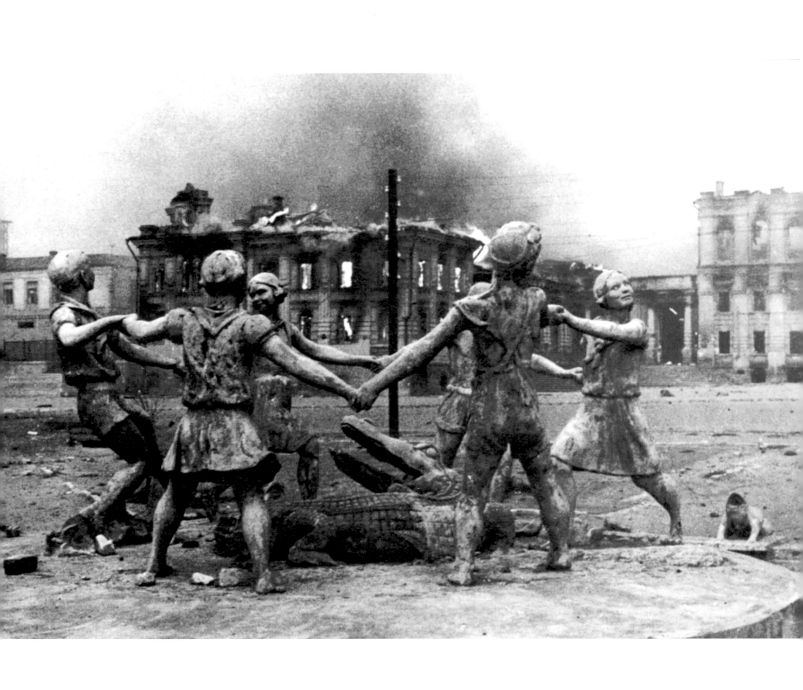

the child dreams

. . . SOME DAY YOU WILL BE OLD ENOUGH
TO START READING FAIRY TALES AGAIN.

C.S. LEWIS

During the thirties and forties, tumult and ferocity prevailed. Survival often took precedence over other things -- including children's literature. Although poverty and war have never been popular material for children's books, that is not to say that authors have not tried. Over four hundred books about the Depression and World War II came to market; only a small handful remain in print today.

The one genre of children's books that did survive was the fairy tale. It emerged in a renewed form, exemplified by the works of J.R.R. Tolkien, Antoine de Saint-Exupéry and C.S. Lewis. These writers took children's fantasy literature to places it had rarely gone before. Their method was to make the child a central participant in the world's troubles and their genius was to invite children to dream.

Fairy tales have always offered glimpses of worlds where fundamental truths endure and moral values are strong. So, in an age of pain, suffering and unprecedented change, it is neither surprising nor accidental that this genre proved so popular. It was a time for stories to infuse children with an added strength to live in hope. Seeing what virtue reaped in the world of make-believe, children were empowered to act positively in the world in which they lived.

The child psychologist Bruno Bettelheim noted that "[f]airy tales are unique, not only as a form of literature, but as works of art which are fully comprehensible to the child as no other form of art is." Perhaps no other form of literature is able to speak so directly and simply to children. The monsters in these tales most often do not scare them; rather they help children deal with the monster they feel, or fear, within themselves.

J.R.R. Tolkien, the father of this new genre, felt that what was needed to help children recover from the wounds of war was to return to the healing power of myths, and, for Tolkien, this took form in the bedtime stories he told his four children. An Oxford don, fastidious by nature, he carefully committed these stories to writing, along with drawings, maps and even a language of his own creation. They formed the basis for *The Hobbit* (1938) and its sequels, *The Lord of the Rings* series (1954-1955).

Tolkien created one of the most engaging other-worlds ever imagined by any children's writer -- Middle-Earth, a place inhabited by friendly albeit often greedy dwarfs, pleasant elves, ill-tempered dim-witted trolls, malevolent goblins and evil wolflike creatures called wargs. Added to this *mélange* were hobbits, a race of small, plump creatures with furry feet and a penchant for good food and drink. One of them, Bilbo Baggins, lives contentedly in his comfortable hobbit hole until a wizard named Gandalf arrives and convinces him to lead a group of dwarfs on a quest to reclaim their rightful property from the evil dragon Smaug. As the adventure unfolds, Bilbo outwits menacing trolls, cruel goblins and fierce wargs. In the story's climax, he slays Smaug,

gains the dwarfs their fortune and, with characteristic hobbit humility, returns home to enjoy the pleasures of a quiet life.

A child (and even a discerning adult reader) knows almost immediately that there is more to Bilbo than meets the eye. He possesses neither athletic skills nor superior physical strength, holds no magical powers save the ability to disappear quickly and quietly and, on occasion, to get assistance from a friendly wizard. He has to use wit and good sense to accomplish his heroics. A child can relate to that. Tolkien's work contains a profound message -- no matter how bad things seem, a person (even a child) has the power to right them.

If Tolkien is the father of this genre, Antoine de Saint-Exupéry might well be considered his progeny. He, like Tolkien, was profoundly affected by war. A French pilot during World War II, he was shot down by German fighter planes on what was to be his last flight and perished in the Mediterranean. Saint-Exupéry's writings, slender memoirs about his extraordinary life, are laced with poignant pleas for men, women and children to recognize the responsibility that all humans have toward one another. His most effective work, *The Little Prince* (1943), took the form of a personal testament encased in a fairy tale.

The story is narrated by a pilot downed in the desert with little food or water. There he meets a young prince from a small, distant asteroid. The Little Prince was alone on his small planet save for a solitary rose that he adored, notwithstanding her constant demands. He meets the pilot-narrator during his travels from planet to planet. Along his journey, he encounters a garden filled with

A MAP OF NARNIA AND THE SURROUNDING COUNTRIES

roses, which both delights and depresses him. He learns that flowers do not live forever and he begins to long for his rose. A fox then reveals to him that the important things in life are visible only to the heart. His rose had told him that she was the only one. He now realizes that even though there are many roses in the world, there is only one for him and that is what makes her unique. His heart dictates his return so he submits to a lethal snakebite, which supposedly will send him back to his rose. There the story ends. The narrator is skeptical that the prince in fact made it back home, but he finds some comfort from the twinkling of the stars, in which he is almost sure he hears the Little Prince's unique laughter.

What sets this work apart from previous children's literature is the maturity of its theme. It deals with issues of profound consequence, emphasizing a person's responsibility for shaping priorities, as well as stressing the importance of personal freedom and the need to be true to oneself. It also underscores that life is often a painful journey and that anguish, loss and death are integral to it. Heretofore, authors had found those subjects difficult for children. The war changed that. Children came to realize with trepidation that life was transitory. *The Little Prince* did not attempt to supplant those fears; rather, it tried to explain that life has meaning only in the context of death. The young reader who is truly immersed in *The Little Prince* finds it not so much a place of fantasy, but rather a place of intense reality where pain and loss are essential nutrients for the soul.

Completing the trinity of the new fantasy writers was C.S. Lewis, another Oxford don

and a close friend of Tolkien. With his extraordinary allegorical fable, *The Chronicles of Narnia* (1950-1956), he joined Tolkien and Saint-Exupéry as the group's spirit. His tales centered around a lion named Aslan, a thinly disguised Christ figure, who rules a supernatural land named Narnia. The story is built around the improbable adventures of four young English evacuees during World War II who stumble into a magical wardrobe in their host's home. They discover a portal that takes them to a land cursed by the White Witch, where winter is perpetual.

In the forest, they meet a cast of engaging characters -- a fawn carrying an umbrella, a fish with a fishing pole, a beaver with a sewing machine and an assortment of articulate beasts and loquacious trees. Yet in the midst of all this enchantment, there is an eternal story to be told -- the story of Aslan's sacrifice for the denizens of Narnia. Clearly referencing the Bible, Lewis tells a story of death and rebirth that holds its own without allegory. Aslan is required to offer up his life for one of the children's transgressions. But he is born again, and with his resurrection, the winter of the White Witch is turned into spring.

Lewis's genius was to make his young audience understand and embrace basic issues of trust, failure and consequences. His readers, regardless of religious training, grew to love Aslan and everything he symbolized, and many came to wish for someone like him in their world.

The Hobbit, *The Little Prince* and *The Chronicles of Narnia* are in a sense cautionary tales. These writers had grave concerns as to where the

human spirit was headed. Yet the immense popularity of these books made it clear that young readers were up to the challenge and ready to confront life's vicissitudes. The overwhelming weight of the war made them receptive to stories that would take them out of their world. Yet the most pressing need for children who survived the war was to find meaning in their lives, and they found it in these tales of quest and redemption.

The association between literature and autonomy is strong. Reading is one of the best ways to promote independent thinking, for it permits and encourages children to look beyond the limitations of their own circumstances. As the renowned English writer Francis Spufford put it: "The books you read as a child brought you sights you hadn't seen, scents you hadn't smelled, sounds you hadn't heard. . . . [A]s a result, [you knew that your] own particular life only occupied one little space in a much bigger world of possibilities."

Perhaps the most important contribution made by these classics was to the maturation process of their readers. These books have helped countless young people reignite their imaginations, awaken their passions and position themselves for a place in society.

After years of deprivation, destruction and death, dreams and fantasies were necessary to return a certain balance to life. The works of Tolkien, Saint-Exupéry and Lewis encouraged those dreams. As their readers came of age, they gradually left those fantasy worlds and began to understand that the disappointments that inevitably awaited them in adulthood were the price of joy and self-realization. Dreaming helped them get there by letting them see clearly with their hearts and, to paraphrase Saint-Exupéry, to realize, as the Little Prince did, that "anything essential is invisible to the eyes." Those invisible essentials are in fact the stuff of dreams.

One learns from these books that the children of the war were not only capable but also desirous of participation in affairs that affected them. They asked pertinent questions as the Little Prince did, took on responsibility as Bilbo did, and even made a difference as the children of Narnia did.

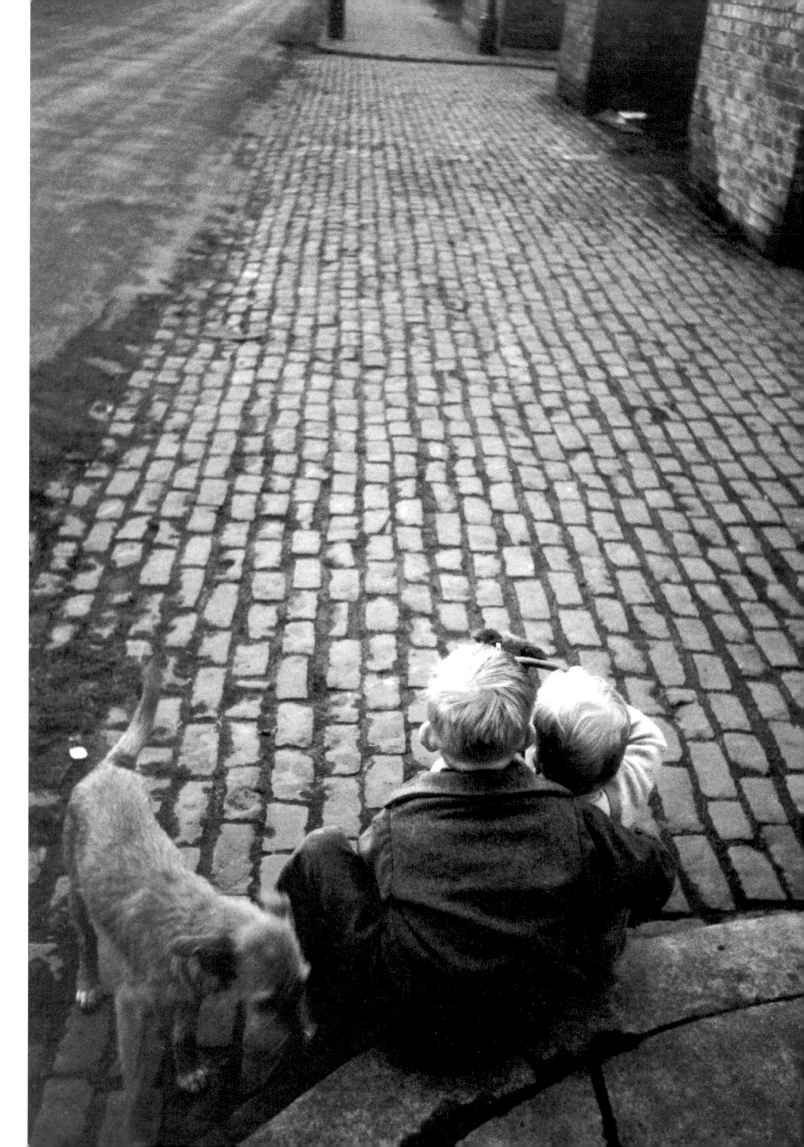

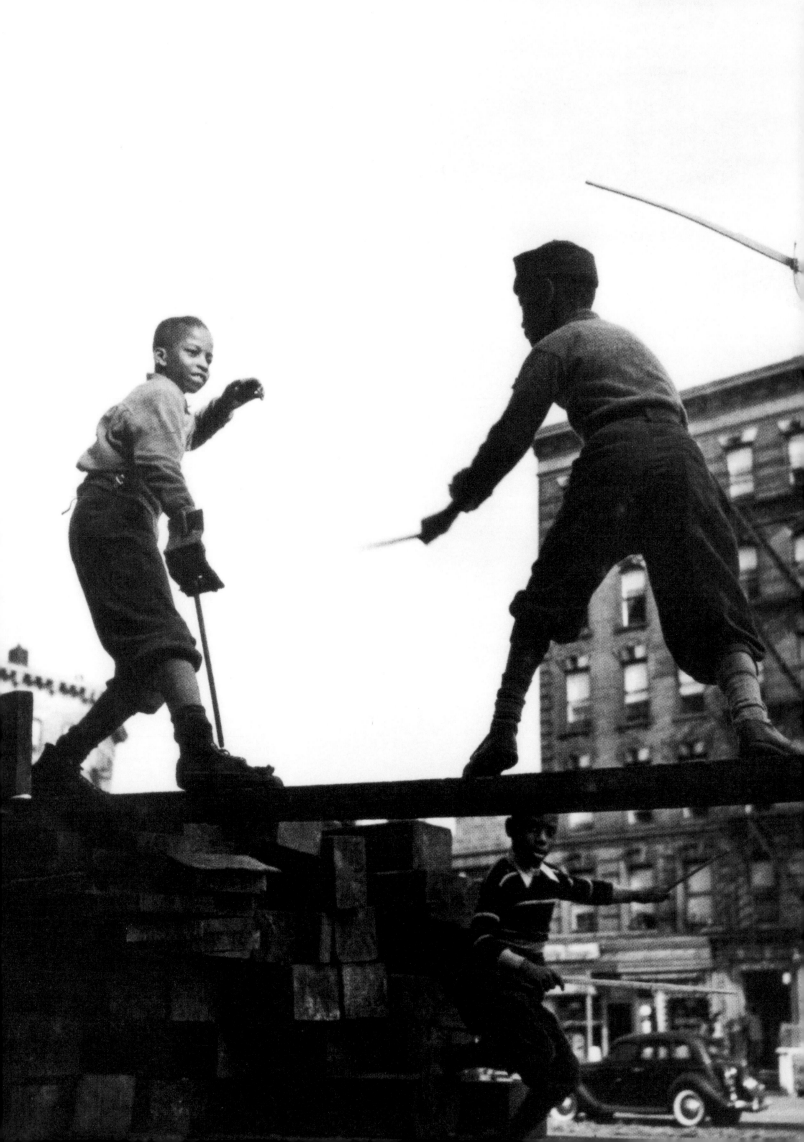

FAIRY TALES ARE MORE THAN TRUE,
NOT BECAUSE THEY TELL US DRAGONS EXIST
BUT BECAUSE THEY TELL US
DRAGONS CAN BE BEATEN.

G.K. CHESTERTON

Aaron Siskind, Harlem, New York, c.1940

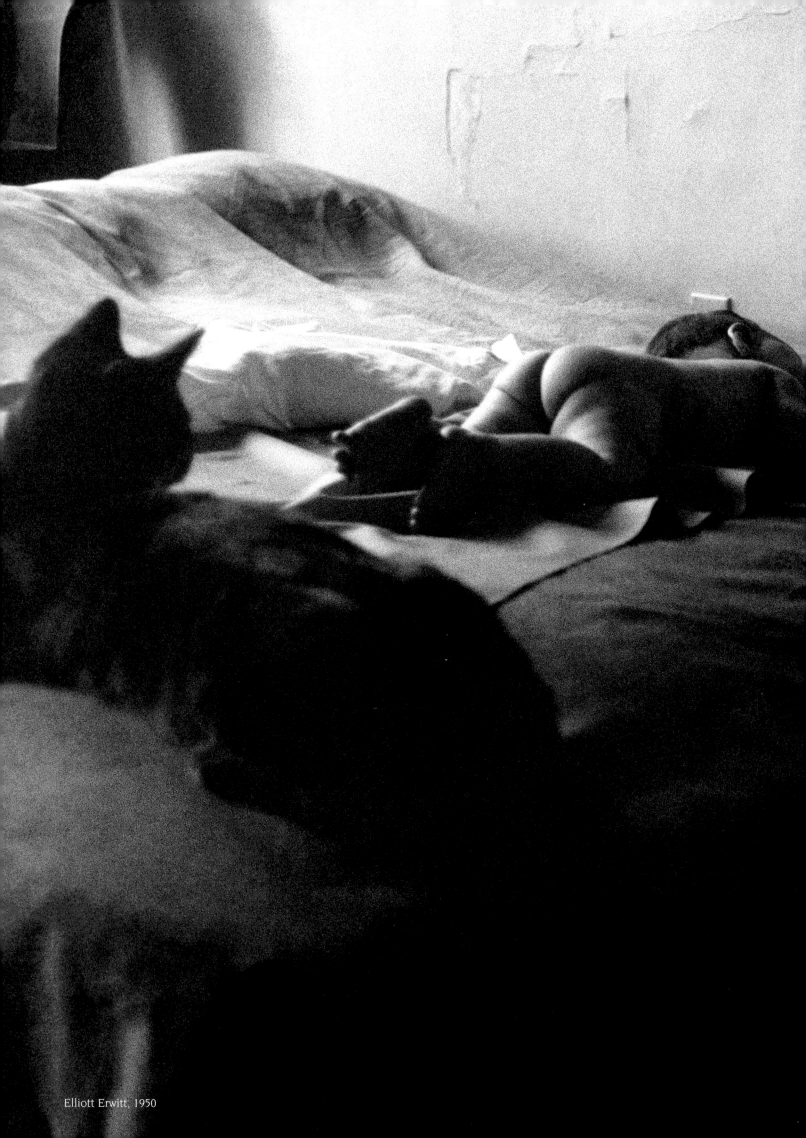

Elliott Erwitt, 1950

the child in focus
1950-1980

IF HELP AND SALVATION ARE TO COME,
THEY CAN ONLY COME FROM THE CHILDREN,
FOR THE CHILDREN ARE THE MAKERS OF MEN.

MARIA MONTESSORI

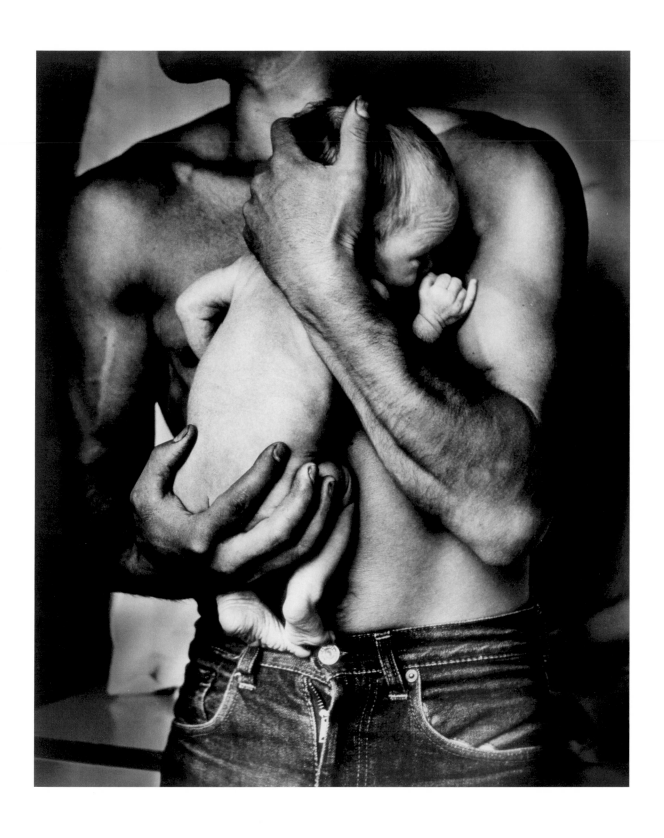

Jan Saudek, 1966

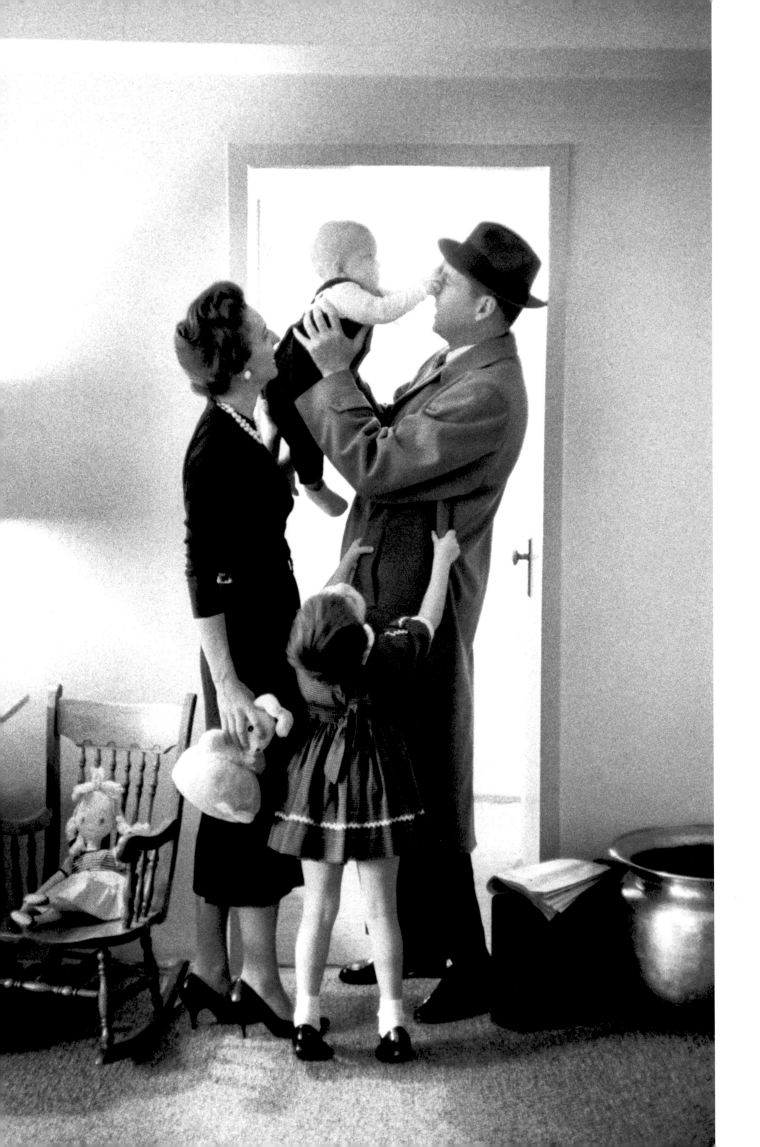

the child perfect

CHILDREN BEGIN BY LOVING THEIR PARENTS,
AS THEY GROW OLDER THEY JUDGE THEM,
SOMETIMES THEY FORGIVE THEM.

OSCAR WILDE

The war had ended, the celebrations were over and by midcentury a societal lull had set in. Peace brought prosperity and babies in abundance. The fifties engendered the largest increase in the population ever experienced in the United States and Western Europe. For some, it was yet another golden age. The cultural construct of childhood that had been evolving for the last century had become firmly established and defined in the thirties and forties in terms of labor and education law. It was perfected further in the prosperity of the fifties. Mothers sought the advice of Dr. Benjamin Spock, whose runaway best-selling baby book encouraged love and closeness. Children, freed from the necessity of work and the relentless concerns of war, spent their days in school and became more engaged with their contemporaries. Prosperity was becoming, if not the norm, vastly more common than before, and children benefited in innumerable ways. Many children lived in seemingly idyllic suburban communities. The toy famine of the war years had ended and there was a plethora of new products marketed directly to children. An abundance of leisure time fostered a child-centric industry. The result was an environment for children in which play reigned supreme. Its epicenter would be in Southern California, where Walt Disney's visionary theme park, in which children and parents could have fun together, became a magical reality. Disneyland opened in 1955 and, with the help of brilliant marketing to children through a new media phenomenon called television, captured kids' -- and the world's -- attention.

At least in North America, the 1950s epitomized the era of the perfect nuclear family, celebrated in television dramas and a new fictional hybrid -- the sitcom -- and reinforced by movies, radio, magazines and advertising. Women, many of whom had worked during the war, were encouraged by the government to return to their traditional jobs as mothers and wives. Couples were encouraged to marry within their religion and class. In many ways, large and small, the decade of the fifties was a period that advocated conformity and conventionality. This was partly because over half of the males who came to adulthood in the fifties were veterans, shaped by training in obedience and regimentation but longing to leave war behind for the security and safety of a predictable life. As uniformity passed into the civilian ethos, "the soldier" was transformed into "the organization man" of postwar managerial life. This conformity would inevitably put such men on a collision course with character traits they valued even more -- individuality and autonomy.

It is hard to fault the parents. Baby boomers grew up in a radically different world from that of their parents and grandparents, whose lives had been seared by the two World Wars and the Depression, and who now wanted to ensure that their children received all the trappings of stability and comfort.

Dick and Jane were preempted by newer media kids, Beaver Cleaver and Dennis the Menace, as well as the sitcom families of

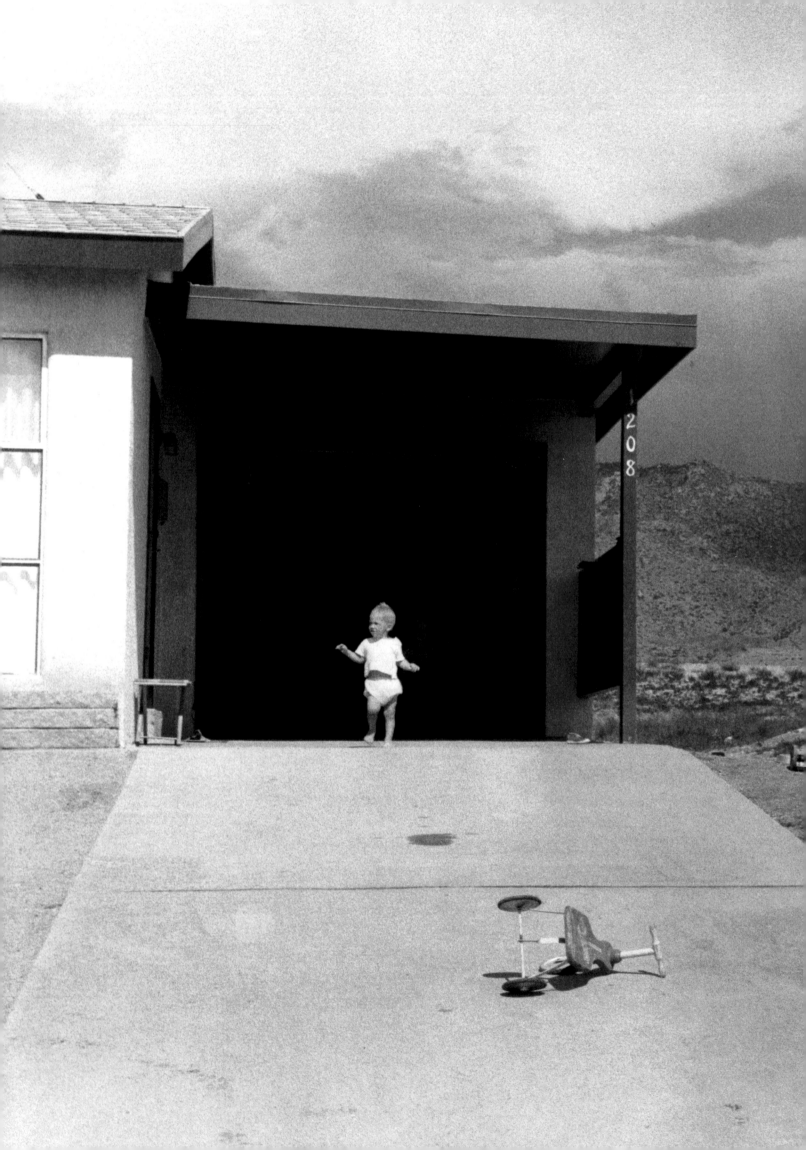

Garry Winogrand, 1957

Ozzie and Harriet, Father Knows Best and *The Donna Reed Show* -- all seemingly perfect, always white and middle class, always respectful, if a tad willful at times. These families reveled in conformity over substance. In the world of TV, gender distinctions between boys and girls were rigorously reinforced. Boys were encouraged to behave in ways appropriate for boys, and girls were expected to behave in ways that were then considered feminine.

The fifties ideal presented marriage, children, a home and a car as a package. Technology was redirected from protection to pleasure. The defining technology in the lives of children was television. Seemingly overnight, it became their dominant exposure to mass media. The young would watch television more hours than they attended school and would accept what was portrayed on TV as the norm. TV started at 5:15 p.m. with the call of Buffalo Bob, "It's Howdy Doody Time," introducing "Buffalo" Bob Smith and his marionette, Howdy. That was followed by *The Mickey Mouse Club*, which in turn led to *The Honeymooners*, *Lassie* and *I Love Lucy*.

Sociologist William H. Whyte described post-war society in the United States as a filiarchy, a society dominated by its young. The sheer number of children produced during this period forced the economy to tool up to feed, clothe, educate and house this new genera-tion. For children, these times were the "Nifty Fifties" -- Mr. Potato Head, Slinky, the Good Humor truck, 3-D movies, cap guns, cigarettes made of chocolate, coonskin caps, Silly Putty, Hula Hoops and Frisbees -- not to mention Barbie and, for the older set, Elvis. In reality, however, even if those times seemed perfect, they lasted only a few years.

Dan Weiner, c. 1956

Many middle-class children of the fifties found themselves pressed between their parents' restrictive idealism and their own burgeoning sense of freedom. Adolescents, viewing themselves as having complex and distinctive needs, separated themselves from adults. Teenagers diverged from their parents' style and attitude, making them increasingly incomprehensible to adults. Their taste in clothes reflected working-class style -- leather jackets and blue jeans -- and their musical preferences were based in African-American rhythm and blues. Teenagers popularized what is now call the "dating process." A whole culture flourished around it -- drive-ins, soda fountains and movies. Prior to the fifties, males still "called" on females in their homes and young people were often chaperoned.

Although adults still believed that adolescents should be protected, there was a growing feeling at the end of the fifties that teenagers were also to be feared. The veneer of perfection created by prosperity and peace began to show fault lines. Children all too often seemed sullen. Movies like *Rebel Without a Cause*, *Blackboard Jungle* and *Psycho* underscored the issue; ducktail haircuts, zip guns, rumbles and switchblades exacerbated it. The stereotypes were morphing from Beaver and Dennis to James Dean and Sal Mineo. The adolescent -- now dubbed "teenager" -- became a figure of significant concern.

Those fault lines broke open in the sixties. That decade's symbols were bell-bottom jeans, sandals and clenched fists. As the Rolling Stones intoned "I Can't Get No Satisfaction," parents viewed teenage behavior as the sign of a generation that was going wrong. In fact, what was occurring

Esther Bubbley, 1958

was nothing short of a "youthquake," as educator Steven Mintz described it -- student revolution, sexual revolution, cultural revolution and a rights revolution -- and the foot soldiers were the children of the fifties. When the sixties arrived, the young were in full battle gear. In America alone, seventy million baby boomers became teenagers and they effected a vivid change in the fabric of American life. Their rebellious activities -- recreational drug use, sit-ins and love-ins -- transformed the construct of childhood.

It would be music (and the personalities that created it) that would galvanize the young. Elvis Presley, the Beatles and Bob Dylan were more than just musical superstars. They opened doors for this period's youth and gave them an aesthetic, economic and political voice that could not be ignored. These performers not only affected dress, hairstyle and even speech, but, more importantly, they used their popularity as a platform to sing out against intolerance and injustice, putting into song what people felt but could not quite put into words. Collectively they reached society's subconscious and became the most influential cultural force of the twentieth century. Children and their idols would never again be ignored.

"There's something happening here . . . what it is ain't exactly clear," sang the rock group Buffalo Springfield in the mid-1960s. They were right. Student activists in Britain, France, South Korea and Japan protested against their governments' policies. Over 70,000 young people participated in sit-in movements fighting racial discrimination. In America, the young stood in the front lines of the protests against the Vietnam War. Armed with nothing but their ideals, they gave a somewhat incredulous adult society a crash course in nonviolent protest. The apathy of youth gave way to affirmative action. What resulted was the creation of a societal wedge -- or the widening of what was called the generation gap.

The young had already separated themselves in dress, style, music and language. Yet, the most profound separation was occurring in their ethos. Anger was rising against what they viewed as adult repression of any form of individuality, and they railed against inequities in the treatment of minorities, unjust distribution of power, resources and opportunities, and inappropriate and self-serving intervention by nations in their neighbors' affairs. It was a heady time with an abundance of challenge, exuberance, civic-mindedness and reckless indulgence, often including the use of hallucinogenics and other drugs. The era was dominated by a youth movement that has had an enormous, lasting and multifaceted effect on culture and politics, transforming them for the better but also causing a backlash against its excesses that has manifested itself in the renewed fervor of conservative activism and the rise of religious fundamentalism.

In spite of this backlash, the energies and idealism of the young during the sixties and seventies transformed them into more complete adults and imbued them with sensibilities that they would pass on to generations to come.

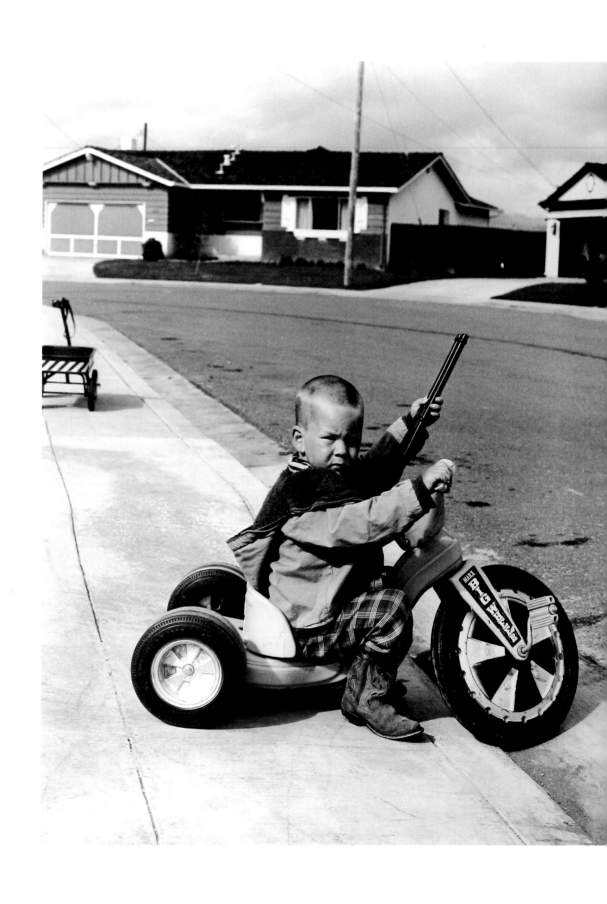

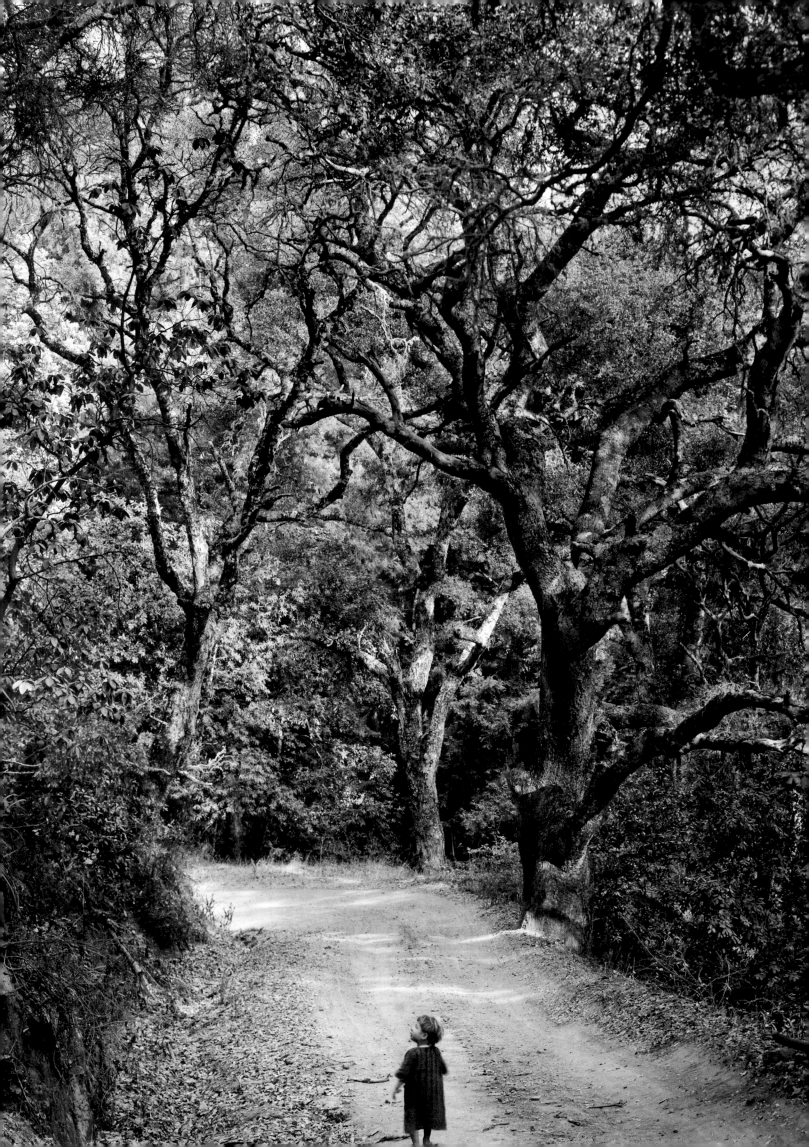

I LEAVE TO CHILDREN EXCLUSIVELY,

BUT ONLY FOR THE LIFE OF THEIR CHILDHOOD,

ALL AND EVERY OF THE DANDELIONS OF THE FIELDS

AND THE DAISIES THEREOF, WITH THE RIGHT TO PLAY AMONG THEM FREELY,

ACCORDING TO THE CUSTOM OF CHILDREN.

AND I DEVISE TO CHILDREN THE YELLOW SHORES OF CREEKS

AND THE GOLDEN SANDS BENEATH THE WATERS THEREOF,

WITH THE DRAGONFLIES THAT SKIM THE SURFACE OF SAID WATERS,

AND THE ODORS OF THE WILLOWS THAT DIP INTO SAID WATERS,

AND THE WHITE CLOUDS THAT FLOAT HIGH OVER THE GIANT TREES.

AND I LEAVE TO CHILDREN THE LONG, LONG DAYS TO BE MERRY IN,

IN A THOUSAND WAYS, AND THE NIGHT AND THE MOON

AND THE TRAIN OF THE MILKY WAY TO WONDER AT.

WILLISTON FISH

Wynn Bullock, 1958

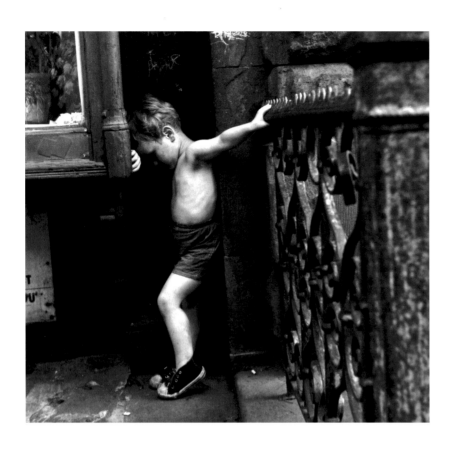

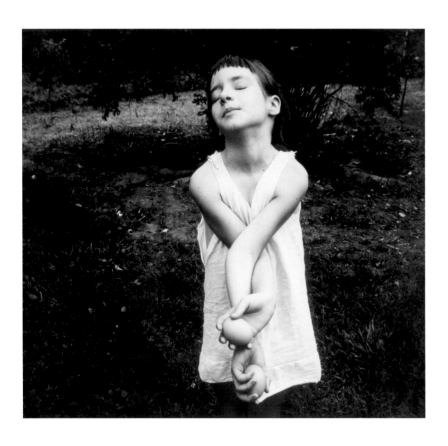

Ken Heyman, 1960
Emmet Gowin, 1969 (bottom)

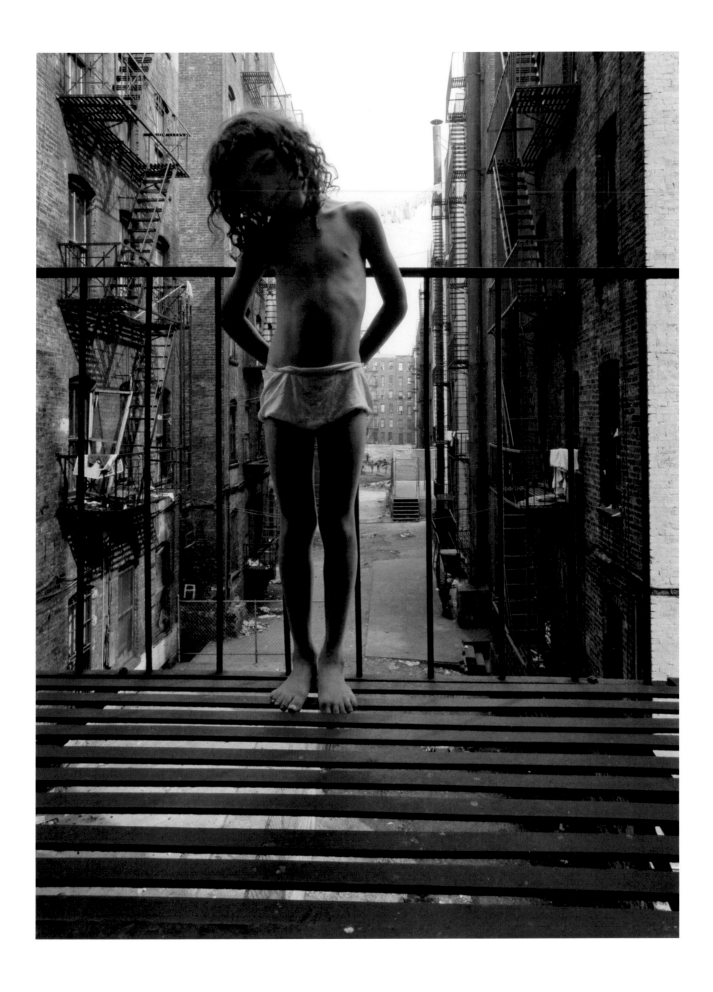

Bruce Davidson, 1963

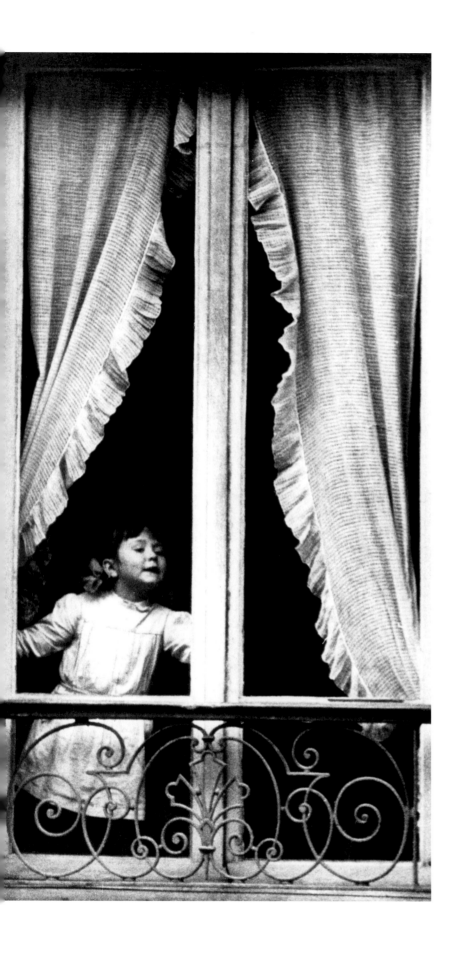

Gordon Parks, Paris, 1950
Elliott Erwitt, 1955 (right)

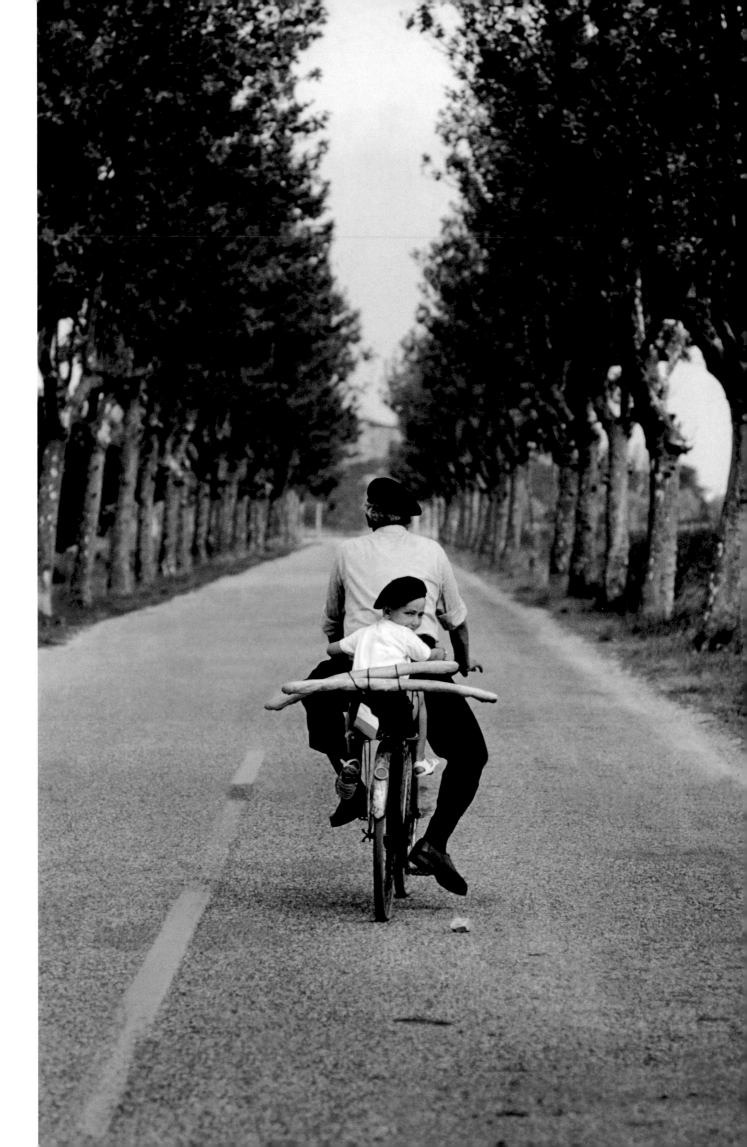

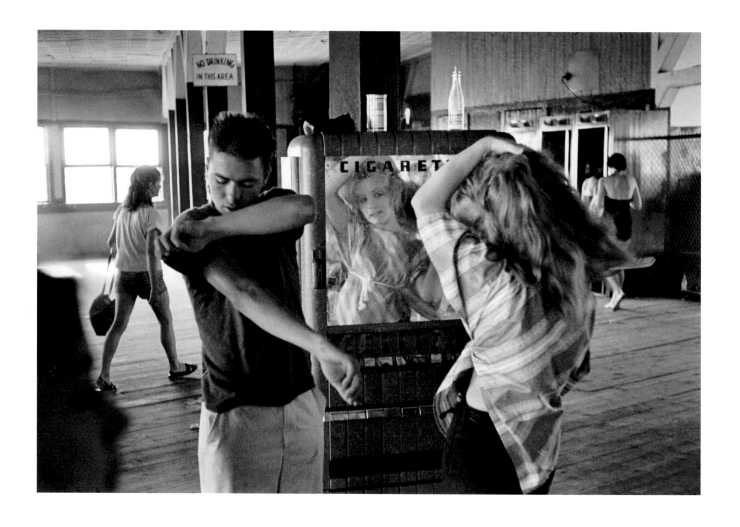

Bruce Davidson, 1967

A LETTER FROM MY FATHER

As long as I can remember, my father always said to me that one day
he would write me a very special letter. But he never told me
what the letter might be about. I used to try to guess what I might read
in the letter; what mystery, what intimacy we would at last share,
what family secret could now be revealed.
I know what I had hoped to read in the letter. I wanted him to tell me
where he had hidden his affections.
But then he died, and the letter never did arrive, and I never found that place
where he had hidden his love

Duane Michals

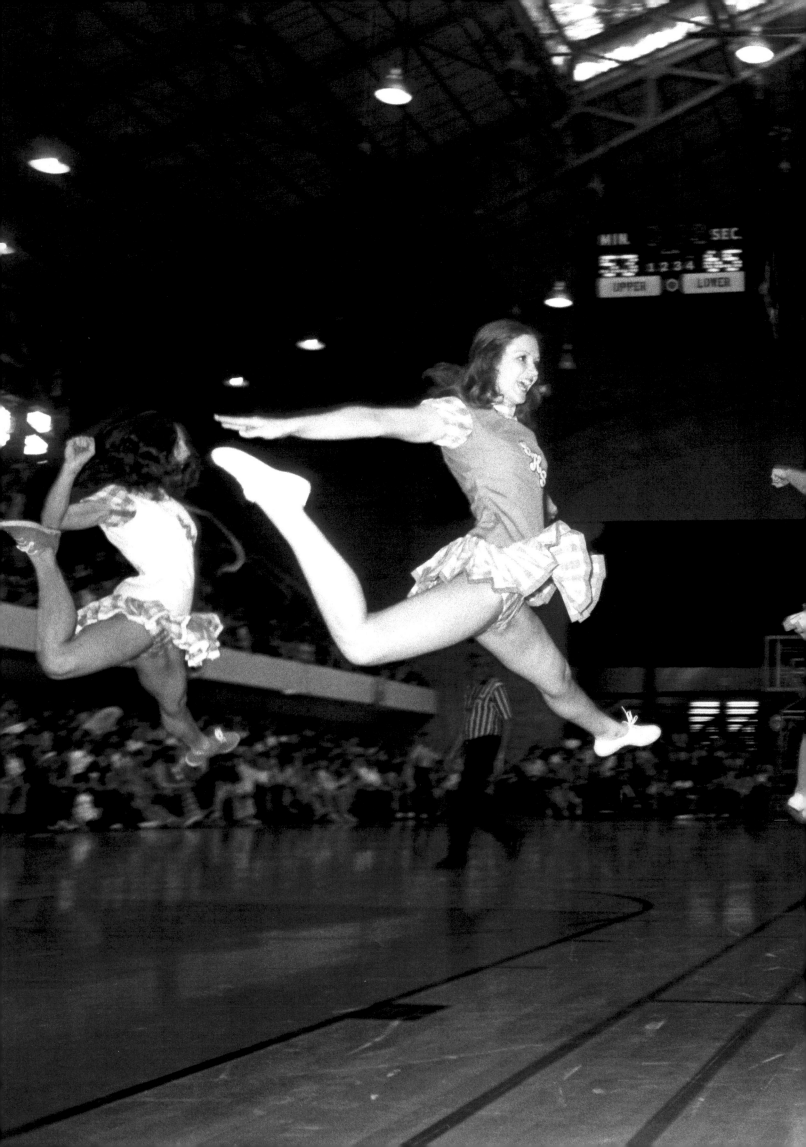

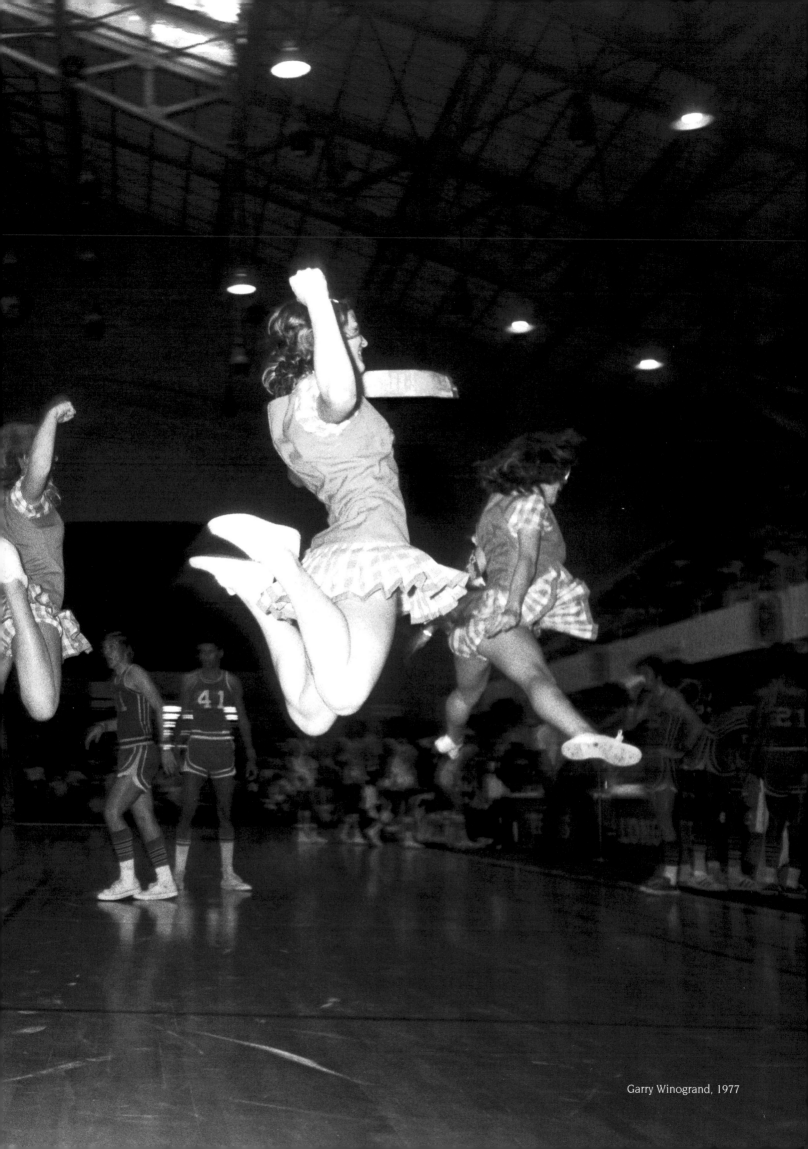

Garry Winogrand, 1977

TIME MISSPENT IN YOUTH
IS SOMETIMES ALL THE
FREEDOM ONE EVER HAS.

ANITA BROOKNER

Peter Keetman, 1957

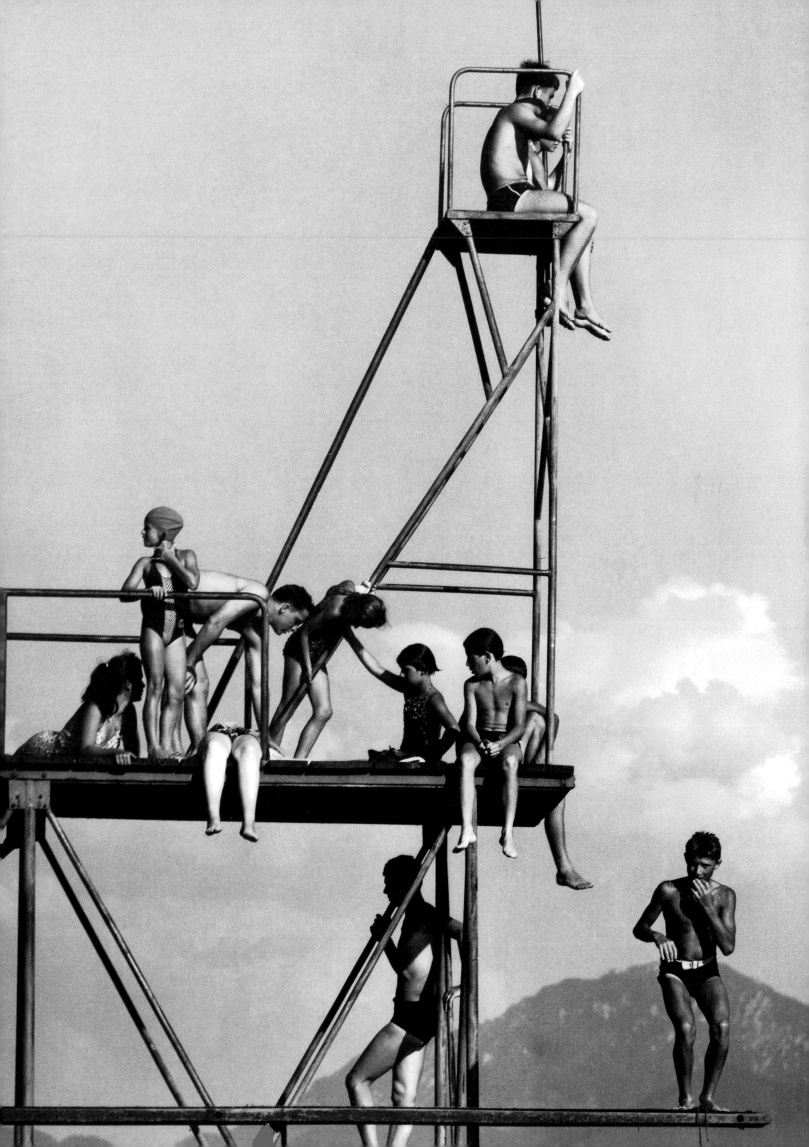

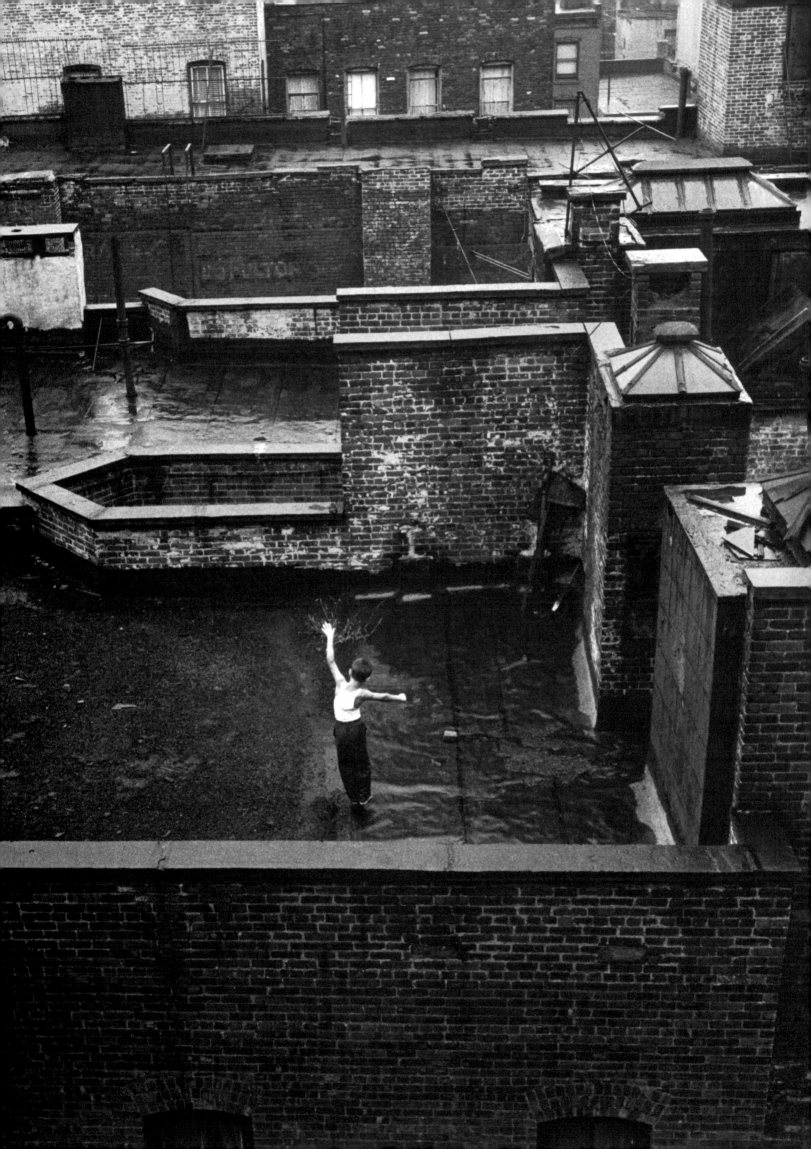

the child alone

The number of children's books that came to market in the period from the fifties to the eighties was staggering and, as one might expect, these books reflected the mood of the period, a mood that had become increasingly turbulent and challenging. Only a handful would become classics, and those often told engaging yet disquieting stories -- ones that spoke of alienation, loneliness and resilience.

For the very young, Theodor S. Geisel, better known as Dr. Seuss, led the way. With wry, relentless rhythm, his cavorting creatures flaunted tradition and authority figures with exuberance. He was certainly not the first writer to blend social concerns into the fabric of his tales. Carroll and Twain had done so a half-century earlier. Seuss's stories, however, were much more iconoclastic and, to some, subversive, delivering searing social commentary through seemingly superficial and non-sensical verse. He would become the most successful writer of young children's literature of the twentieth century. By the time of his death, he had sold over 200 million books.

Two of Dr. Seuss's most endearing stories are *Horton Hears a Who* (1954) and *The Cat in the Hat* (1957). *Horton* tells the story of an elephant with ears like a butterfly, who hears voices coming from a speck of dust. He discovers a world inhabited by microscopic creatures called Whos. It seems that they face extinction by an uncaring and unhearing animal world. Horton takes on, as his personal cause, the survival of Whoville. He pleads that "a person is a person, no matter how small." In order to prove the Whos' existence to a skeptical animal world, Horton gets all the Whos to make as much noise as they can. Fortunately, the animals finally hear them. Whoville is saved thanks to Horton's commitment to the cause of those considered insignificant -- those who are not part of the establishment. *Horton Hears a Who* is a kind of morality play condemning the mindless conformity of fifties suburbia, where there was no room for anybody different.

Shortly after *Horton* came *The Cat in the Hat*. Dr. Seuss's protagonist, a fast-talking trickster with a striped stovepipe hat, was even more upsetting to the prevailing mores. Uninvited, this slick cat entices two bored children, left unattended by their mother, to join him in a boisterous rampage. With the willing complicity of the children, the Cat and his two cohorts, Thing One and Thing Two, wreak havoc until they see that the children's mother is returning. With miraculous speed and efficiency, the Cat cleans the house and disappears. When their mother asks them about their day, the children skirt the truth -- conduct unbecoming of Dick and Jane, but then they did not have Spot to nudge them. In overturning conformity and condoning dissembling, Seuss was able to contradict the conventions of the fifties and score a direct hit on children's fancy. A man of strong principles, Seuss was willing to flavor his stories with large doses of social issues to challenge the minds of children. He was always encouraging them to act on their own:

"Think left and think right and think low and think high. Oh, the thinks you can think up if only you try."

A few years later, Maurice Sendak went even further with his "thinks" in *Where the Wild Things Are* (1963). His protagonist, young Max, angry at his mother for calling him a "wild thing," snaps back at her, threatening to "eat her up." Banished to his room without dinner, alone and lonely, he dreams of a world inhabited by monsters of all shapes and sizes. It is there that he overcomes his terror, taming the wild beasts and making them his friends. Yet, in time, he gets lonely for his family. He sails back home to find his supper waiting -- and still warm. The influence of Sendak's little story on children was profound. Max's tantrum leads to an appropriate "time out," and Max uses his imagination to endure the loneliness that solitary confinement brings. This book is about much more than loneliness; it is also about rebellion -- in a sense a manifesto about finding one's own compass. The verve with which Max sets off by himself to encounter and subdue the Wild Things deeply affected young readers. Many of those readers believe that Sendak's story helped ignite in them the spirit of liberation that prevailed in the sixties. They would later wail, along with the rock group The Troggs: "Wild Thing! You make my heart sing!"

There is a Max in every person, no matter what age, for as psychologist Carl Jung said, "in every adult there lurks a child -- an eternal child, someone who is always becoming, [and] is never completed." Some psychologists, including Bruno Bettelheim, feared that Max's rebellion against parental authority

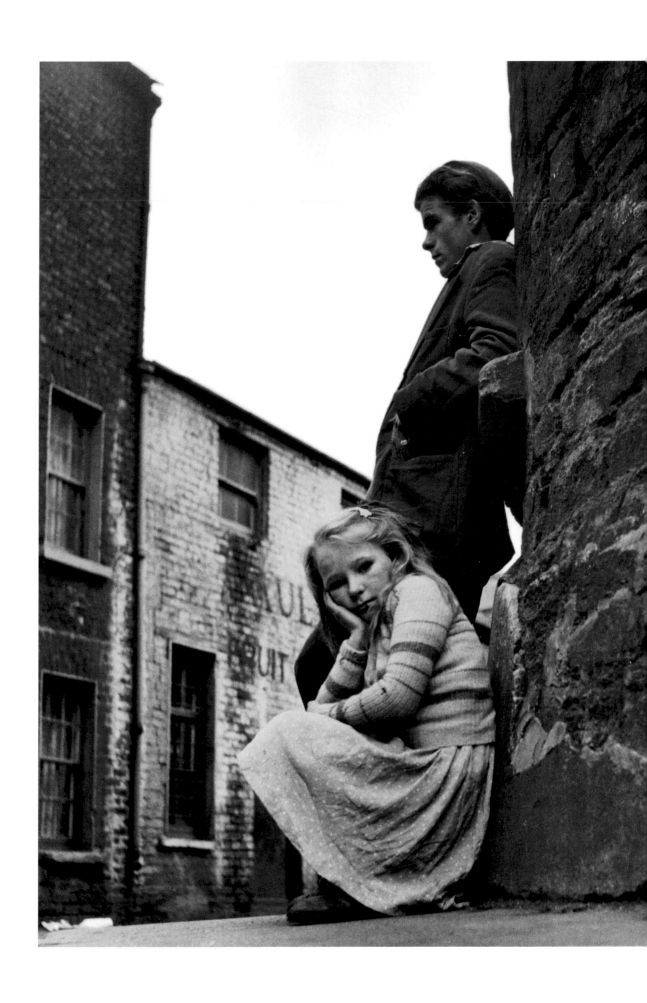

Dare Wright, 1957

might be harmful. Yet most children found
strength not so much in his rebellion as in
his willingness to set off on his own and to
best the befanged and beclawed monsters.

Two other books popular with the young
during the fifties and sixties were *Charlotte's
Web* (1952) and *The Lonely Doll* (1957). They
both stressed the pain of loneliness and the
importance of friendship. In E.B. White's
masterpiece, *Charlotte's Web*, Wilbur, a runt of
a pig who lives in constant fear of being
butchered, befriends a graceful aging spider,
Charlotte, who understands the inevitable
cycles of life. She helps Wilbur avoid an
untimely death at the same time that she
herself prepares for her own demise. During
those preparations, she shows Wilbur the
true essence of life and friendship. Wilbur's
travails are indeed paradigmatic of childhood.
Insatiably curious and susceptible to anxi-
eties and boredom, he yearns for a playmate.
He cures his loneliness by finding compan-
ionship in a family of farm animals, and it is
there that he comes to terms with his own
mortality.

The Lonely Doll, by writer-artist Dare Wright,
is one of an engaging and elegant series of
books that tells the story of a little doll's
need for friendship and companionship.
Wright's books proved immensely popular for
over a decade, particularly with young girls.
She used an art form that was rare in chil-
dren's literature -- photography. Employing
a technique that today is known as tableau
photography (the use of staged and crafted
sets), she let the doll, Edith, tell her poignant
story. The photographs added a heightened
sense of realism that enthralled her young
readers. As in many of the stories discussed

here, there is no parental presence. Alone and lonely, Edith is overjoyed when a teddy bear and his father arrive at her home. She sets forth to make a life with her new friends, though always harboring fears of their departure. Children empathized with Edith.

These five books addressed with great subtlety the timeless issues of loneliness, the need for and cost of friendship, and the stark reality that vulnerability to fear, loss and frustration are all a part of life -- even for the very young. It is interesting to note that these classics, unlike many of their predecessors, relied on visual imagery as much as they did on words. Seuss and Sendak were first and foremost illustrators. Wright was a gifted and innovative photographer. Garth Williams's beguiling illustrations served an integral role in the success of E.B. White's books. The visual was assuming a more important role in young children's books -- a trend that would continue and strengthen.

As stories for younger children embraced broader social issues, books for teenagers boldly announced the altering of the social place of the child entering adulthood. Stories of self-worth, suffering, sexuality and fear of isolation and even of dying relegated the straightforward adventures of Nancy Drew, the Hardy Boys and even comic characters like Archie to the back of the shelves, replacing them with angst-ridden coming-of-age anthems. *The Catcher in the Rye*, published in 1951, set the standard for this genre. Authored by J.D. Salinger, it ignited a generation with the beguiling but deadly serious denunciations of its sixteen-year-old hero, Holden Caulfield.

Theodor S. Geisel, 1957
Carol Bremer, 1956 (right)

Holden, who has flunked out of prep school twice and subsists on little more than cigarettes and Scotch, has disdain for almost everyone except Phoebe, his ten-year-old sister, Jane, an out-of-reach summer passion, and Mr. Antolini, a former teacher-cum-mentor. He still mourns the death of his younger brother Allie from leukemia a few years before. His parents are viewed as distant inhabitants of another world that he must eventually reckon with. Everyone else merits his favorite indictment: they are phonies. Holden's relentlessly critical view of everything and everyone is delivered with candor and lacerating, self-deprecating humor. In sum, the novel is a revelation of the jumble of emotions -- turmoil, exhilaration, love and hate -- that is called adolescence.

Yearning to be true to one's self amidst the slippery social whirl and oppression of convention, the teenager sits in grim, frightened judgment on all around him. The only untarnished person, in Holden's view, is Phoebe. Faced with his depression, she challenges Holden to name one thing he likes or would like to be. He dreams of becoming the "catcher in the rye," saving children who metaphysically run too near the edge of a cliff in the field of life. Although Holden tells his story from an institution where he is recovering from an emotional breakdown -- his present bleak and his future by no means clear -- the novel's end is wistful and defiant. In the depths of fifties conformity, Holden's cry expressed the bewildering madness and beauty of that last aching stage when childhood must be abandoned.

Another quintessential American ode from the fifties that embodies the freewheeling

essence of successive generations of young would-be rebels is Jack Kerouac's *On the Road* (1957). His protagonists, Sal, a writer, and Dean, a dreamer, hit the road, testing the limits of the American dream. The appeal of the road, the car and the highway transport them to open landscapes where, free of conventional courtesies, they can abandon propriety and security. Kerouac presented this "beat generation" as a "holy" one because it was liberated from the sins of ambition and materialism.

This youth movement, like those before and after it, was idealistic. Ironically, it was also grounded in what these young rebels' parents had taught them. (Salinger's book, after all, is dedicated to his mother.) But parents had apparently underestimated the effect of their advice as they remembered their endurance through the Depression, the war against fascism, the witnessing of the Holocaust, and the democratic impulses and "can-do" attitude that drove the postwar boom. Consequently, they were surprised when their children demanded that those same standards be applied in the social discourse -- on race, then war and then gender and every other aspect of human interaction -- that was taking place in the streets, ghettos and universities, locally, nationally and internationally. The rumbling dissatisfactions and artistic surges of the 1950s accompanied the children of the sixties and seventies through the explosion of energy, protest and sexual exploration and the social and political movements that dominated that era's cultural expression.

Even with all the upheaval, the world remained male-dominant. The rise of the

women's movement in the seventies revived days of suffragists and Rosie-the-Riveters, and young women recognized themselves in Rosa Parks and other historic beacons of female determination. Karen Carpenter sang it best: "Bless the beasts and children for in this world they have no voice, they have no choice."

Perhaps the loneliest child ever to grace a literary page came to life in 1970 as the protagonist of *The Bluest Eye* by Toni Morrison. Pecola Breedlove fantasized that blue eyes would bestow a beauty that would deliver her from the invisible suffering of being a black girl in America, for "in her eleven years, no one had ever noticed Pecola." Morrison's book is a stirring anthem to the grief and rage that continue to devastate some children -- outrage at being ostracized, abused and unloved.

Finally, a voice from the past -- Tolkien's -- gave us yet another literary character to gain iconic status during this period. Frodo Baggins is the young hero of his epic, *The Lord of the Rings* (1954-1955). A hobbit like his kin Bilbo, Frodo is entrusted with the mission of personally destroying a potent evil ring by throwing it into a fire. If he fails to do so, calamity will befall his family and neighbors. For Frodo, the journey is a rite of passage. Although he fails in his mission, fate intervenes and the ring is in fact destroyed by flames. Young readers identified with Frodo's efforts and understood that he gave his best against the armies of the evil Mordor, the lava pits of Mt. Doom and the Dark Lord himself. Idealistic youths imagined that together with their friends they were a fellowship, ready to embark on great deeds on which the

fate of the world might depend, and to show their solidarity and their resolve they would inscribe "Frodo Lives" at every opportunity.

That phrase symbolized the coming-of-age ethos of this period. Bob Dylan prophesied that times indeed were "a-changin'" and those changes were "blowin' in the wind." Children of all ages were coming to realize that life was even more complex than they had realized, and that even though opportunities might be abundant, they could not always be seized. Yet they knew the effort was worth making. That was the message they were hearing from the voices of popular literature, and it became a recurring anthem in their revolution as they stood poised at the chasm that separated them from adults.

Graham Nash of Crosby, Stills, Nash and Young urged them on in his song *Teach Your Children*:

"You, who are on the road, must have a code that you can live by.

And so become yourself because the past is just a good-bye.

Teach your children well, their father's hell did slowly go by.

And feed them on your dreams, the one they fix, the one you'll know by.

Don't you ever ask them why, if they told you, you would cry.

So just look at them and sigh and know they love you.

And you of tender years can't know the fears that your elders grew by.

And so please help them with your youth, they seek the truth before they can die.

Teach your parents well, their children's hell will slowly go by.

And feed them on your dreams, the one they fix, the one you'll know by.

Don't you ever ask them why, if they told you, you would cry. So just look at them and sigh and know they love you."

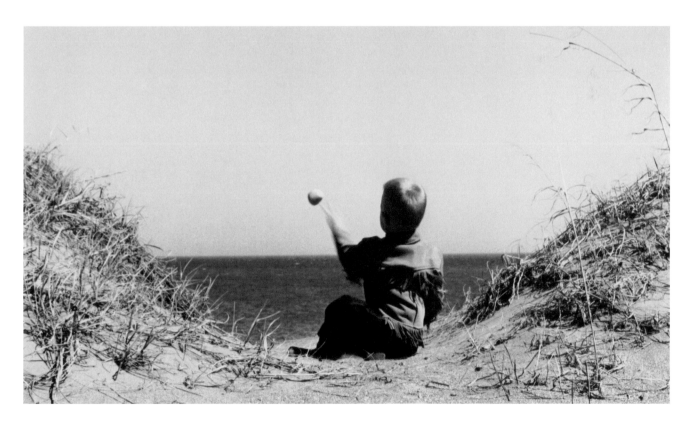

SOLITUDE IS A DEEP NEED

TO BE ALONE WITH YOURSELF.

TO BE ALONE, THE WAY A

CHILD IS ALONE.

RAINER MARIA RILKE

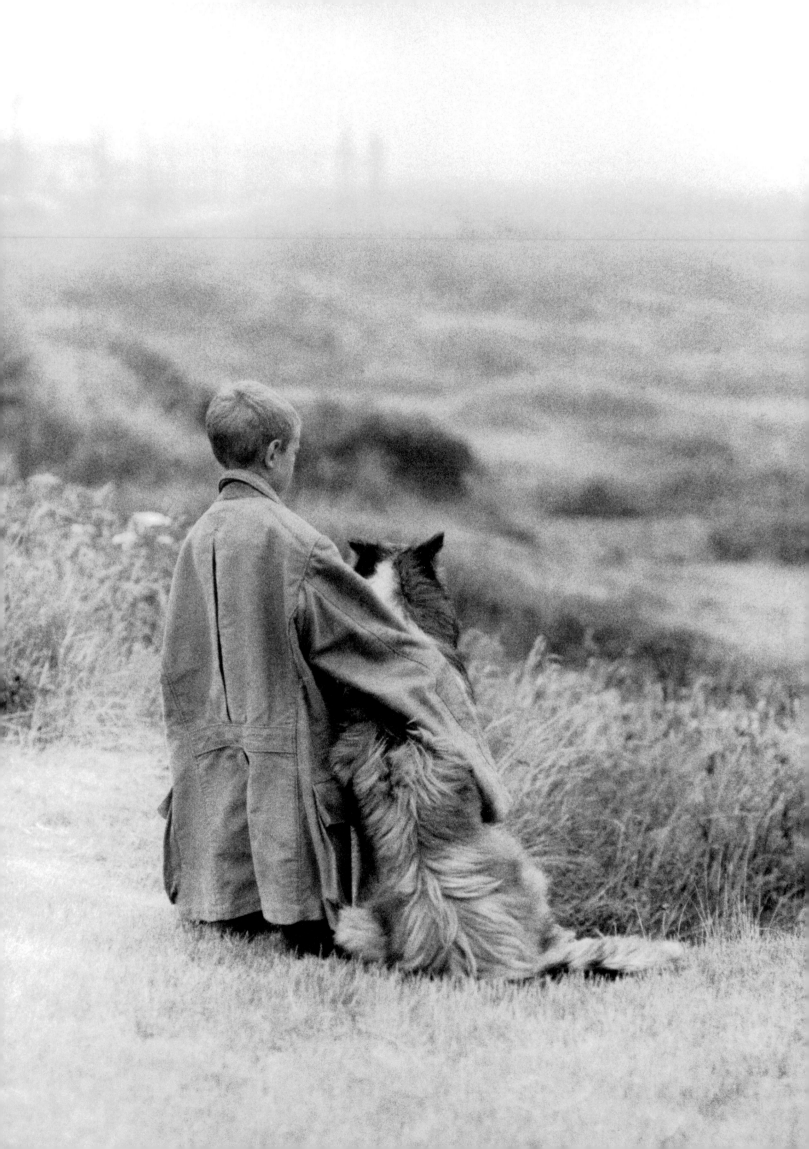

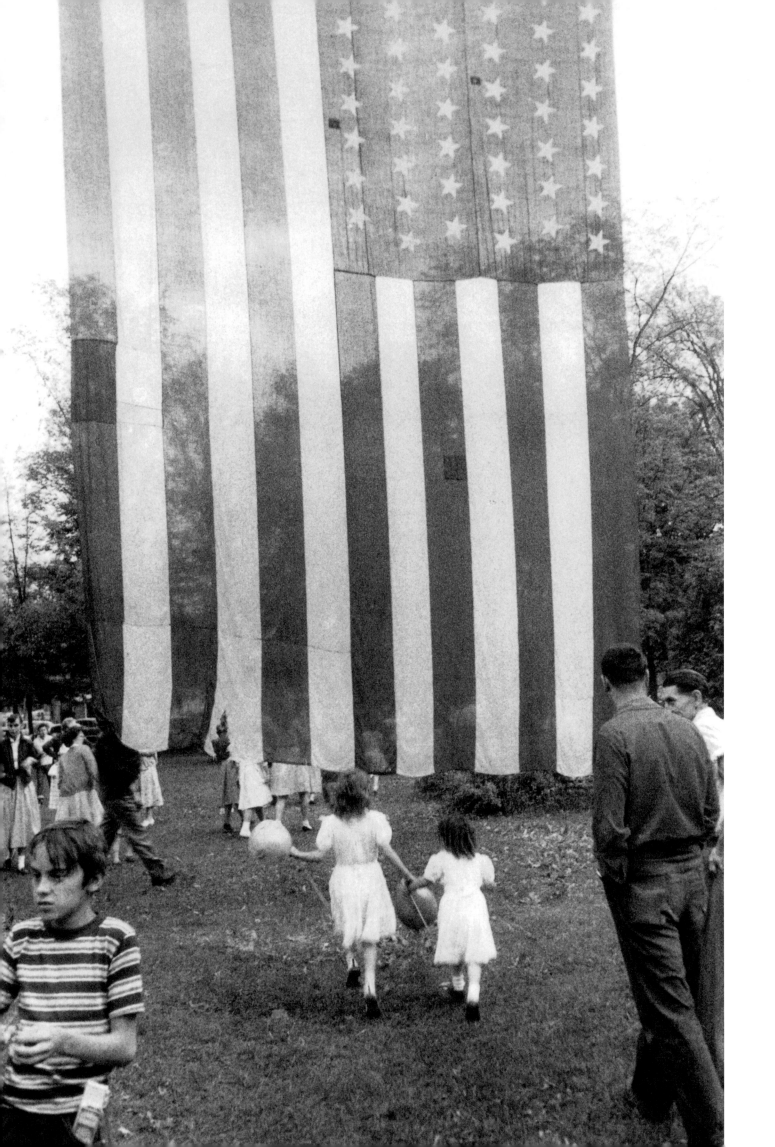

the child deconstructed

A CHILD IS NOT A VASE TO BE
FILLED BUT A FIRE TO BE LIT.

FRANCOIS RABELAIS

The fifties to the eighties were incendiary
times for the young, and the conflagration
that erupted during their cultural maturation
was reflected in the arts. The postwar shift to
America as the center of world affairs also
happened in art photography. This and the
particularities of the American experience
set off a "deconstruction" of conventional
depictions of both adults and children.
That was photography's contribution to an
emerging postmodernism. It sought a way
through and beyond the classicism of Strand
and Weston to a place that was often more
subjective and more confrontational. That
period may well have been the most explo-
sive in the history of photography and was
highlighted by a number of major events,
principally the opening of Edward Steichen's
exhibition, The Family of Man, and the publica-
tion of Robert Frank's The Americans. Certain
events deserve mention, principally the
emergence of Magnum Photos, Aperture
Foundation and, later, Lustrum Press.
Magnum was the first significant photograph-
ic cooperative owned and administered by its
members. Its most important innovation was
the extent of control it gave photojournalists
over their assignments. Aperture, in turn,
was founded to promote photography's
potential as a potent medium for human
expression. Its magazine, Aperture, gave
photographers important public exposure.
Lustrum Press, founded by photographer
Ralph Gibson, gave art photographers an
opportunity to publish in book format.

These events are best understood in their
sociopolitical and cultural contexts. The
illusion of peace was dimming. The Russian
atom bomb tests sobered a giddy nation
as Americans became increasingly defensive.
Many saw domestic radicals lurking on every
corner. Academics became suspect; even
photography came under attack. Criticism of
photography lessened, however, after the
1955 opening of Edward Steichen's mammoth
photographic affirmation of the "essential
goodness of man." The show was a visual
extravaganza -- 503 images from 68 countries
(240 of which images included children).
They were displayed in a theatrical walk-
through installation, many in large formats,
accompanied by quotations and presented in
the manner of a photo essay. Organized by
the New York Museum of Modern Art, the
show remains the most viewed photographic
exhibition ever mounted. From its opening
night, it proved very popular with the public,
many of whom did not normally visit modern
art museums, and it is still being exhibited in
a permanent installation in France.

The Family of Man shattered barriers between
art sophisticates and popular audiences.
It was understandable in the straightforward
yet visceral way that is one of documentary
photography's most enduring qualities. The
exhibit showcased humanity throughout the
world, celebrating the commonalities among
all people, as did the newly created United
Nations. Steichen's one-world view, however,
had its detractors. Critics attacked the show
as simplistic, claiming that it represented a
filtered and overly roseate view of the world.
Paul Strand found the image selection over-

loaded with elegance and superficiality. Roland Barthes was repelled by it, faulting it for ignoring history and national differences while seductively reflecting American imperial aspirations. Whatever its failings, the exhibit remains for millions a profound revelation. Images of children playing, lovers meeting, marriage and birth captured the viewer's heart. In the process, the exhibit underscored that photography, as both art and documentation, had come of age as a dominant mode of expression and an undisputed art form.

What the show also did, perhaps unintentionally, was to spawn an army of young photographic rebels who sought to stake out a place for photography that was independent of the dictates of the prevailing social order. These photographers yearned to be catalysts for change more than barometers of such change. Their clear leader was Robert Frank, a Swiss, who in 1955 set out on a journey to photograph America. What he produced was arguably the most influential photographic essay ever created. His America was very different from that found in *The Family of Man* exhibition or *Life* magazine. With a distinctively bleak beauty, he showed an emotionally impoverished society coping in quiet desperation. Frank made loneliness as visible as Jack Kerouac's stories made it palpable, and he did so in a style that seemed as immediate as a snapshot. What he was in fact doing was creating a whole new visual vocabulary, as Carroll and Cameron had done a hundred years earlier. Unlike Cartier-Bresson, who sought to capture the "decisive moment" -- that perfect confluence of chance elements that creates a photographic epiphany -- Frank sought perhaps a more artless vision, no

Robert Frank, 1955

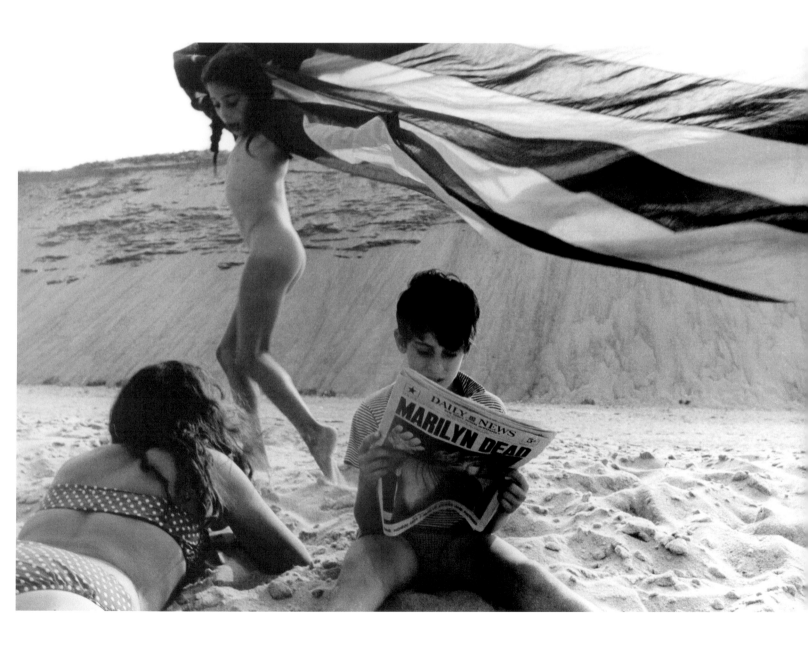

Robert Frank, 1962

truer to life but one that touched a rawer nerve. He called it the "moments in between." He later elaborated on his views: "There is one thing the photograph must contain, the humanity of the moment. This kind of photography is realism. But realism is not enough -- there has to be vision and the two together can make a good photograph. It is difficult to describe this thin line where matter ends and mind begins." It is often observed that Frank's images stand in stark relief to the cheery sentimentality of Steichen's *The Family of Man*. Frank's photo essay *The Americans* consists of only ninety images, twenty of which feature children. Although it is widely believed that Frank paints an unvarnished and sad image of the family of man, the fact remains that his images of children are most often very positive. In Frank's photo essay, men are rarely shown with children and often seem sad, solitary and angry. Women, on the other hand, are presented as warm, sweet and nurturing -- clearly the protector of the species. Frank's voracious glance seeks out the very essence of his subjects. As his friend Jack Kerouac said about him in the introduction to *The Americans*: "You got eyes."

The very first photograph Frank made for his book was of a Fourth of July celebration in upstate New York. The flag, slightly torn and threadbare, is often seen as a symbol of the tarnishing of a country after years of proud polishing. Yet, one can look at it very differently. Little girls in white dresses are shown passing through a translucent curtain as a boy in the foreground prepares his firecracker. The flag and the firecracker, when viewed as pictorial *puncta*, may more aptly represent a new generation's passage to a

better society. Students of the medium would pore over Frank's images, analyze them, criticize them and, in most cases, emulate them. His approach became a point of departure for the next generation of photographers.

Those who followed Frank could be divided into two camps. Those in the first camp are often referred to as photographers of the "social landscape." That group included artists such as Diane Arbus, Bruce Davidson, Larry Clark, Lee Friedlander, Danny Lyon, Mary Ellen Mark and Garry Winogrand. The other group, intentionally nondocumentary, could be styled photographers of "personal scapes" and would include photography greats such as Ralph Gibson and Ralph Eugene Meatyard.

Ralph Gibson, one of the most prominent creative sages of this period, expressed the spirit of the times, as well as the essence of photography, as follows: "Photography is like electricity. We knew how to use it, but we didn't know what it was. We knew it was a medium that enables us to depict everything from the sacred to the profane; yet we could find no absolute photographic act, it is only a question of process. One made a photograph and that led to the next and the next. It seemed you would have to make all three of them rather than go directly to the last one. We were looking to find what was primal in society." That search directed photographers like Gibson, Clark, Davidson and Meatyard in distinctly personal directions.

Gibson, Clark, Davidson and Meatyard -- each in his own unique way -- were Frank's disciples and set the standards by which others would

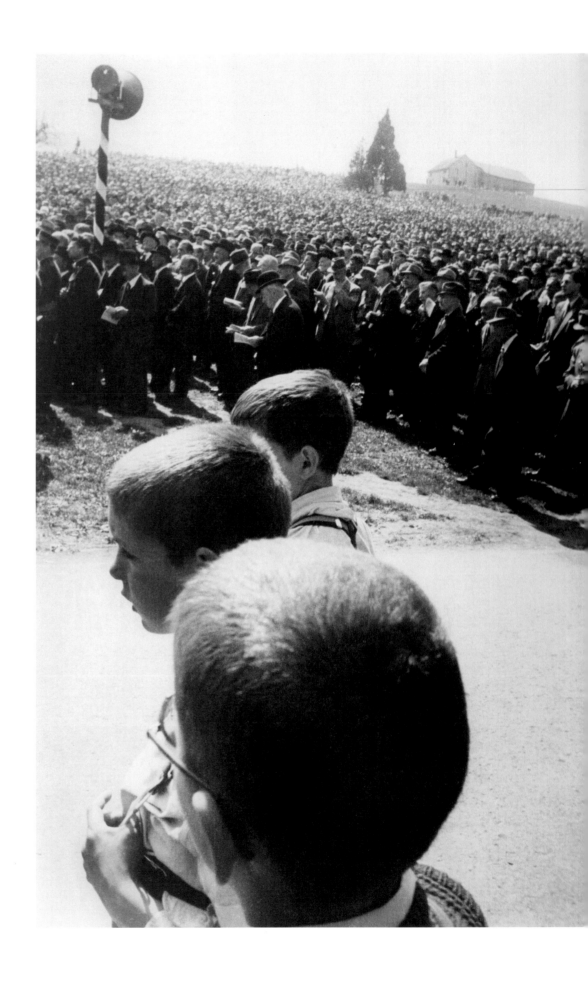

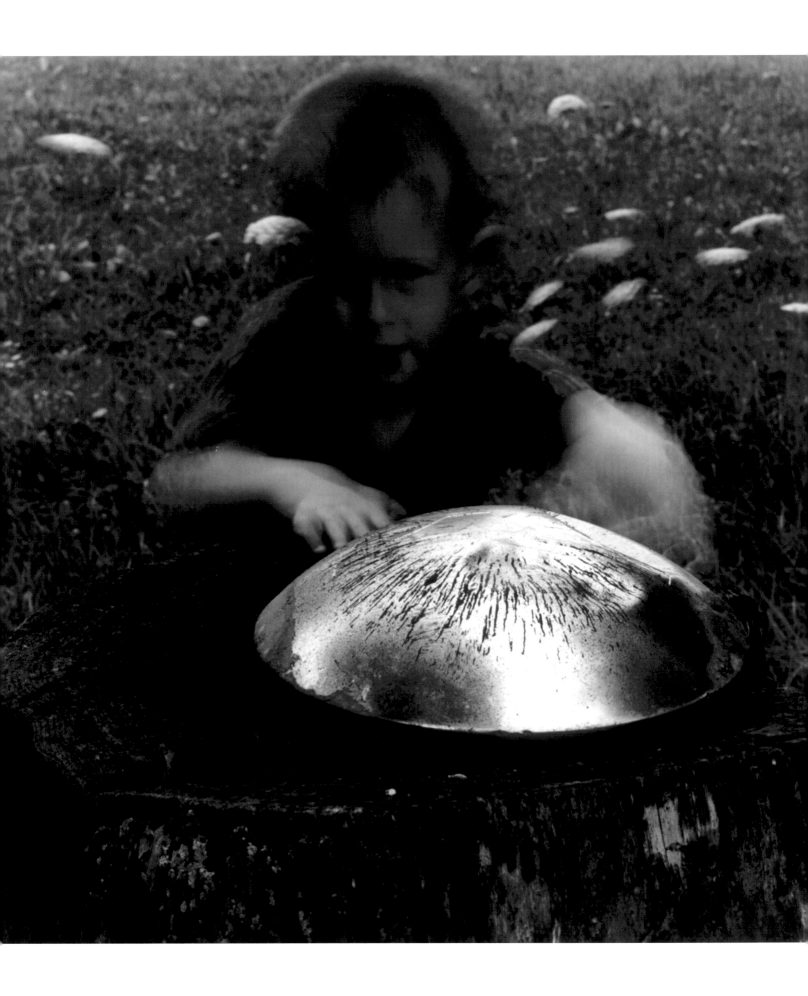

Ralph Eugene Meatyard, 1959

be measured. Each possessed technical proficiency; all had great vision. They produced pictures that are not easy to comprehend on first viewing for they require serious attention by the viewer.

Ralph Eugene Meatyard was an optician by vocation and a photographer by avocation -- a self-styled "dedicated amateur." He began his career as an art photographer in 1950 and died prematurely in 1972. During that short period, he created images that were imbued with dreamlike mystery. His body of work is populated with masked children, often in decrepit settings, enacting inscrutable charades with disquieting intimations. He created magical tableaus with multiple meanings. Each seemed to capture the point where suspense meets a kind of delightful fear.

Meatyard was very much ahead of his time. Robert Frank's sensitivity was taking hold, yet, for many, the formalist tradition of Paul Strand and Harry Callahan was still the standard. Meatyard introduced a new kind of imagery that he felt was suitable for a more metaphysical form of communication. An enthusiast of Eastern transcendental philosophy, he hoped to capture the spiritual essence that the study of Zen Buddhism taught him lay behind the visible by transforming quotidian objects into photographic riddles.

Like Robert Frank, but more lyrical, Meatyard documented the vulnerable soul with images of quiet, often lonely, despair. Some read them as an indictment of postwar prosperity and the insidious commercialism it spawned; others see them as profound statements on the frailty of corporeal existence. Meatyard attempted to dissect the place that lies between the visible and the invisible, which he called the "sur Real," hoping that his fantasies would not replace reality but rather permit viewers to transform his images into memories of their own.

Many of Meatyard's images involve children. Clearly, he remembered that childhood was for the most part an apparently ordinary idyll, free of care and filled with curiosity. A child, however, often makes the ordinary magical. In Meatyard's "Hub Cap" images, for example, the child seems to have imbued the object with a potent radiant power.

Meatyard also uses his props -- especially masks -- to address a child's gradual but inevitable march to maturity. Such artifices might at first seem too obvious, yet they work in large part because of his genius for settings and poses and his technical proficiency. Finally, many of his images of children contain ghostlike traces or other symbols of death, a juxtaposition that sums up life's journey and suggests the possibility of an afterlife.

Meatyard is hard to place in the history of art photography. His work is in many ways a precursor to that of Cindy Sherman, yet it is hard to call him an early postmodernist. Perhaps he was simply one of those unique figures that surface in the history of art -- an outsider with a vision and the ability and determination to capture it. Had he lived longer and produced more work, he might have been ranked among the giants of the medium.

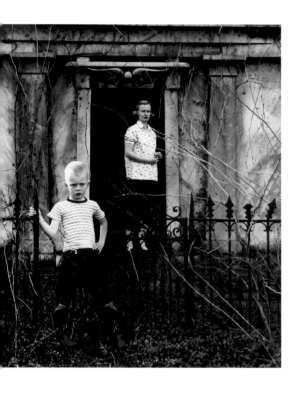

FROM THE BEGINNING OF MY PARTICIPATION IN
PHOTOGRAPHY, I HAVE ALWAYS FELT
THAT IT WAS A FORM OF FINE ART.
I HAVE BELIEVED THAT WE MUST BE TRUE TO
OUR MEDIUM.
THAT WE MUST KNOW WHERE WE HAVE BEEN
AND WHERE WE ARE GOING IN ORDER TO MAKE
SOMETHING ORIGINAL OUT OF OUR ART.
I HAVE ALWAYS TRIED TO KEEP TRUTH IN MY
PHOTOGRAPHS.
MY WORK, WHETHER REALISTIC OR ABSTRACT,
HAS ALWAYS DEALT WITH EITHER A FORM OF
RELIGION OR IMAGINATION.

RALPH EUGENE MEATYARD

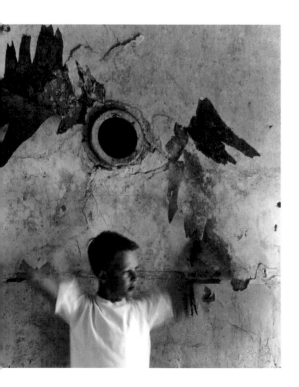

Ralph Eugene Meatyard, 1955
Ralph Eugene Meatyard, 1960 (bottom)

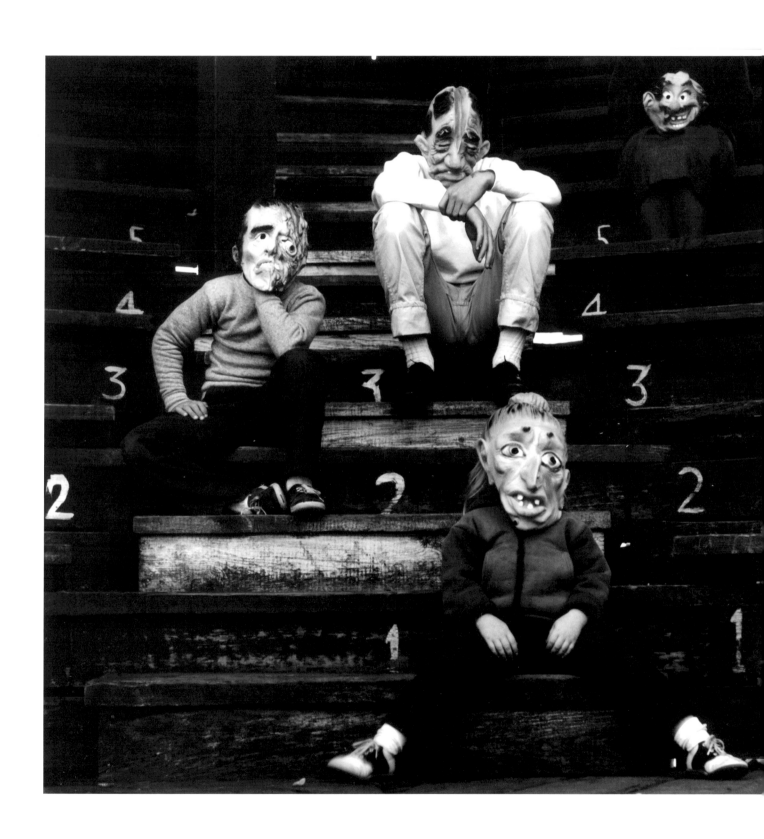

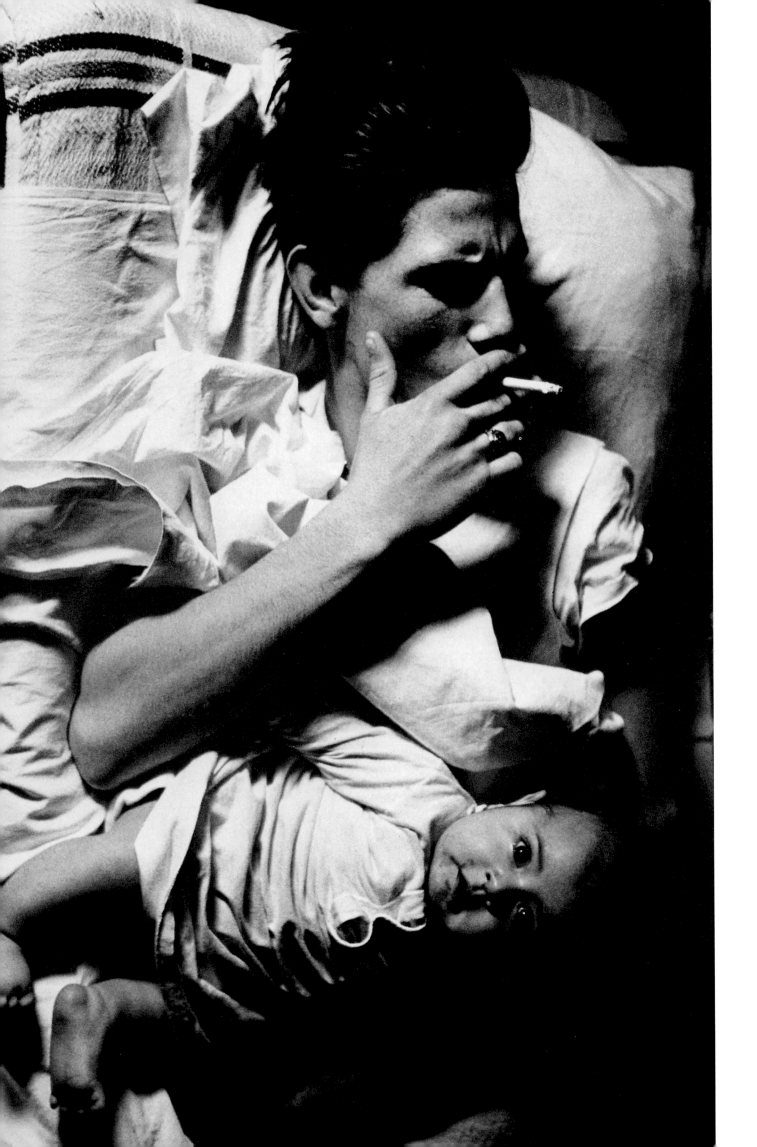

Unlike Meatyard, Larry Clark was born into the world of photography. His mother was a "kidnapper" -- the vernacular for a door-to-door baby portrait photographer. At a very early age, Clark became proficient in her craft. He would later utilize those skills to chronicle the world of youth outlaws -- a group of young people drawn together by sex and drugs. He did so in the role of both participant and observer.

A consummate and inveterate storyteller, Clark formed a visual diary of disaffected youth, one that is intense and intimate. In doing so, he exposed the perils and vulnerabilities of a certain segment of society. His seminal book, *Tulsa* (1971), opens with a confession: "i was born in Tulsa in 1943. when i was sixteen i started shooting amphetamines. i shot up with my friends every day for three years . . . once the needle goes in it never comes out." For Clark, the needle did come out, however, and once he started his photographic journey, he never stopped. *Tulsa* was followed by *Teenage Lust*, which in turn was followed by *The Perfect Childhood*, 1992 and his most recent book, *Punk Picasso*.

Clark's art (photography and film) often focuses on the verities of sex and violence among the young, and in doing so it addresses the corrosiveness of dysfunctional families and the perils and vulnerabilities of adolescence. His coming-of-age saga is far from the Hollywood version.

His youths seem amoral and narcissistic to a fault. Yet, within these disturbing images, Katherine Dieckmann finds that elusive quality of grace: "Clark is fascinated by the volatile existence of troubled teens, whose bodies speak eloquently of fierce libidos, near-total lack of impulse control and fleeting grace."

Clark's art is transgressive in the sense that it exceeds the boundaries of what is perceived as socially acceptable. Yet he manifests a clear love of looking. For Clark, what you are looking at is not as important as what you are looking for. His disaffected youths straddle that elusive zone between adolescence and adulthood.

Most critics who rail at his imagery want to see the young as fully innocent or fully mature. Instead, what Clark gave them was the worst of both worlds. He stripped away the myth that middle America was immune to the social convulsions of the sixties, presenting a youth culture that was increasingly overwhelmed and veering toward self-destruction.

His art remains an important cautionary tale, but one that perhaps neither his viewers nor his subjects want to hear. Many of his subjects appear to be embracing their own annihilation in order to avoid what lies ahead -- the responsibility of growing up.

Clark does not seek to exonerate or romanticize his subjects' alternative lifestyle, but neither does he condemn it. His work is important to a fuller understanding of the construct of childhood.

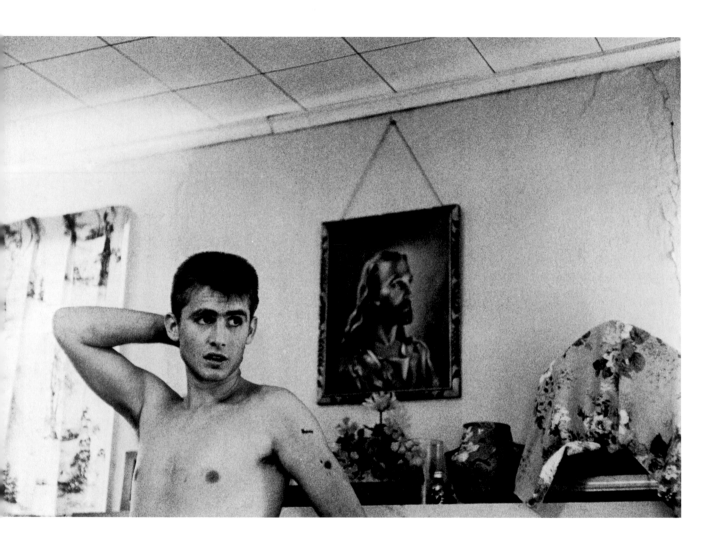

Larry Clark, 1971

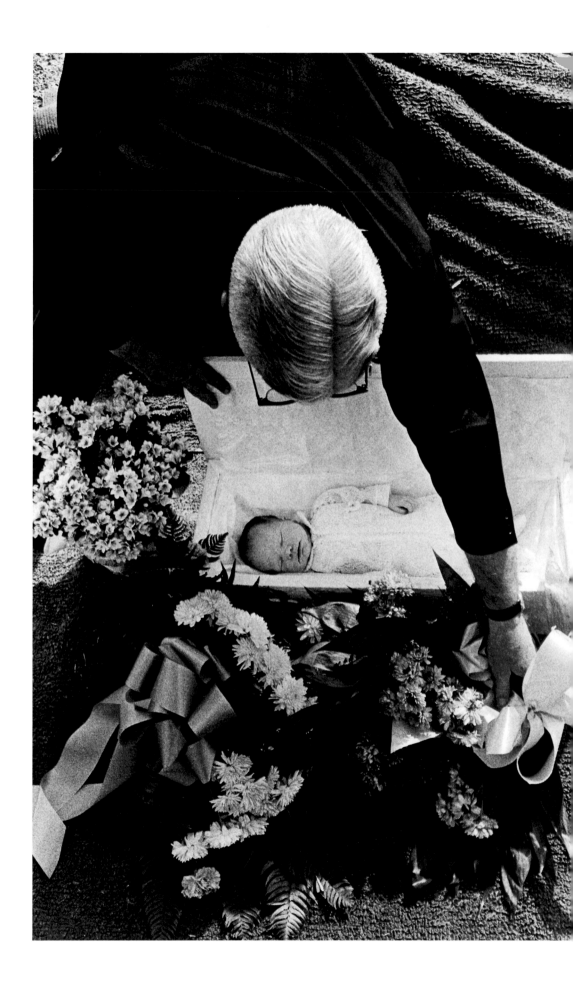

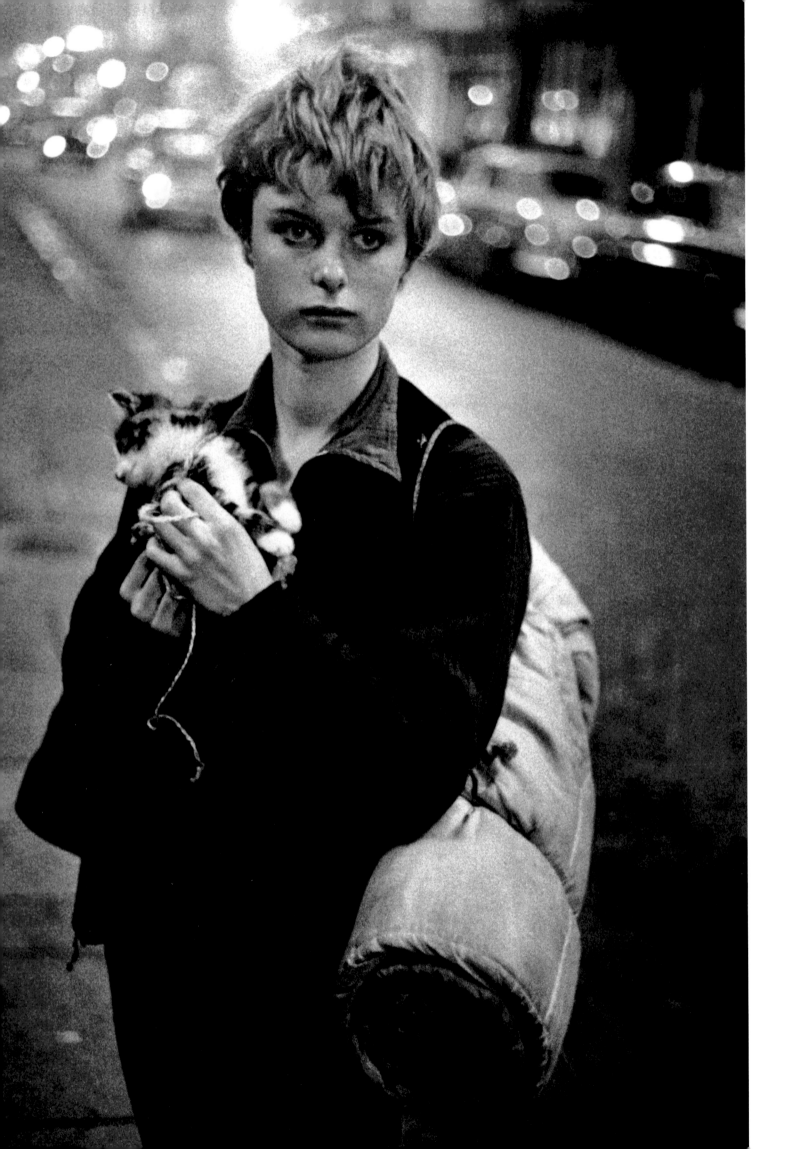

Bruce Davidson, like Larry Clark, learned photography when he was very young. With money from his paper route, he purchased his first camera and by the age of sixteen was wandering the streets in search of photographic studies. Davidson focuses primarily on landscapes of injustice, particularly where children are prominent. His first influential photographic essay -- a visual narrative form refined by W. Eugene Smith while working at *Life* a decade before -- profiled a Brooklyn gang called the Jokers. Davidson's image of a gang leader's girlfriend fixing her hair in the mirror of a Coney Island cigarette machine embodies both irretrievable time past and the fragile beauty of working-class adolescents everywhere. That fragility was affirmed fifteen years later when Davidson saw her again and she remarked, "We all had a dream but we lost it. Most of the kids we knew are on drugs, in crime, or dead."

Davidson's subsequent work, whether of the Freedom Riders and Selma marchers in the battle for African-American civil rights, children in the coal-smeared mining community of South Wales, the inhabitants of one block in New York City's Harlem in the 1970s or the subterranean inhabitants of the city's subway, reiterates the same cry and demand. It is a cry for those left out of *The Family of Man* and a demand, with love and anger, for recognition of their essential place not only in the social mosaic but in museums and art galleries as well.

Although steeped in the tradition of photo-journalism and deeply affected by the brilliance of W. Eugene Smith and Henri Cartier-Bresson, Davidson views himself as an artist. Yet he is an artist with a humanist mission -- a burning interest in contemporary social problems: poverty, race and youthful unrest. He works not with the zeal of a reformer like Hine, but more like a visual sociologist. Among his best works are photographs of children. His images contain a wealth of detail and evoke multiple reactions. Davidson's children are not just poster material for poverty, discrimination or alienation. They capture a full panoply of human emotion. The face of the English girl with her kitten captures a distinct quality in the disaffected young that words cannot adequately explain.

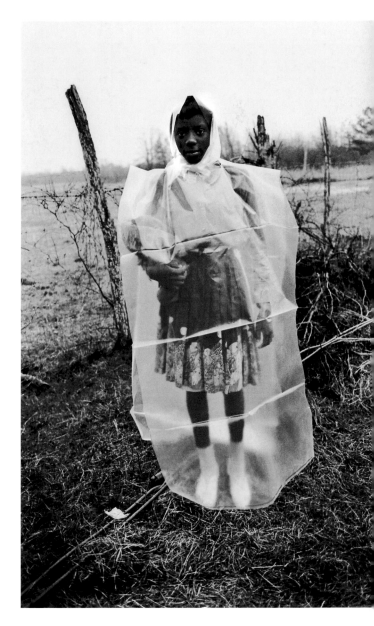

The dignity with which the girl on a freedom march protects her fineries in the face of the inclement forces of nature parallels her protests against the forces of bigotry. The innocence of the child in the tenement manifests her delightful oblivion to her conditions. Davidson's quiet embrace of the forgotten groups in our society is particularly effective when it comes to children. Perhaps that is part of the reason that he, like Cartier-Bresson, was one of the first photojournalists to be recognized as an artist in his own lifetime.

The photographers discussed above had an enormous influence on the photographic community during the fifties, sixties and seventies. Meatyard was an outsider looking in on a world he could never occupy. Clark was an insider showing us a world that he might have hoped to leave but still inhabited. Davidson brought compassion to disparate causes in his uniquely emphatic way. Their work is illustrative of that hard edge -- sometimes critical or even sardonic, yet always perceptive -- that frames much of the good photography produced in this period. Jacques Lacan once observed that "as subjects, [people] are literally called into the picture and represented . . . as caught." In the work of many of these photographers, it often seems as if the subjects have not only been caught but also deconstructed so the viewer can see their fleeting grace.

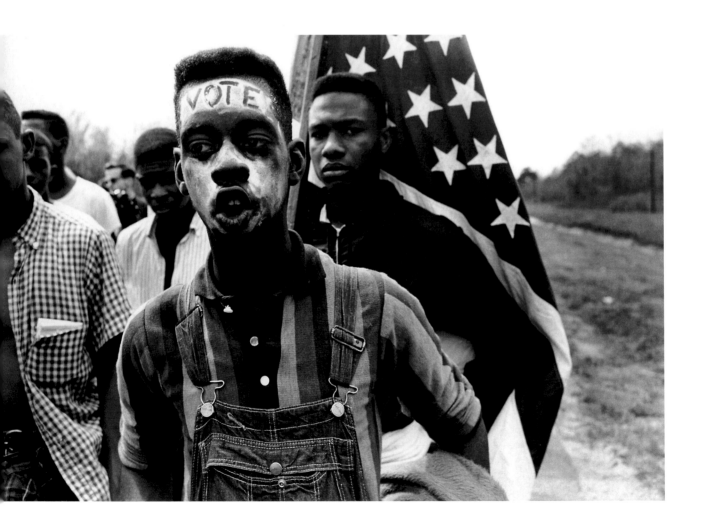

240

Bruce Davidson, 1965

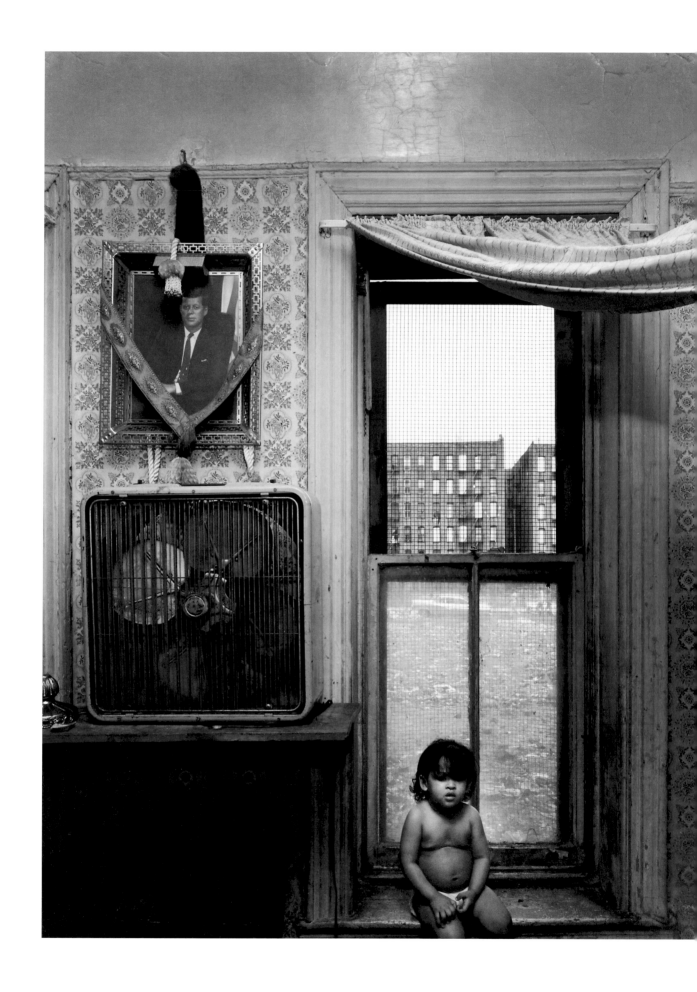

EVERY AGE HAS A KEYHOLE

TO WHICH ITS EYE IS PASTED.

MARY MCCARTHY

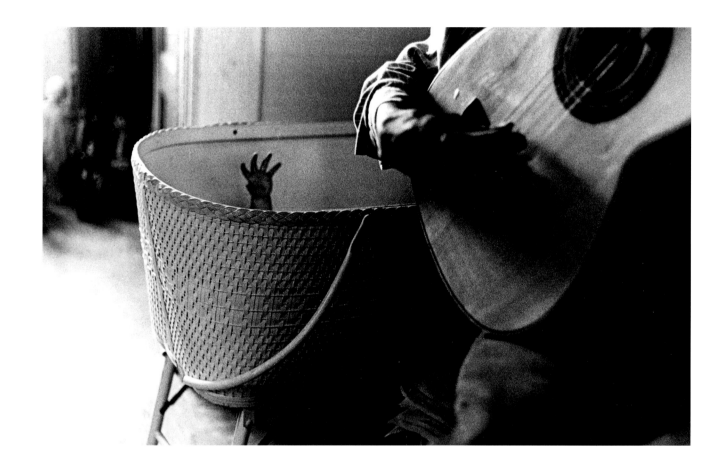

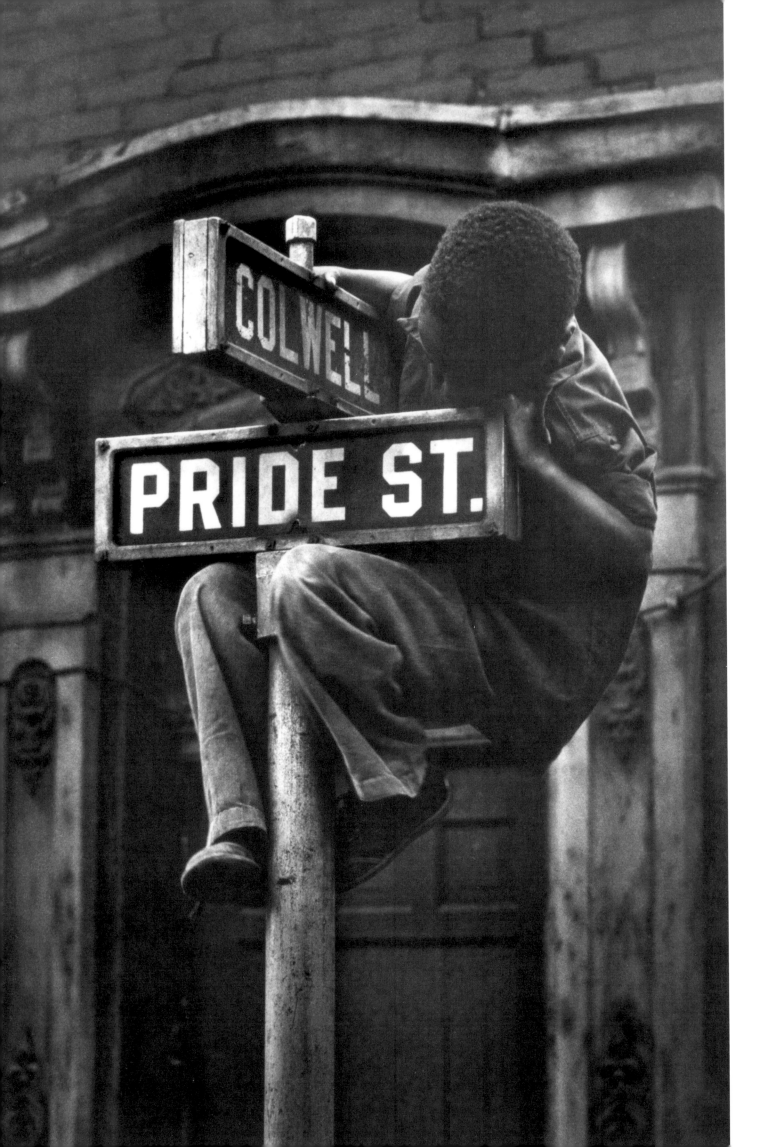

the child in turmoil

PHOTOGRAPHY IS A SMALL VOICE, AT BEST, BUT
SOMETIMES ONE PHOTOGRAPH, OR A GROUP OF
THEM, CAN LURE OUR SENSE OF AWARENESS.

W. EUGENE SMITH

The segment of photography that enjoyed the largest exposure and experienced the greatest expansion during the fifties, sixties and seventies was photojournalism. The rights revolutions that fueled this period also caused a sea change in the approach and attitude of photojournalists. No longer required to serve as propagandists for governments or industry, they staked out their places and put their personal marks on the visual recordation of the important issues of their day. Edward Steichen had felt that "photography was a major force in explaining man to man," and the great photojournalists were realizing the power they possessed.

By the fifties, the picture magazines had saturated their pages with documentary images from every corner of the globe. The view of the world for those who came of age in the fifties was, in fact, shaped by *Life*, *Look*, *Picture Post*, *Paris Match* and *National Geographic*, as well as by comparable picture magazines in the other industrialized nations. By 1960, television had dramatically enlarged the visual window into the world and the baby boomer generation embraced this visual medium as its birthright. Photojournalism, once thought doomed as picture magazines lost readers, expanded its presence in television, newspapers and books and moved into the art world. Photographic editorial expression competed with image-rich commercial advertising for public attention.

The best documentary photographs of historic events were assuming a new role as social icons -- their stopping of time encouraged reflection and created more lasting memory than other forms of mass media. The image of three-year-old John Kennedy, Jr. saluting at his father's funeral in 1963 has enduring emotional power because it captures a nation's, as well as a child's, loss. Earlier documentary photographs were also achieving iconic status. Dorothea Lange's 1936 *Migrant Mother*, for example, became one of the most revered of all American images at this time.

It was also in this period that visual reportage from beyond the industrialized world consolidated a view of "other" faraway people as both exotic and unfortunate. Initially, Europeans were among the suffering others, as dustbowl, Depression-era Americans had been before them. Europeans were also among the first to be visually depicted accepting handouts of food, shelter and basic health care. But as Western Europe recovered, the developing world became the central focus of strife and misery.

The picturing of the emerging "other" world was determined to a great extent by two larger historical factors. One was the rise of international humanitarianism, an impulse that flowed logically from postwar relief efforts to aid populations in Europe, Japan, China and elsewhere and was solidified by the 1948

United Nations Universal Declaration of Human Rights. As humanitarian aid grew to embrace the entire developing world, the deprivations and misfortunes of people caught in natural or man-made disasters and lacking modern health, hygiene and other care were exposed for all to see.

The second and more decisive factor shaping the perception of relentless suffering was conflict. In the second half of the twentieth century, most open wars were located in the developing world. Some were ignited by tribal fighting but most were set ablaze in protracted stuggles for independence from colonial powers. Others were sparked or deepened by the Cold War's competition for spheres of influence. Deterred from fighting each other by the threat of nuclear annihilation, Northern countries intervened in Southern conflicts that became more deadly proxy wars.

As the decades wore on, these calamities came to be symbolized most poignantly and persistently by the image of the suffering child, victimized by starvation and disease and living in dire conditions aggravated by war and other preventable disasters. Don McCullin's documentation of Biafra's blockaded citizenry, Philip Jones Griffiths's immersion in Vietnam and Susan Meiselas's coverage of Nicaragua's insurrection pay tribute to war's toll on children. Essential and eloquent, their imagery also contributes to a view of faraway victimized children and childhood that is now ubiquitous. But, contrary to Steichen's hopeful promise, photography witnesses more than it explains.

As these injustices rained down on the youngest, many older children took to the streets in open rebellion. Fueled by idealism, energy and the exhilarating illusion of immortality that is part of being young, they spread their protests from America's segregated towns and ghettos to its university campuses, from the townships of apartheid South Africa to France's Sorbonne, and from Czechoslovakia's short-lived Prague Spring Uprising to the mass hysteria of China's Cultural Revolution. As Dylan had advised, times were changing.

It was a tumultuous and defining time, transforming relations between parent and child, black and white, rich and poor, soldier and civilian, youth and government, artist and industry, women and men and children and the world. Replete with love and hate, and with advances and backlash, it was a time whose impulses and events continue to act upon the generations that have followed.

Photojournalism was now on a global stage as history's witness. What would become evident was that photographs do play a vital and pivotal role in helping to alleviate or even end such suffering. They create searing mental images that continue to resonate in the viewer's mind. Hopefully, the images that follow will do just that.

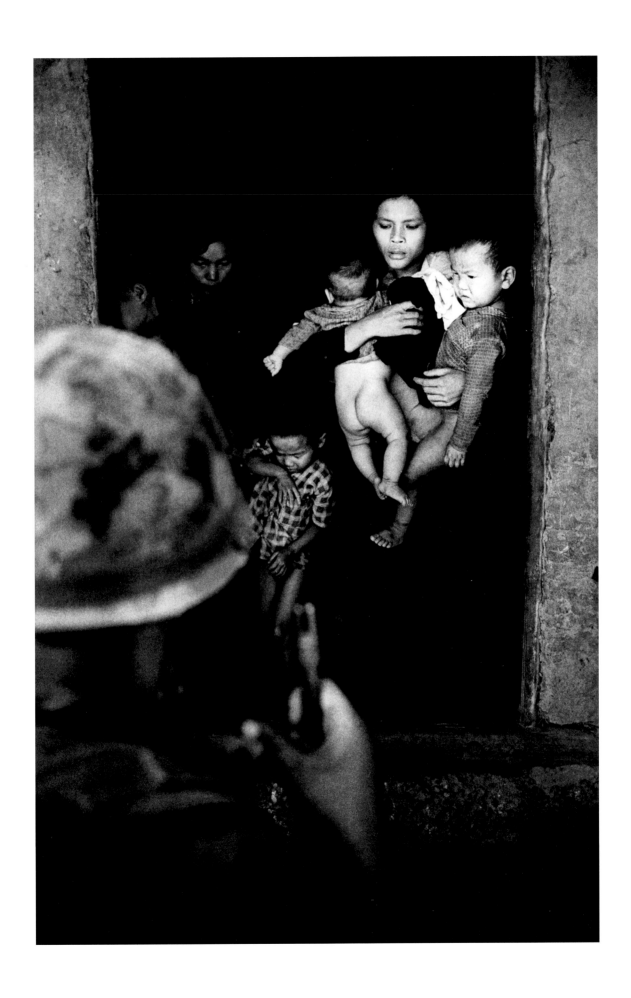

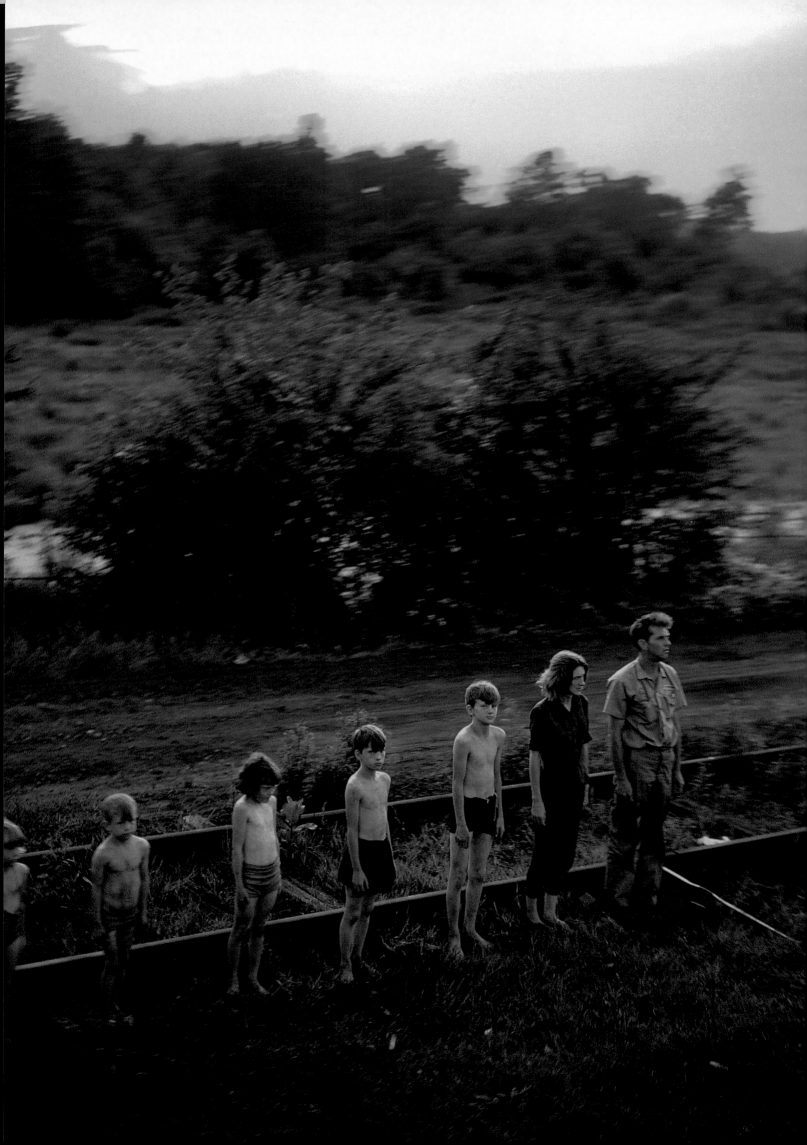

WHAT IS OBJECTIONABLE, WHAT IS DANGEROUS,
ABOUT EXTREMISTS IS NOT THAT THEY ARE
EXTREME, BUT THAT THEY ARE INTOLERANT.
THE EVIL IS NOT WHAT THEY SAY
ABOUT THEIR CAUSE, BUT WHAT THEY
SAY ABOUT THEIR OPPONENTS.

ROBERT F. KENNEDY

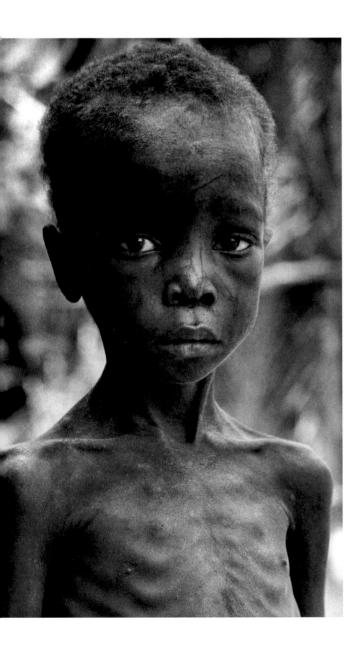

Horrific, jarring images of skeletal children made Biafra the universal symbol of starvation. The Nigerian government used starvation as a strategy to quell an uprising among its citizens. As a result, over two million people are thought to have died, many of them children.

Hunger is not a new phenomenon, yet it took the tragedy of Biafra as viewed through the works of photojournalists to galvanize the world. Biafra made manifest that man and his machinations were more responsible for hunger than an angry God. As Dwight Eisenhower so effectively put it, "every gun that is made, every warship launched, every rocket fired signifies, in the final sense, a theft from those who hunger and are not fed."

No Madonna and Child could touch that picture of a mother's tenderness for a son she soon would have to forget. The air was heavy with odors of diarrhea, of unwashed children with washed-out ribs and dried-up bottoms struggling in labored steps behind blown empty bellies. Other mothers there had long ceased to care but not this one; she held a ghost-smile between her teeth and in her eyes the memory of a mother's pride as she combed the rust colored hair left on his small skull and then -- singing in her eyes -- began carefully to part it. In another life this would have been a little daily act of no consequence, now she did it like putting flowers on a tiny grave.

Chinua Achebe
Mother's Day in Biafra

Don McCullin, 1970

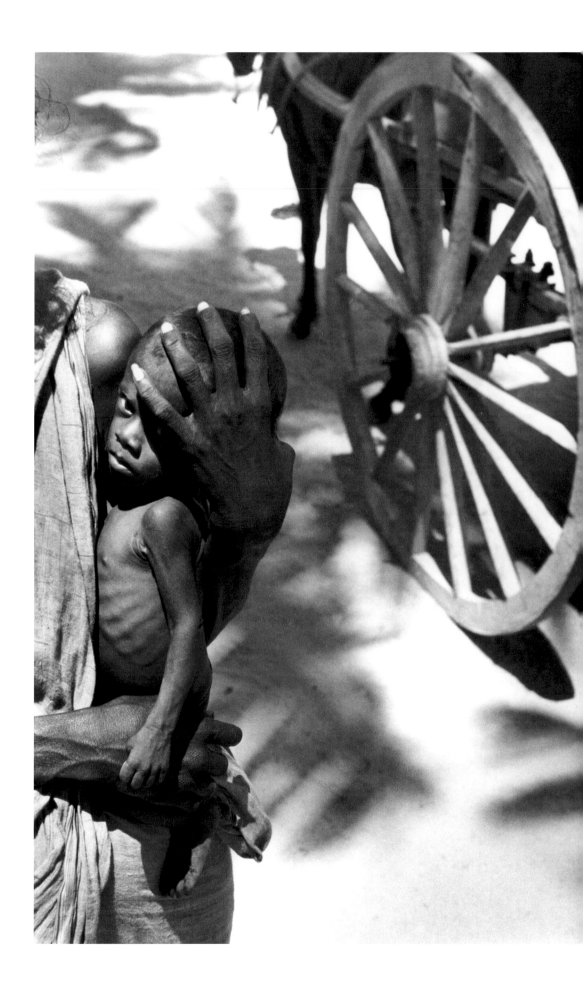

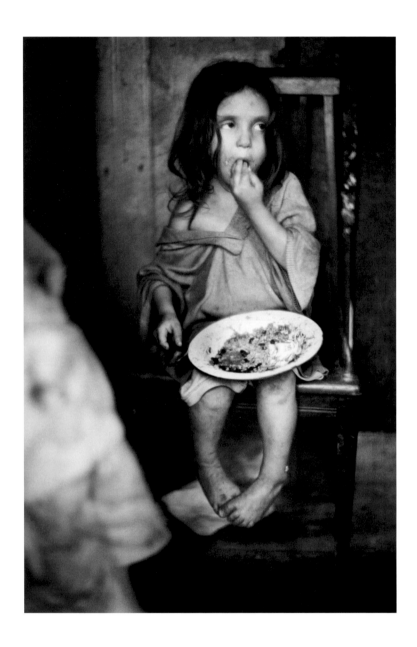

One of *Life* magazine's most affecting photo essays was the result of a 1961 collaboration between photographer Gordon Parks and reporter José Gallo. Poverty had overwhelmed many of South America's urban areas during the sixties. To bring public awareness to the problem, they elected to profile a family in one of Rio's most impoverished *favelas* (slums). They entitled these photo essays *The Favela, a Hillside of Filth and Pain*. The Da Silva family and their eight children lived in abject poverty. The parents spent their days scavenging for food while Flavio, their asthmatic twelve-year-old son, cared for the other children. The impact of Parks's emotive images and Gallo's rhetoric is an example of photography's power to effect change. Shortly after the article appeared, contributions from readers were sufficient to move the Da Silvas out of the slum and give Flavio much-needed medical attention.

POVERTY IS LIKE PUNISHMENT FOR A CRIME YOU DIDN'T COMMIT.

ELI KHAMAROV

Gordon Parks
Isabel, Flavio's sister, 1961

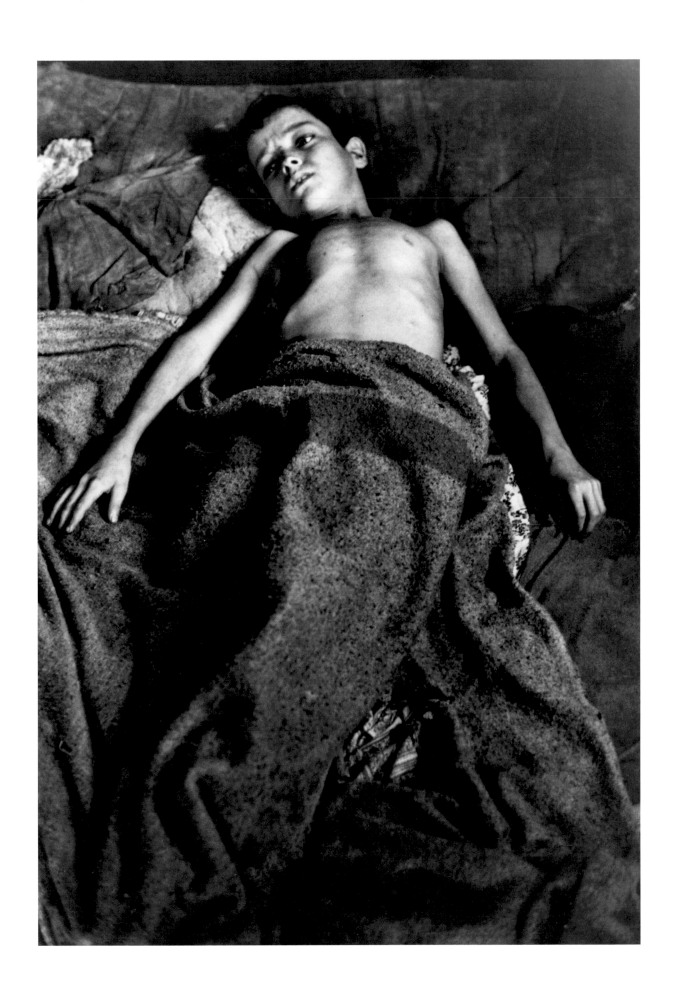

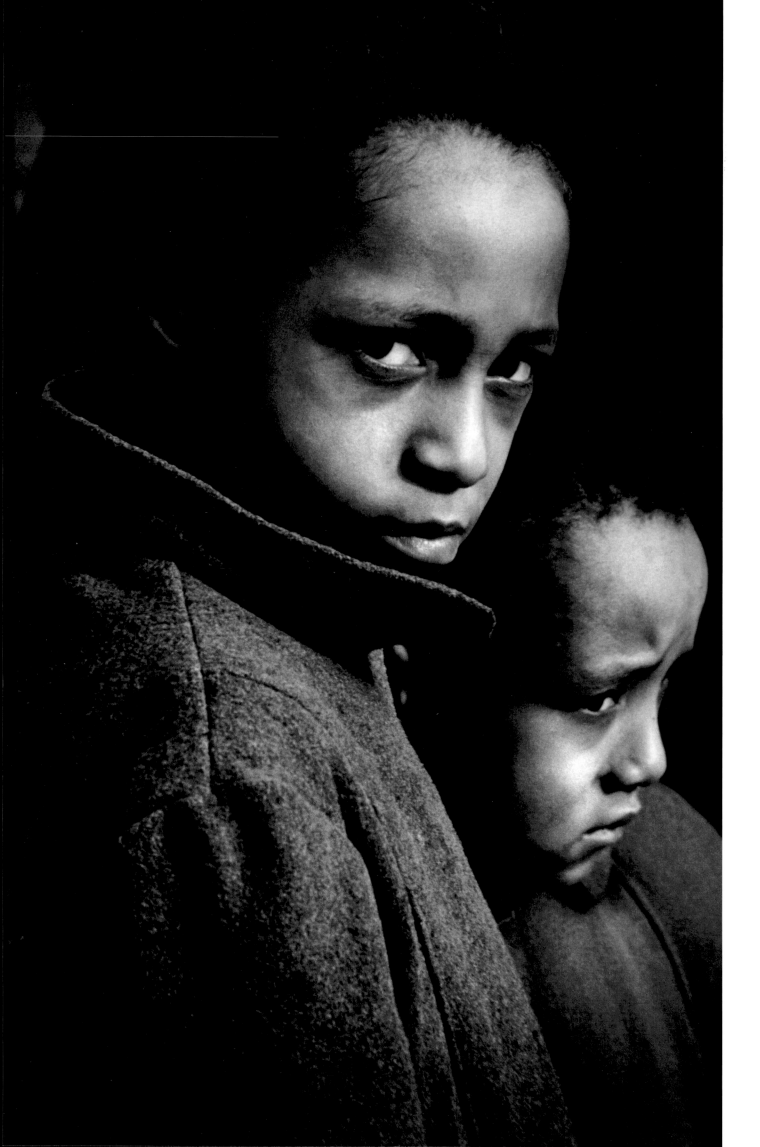

The Civil Rights Movement was one of the major catalysts for social change in the sixties, and it was the young who were most effective in that battle. Supporters of the movement staged a march from Selma, Alabama to the state capital, Montgomery, on March 7, 1965. Photographers captured police turning water hoses and attack dogs on women and children. Notwithstanding such imagery, the movement led by Dr. Martin Luther King, Jr. failed to gain wide support. That did not occur until a group of black children, between the ages of six and eighteen, decided to join in the Birmingham protest. They were quickly arrested and yet more of their classmates followed suit until Birmingham's prisons were overflowing. The city fathers could not stand up to the media glare that their actions had caused. Within a few days all the children were released. The bravery and determination of those children irreparably broke the segregationists' resolve and was the starting point for meaningful measures to end segregation in the United States.

"We come then to the question presented: Does segregation of children in public schools solely on the basis of race, even though the physical facilities and other 'tangible' factors may be equal, deprive the children of the minority group of equal educational opportunities? We believe that it does Separate educational facilities are inherently unequal. Therefore, we hold that the plaintiffs . . . are, by reason of the segregation complained of, deprived of the equal protection of the laws guaranteed by the [Constitution]."

Brown v. Board of Education
U.S. Supreme Court, 1954

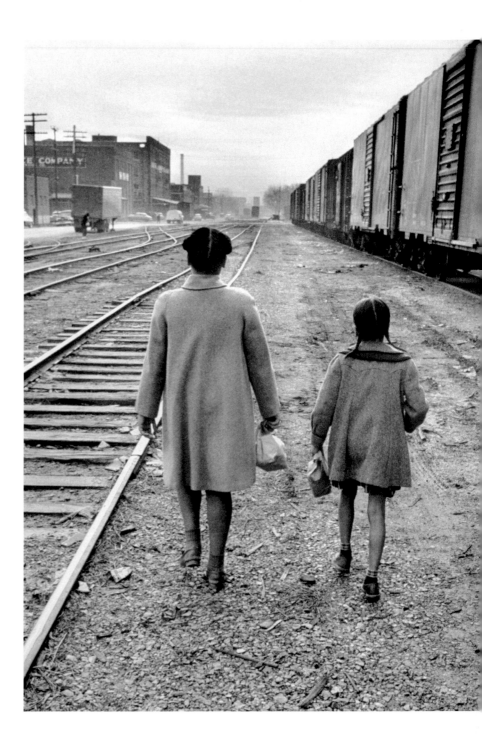

Carl Iwasaki, Linda Brown, age 10, and her sister en route to their all-black school in Kansas, 1954
David Heath, 1955 (left)

to everything there is a season, and
a time to every purpose under heaven;
a time to be born, and a time to die;
a time to plant, and
a time to pluck up that which is planted;
a time to kill, and a time to heal;
a time to break down, and a time to build up;
a time to weep, and a time to laugh;
a time to mourn, and a time to dance;
a time to cast away stones, and
a time to gather stones together;
a time to embrace, and a time to refrain from embracing;
a time to seek, and a time to lose;
a time to keep, and a time to cast away;
a time to rend, and a time to sow;
a time to keep silence, and a time to speak;
a time to love, and a time to hate;
a time for war, and a time for peace.

Ecclesiastes 3:1-8

Dissenting youth often fan the fires of civil unrest.
Don McCullin is one of those photographers who risk
their lives to capture these moments. Pictured here
are young Catholic boys creating havoc in Derry,
Northern Ireland. McCullin was temporarily blinded
by gas while working on this story -- an occupational
hazard for photojournalists.

Don McCullin, 1971

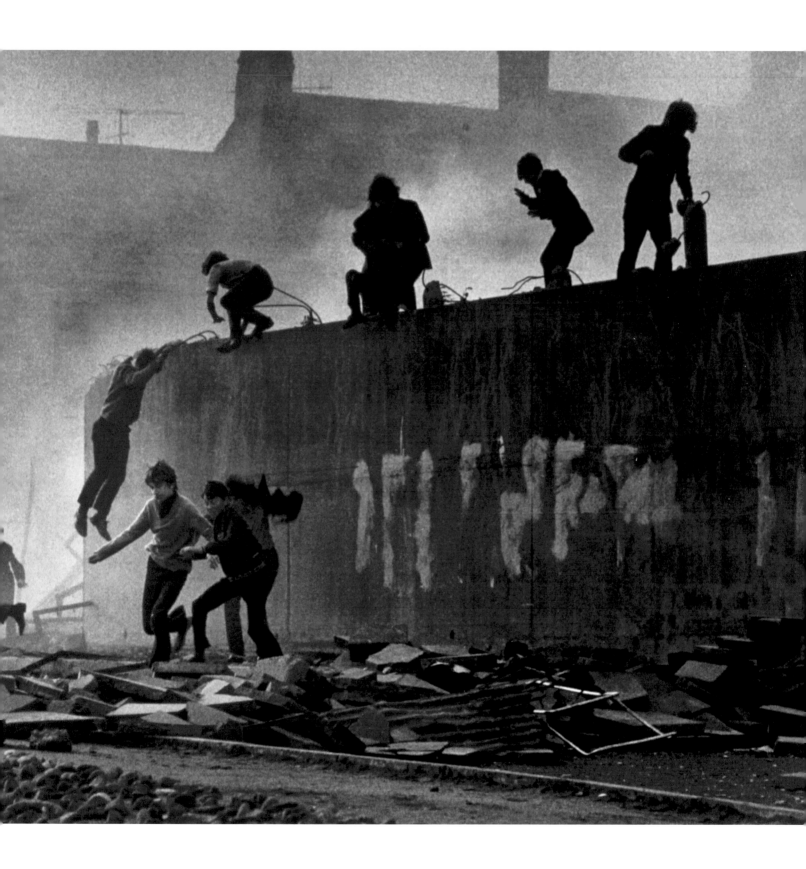

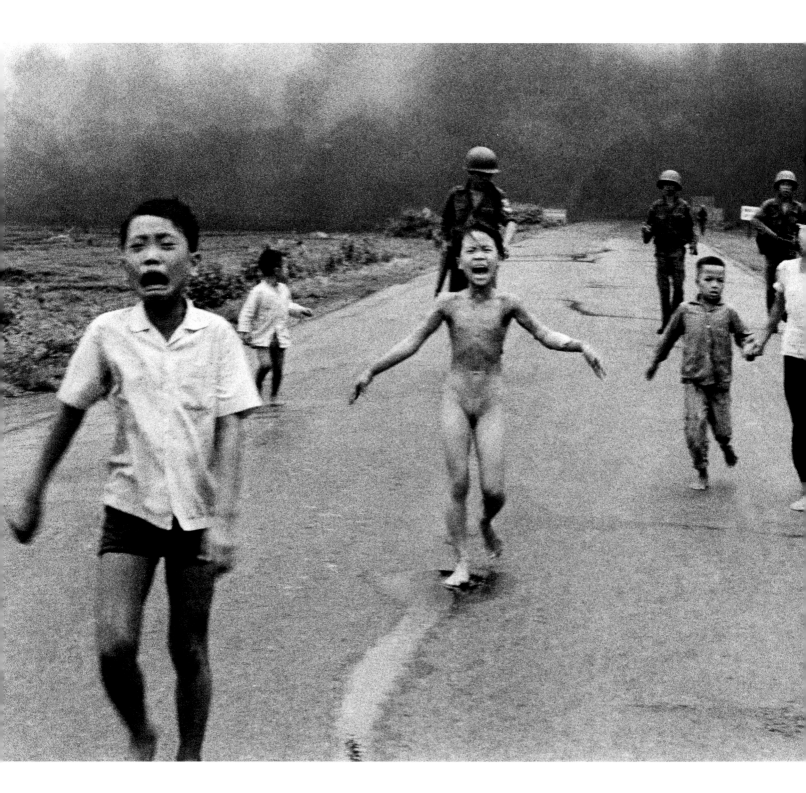

"I am that girl and my life changed forever that day.
For many years I lost my ability to trust.
I was filled with anger and bitterness. . . .
I am happy now because I can experience love,
peace and forgiveness."

Kim Phúc, 2003

Although sixty-five percent of her body was burned by napalm, Phan Thi Kim Phúc survived and eventually immigrated to Canada. She is the mother of two children and spends her life advocating for peace.

TRAGEDY

Every so often, a photographer happens upon an event that presents an unexpected (and often tragic) opportunity to capture history and, in the process, to change that history. Photographer Huynh Cong Ut, also known as Nick Ut, is one such photographer. Born in Vietnam, Ut began taking pictures for the Associated Press when he was sixteen. He was on assignment when a group of terrorized and injured South Vietnamese children fled from an accidental napalm attack on a building in which they had taken refuge. His photograph of a naked nine-year-old girl, Kim Phúc, won the Pulitzer Prize. Images, like Ron Haeberle's photograph of the My Lai massacre, created such furor that public opinion forced the American govern-ment to end its support of the existing South Vietnamese regime.

The torture and execution of hundreds of thousands of Cambodians by Pol Pot's Khmer Rouge during the seventies ranks as yet another example of the madness of twentieth-century genocide.

The Khmer Rouge operated a secret prison known as S-21. It was there that thousands suspected of counterrevolutionary activity were photographed prior to being tortured and executed. They were usually killed by batterings with iron bars, pickaxes and machetes. Bullets were too valuable. Of its 14,200 prisoners, only seven are known to have survived. Among those killed were thousands of children.

The inclusion of children in political and racial mass killings is all too common, as was witnessed in Nazi exterminations, Indonesian massacres and Argentine military abuses, and in Bosnia and Rwanda.

What is unique about S-21 was the perpetrators' compulsion to systematically photograph and catalogue each of the victims. American photographers Doug Niven and Chris Riley gained access to the prison and those images. Although many of the photographs had been destroyed, they were able to clean, print and catalogue over 6,000 of them. These images stand as a visual testament to the horrors of the Cambodian killing fields, and the work of Niven and Riley exemplifies the importance of photography in documenting history.

Unknown Photographers, Khmer Rouge victims, 1975

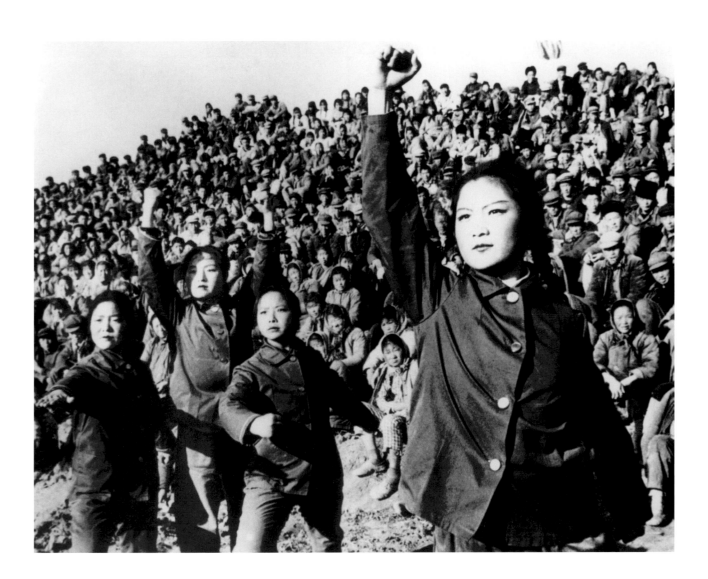

The Cultural Revolution drew China's adolescents into the Red Guards following Mao Zedong's directive to "make revolution." Their zealotry was noble, but their excesses -- barbaric acts of assault, vandalizing, looting and summary punishment -- demonstrated the danger of inciting the young. An entire generation of children had their education suspended or ended by the turmoil. Many of the young on both sides of the turmoil lost their lives as the children of intellectuals were pitted against the children of the elite. Once again, children served as the foot soldiers in society's ideological battle.

STRUGGLE

"I saw huge numbers of schoolchildren coming towards me. I started taking pictures. And I could see hands that were gesturing -- no pictures. I went over to them. 'Why do you say I can't take pictures?' 'Because the police might be able to identify some of us.' And I said to them, 'A struggle without documenting is no struggle.'"

Peter Magubane

The day was June 16, 1976. Thousands of children from Soweto marched, protesting the imposition of the Afrikaans language on black school children. The bloody protests on that day resulted in what observers recounted as over 200 deaths, mostly of nine- and ten-year-olds. Their courage and their sacrifice led to the ending of apartheid. June 16th is now celebrated in Soweto as Youth Day.

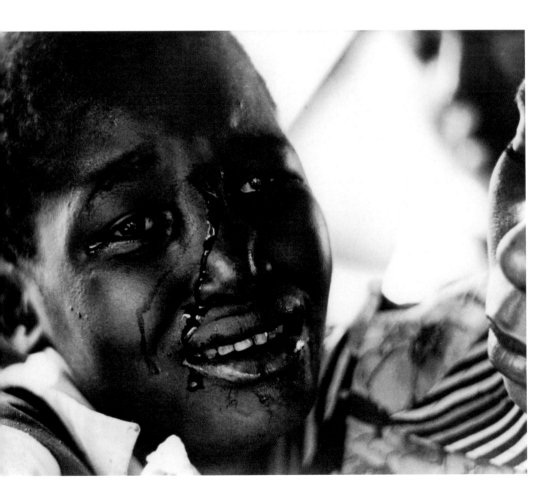

Peter Magubane, Soweto, 1976

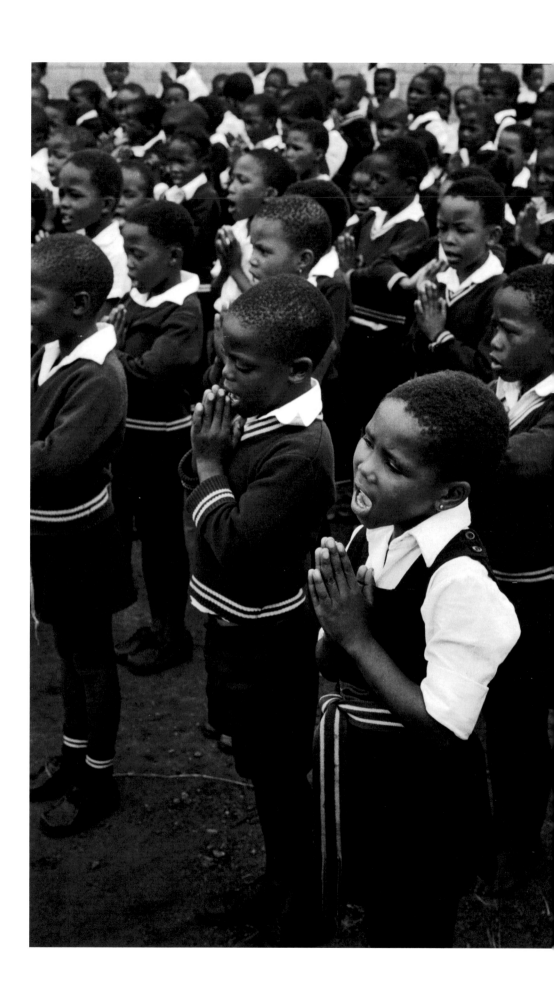

IMAGINE

IMAGINE THERE'S NO COUNTRIES
IT ISN'T HARD TO DO,
NOTHING TO KILL OR DIE FOR,
AND NO RELIGION TOO.
IMAGINE ALL THE PEOPLE
LIVING LIFE IN PEACE. . . .
IMAGINE NO POSSESSIONS,
I WONDER IF YOU CAN.
NO NEED FOR GREED OR HUNGER,
A BROTHERHOOD OF MAN.
IMAGINE ALL THE PEOPLE
SHARING ALL THE WORLD.
YOU MAY SAY I'M A DREAMER,
BUT I'M NOT THE ONLY ONE.
I HOPE SOME DAY YOU'LL JOIN US
AND THE WORLD WILL LIVE AS ONE.

JOHN LENNON

Larry Clark, 1971

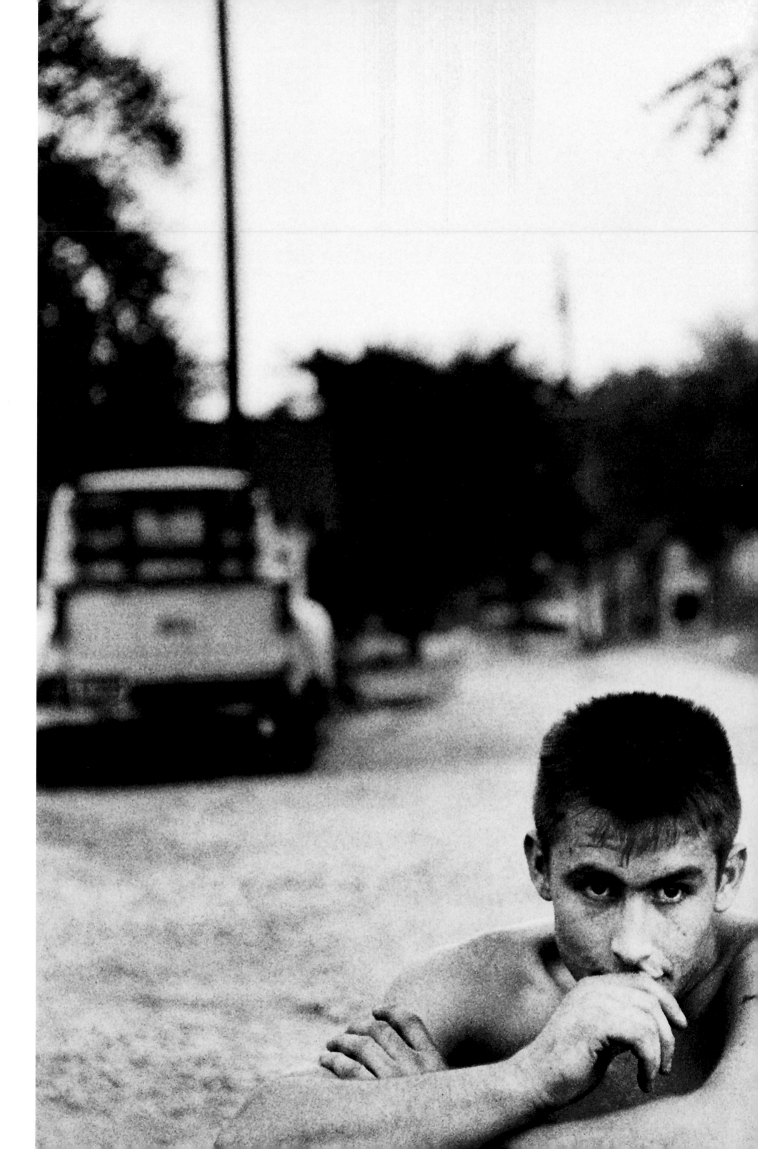

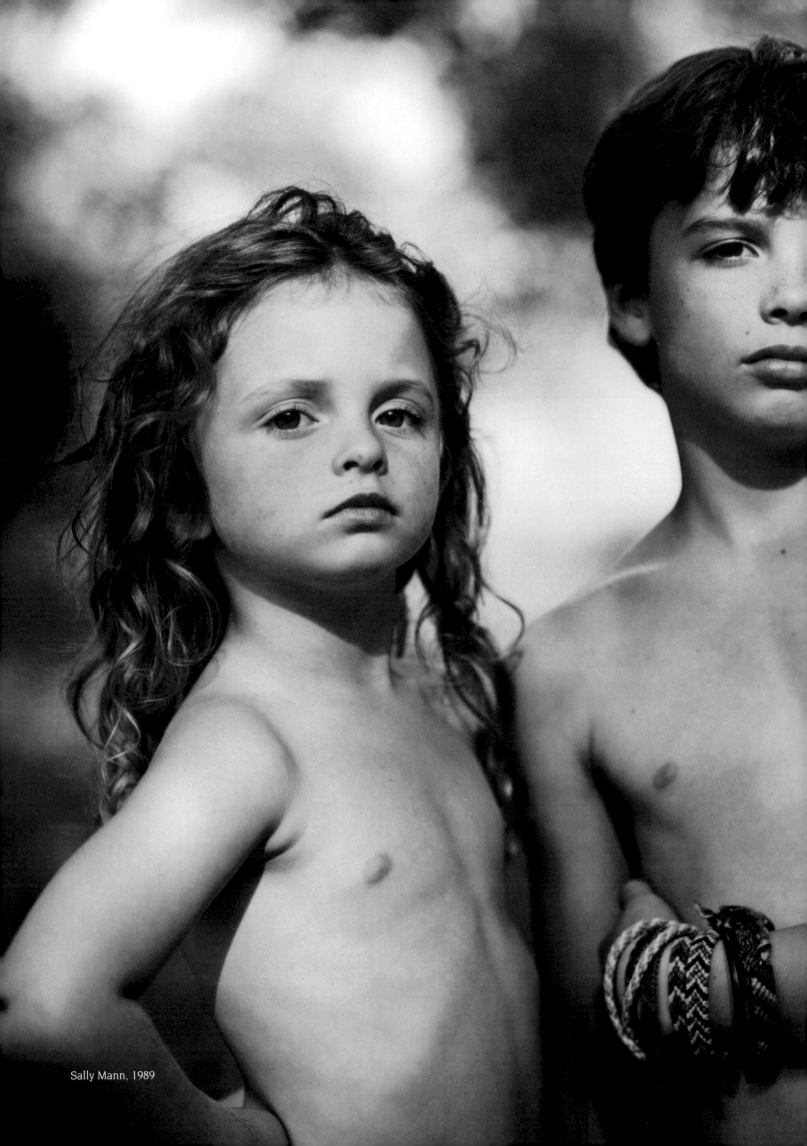

Sally Mann, 1989

the graceful child
1980-present

IN EVERY CHILD WHO IS BORN,

NO MATTER WHAT CIRCUMSTANCES,

AND OF NO MATTER WHAT PARENTS,

THE POTENTIALITY OF THE HUMAN RACE

IS BORN AGAIN AND IN HER, TOO,

ONCE MORE, AND EACH OF US,

OUR TERRIFIC RESPONSIBILITY

TOWARD HUMAN LIFE.

JAMES AGEE

Fazal Sheikh, 1992

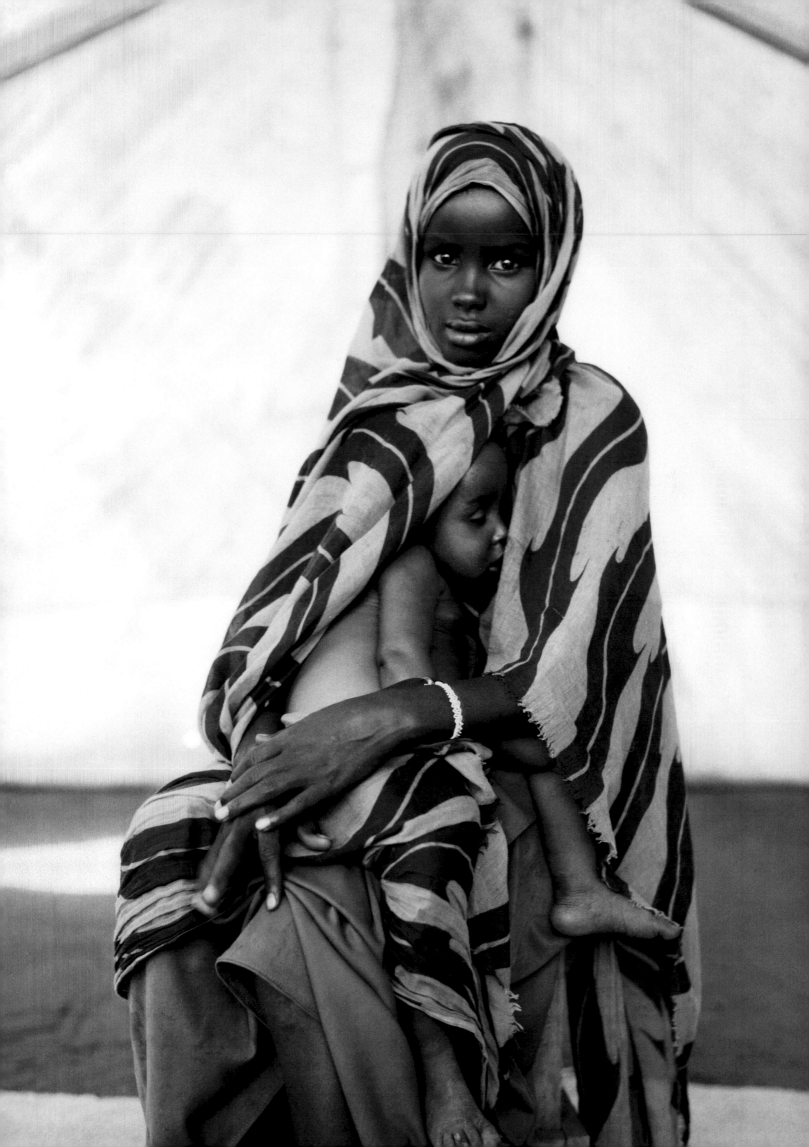

the child knowing

LIKE A TEAR IN ALL WE KNOW
ONCE DISSOLVED, WE ARE FREE TO GROW

PEARL JAM

The forecast for childhood, in the view of certain commentators, is bleak. For some, there is a sense that childhood as we know it is dissolving. After the first ten years, which, for the offspring of the affluent, consist of acculturating boot camps of tutored lessons, children join the 'tweens -- Madison Avenue's newest market. They are then ready for all the joys and toys of adulthood -- rocker duds, iPods, cell phones, e-mails and chat rooms. Already proficient at tennis, golf, soccer, snowboarding and swimming laps, these kids can idle away time surfing the net, fingering Nintendo, feasting their eyes on the marvels of animation or rapping to lyrics of anthemic angst. Their pockets hold the essentials of life -- a handful of uppers to lose their boredom and a few grams of Ritalin to focus their concentration.

To keep kids on this trajectory, advertisers reinforce stereotypes with monumental posters of teenage boys in tattered shorts and of nubile girls with pierced and tattooed navels. When teens tire of *American Idol* and their blogging chores are done, the news channels provide them with sensational fodder to obsess over -- lost (and presumed murdered) prom queens, Amber alerts for abducted children, teen suicide bombers and youths massacring classmates. If the 1979 rockumentary *The Kids Are Alright* were rereleased today, it might require a title change.

And it is not just the 'tweens and the teens. A recent foundation study found that more than half of all American four- to six-year-olds play video games. Marketers are now aiming at three-year-olds and even younger children with Sesame Street's new reach to infancy. These diversions engage the mind in ways very different from Barbie, Legos and Clifford, the Big Red Dog. Computer games go even further. Donkey Kong prepares kids for Mortal Kombat, which takes them to Halo, and before long the little tykes are morphing, in their imaginations at least, into mighty action-hero transformers -- subatomic agents capable of mayhem.

Simply put, a great deal is perceived as wrong with children in the digital age. They seem joined at the eyesocket to TVs, iPods, Game Boys and the screens on their cell phones. Kids' attention spans, some fear, are getting too small to measure. They multitask on everything and concentrate on nothing, except perhaps on the assembling of plastic weapons of mass destruction. Kids in this post-Napster generation, some complain, cannot resist any new product that media moguls offer them, but quickly lose interest when the next hype comes along. These phenomena are not all that new, but some find their intensity alarming.

The above description applies to only a small percentage of today's children. Throughout the developing world or in regions beset with armed conflict, there is a different kind of "knowing." Where violence is an everyday occurrence, disease is rampant or religious fundamentalism has taken hold, children adapt to survive. For centuries, physical abuse and sexual exploitation have been visited on children in all societies, privileged

or not. Today, there is a vast increase in communication, as well as a frankness in discussing these issues -- a public airing that is critical to addressing them.

What clearly seems lost in this digital age is the notion that children live in their own little worlds, protected and preserved by parents. That idea may well have always been an adult invention -- a fantasy of the nineteenth century that evolved when parents in the emerging middle class sought to shelter their young from premature entry into the workplace. The concept of a child's "secret garden" of fantasy, as in Frances Hodgson Burnett's classic book, has been replaced by the wired and war-weary world of today's child. The reality is that since the invention of the printing press children have embraced every opportunity, particularly when it is not provided by parents and teachers, to garner knowledge that they believe will bring them closer to their own emancipation. With the Internet, they now have at their fingertips an even more immediately accessible portal to the world.

Writers and educators like Neil Postman, David Elkind and Marie Winn argue that contemporary childhood is so foreshortened that the cultural construct of childhood has all but disappeared. Many of the factors discussed above, as well as the large number of orphans being created by disease and social conflict, the increase in divorces and the greater incidence of single parenting, have contributed to children's assuming greater control over some aspects of their lives at earlier ages than before. Winn describes them as a generation of "unchild-like children."

Paradoxically, it can also be argued that childhood in more affluent societies has been extended rather than shortened. Today's parents fret about "children" in their post-teens. After college -- for some a four-year sabbatical from life -- there remains a sizable group not quite ready for adult reality. Psychologist Jeffrey Jensen Arnett dubbed them "emerging adults." These twenty- and even thirty-somethings are delaying marriage and childbearing, often seduced by the desire to continue their education, which in turn necessitates continued parental support, emotional as well as financial. Salinger's Holden Caulfield could be aged anywhere from sixteen to twenty-six. A recent U.S. study, in fact, pegged the entry into full adulthood exactly at this latter number.

If one defines childhood as that period when people are dependent on their parents, this could well be called the "Age of Endless Childhood." Alarm has set in among some educators that the world has become, as psychologist Penelope Leach phrased it, "inimical to children." Parent-centric psychologists proselytize that blame should be centered on a sexually permissive, materialistically obsessed, secular culture replete with corporate greed and government meddling.

Yet, despite all the pessimism, young people today are mentally and emotionally stronger than ever before. A recent survey in the United States showed that members of Gen Y (as they are called) feel very good about themselves. Over two-thirds of those polled between the ages of fifteen and twenty-one described themselves as content to extremely happy. Ninety-six percent identified good friends as the key ingredient to a good life and eighty-four percent felt that getting along

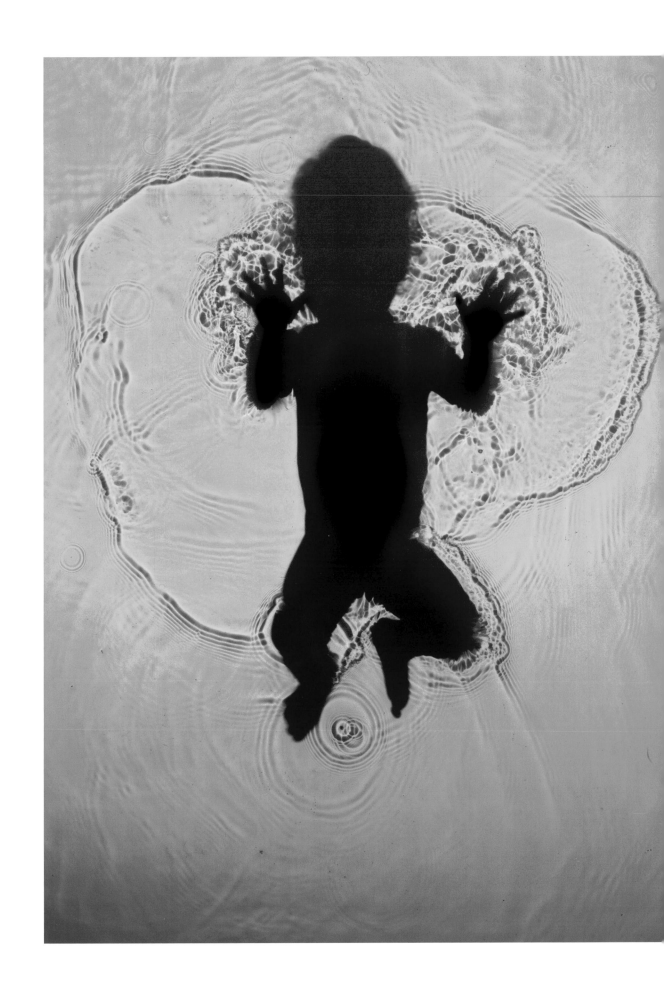

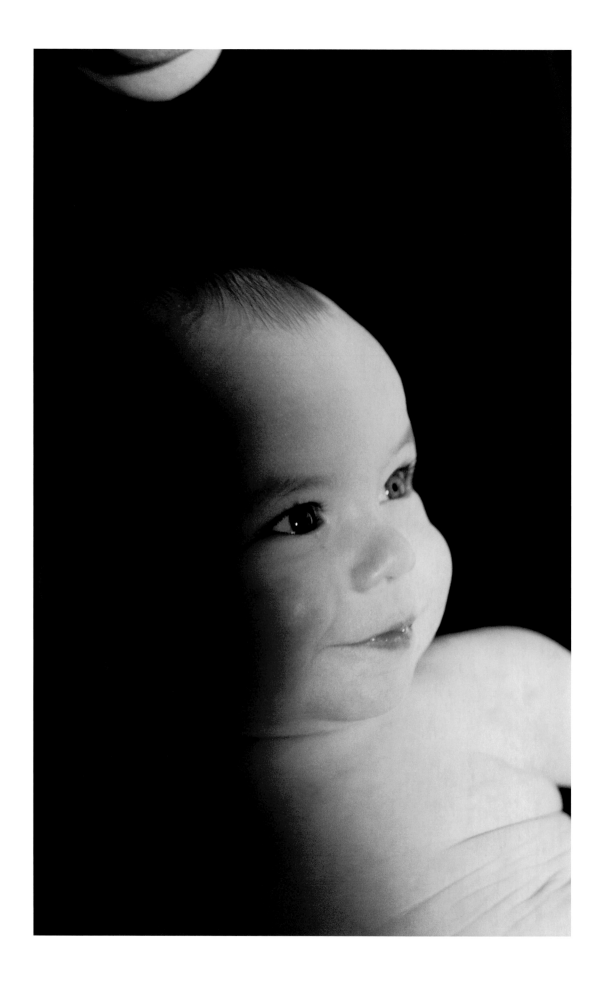

274

Ralph Gibson, 2000

with one's parents was the second most important factor.

Evidently, the contradictions in today's construct of childhood abound. Adults celebrate the young, as they adopt their styles, revel in their music and emulate their vitality. Yet, some adults also harbor considerable ambivalence and jealousy toward children, recognizing that as their own childhood becomes more distant, their mortality looms nearer. Adults constantly complicate the lives of the young by sending them mixed signals -- remain innocent but look alluring, be obedient but assert your independence, be youthful but not childish, grow up fast but remain our little darlings. Parental anxieties over the safety of their offspring, the demands imposed to ensure kids'

advancement in class status, and parents' guilt that they cannot guarantee a perfect childhood all contribute to a child's burden.

A salutary effect of all of this is that the myths of the so-called perfect childhood are finally being debunked. Childhood is not carefree; it is and has always been a complicated time of life. The home is not and perhaps never was the universal bastion of stability. Childhood is not the same for all; rather it is shaped by class, ethnicity and gender. Steven Mintz's book on the history of American childhood, *Huck's Raft*, concludes that history offers no easy solution to the problems of disconnection, stress and role contradictions that children face today, but it does provide certain insights. He believes, for example, that because "we cannot

insulate our children from malign influences, it is essential that we prepare them to deal responsibly with the pressures and choices they face," and underscores that this task requires knowledge. "In a risk-filled world, naïveté is vulnerability." His second insight is the recognition that parents cannot go it alone -- society must provide the young with opportunities to be involved with their communities as well as with diverse adult mentoring relationships. Mintz ends his book by noting that "young Huck Finn needs Jim as he and his little raft brave a raging river." What child doesn't?

There are over two billion children in the world today. In most of the world (with the exception of parts of sub-Saharan Africa), they are healthier, more protected and better educated than ever before. They are also not as innocent or malleable as parents would like to believe, nor as vulnerable as parents fear. Yet, childhood today is not without significant challenges. Childhood cannot be viewed as a steady progression toward perfection. Rather, it is a journey that, at times, takes dramatic turns. Currents of cultural, psychological and emotional change, as well as extraordinary advances in technology, are roiling the waters. The postmodern construct of childhood that prevails in the twenty-first century has yet to be given a name. Clearly, it is neither "romantic" nor "innocent." The "precarious child" seems too negative. The "knowing child" is perhaps too cynical. There have been "tears," as Eddie Vedder of Pearl Jam intoned, in the precepts that adults have taken for granted when it comes to childhood, but that is just part of their continuing maturation process.

What is essential for adults is to realize that the current iterations of childhood are varied and complex and are, at best, works in progress. The construct set forth above is primarily viewed through the eyes of the more fortunate. In some parts of the world, a different childhood is evolving. There are places where most of the young do not play at war games but are prey to warlords and where, due to AIDS or early marriage, many girls no older than ten are heads of households. Thirty percent are not immunized against any disease and suffer from malnutrition in the first five years of their lives. Over eighteen percent will never go to school and seventeen percent will never learn to read. The life expectancy of today's children varies greatly depending on where they live, ranging from seventy-eight years in the industrialized states to as low as forty-three years in less fortunate countries.

Wherever children are, they need an environment where they can access the information available to them, and one in which they will be protected while exploring new frontiers for themselves. This requires significant dedication and even a realignment of national and global priorities. The Dalai Lama warned that "if humanity is to survive, happiness and inner balance are crucial; otherwise the lives of our children and their children are more likely to be unhappy, desperate and short."

It would appear that the solutions to the problems facing today's children lie only partly with them but much more decisively with their parents.

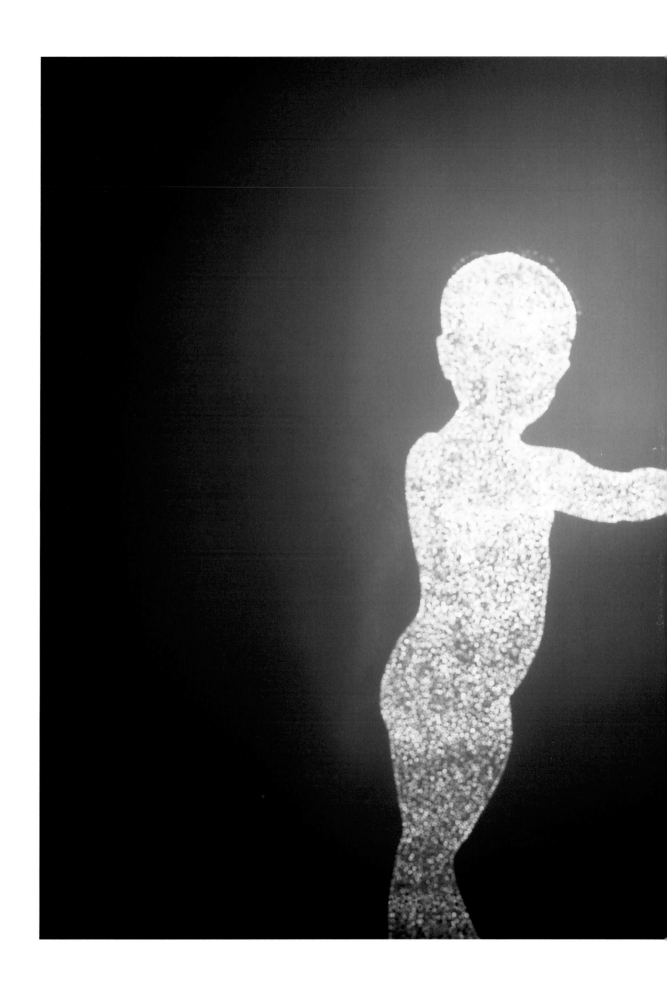

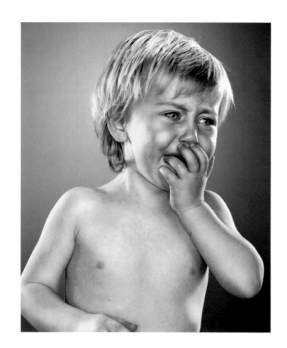

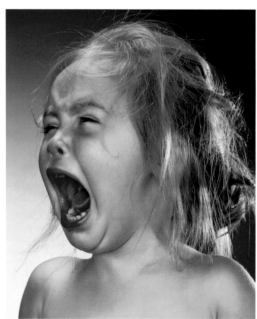

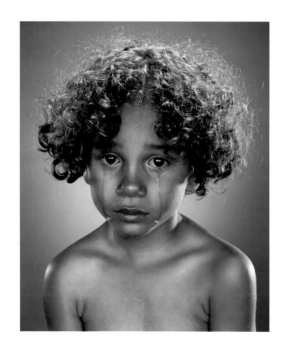

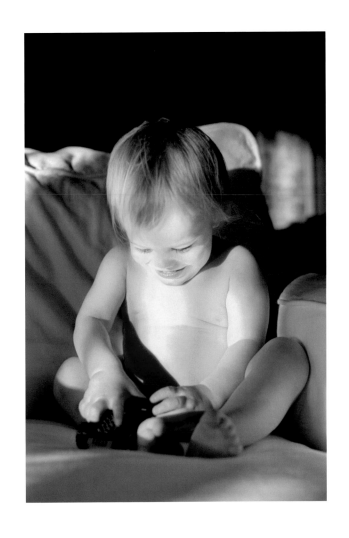

IF CHILDREN LIVE WITH CRITICISM,

THEY LEARN TO CONDEMN.

IF CHILDREN LIVE WITH HOSTILITY,

THEY LEARN TO FIGHT.

IF CHILDREN LIVE WITH RIDICULE,

THEY LEARN TO BE SHY.

IF CHILDREN LIVE WITH SHAME,

THEY LEARN TO BE GUILTY.

IF CHILDREN LIVE WITH TOLERANCE,

THEY LEARN PATIENCE.

IF CHILDREN LIVE WITH ENCOURAGEMENT,

THEY LEARN CONFIDENCE.

Caleb Cain Marcus, 2006

IF CHILDREN LIVE WITH PRAISE,

THEY LEARN TO APPRECIATE.

IF CHILDREN LIVE WITH FAIRNESS,

THEY LEARN JUSTICE.

IF CHILDREN LIVE WITH APPROVAL,

THEY LEARN TO LIKE THEMSELVES.

IF CHILDREN LIVE WITH ACCEPTANCE AND FRIENDSHIP,

THEY LEARN THE WORLD IS A NICE PLACE TO LIVE.

DOROTHY LAW NOLTE

Kimberly Quinn, 2006

NEVER ALLOW CHILDREN TO BE WITHOUT DELIGHTS.

COMENIUS

Nadav Kander, Turkey, 2003

284

David Graham, 1994

Susan Paulsen, 1998

Keith Carter, 1992

GIVE ME BACK THE SOUL I HAD OF OLD,

WHEN I WAS A CHILD MELLOW WITH LEGENDS,

WITH A FEATHERED CAP AND A WOODEN SWORD.

FEDERICO GARCIA LORCA

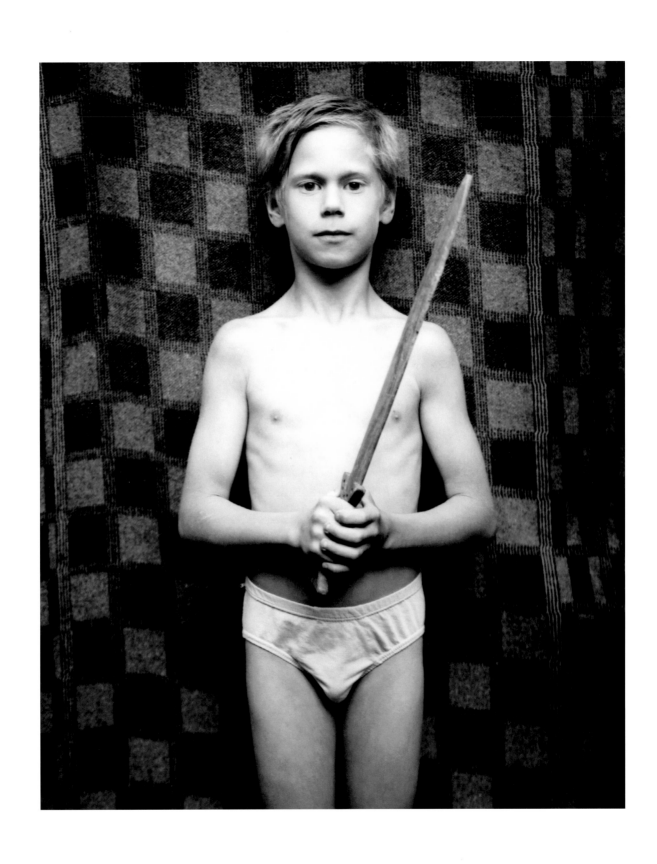

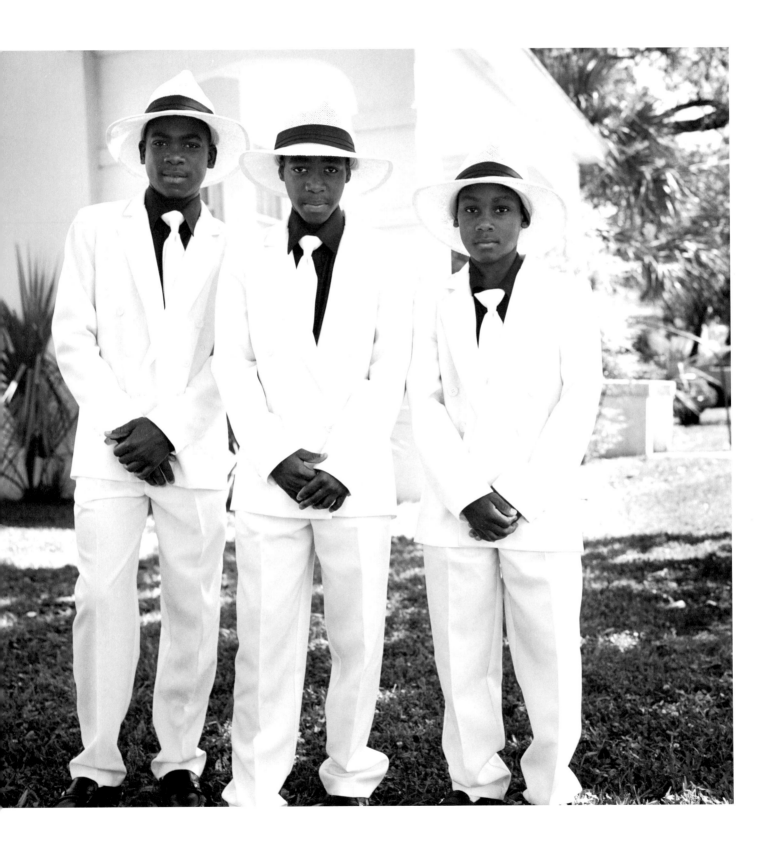

294

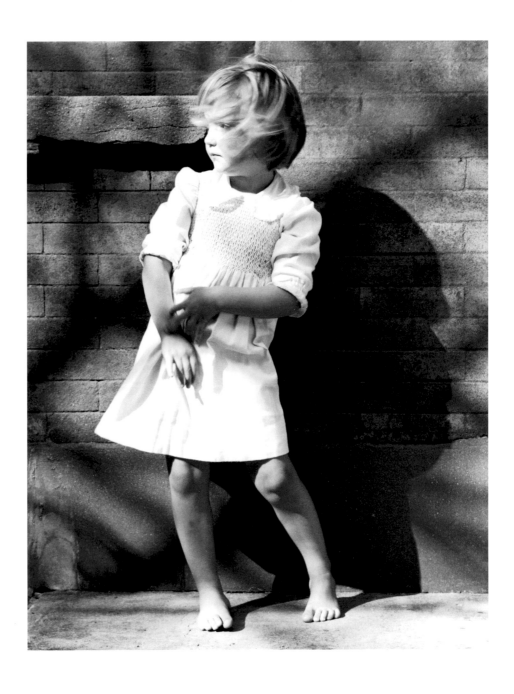

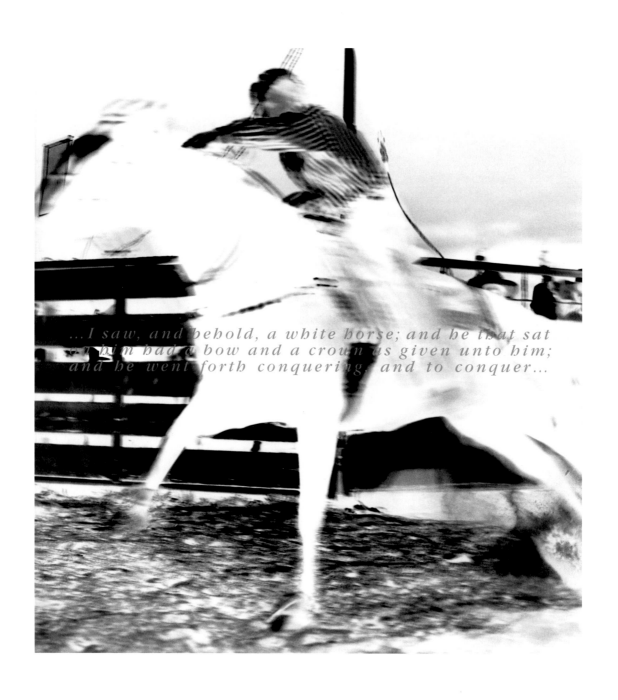

...I saw, and behold, a white horse; and he that sat upon him had a bow and a crown as given unto him; and he went forth conquering, and to conquer...

Jill Mathis, 2000

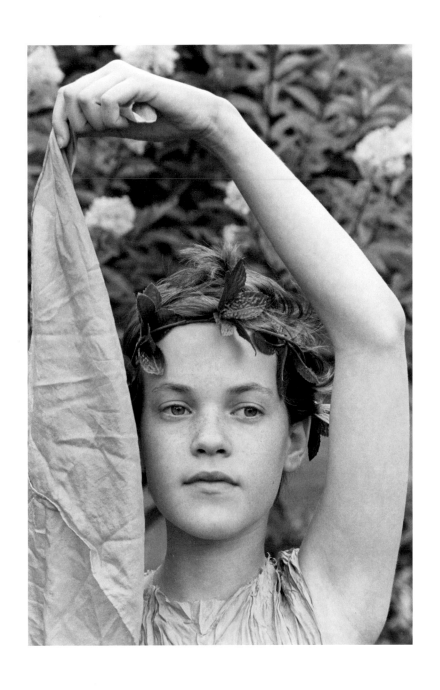

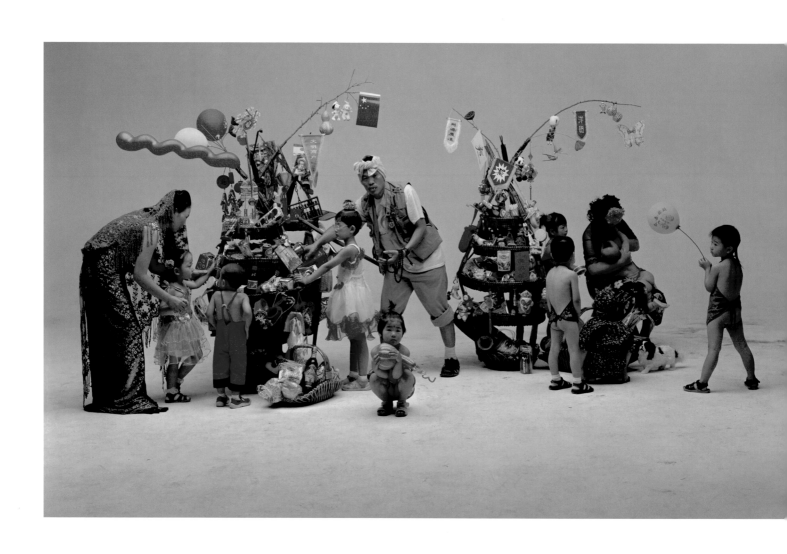

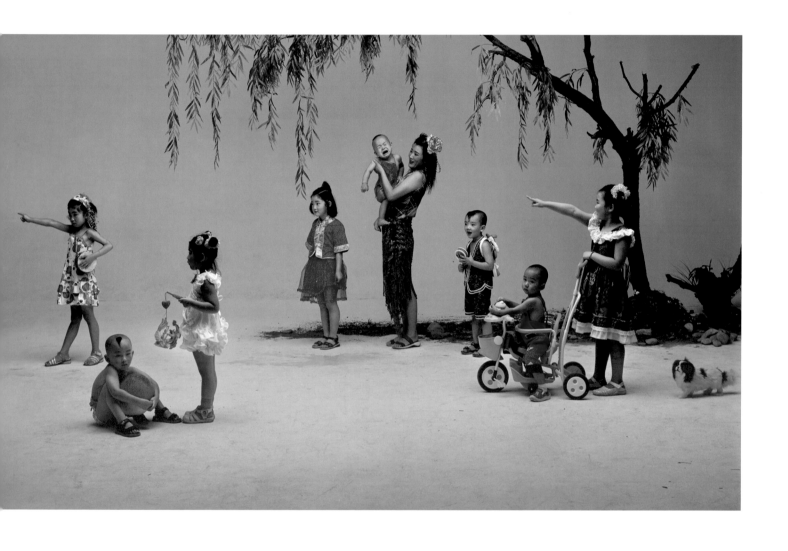

299

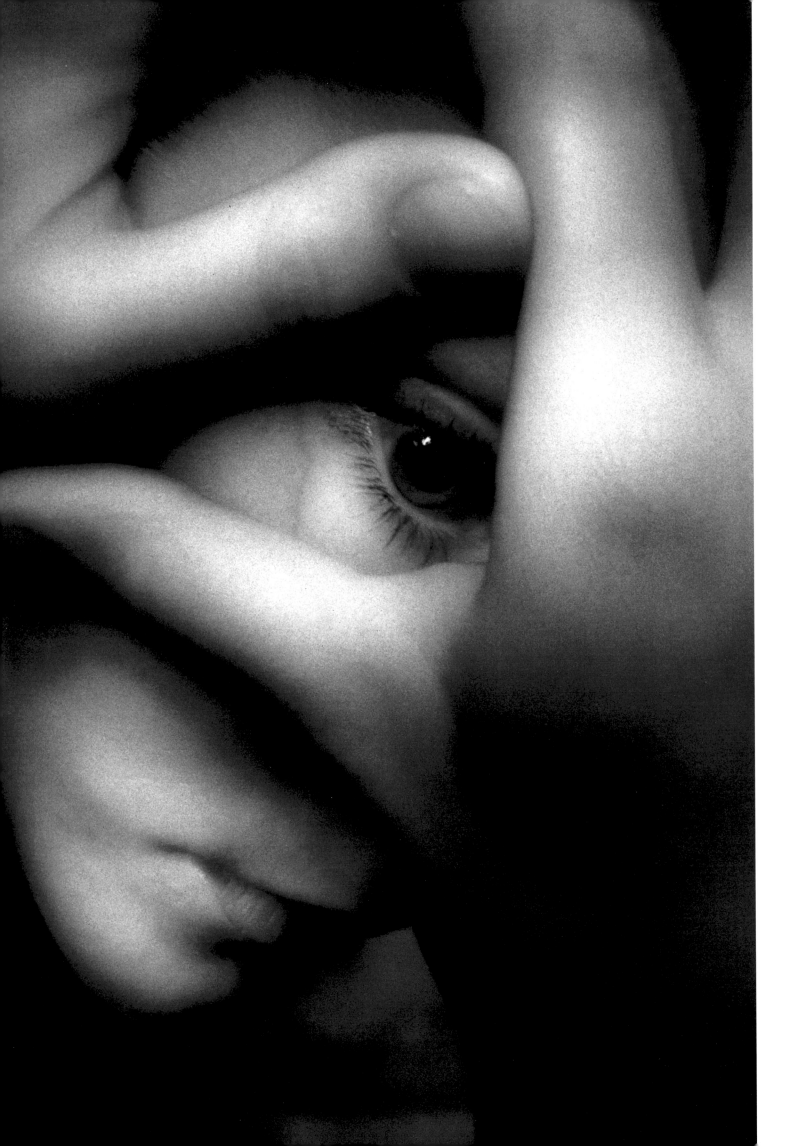

the child revealed

PEOPLE ARE LIKE STAINED-GLASS WINDOWS.
THEY SPARKLE AND SHINE WHEN THE SUN IS OUT,
BUT WHEN THE DARKNESS SETS IN,
THEIR TRUE BEAUTY IS REVEALED
ONLY IF THERE IS A LIGHT FROM WITHIN.

ELIZABETH KÜBLER-ROSS

After just over 165 years, photography is finally enjoying unquestioned acceptance as an art form. The dynamism of photography during the last three decades has arguably exceeded that of any other period. When movements like Pictorialism, Constructivism and Surrealism arrived, pundits gave them a label, but the present state of photographic art has not been so baptized. It would appear that modern photography has risen above the confines of labeling. It is also challenging its own history and is doing so with new languages and new forms of visual expression. At the same time that it is constructing new realities, it is rediscovering old technologies -- photogravure, collodion printing and even daguerreotype.

Although photography has no boundaries when it comes to subject matter, starting in the eighties, artists have shown an increased interest in people as a subject for exploration. Photographers such as Robert Mapplethorpe, Philip-Lorca diCorcia and Cindy Sherman have explored the sensual, the conceptual and the personal. Others, like Nan Goldin and Sandy Skoglund, have plumbed the intimate and the fantastic. Still others find people to be the best subjects for cultural or political statements. Wang Quingsong in China and Boris Mikailov in Russia are apt examples.

Within the core of this genre are images of children. Contemporary artists have been using children as a vehicle to explore profound issues and have done so with a dazzling array of approaches -- some serious, some engaging and some of questionable appropriateness. These images can be invigorating as well as ennobling. Such variety makes children the most compelling and popular subject of the medium. As family dynamics have grown more complex, photographers have increasingly turned to their own families as subjects. The reconfiguring of family is central to the works of Andrea Modica, who explores the tensions between childhood and adolescence, and Tina Barney, who sets a stage for upperclass rituals and rhythms. Some artists are attracted by anxieties and disconnects, while harmony and grace draw others in.

In the postmodern period, the template for family images was set by Sally Mann, the most important photographer of children of our time. It was *Immediate Family*, a series of photographs of her husband and children, that marked a turning point in the history of picturing children. Shooting with a large-format camera, Mann created black-and-white images that stand alone as beautiful period pieces, but serve even better as portals to explore more than surface reality. At first, viewers are unsure of whether they might be intruding on her family's privacy, but then quickly come to the realization that they are invited guests and that her family's daily life and intimacies represent universal visual tropes.

In the confluence of past and
future, reality and symbol, are
Emmett, Jessie and Virginia.

Their strength and confidence,
there to be seen in their eyes, is
compelling;

nothing is so seductive as a gift
casually possessed.

The withering perspective of the
past, the predictable treacheries
of the future.

For this moment, those familiar
complications of time all play
harmlessly around them as
dancing shadows beneath
the great oak.

Sally Mann

In the introduction to her series, Mann wrote:
"Many of these pictures are intimate, some
are fictions and some are fantastic, but most
are of ordinary things every mother has seen --
a wet bed, a bloody nose, candy cigarettes.
They dress up, they pout and posture, they
paint bodies, they dive like otters in the dark
river. . . . At times, it is difficult to say exactly
who makes the pictures. Some are gifts to
me from my children: gifts that come in a
moment as fleeting as the touch of an angel's
wing." Mann created a mosaic of classical
dimensions -- a visual story of growing up,
with love, beauty, angst and even anger
coursing through it. Within these images one
finds moments of joy, envy, contemplation,
make-believe and discovery.

Mann's three children accepted their mother's
invitation to be part of this mosaic. They per-
mitted their personalities to be explored and
exposed. Confidence was often matched with
insecurity, exuberance paired off with pen-
siveness. The viewer feels like an unobtrusive
visitor to the recesses of their subconscious
minds. What Mann accomplished with this
imagery finally puts to rest, or, perhaps more
fairly, puts into proper perspective, the
romantic notion of childhood innocence.
That Victorian construct had dominated the
picturing of children for over a century, and
its effect can be seen throughout much of
the history of the medium -- in Pictorialism,
Humanism and the works of Cartier-Bresson
and Levitt, for example, and even in the pro-
gressive populism of Hine and the mundanity
of *Life*.

Before Mann, photographs of children often
served as mirrors to reflect for the viewer
universal verities and aspects of self, perhaps

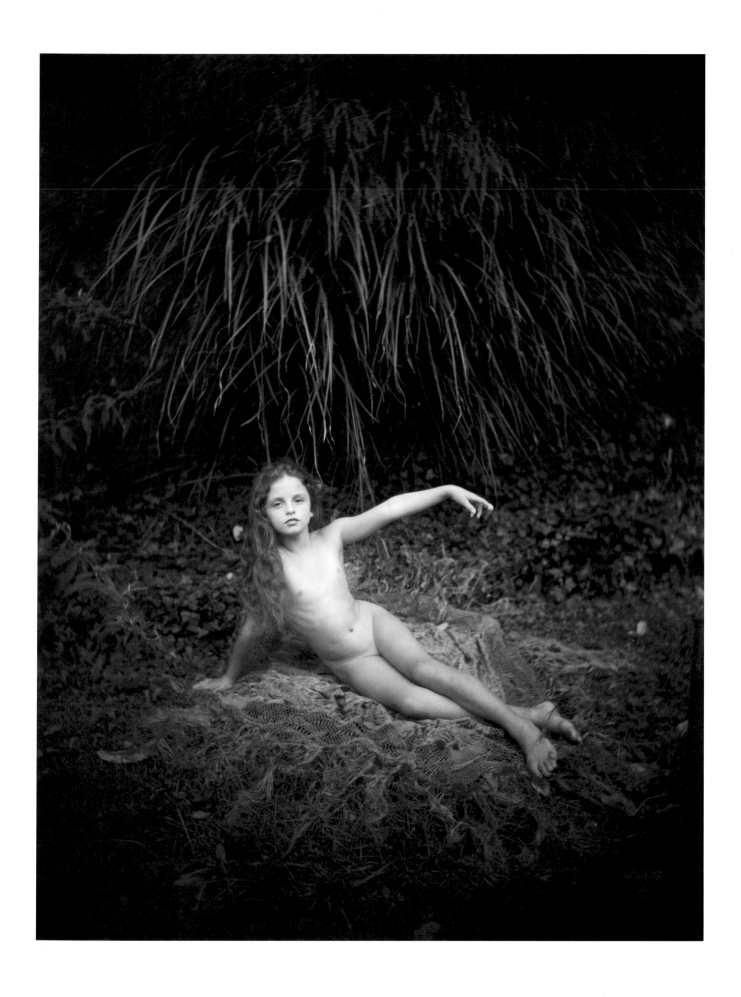

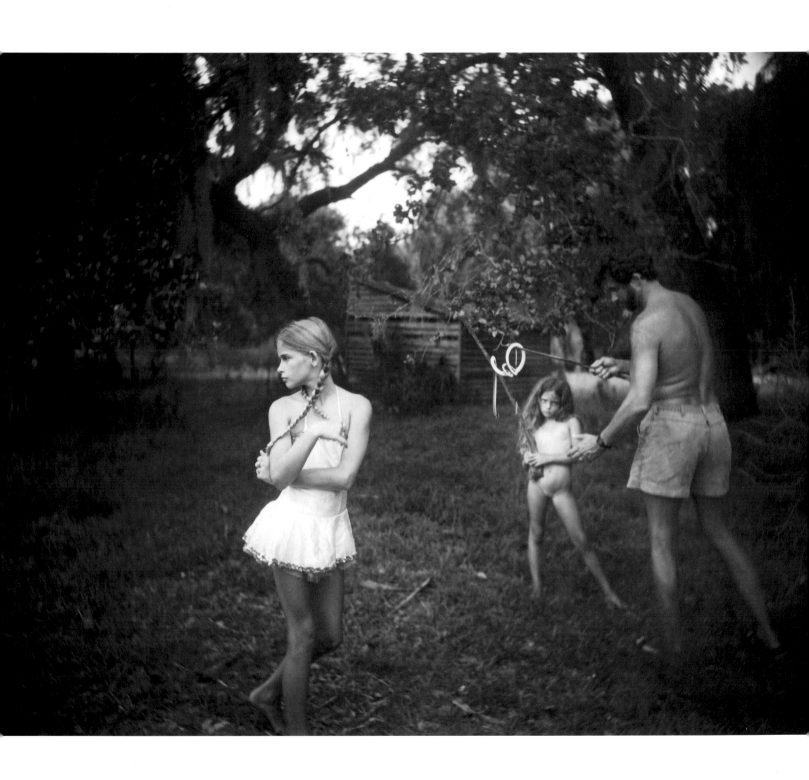

Sally Mann, 1992

long lost. The most memorable ones were often riveting and even magical and conveyed a wealth of information. This information was most often lyrical or universal but rarely about the subject. Mann turned that mirror into a window, for rather than revealing generalized verities about children, she filled in personal and intimate details about her subjects. She ignored sexuality for substance and exposed the private personae of her children. Her visual stories are about nature, love, sensuality, death and fear; the noble and the base commingle with the serious and the silly. In that respect, the children portrayed are childlike, in the true sense of the word. Her critics rant that she upset cherished conventions created to encapsulate children with love. Any parent with a memory knows better.

One sees in Mann's work elements that go back to photography's beginnings. Julia Margaret Cameron and Lady Hawarden both used their children as models and were able to produce evocative work. Later, great artists like Edward Weston, Lewis Hine, Dorothea Lange, Walker Evans and Henri Cartier-Bresson often illuminated their child subjects with pathos. Mann, however, expanded the contextual boundaries of child photography, opening the door to a broader way of perceiving children.

To the extent that Mann had predecessors, they were few -- perhaps Nicholas Nixon, Emmet Gowin and Ralph Eugene Meatyard might be considered as such -- but her followers are many. Hellen van Meene, a young Dutch artist, strives with success to capture the awkwardness and vulnerability of teens. Rineke Dijkstra, another Dutch artist, hones

in on details, stripping her subjects of contextual backgrounds, a technique that requires an intensity of observation on the part of the viewer. Anna Gaskell pictures children's fantasies by referencing their fictions. In doing so, she creates haunting tableaus of adolescence that are filled with content. Wendy Ewald helps children photograph themselves, then embellish their pictures and, in that process, explore their feelings. Gillian Wearing does the same with video. Loretta Lux and Ruud van Empel are working with digital processes to further explore various aspects of childhood.

It is interesting to note that many of today's most important photographers are women working with children as their subjects. Once the boundaries were breached by Mann, a rich and vibrant new field became ripe for exploration, and women were there to mine it. Mann made it manifest that through photography an artist is able to reveal complex and ambiguous elements of our species and at the same time say much about society. She and those who follow her have collectively effected a new vision of childhood in which innocence has been relegated to infants. This construct is more in tune with today's child. Anne Higonnet calls this generation "knowing children." Another description is simply "the child revealed," for images like Mann's embrace children as complete and complex beings, reflecting, as Kübler-Ross called it, their "light from within" -- a light that is wondrous if not always innocent, graceful if no longer romantic.

By the nineties, a new phenomenon -- the digital age -- had arrived, and its effect on image-making was profound. The artist David

Hockney, lamenting the onslaught of computer generated imagery, predicted "the end of . . . photography," reminiscent of artist Paul Delaroche's 1839 declaration, upon viewing his first daguerreotype, that painting was dead. Neither fear has been realized. In fact, the introduction of digital photography constituted the most significant event in the medium's history since the camera's invention. In 1990, Americans made over seventeen million photographs -- virtually all of which were analog, that is, recorded on film. A scant ten years later, more than half the photographs produced were digital. The differences between the processes are profound. Photography's uniqueness came from the perception that it conveyed reality, no matter how filtered or manipulated. The power of traditional photography came from the tension inherent in a process that is based on the alchemy of the reaction of silver particles to light and the magic of chemistry. Artists were intent on reducing the universe into frames that could be comprehended and, in so doing, exercised significant discretion over what was photographed, from what vantage point and with what equipment. The world and its inhabitants, however, were often uncooperative. Reality often delivered more or less information than the photographer wanted.

Although achieving the perfect balance continues to prove frustrating for the photographer, the advent of digital imaging does permit photography to be something else -- a representation more of a vision than of reality. This new process releases artists from the confines of the real and the past, granting wider margins for the imagination. Prior to the introduction of digital cameras, photography was a partnership among the subject, the photographer and the instrument, each making its own contribution. With the digital process, the photographer can continue on a solitary, interpretive journey in a nontactile but still sensuous digital universe. The move from silver dust to pixels has finally pushed photography into a new postmodern world. In photojournalism, digitality offers virtually instantaneous access to global images as photographs of people and events taken minutes before flood press rooms daily. Image scanning provides for limitless Web-based archives and virtually immediate access to images. The Internet permits the easy downloading and editing of photographs.

For many this transmogrification is confounding. The question is no longer whether photography is art, but whether digital imagery is photography. Purists initially viewed this development as the end of photography, but they were soon overtaken by digital photography's omnipresence, including in art galleries. Today, however, most believe that digital technology will not only expand photography's future, but also open up its past. Clearly these new techniques have made the viewer more knowing. Software programs such as Photoshop have made us aware of how easy it is to alter reality. Such manipulation, once shunned, is now a part of the craft just as darkroom techniques are. The digital age has been liberating in other ways. The most important is the easy and inexpensive entry it permits aspiring practitioners -- particularly in the developing world. No longer do they need expensive physical space, costly equipment or exposure to noxious chemicals. In this sense, digital photography has democratized the profession.

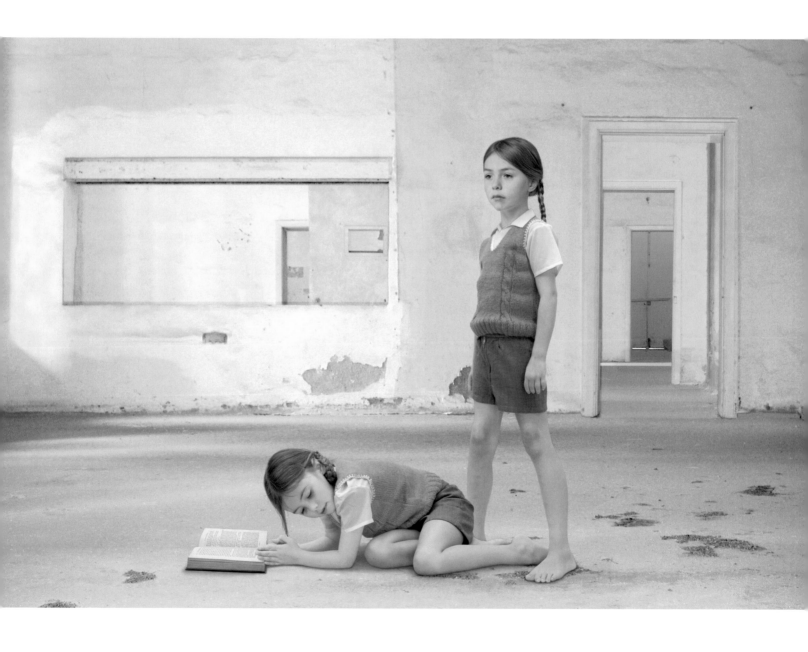

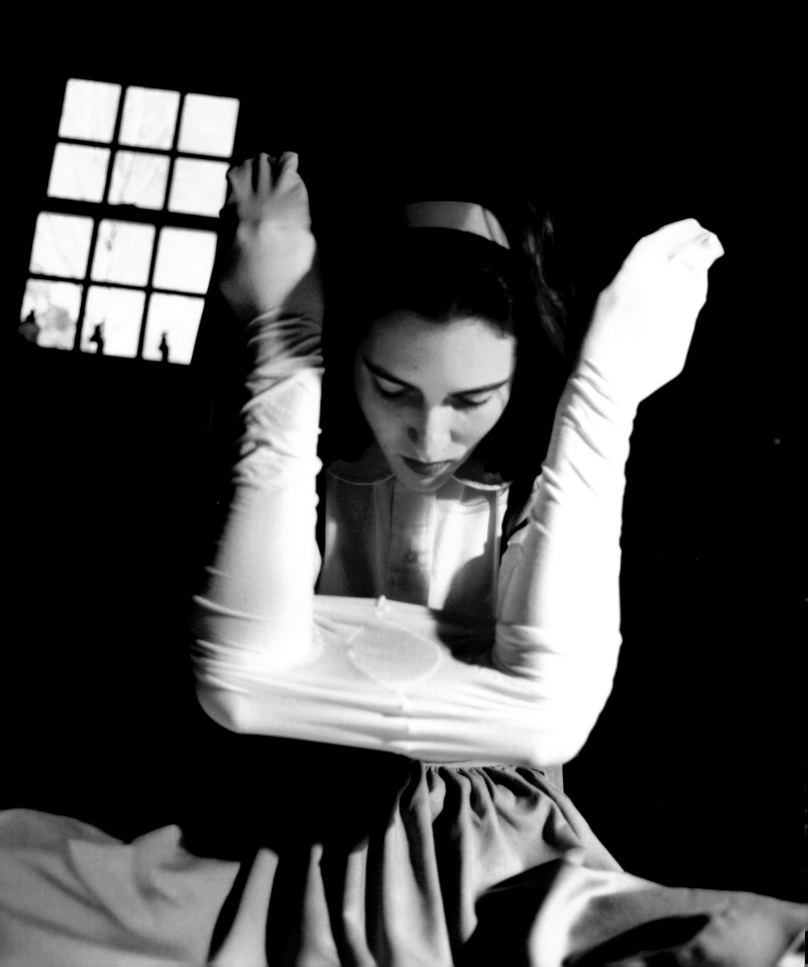

FOR CHILDREN, CHILDHOOD IS TIMELESS.

IT IS ALWAYS THE PRESENT.

EVERYTHING IS IN THE PRESENT TENSE.

OF COURSE, THEY HAVE MEMORIES.

OF COURSE, TIME SHIFTS A LITTLE FOR THEM AND

CHRISTMAS COMES ROUND IN THE END.

BUT THEY DON'T FEEL IT.

TODAY IS WHAT THEY FEEL, AND WHEN THEY SAY "WHEN I GROW UP,"

THERE IS ALWAYS AN EDGE OF DISBELIEF --

HOW COULD THEY EVER BE OTHER THAN WHAT THEY ARE?

IAN MCEWAN

I like rap. My favorite rap
music is Boyz II Men. I like to
eat seafood. I like to play
basketball. I like to play
video games. I am eleven
years old. My favorite color
is hot pink. I have glasses.
My favorite team is the
Chicago Bulls. My favorite
state is New Jersey.

Jesse Beck/Black Self

the child animated

ANIMATION CAN EXPLAIN WHATEVER
THE MIND OF MAN CONCEIVES.

WALT DISNEY

Illustration has been part of children's lives for centuries. Thought to have been first used in 1658 in Comenius's children's primer, it took hold when the publisher John Newbery included alluring woodcuts in *The Renowned History of Little Goody Two-Shoes* (1765). By the time John Tenniel partnered with Lewis Carroll on the Alice books (1865), it was clear that illustrative art created visual portals through which the stories could leap to life. In fact, illustration would prove virtually essential in satisfying the imagination of children. Children are supremely comfortable within their imaginations, which remain limitless until barnacles of maturity accumulate. As soon as technology permitted, illustration led to animation, which came to the silver screen in 1937 as a feature film with Disney's *Snow White and the Seven Dwarfs*. A half-century later, computer technology brought animation for children to new levels with the release of *Toy Story* (1995) and *Shrek* (2001).

A parallel phenomenon was a continuing interest in comic books. In some respects, the origins of comic books may be older than illustration itself. Comics can be traced to prehistoric cave paintings and Egyptian hieroglyphics. Those series of drawings and symbols represented man's early attempts to visually depict the world in which he lived. By juxtaposing images with pictographs and later words, these early artists enhanced the narrative flow. Today's comics do the same thing. Originally their themes were mostly about children and their pets, and it was not until the fall of the financial markets in 1929 that their popularity started to rise. Adventure became the dominant theme and their escapist allure and Everyman heroes proved a palliative to the unemployed. In America, Flash Gordon, Dick Tracy, Tarzan, Rip Kirby and Mandrake enthralled children and adults alike, while Hergé's Tintin captivated the French. By the forties, comics had become part of mass culture. DC Comics and Marvel introduced heroes that children could better relate to, particularly when the hero was personally challenged or conflicted, such as Peter Parker, the "geek" behind the Spider-Man outfit.

By the fifties, some educators and psychiatrists became alarmed. They felt that comics were corrupting the very young and causing delinquency in those older. To the rescue came a new brand of comics that addressed children's lives and problems more positively. *Peanuts*, by Charles M. Schulz, introduced Charlie Brown, a quintessential six-year-old. He was insecure but at his core ingenious and, with the help of Snoopy, a philosophical beagle who lived atop his red doghouse, and a neighborhood friend, Lucy, he addressed the issues that children face. Charlie was a born loser; he came to symbolize the uneasy partnership of insecurity and ingenuity that exists in childhood.

Some pundits also found animation suspect. Even the revered Disney franchise was accused of having a hidden agenda, promoting racism

and sexist stereotypes, revising history and promoting conformity, all in the name of commercialization -- harsh words that could make even Mickey weep. Animated interactive video games were understandably of concern due to their violent and pornographic content. It is hard to find redeeming features in the phallo-militaristic Mighty Morphin' Power Rangers. Educators, psychologists and parents began to fear that the "kinderculture" of the postmodern child was being constructed by and for the benefit of media corporations. They faulted animation for monopolizing the "information age" so that juvenile perspectives could be directed toward consumerism, and they considered the extent of the conspiracy very wide -- even Ronald McDonald was implicated.

Exceptions to this indictment were shows like Sesame Street, produced by the nonprofit organization Sesame Workshop. This organization set the standard for combining education and entertainment in children's television. For nearly four decades, Sesame Street has broadcast lessons on letters, numbers, health and tolerance, utilizing puppets, animation and live performances. Bert, Ernie, Elmo, Big Bird and the Cookie Monster have traveled from the Bronx to Bhopal, Cape Town to Kabul, providing preschool education in places where little existed. Localized co-productions of the series also confront such issues as the stigma of HIV and AIDS in South Africa and the need for girls' education in Egypt, and each series consistently fosters respect and understanding among children worldwide -- a welcome difference from much of the networks' children's fodder. Recently, the Workshop introduced Sesame Beginnings, a program geared toward infants from ages six months to two years and their caregivers. It received mixed reviews. The critics attacked it with Luddite-like ferocity, often without the benefit of having seen it. Certain child health experts continue to wail that television is noxious to developing minds. Those cries have fallen mostly on deaf ears, big and small.

Without question, animation now dominates children's visual entertainment experiences, not only in the United States but throughout the world. In Japan, it has come to exemplify the merger of high art and high technology. Japanese comic illustration is known as *manga* (loosely translated as "whimsical imagery") and its origins reach back over a thousand years. In modern times, *manga* began to flourish with the creation of the

Sesame Street Workshop, 2006
Ramon F. Bachs, Sally Floyd, Marvel's new heroine,
an adolescent photojournalist, 2006 (right)

series *AstroBoy*, featuring a thinking, caring child robot complete with heart and soul. His creator, Osamu Tezuka, had a simple message -- "Love all the creatures! Love everything that has life." From his *manga* origins, *AstroBoy* became an animated feature in 1982 and has remained one of the strongest and most resonant pop icons in Japanese culture. *AstroBoy* also spawned the *anime* (animation) craze in Japan. By the 1980s, animated features entered the mainstream of Japanese culture and, through the genius of Hayao Miyazaki and Mamoru Oshii, became universally recognized as animation at its best. Miyazaki's seminal works, *Princess Mononoke* and *Howl's Moving Castle*, stand at the apex of the genre. Many of the stories involve resourceful, serious girls -- characters conspicuously absent in American animation. The core themes are the irrationality of violence, the need to live in harmony with nature and the beneficial consequences of

kindness and compassion. Unlike their American counterparts, which initially featured sentimental affirmations of the triumph of good over evil and were flavored with more than a dollop of violence, Miyazaki's stories show that a child's journey toward happiness is often not direct and that, while it can be complex and arduous, it does not need help from weapons of mass destruction or other forms of mayhem.

American animation came of age when its creators decided to make their characters relate to the concerns of children today. Joel Cohen, a creator of *Captain Cur and Wonderflea* and one of the Academy Award-nominated writers of *Toy Story*, put it as follows: "Modern animation is driven by the 'freuds' -- the psychological struggles that children constantly wrestle with. For example, *Toy Story* is about Woody's feelings of abandonment in his previous living situations and

his desire to fight for and defend his place on Andy's bed. Buzz has the delusional idea that he is an actual spaceman and not just a toy. In this way he is very much like Don Quixote, who is fighting windmills, believing them to be dragons. In *Shrek*, the abiding feeling is loneliness. Shrek has had a hard time whenever he has ventured into the larger world, so now he just wants to be left alone, while his donkey is so lonely he talks constantly, as if to create the illusion of never being alone, even if it is just his own chatter that keeps him company. *Finding Nemo* is driven by more adult anxiety -- the idea that in this modern post-9/11 world it is possible to get separated from loved ones by accident or a deliberate act of terror." Animation is heady stuff for the young mind.

It now seems clear that Walt Disney was right when he said that animation can explain whatever the minds of children can conceive. Animation so dominates children's entertainment that it has relegated most children's books to literary purgatory, where they are considered to be mere promotional props that help movies sell. That is unfortunate, for many believe that reading is a skill that is essential to knowledge, while animation, though highly creative, often serves only as a temporary palliative to quench a child's impatient imagination. The truth is that both are important and both help to nurture young minds. Francis Spufford, who in 1964 wrote a memoir of childhood reading, said, "There were times when a particular book, like a seed crystal, dropped into |my| mind when |I was| exactly ready for it." William Hazlitt, the nineteenth-century literary seer, observed that "books alone teach us to judge truth and

good in the abstract . . . and |through them| we are ennobled from savages into rational beings." If Spufford and Hazlitt were writing their books today, they would probably mention the best of animation as well, for both what children watch and what they read free them from having only one point of view and help them realize that in the wired world they inhabit, they occupy but a small place in a vast sea of possibilities.

Unfortunately, reading has become an institutional and parental requirement more than a cherished pastime. It was not too long ago that when children completed their chores, they retreated to their rooms, anticipating the company of a good book. Today it's "tube time" that a child craves. Children are drawing much of their culture from animated films and TV. Many people began to believe that even if the pronouncement about the death

of childhood turned out to be premature, reports of the imminent demise of children's literature might in fact prove to be accurate.

That is until a bespectacled eleven-year-old character named Harry Potter appeared in our lives. With his arrival, all those assumptions about reading and today's child were short-circuited. J.K. Rowling conceived of her young wizard, with a lightning-bolt scar on his forehead, as "Everychild," and the world (including more than a few adults) has avidly followed him in volume after volume. The series' success is so extraordinary that when it comes to contemporary children's literature, it is all about Harry. In less than a decade, the Potter books brought life back to children's reading. But the phenomenon is about more than juvenile literacy. The unquenchable hunger for Rowling's novels shows that children are more discerning than their handlers have given them credit for, especially those handlers intent on selling products. Harry has proved that young readers do not need cinematic moments to hold their attention, confirming that they suffer no attention deficiencies when it comes to a good read.

Rowling's novels have many of the elements that enchant children. They take place in a boarding school where life is structured and planned. Children have identified with that setting since Tom Brown's Schooldays (1857), although the Hogwarts School of Witchcraft and Wizardry is not your typical prep school. There are no parents around to divide kids' loyalties or to exercise control, a scenario we know children like, as evidenced by the success of Alice, Dorothy and Huck. Rowling's books feature a coterie of close

friends, much like Frodo had, who help Harry parse out his problems. They are peppered with magic and wizardry similar to that of The Hobbit. They feature the forces of good and evil, much like The Chronicles of Narnia. They are sprinkled with ideas that adults might find subversive, but no more so than The Adventures of Huckleberry Finn and The Cat in the Hat are. Despite the fact that Rowling borrows shamelessly from children's literary history, her success has proved unprecedented. Some see Potter's world as rife with sin, temptation and devilry. Others lament its violence and its fixation on the occult and the symbolic. Rowling has made it onto the list of writers of banned books, in the esteemed company of authors Maya Angelou, Mark Twain, Judy Blume and J.D. Salinger. The fact is that the Potter books have all the proper ingredients for success -- elements of the fairy tale and Bildungsroman: adventure, mystery and quest. Additionally, Rowling gives a forceful voice to the qualms of today's children. Her protagonist is kind of a Cinderfella -- the nerdy underdog in all of us -- and we cannot help but cheer when he stands up to consummate evil in the person of the dark Lord Voldemort.

The Potter books are this generation's most formative reading experience and should not be dismissed as simply pop diversion. The books children read and the movies and television they watch comment on current cultural assumptions. Rowling's books are no exception. In today's world, mayhem, hatred and rebellion are broadcast daily. The eruption of malignity that lurks in Rowling's stories simply mirrors current events. It seems that evil is lurking where one least expects it. Terrorism is just one example. People exist

who are more malevolent than Lord Voldemort, buildings fall to the ground, bombs fall from the sky and trains explode, while giant waves and hurricanes wash away all in their path. Violence is an everyday occurrence. Compared to reality, Potter's world is almost calm.

Living in complex times that seem both less child-centric and more youth-centered than previous decades, our culture has found its literary lion in Harry. Rowling's books did not need illustration to accomplish this and, in that respect, they are the exception that rules.

Beyond all this, the question remains: what makes Harry work? The answer may well be found in the eyes of a child engrossed in a Potter book. One senses that the youthful reader has removed himself or herself into a private world and is secure in a place that is impenetrable to adults. That world is a place of wonderment where a child can experience grace. That is the real magic of Harry Potter.

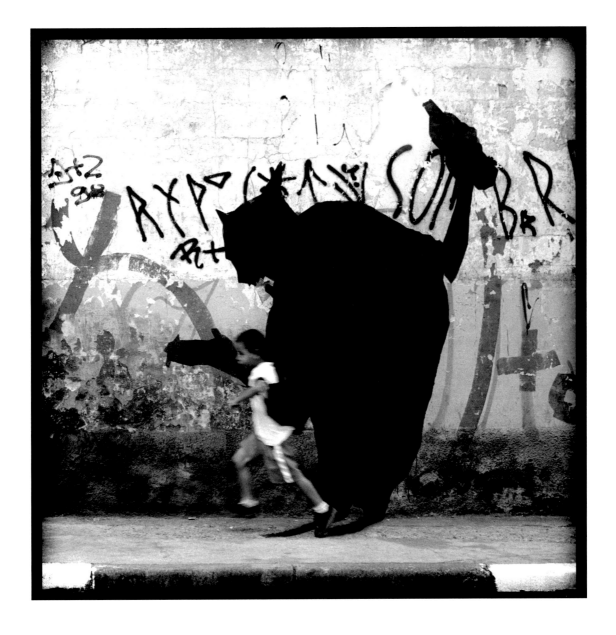

Alexandre Orion, 2002

319

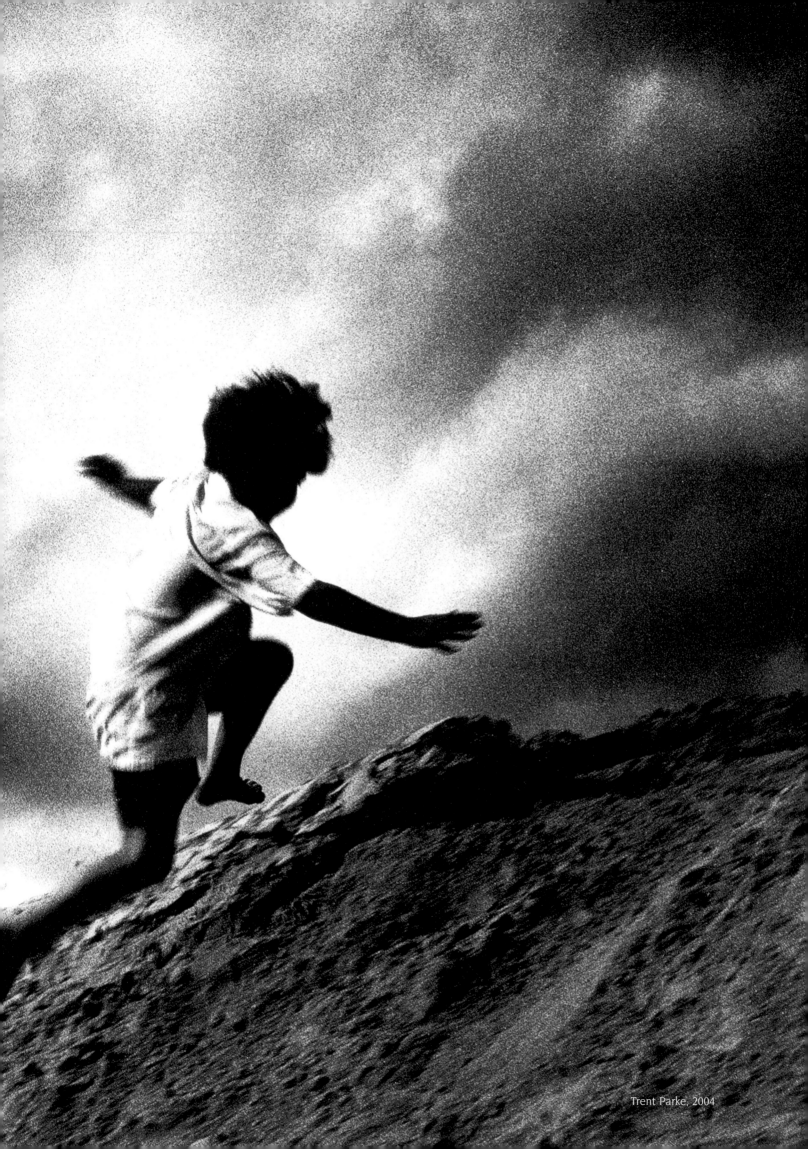

Trent Parke, 2004

IMAGINATION IS THE BRIDGE BETWEEN THE THINGS

WE KNOW FOR SURE AND THE THINGS WE NEED

TO BELIEVE WHEN OUR WORLD BECOMES UNBEARABLE.

BUT IN THIS WORLD OF SCHOOLBOY BULLETS,

BIOLOGICAL WARFARE AND KIDDIE PORN -- IT TAKES GUTS

TO BELIEVE IN ANY GOD SO I PRACTICE ON

BELIEVING IN THE SMALLER THINGS 'TIL I AM ABLE

TO MAKE ROOM FOR THE REST. AND I BELIEVE

IN MONSTERS LURKING UNDER THE BED BECAUSE

THEY GIVE CHILDREN SOMETHING TO CONQUER,

BEFORE THE WORLD BEGINS TO CONQUER THEM . . .

STACEYANN CHIN

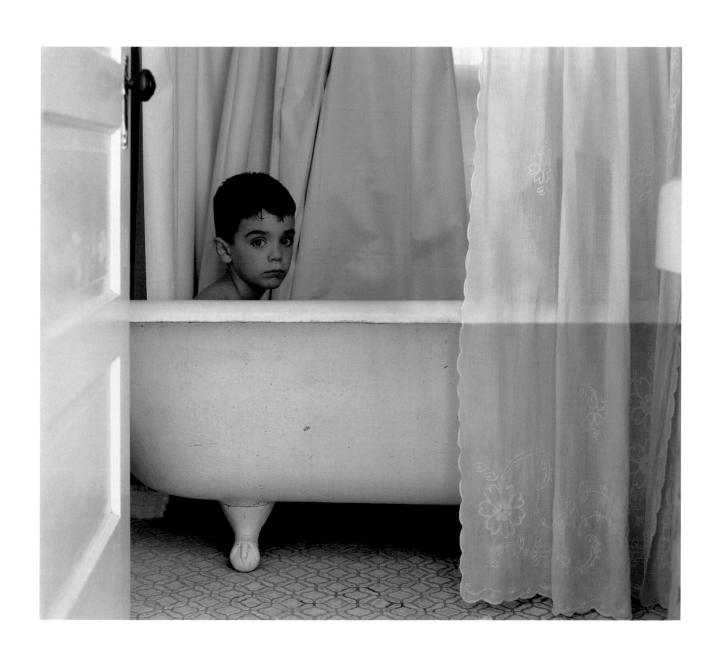

Loretta Lux, 2001–2002
Caleb Cain Marcus, 2003 (left)

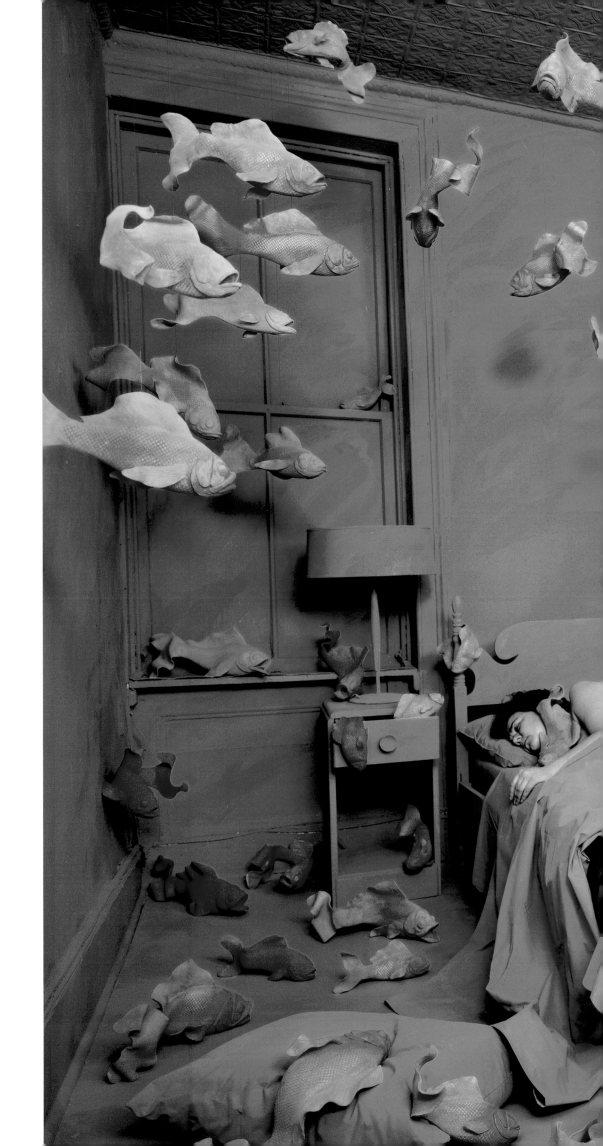

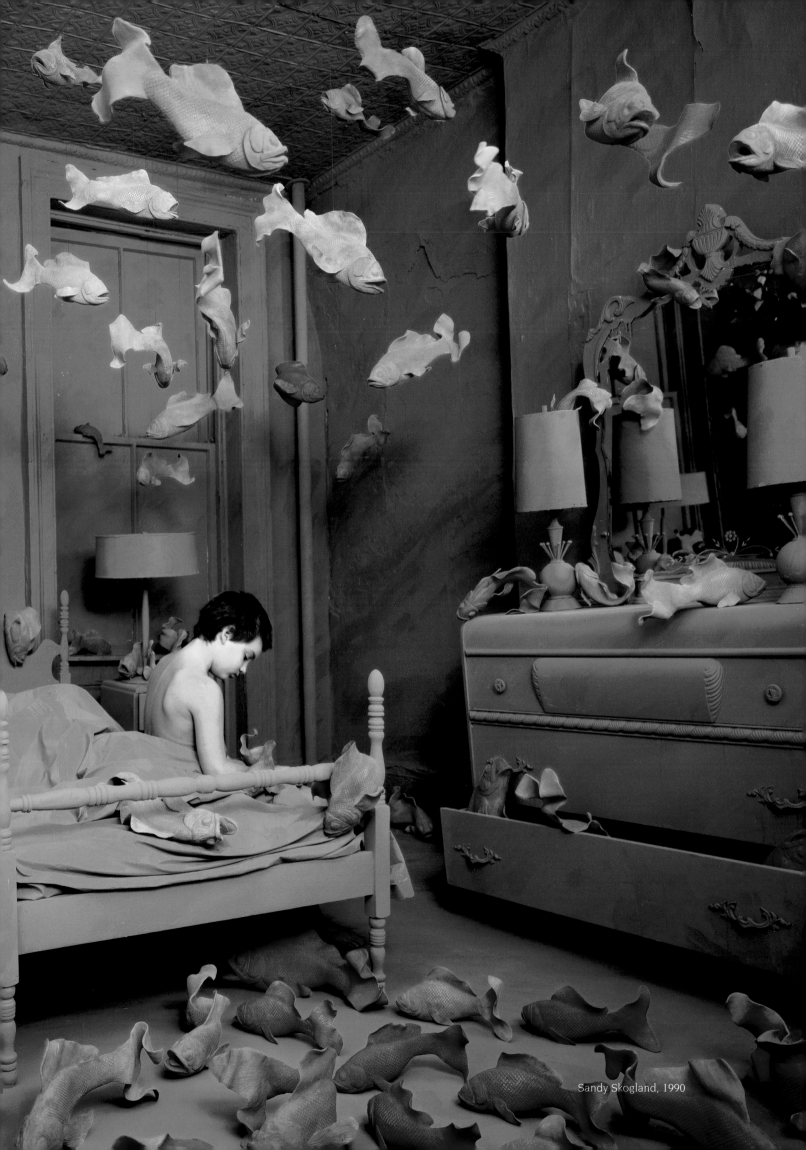

Sandy Skogland, 1990

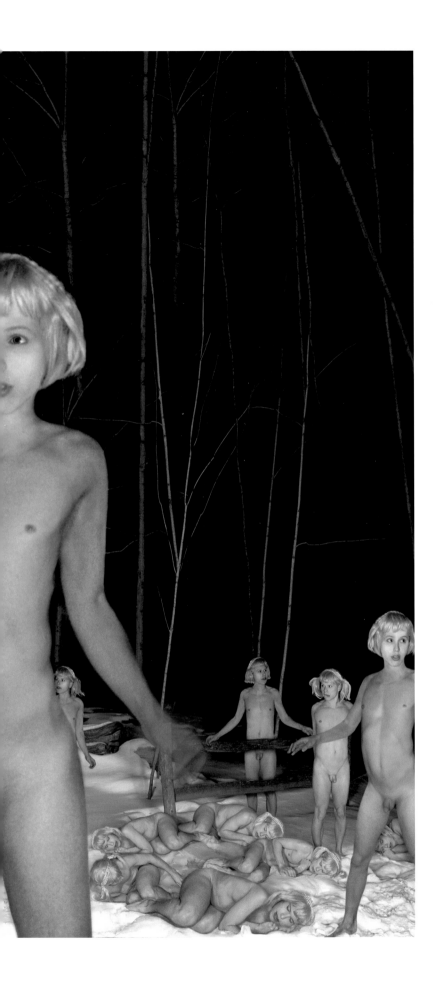

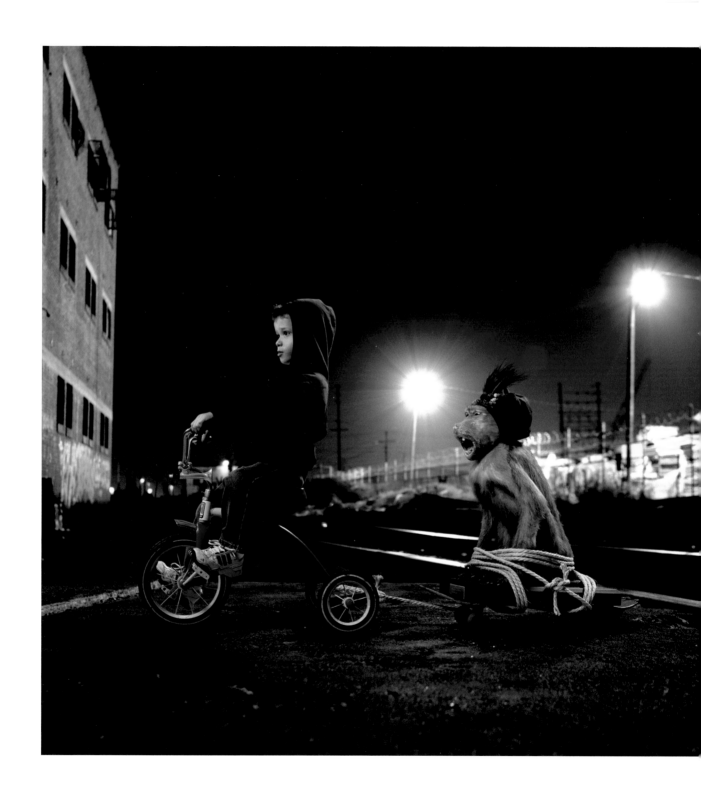

BEFORE YOU JUDGE ME, TRY HARD TO LOVE ME,

LOOK WITHIN YOUR HEART THEN ASK,

HAVE YOU SEEN MY CHILDHOOD?

PEOPLE SAY I'M STRANGE THAT WAY

'CAUSE I LOVE SUCH ELEMENTARY THINGS,

IT'S BEEN MY FATE TO COMPENSATE,

FOR THE CHILDHOOD I'VE NEVER KNOWN . . .

HAVE YOU SEEN MY CHILDHOOD?

I'M SEARCHING FOR THAT WONDER IN MY YOUTH

LIKE FANTASTICAL STORIES TO SHARE

THE DREAMS I WOULD DARE . . .

MICHAEL JACKSON

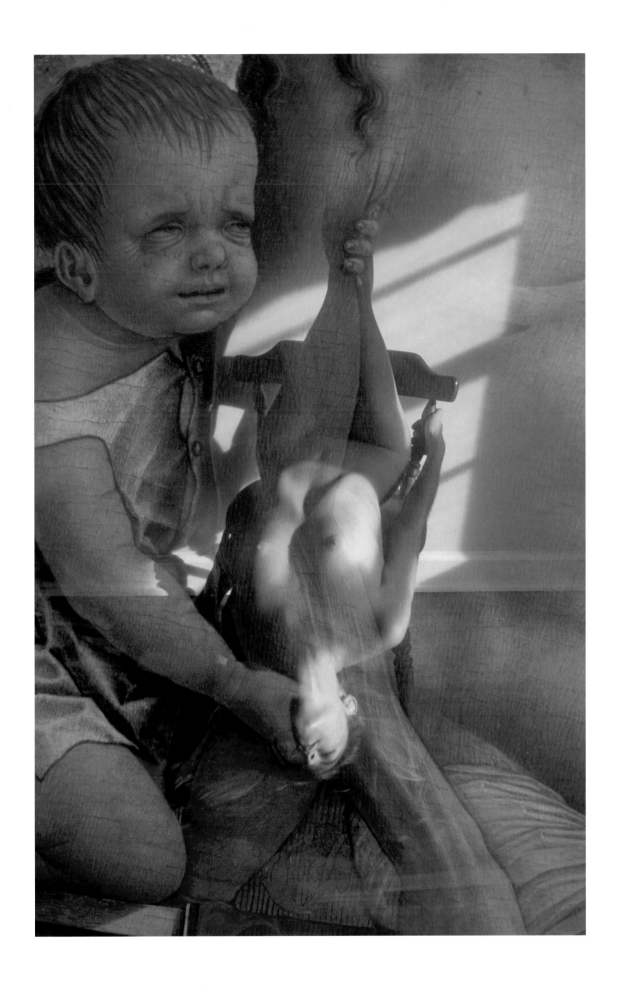

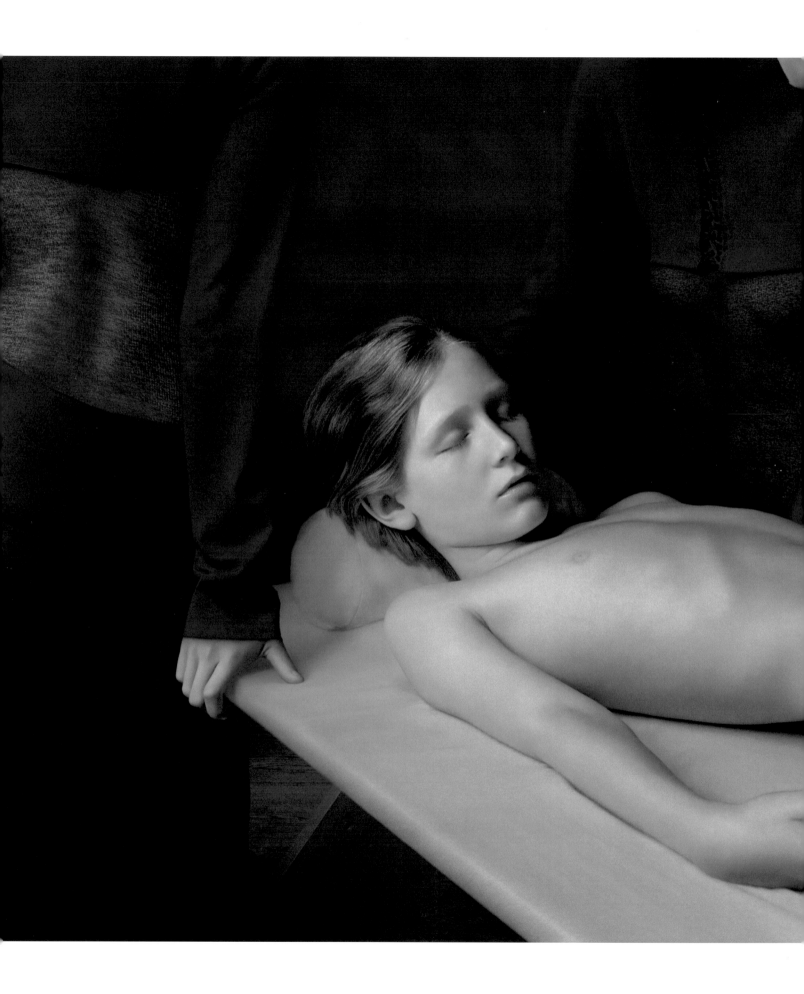

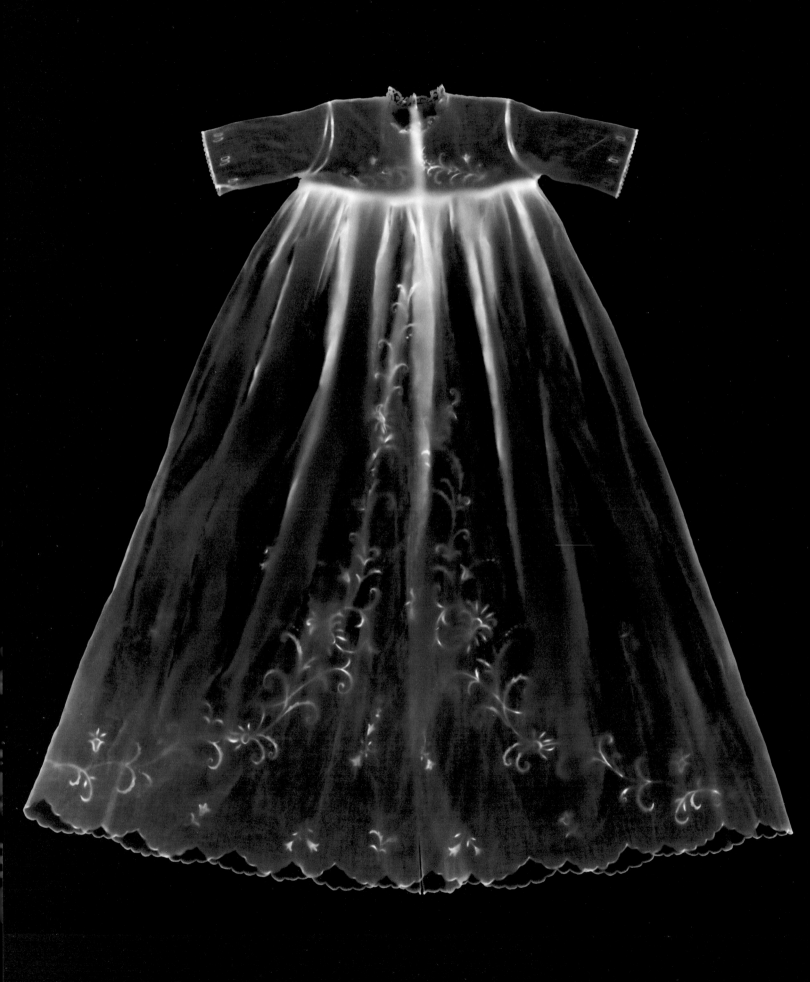

the child unveiled

PERFECTION IS FINALLY ATTAINED NOT WHEN THERE IS
NO LONGER ANYTHING TO ADD BUT WHEN THERE IS
NO LONGER ANYTHING TO TAKE AWAY, WHEN A BODY
HAS BEEN STRIPPED DOWN TO ITS NAKEDNESS.

ANTOINE DE SAINT-EXUPÉRY

The depiction of children nude is as old as
the camera. A number of Lewis Carroll's and
Julia Margaret Cameron's signature images
celebrate the nude child. Many Victorians
and Edwardians, convinced of children's
primal innocence, found no fault with this,
and during the first one hundred years of
photography, such images raised little ire.
Nude and lewd were not viewed as synony-
mous and throughout the history of photog-
raphy, great artists have rendered children
unclothed.

There is no question that the representation
of a child's body can be erotic, and when its
primary objective is to titillate, it can be
obscene. Starting in the late 1970s, these
differences thrust the appropriateness of
such images into the light. More and more
sexual content was being ascribed to art
photographs of nude children. In part, this
was due to the saturation of mass media
with erotically charged imagery of children.
The 1980s Calvin Klein jeans campaign was
a prime example of such images. In addition
to the fashion industry, cinema and sports
began highlighting beguiling and eroticized
children, from precocious stars to robust
cheerleaders and preening teen queens.
Romantic innocence was being supplanted
by latent eroticism.

In the 1980s, sensitivity in the United States
over such imagery increased. There has

always been a fine line, often not articulated,
between the appropriate and the inappropri-
ate. It was more complex than reveling in
the beauty of the human form versus its
intentional degradation for prurient purposes.
There are legitimate differences in priorities
between the individual and the state and
between the interests of the viewer and
the viewed. When one adds the inability of
young subjects to give meaningful consent,
it is not surprising that controversy should
arise.

These concerns, fueled by a perception that
sexual abuse of children was on the rise,
provoked an acrimonious debate about the
right of photographers, both amateur and
professional, to picture children's genitalia
or to film children in what some might find
provocative or sexually knowing positions.
The contention was that such imagery might
embolden sexual predators and, as photo-
graphs became more graphic, they could
become the catalysts to sexual violence. In
1986, the United States Congress passed the
Child Sexual Abuse and Photography Act and
created a commission to examine the subject.
In the acrimony that surrounded the Act's
adoption, the government almost threw the
baby (and its parents) out with the bath
water. Photo labs and drugstores were put
on notice to report pictures of nude children
brought in for processing. Photographers,
both professional and amateur, became sus-
pect and in some cases were hounded and
charged. Children were temporarily taken to
foster homes and photographers were sub-
jected to search, seizure and the destruction
of personal records. Charges of "production

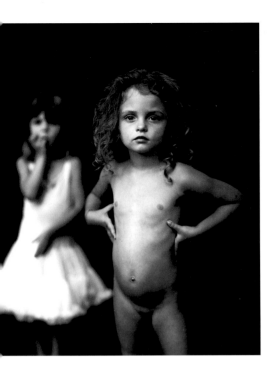

of child pornography," "sexual exploitation of children" and "corrupting a minor" were commonplace and the potential consequences -- long jail terms -- severe. Initially, the various state laws were aimed aptly at those images that documented an actual crime being perpetrated against a child. Then they were broadened to include images that contained real or simulated sex acts between children. The next legal expansion was to ban frontal nudity. Finally, the law was expanded to cover any sexually suggestive photograph of children, regardless of whether they were clothed or naked. Some statutes even went so far as to include sexual images of adults who looked like children and computer-generated composite photographs.

A number of American artists would come to be caught up in this imbroglio. Sally Mann's work was viewed in certain religious and conservative circles as degrading to the image of the family. Jack Sturges's images of adolescents taken in nudist colonies (all of whom had agreed to being photographed and later gave permission for the publication of their images) were considered by some to be sexually provocative and in violation of state law. The negative backlash resulted in the prosecution not only of artists but also of museum officials who had the temerity to exhibit their work. This public ire triggered large reductions in national and local government spending on the arts.

In the nineties, rage over clerical pedophilia and alarm about the extent of teenage sex, combined with a media obsession with juvenile abductions and date rape, renewed concerns and awakened a wave of hysteria.

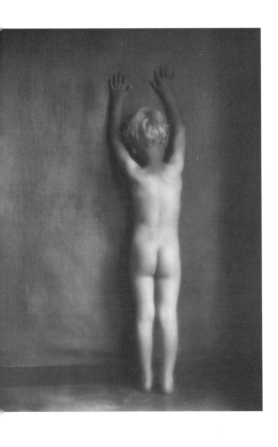

Sally Mann, 1989
Edward Weston, Neil, 1923

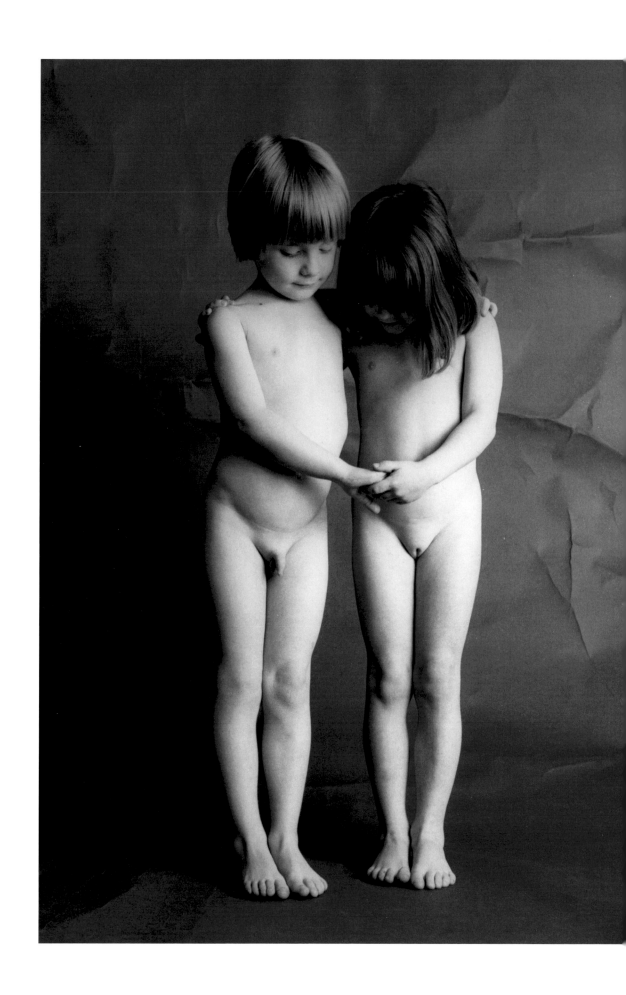

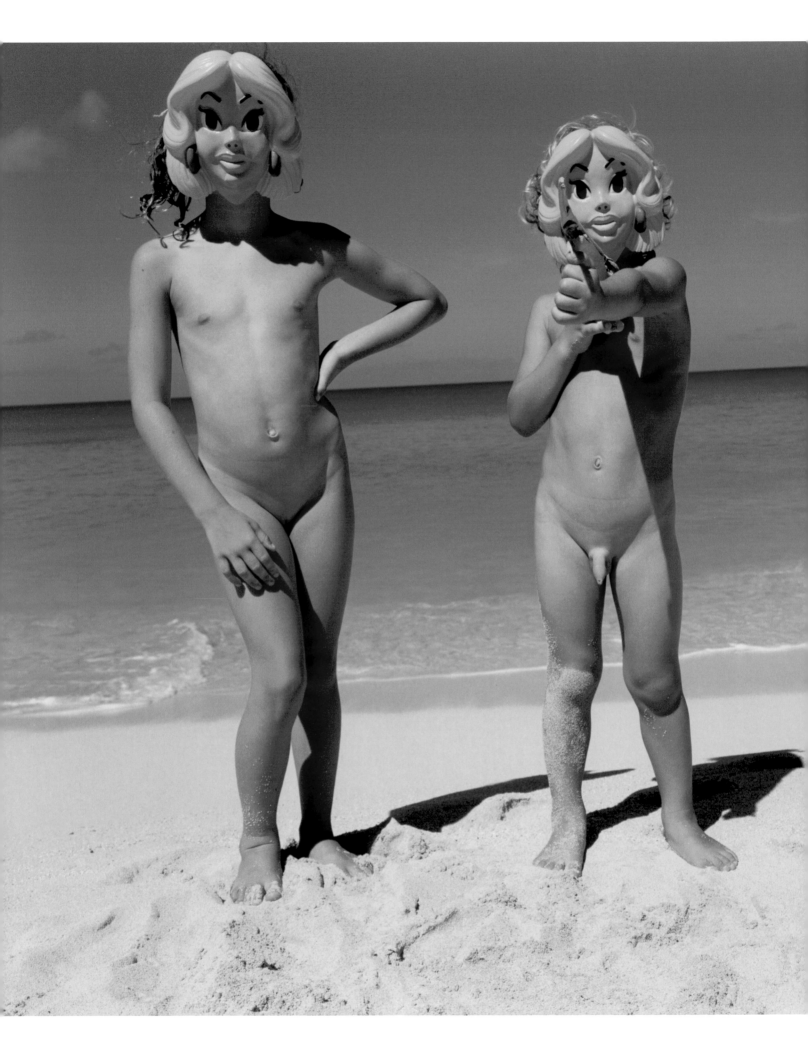

State enforcement of the ban on nude photographs of children was occasionally overreaching. In 1995, *The New York Times* related the story of a forty-five-year-old New Jersey businessman with no criminal record who was handcuffed, jailed and banned from his home for two months because he took a series of photographs of his daughter for an art class assignment at the prestigious International Center of Photography. He was subsequently indicted and a judge refused to dismiss the case. He finally plea-bargained an end to his bitter odyssey, agreeing to participate in an intervention seminar in exchange for having his criminal record expunged.

This debate is very much a part of the long and complex history of the child in our culture and is another manifestation of how imagery of children can serve as a signpost by which society registers its own current crises and visions. The body is the traditional marker of youthfulness, so its viewing is both welcomed and resented. Freud taught us that sexuality has a great deal to do with this. Yet, is the representation of the nude body in photographs of children appropriate? The question of how to deal with nudity in child photographs raises serious societal issues. There is a trinity of core concerns. The primary one is the effect it has on the subject. The next is the rights of the artist, and the third relates to the duty of the state to protect its citizens. If a person were to describe an act of child molestation in writing or in speech, the Bill of Rights would prevent that depiction from being censored. That is how zealously the Constitution protects freedom of speech. Yet, the publication of an image of a child's body that shows genitalia can be a crime.

Conservative legal theorists work hard to deny artistic images any protection under the Constitution's First Amendment. Their argument is that photography is not speech. The sounder view is that photography is indeed a manner of communication, often more potent than the spoken or written word. This is so apparent that one must be in awe of photography's power and sensitive to its effect.

That brings us back to the primary issue -- the subject. Can a child possibly give informed consent in this regard? Will a parent's consent suffice? How much harm will come from disclosure of the images to the subject's peers, or in subsequent viewing by the subject's offspring? Does the child possess the right to later withdraw consent? How will such images affect the child's subsequent perception of self? Sally Mann's three children are among the most notable of contemporary nude child subjects. Because of the genius of their mother's images, their imagery continues to resonate in the world of photography long after they have grown up.

One of these children, Jessie, recently observed: "I have found that my mother's images, our childhood stories, our very characters, were consumed by an outside meaning, which was in a way bigger than we were. As we grew up, we didn't just grow into ourselves, we grew into the larger conception of our characters that others projected for us. But despite the ways in which those photographs complicated and expanded our lives, I believe that the entire process was for our own good, because it was done with a faith in art."

The issues surrounding nude photography of children are further complicated by the easy access afforded by the Internet, with child pornography reputed to be the fastest growing of all on-line businesses.

The issues presented by this subject are perhaps best addressed in terms of context rather than content -- where, when and to whom should these images be available, by what standard should they be measured and who should do the measuring? This debate must balance society's obligation to ensure that children are not subjected to sexual abuse against society's desire to maintain basic freedoms, including freedom of artistic expression. These are two of the most important tenets of a free and healthy society and the balancing, often difficult, must continue. There is also the issue of the child's rights to behave naturally and not be made to feel ashamed by nakedness. Ultimately, the core problem may lie with the viewer.

The existential philosopher Martin Heidegger suggested that we "self-seclude" man's basic nature. Freud taught us that human beings at all ages are sexual and sensual. Yet, many adults do not want to confront those realities in children. It is all right for Balthus to paint young girls provocatively, for Britney Spears to wail about her "oops," and for Judy Blume to write about young anatomies, but photography may well be too potent a form of communication for this subject. Michelangelo once said: "What spirit is so empty and blind that it cannot recognize the fact that the foot is more noble than the shoe, and skin more beautiful than the garment with which it is clothed?" One only wishes it were that simple.

Shirin Neshat, 1996

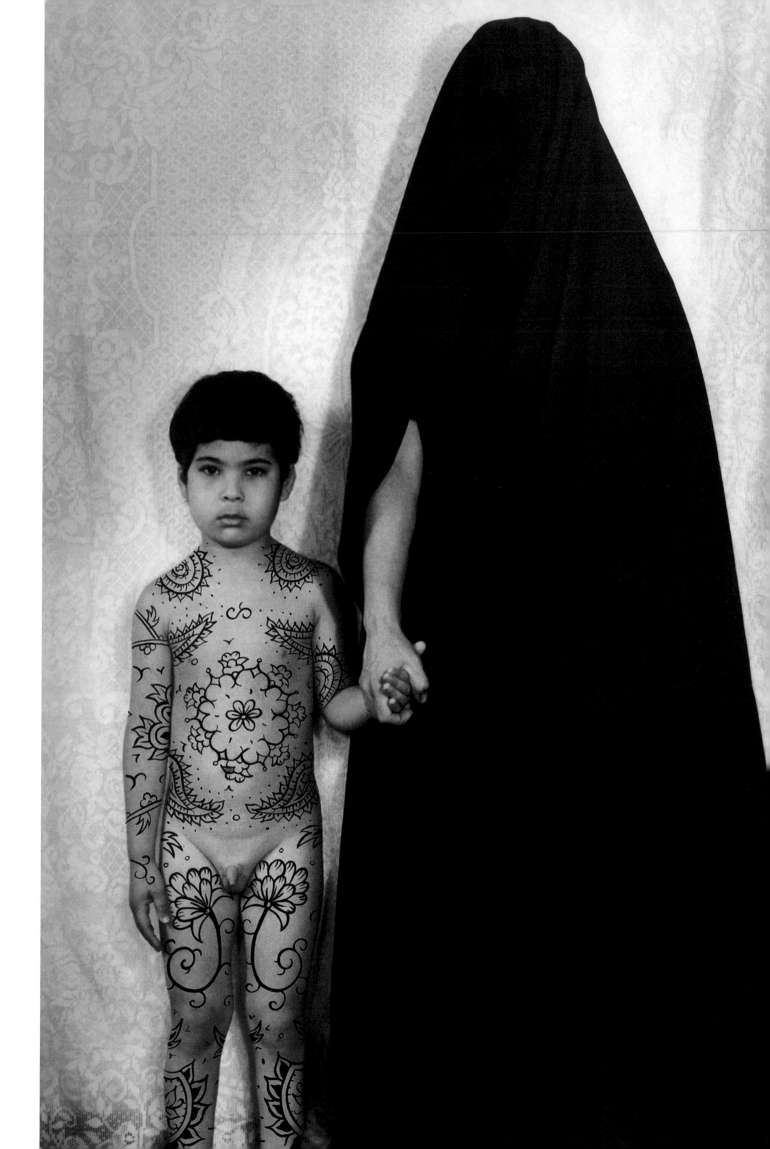

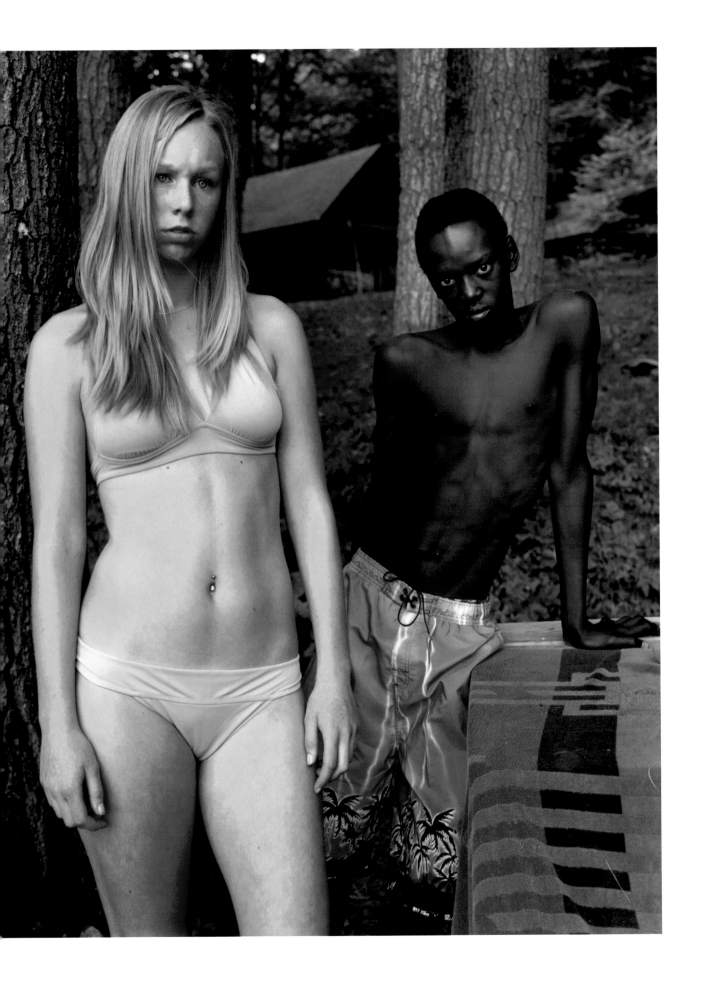

Jocelyn Lee, 2005

CHILDREN NOW LOVE LUXURY;

THEY HAVE BAD MANNERS, CONTEMPT FOR AUTHORITY;

THEY SHOW DISRESPECT FOR ELDERS

AND LOVE CHATTER IN PLACE OF EXERCISE.

CHILDREN ARE NOW TYRANTS,

NOT THE SERVANTS OF THEIR HOUSEHOLDS.

THEY NO LONGER RISE WHEN ELDERS

ENTER THE ROOM. THEY CONTRADICT THEIR PARENTS,

CHATTER BEFORE COMPANY, GOBBLE UP

DAINTIES AT THE TABLE, CROSS THEIR LEGS,

AND TYRANNIZE THEIR TEACHERS.

SOCRATES

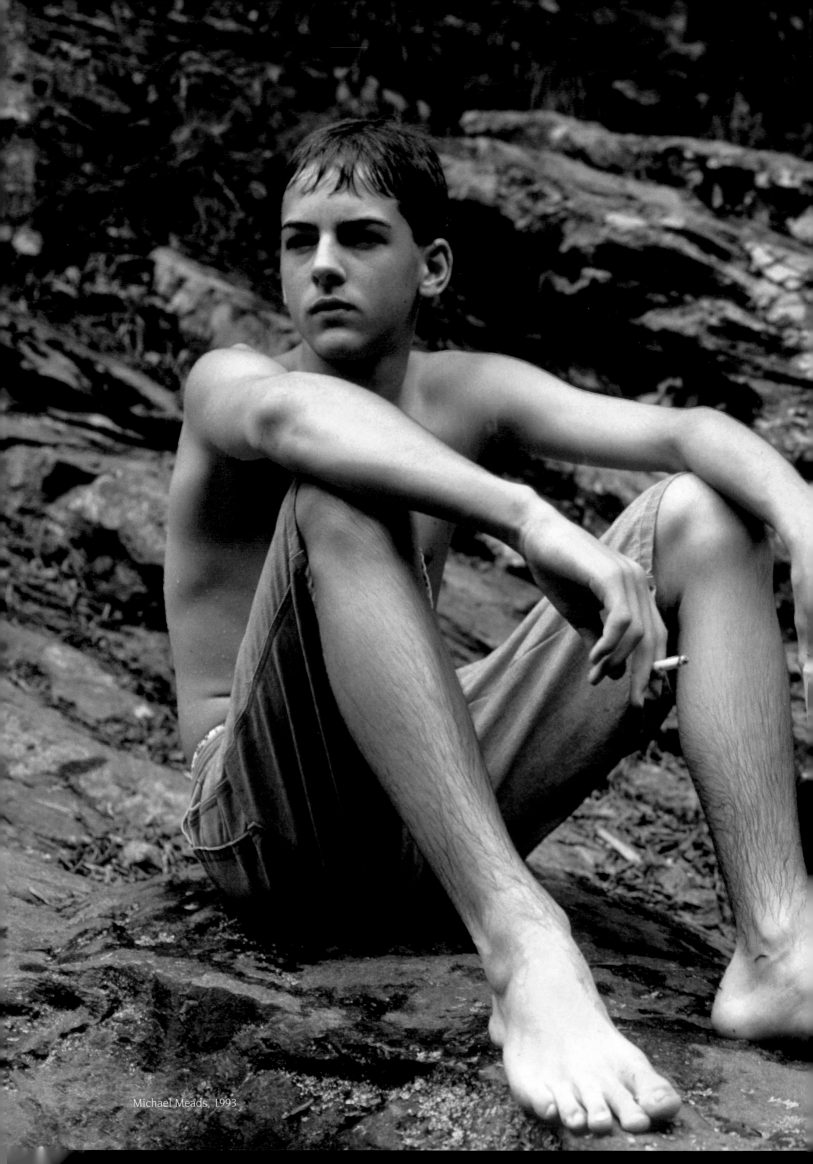

Michael Meads, 1993

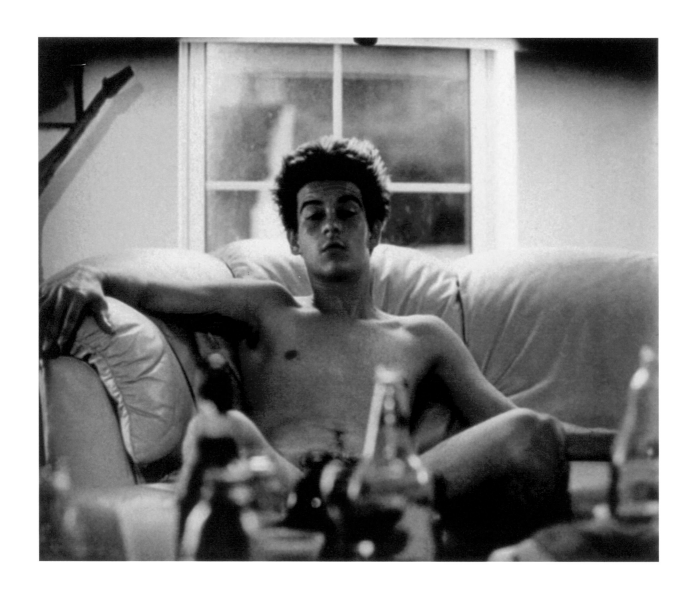

Larry Clark, 1995

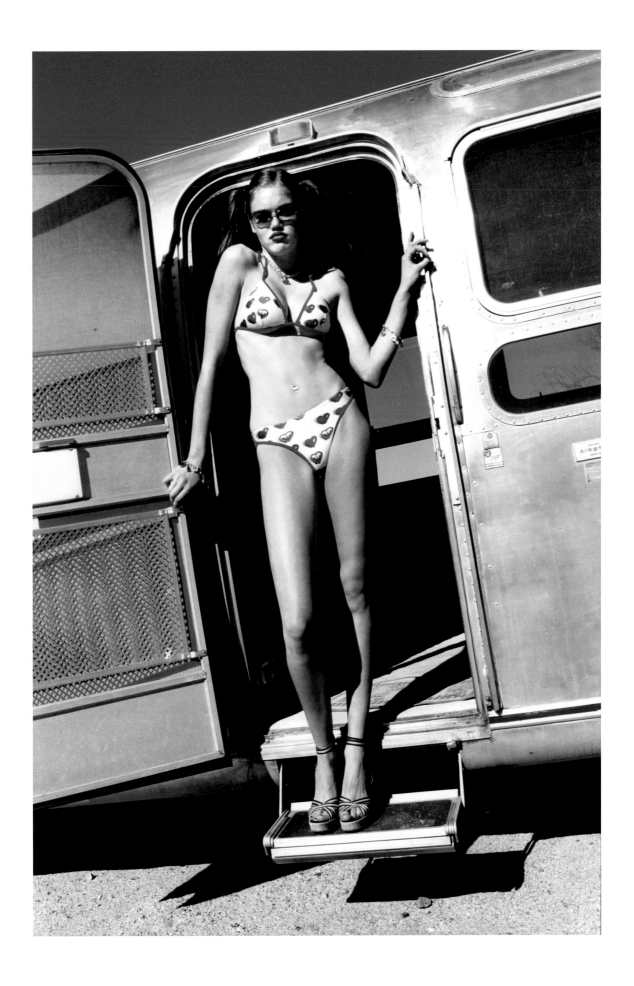

Helmut Newton, 2002

Billy

I grew up pretty much all over the place because my family moved around. I was pretty much just thrown around, like, from family member to family member. I was really depressed because my mom beat the shit outta me. I was going on sixteen and I was sick and tired of my mom beatin' the shit outta me every day, so I had my mom sign custody of me over to my dad. My dad came home at like, four in the morning, all drunk-as-hell and yelled at me, and did stupid drunk things. Alcoholics are just not fun to live with.

Raven

Well, to my Grandma thank you for being my only friend when I was younger and understanding. Everything was perfect, but inside everything was all fucked-up. I'd get locked in my room for days on end having to piss in a pot, granola bars slipped under the door occasionaly, just to keep me well nourished. I mean my parents were both druggies, I mean, not hard-core druggies, I mean not like me.

Fish

My mom had abandoned me. I mean she really had no choice. She was doin' heroin her entire life, so was my dad, and he was just goin' into prison and there was no way she could take care of four kids. I think the first time I ever cared how it made them feel was knowing that my dad died having no idea where I was. Or even if I was still alive. A fond memory of my dad was sitting out in the backyard in the summertime on a blanket, feeding the squirrels. He had never read *Alice in Wonderland* and I had a really old version of it and I pretended to read it to him. I guess I took him for granted, and now that he's gone, there's not a day that goes by that I don't think about him.

Art photographers Bradley McCullum and Jacqueline Tarry have mastered the concept of performance art with their photographs and videos of homeless youth. These life-sized color photographs (along with a companion video) document a twenty-five-hour endurance performance with homeless Seattle, Washington teenagers. Their poignant recollections were recorded minutes before they each stood in total silence for one hour in the streets of Seattle. This act was a challenge for these youths, who are drug addicted and suffering health-related problems. It was also a quiet act of civil disobedience. Seattle makes it a crime to stand or sit motionless in public.

Bradley McCullum and Jacquelin Tarry,
Billy, Raven, Fish, 2005 (following three images)

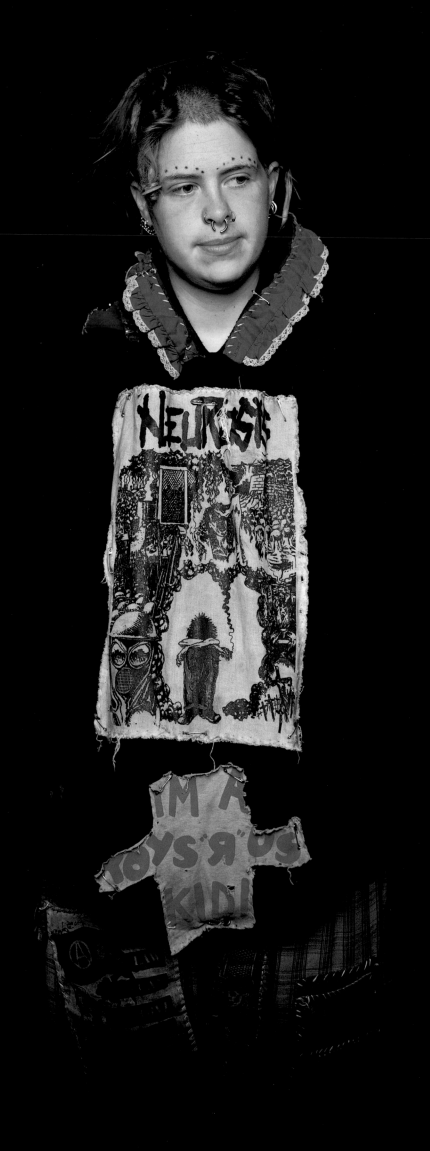

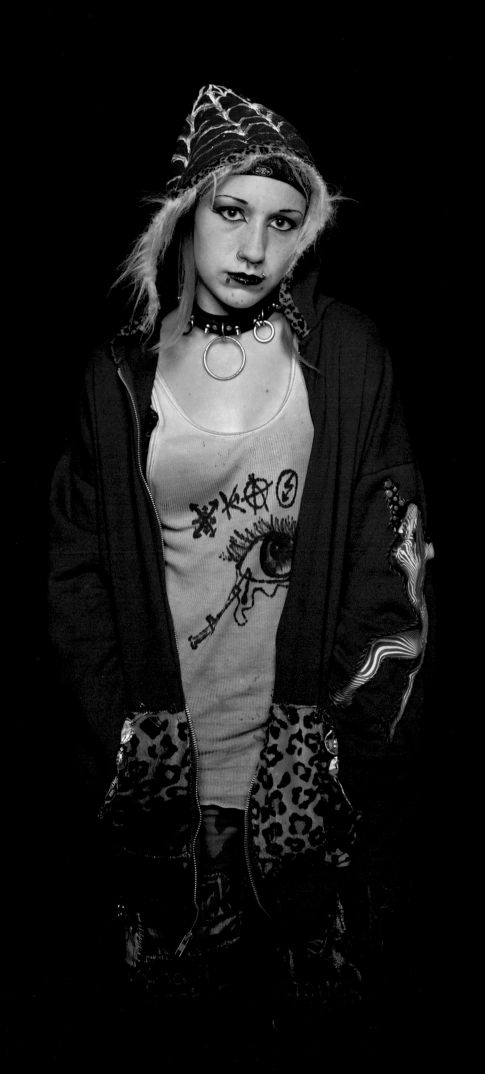

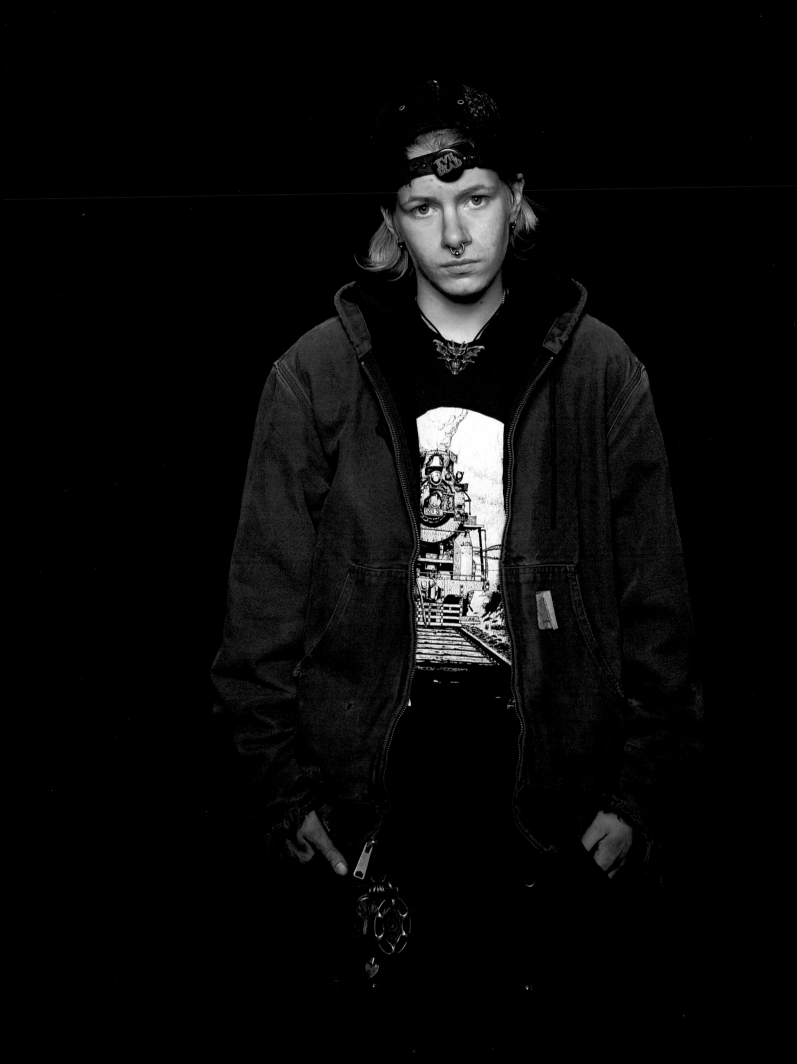

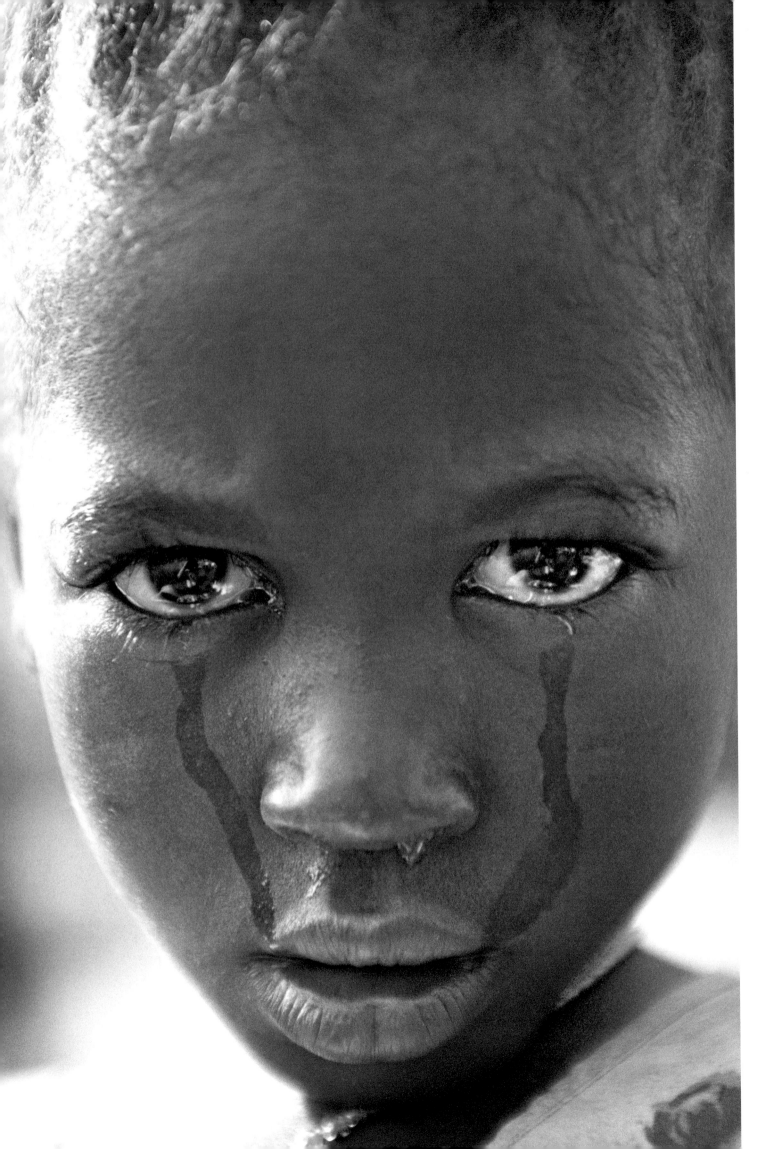

the child violated

IF ALL THE WORLD MUST SEE THE WORLD
AS THE WORLD HATH SEEN THE WORLD
THEN IT WERE BETTER FOR THE WORLD
THAT THE WORLD HAD NEVER BEEN.

CHARLES GODFREY LELAND

Leland's tragic assessment would seem accurate to many whose views are based solely on media coverage. The enduring shock value of tragedy and the hypnotic appeal of documentary photography during the past twenty-five years have contributed to a depiction of a world of seemingly limitless suffering. Citing only the names of countries in conflict during the last quarter-century alone is enough to conjure these images -- Afghanistan, Iran, Iraq, Angola, Sudan, Uganda, Colombia, Ethiopia, Somalia, Rwanda, Zaire, East Timor, Israel, Palestine, Mozambique, Sierra Leone, Liberia and Haiti. Likewise, key words like apartheid, Horn of Africa, Chernobyl, HIV/AIDS, genocide, tsunami and Katrina instantly trigger images of mayhem or human misery.

There is a history to these visions. By 1980, the public had grown accustomed to viewing the rest of the world as a place of tragedy and suffering. That had been a focus of photojournalists since before World War II. As Europe and Japan recovered from that conflict and relief aid expanded, new attention was focused on the global scourges of poverty, famine, disease and war, and the developing world would become the site of repeated and seemingly hopeless civil strife and misery. As we continue to bear steady witness, photographically and otherwise, to this inhumanity, children victimized by poverty, war, famine and abuse have become visual emblems of the entire developing world. While presenting events worthy of the world's attention, and implicitly embracing a call to action against injustice and suffering, these images have, some believe, unintentionally helped shape a stereotyped view of those countries. It is as if the portrait of America were shaped only by images of Katrina and the perception of Thailand were based solely on the devastation from the tsunami.

Since the early twentieth century, there has never been a moment of universal peace. Armed struggles have ranged from coups d'etat to long-simmering conflicts to sustained bloody engagements, resulting in the death and displacement of millions. All these conflicts have taken a severe toll on children in terms of death, loss and suffering. A recent UNICEF report, *The State of the World's Children*, described the millions of children still deprived of society's care and benefits as "excluded and invisible" -- a curious description when images of suffering children have never been more prominent. In fact, children at risk today are indeed both visible and invisible, as many of their rights are consistently violated while their needs remain unmet.

The understanding that children have rights as well as needs began almost imperceptibly during World War I and reached a milestone in 1989 when the United Nations voted unanimously to codify children's rights in a formal treaty. The Convention on the Rights of the Child became international law a year later and was eventually endorsed by every nation

save two -- Somalia, which has been virtually without a government since 1990, and the United States, which signed it in 1995 but awaits an act of Congress to make it legally binding.

As part of the expanding movement concerning human rights, children's rights had arrived, though implementing them is proving to be a difficult matter. Children's basic rights to health, education and freedom from exploitation may be tenets of international law, but news headlines and poverty statistics confirm the extent to which full compliance remains a dream -- even in the most affluent and caring countries. The bestowing of rights commonly assumes a degree of individual autonomy or free will that is not often associated with children, who have an obvious need for care and guidance. Yet, acknowledging children's rights and protecting their special needs do not have to be in conflict. Recognizing rights unique to childhood simply affirms that children, from infancy through adolescence, are human beings entitled to the same services, respect and dignity accorded all people in all civilizations.

During the last fifty years, a legion of photojournalists have underscored the need for those rights and have helped redefine the image of children, especially those at risk. They include the Brazilian Sebastião Salgado, France's Gilles Peress and many other members of Magnum, Contact Press Images and other independent photo agencies. Today's photojournalists often work alongside relief groups, the latter tending the wounds to which the former bear witness. In one example conceived by Peress, war correspondents collaborated with human rights experts on

Crimes of War, a 1999 book detailing the laws relating to war and human rights covenants and their flagrant violation in conflicts throughout the nineties. The role of photographs in that book, its editors wrote, "is to provide visual bookmarks, while documenting the reality behind the words."

Salgado, who became a UNICEF Goodwill Ambassador in 2001, stated it another way. Photographs, he wrote, are humanity's "universal language and its critical mirror. We must not try to escape from this reflection. We must accept it and respect it, so that we can take part in the evolution of society and its process of change." Trained as an economist, Salgado switched to photography in the mid-1970s because, he said, it allowed him to explore the real economics of people's lives. Since then, he has created bodies of work that position him among the documentary masters. His signature achievement has been to situate the human condition within larger frameworks that throw into relief the forces affecting society. Salgado's projects are worldwide in scope. He first examined manual labor in an era of transnational production. This led to a study of the phenomenon of the mass population movement caused by war, poverty and the exodus from the countryside to the city. Both these works exposed the environmental strains resulting from these huge shifts in traditional modes of living and working. Salgado has now turned his eye to the parts of the world where man still lives in harmony with nature. No other documentary photographer has created such a sweeping canvas of humanity.

Children are prominent among Salgado's dispossessed. His most poignant tribute to

children is his companion book to the migration project, *The Children* (2000), consisting of portraits of children taken in refugee camps in more than a dozen countries. Alone in front of the camera, "the noisy crowd became individuals, who through their clothes, their poses, their expressions and their eyes, were telling their stories with disarming frankness and dignity." Salgado's portraits stand out for their unadorned eloquence, yet they are just momentary parts of the visual mosaic recorded by hundreds of photojournalists every day, a mosaic that includes the wondrous enchantment, tragedy, incomprehensible want, servitude, tenderness and repose that

are part of the daily life of the world's children. If it were not for these images, the violated aspects of children's lives, often invisible even in the more affluent parts of their own countries, much less in other countries, would probably remain so.

Clearly their story is worth telling. Children in the developing world number some 1.8 billion or almost a third of all humanity. These children constitute forty percent of the population of developing countries, and close to half the population in the poorest of those nations. Other statistics are even more sobering. One billion suffer deprivation from

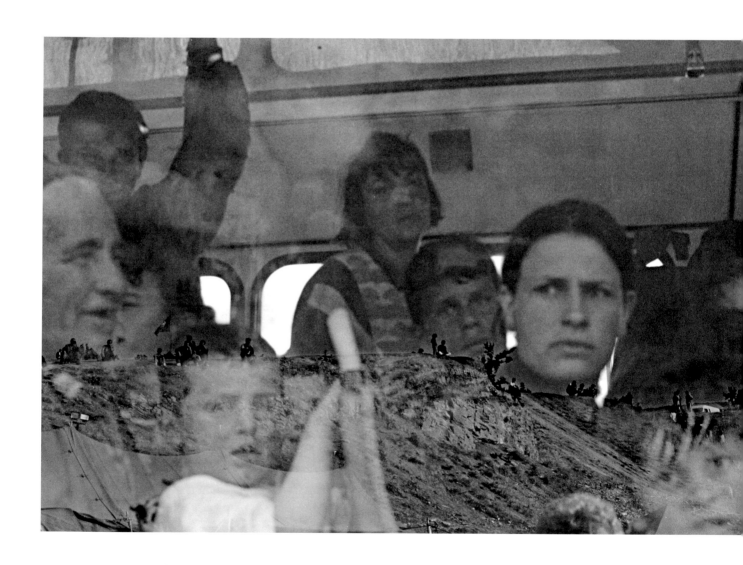

Gilles Peress:
Kosovar Albanian refugees, 1999

poverty, ninety million are severely malnour-
ished, 640 million are without sufficient shelter
and 140 million have never attended school.
In the last decade of the twentieth century
alone, twenty million children were made
refugees. By 2003, more than two million
were HIV-positive and fifteen million had
been orphaned by AIDS. While child mortali-
ty has declined by half since 1950, that statis-
tic varies widely from country to country. The
causes of these harrowing statistics are
known -- poverty, conflict, disease, weak gov-
ernance and discrimination. Though the
solutions are also known, their attainment
remains elusive for one principal reason --
promises notwithstanding, world leaders
choose to invest resources elsewhere.

Salgado summed up the position of the child
in need as follows: "In every crisis situation --
whether war, poverty, or natural disaster --
children are the greatest victims. The weak-
est physically, they are invariably the first
to succumb to disease or starvation.
Emotionally vulnerable, they are unable to
understand why they are forced from their
homes, why their neighbors have turned
against them, why they are now in a slum
surrounded by filth or in a refugee camp
surrounded by sorrow. With no responsibility
for their fates, they are by definition innocent.
And yet, unless they are seriously ill, pure
energy surges from them even in the worst of
circumstances. It is something experienced
by every photographer who has worked

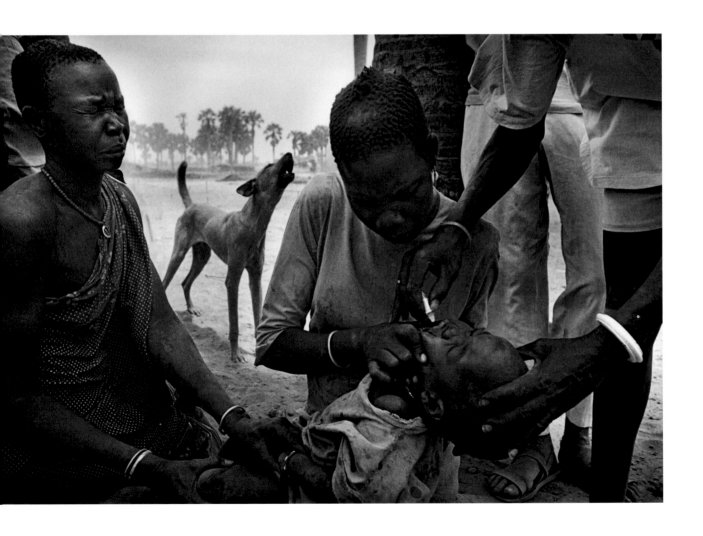

Sebastião Salgado,
Polio-eradication campaign, Sudan, 2001

among refugees or urban migrants. There are children everywhere, usually more visible than adults. When they see a camera, they jump with excitement, laughing, waving, pushing each other in the hope of being photographed. Sometimes their very joy gets in the way of recording what is happening to them. How can a smiling child represent deep misfortune?" This is the abiding paradox of children violated.

Substantial dangers to children lie ahead. The number of displaced children is still near an all-time high, environmental degradation is spawning global climate change and resources decline as armaments increase. Perhaps the most disquieting new development is terrorism. It has attracted significant numbers of deeply alienated young people who, as a result of greater information access, now see and resent the huge gaps in power and living standards that exist. Additionally, religious fundamentalism has driven a deep wedge in the harmony that the world community has shown itself capable of. Fortunately, these same problems are propelling an upsurge in democratic movements in many countries, as well as motivating tens of thousands of people, including artists, photojournalists, reporters and scholars -- and many courageous children -- to expose injustice, demand accountings and promote tolerance.

While it is a truism that humanity values its children above all, the current state of the world's children suggests that this adage continues to hold true primarily for one's own children. The proliferation of images showing children beset by poverty, conflict and abuse testifies to the low esteem in which so many children are still held. It also exposes fault lines in the dominant vision of the child as the most protected member of our species. Children's rights involve obligations not only to protect, feed, shelter and educate them, but also to safeguard their privacy, honor their dignity and ensure their participation in decisions affecting them. Those rights are the backdrop against which a reconsideration of the construct of childhood is now occurring.

This digression from photography is intended to situate what is happening to children in need today, as well as to highlight the contribution that photojournalists make in holding up the critical mirror -- a phrase that Salgado appropriated from the French philosopher Jean-Paul Sartre, who had used it as a metaphor for culture itself. Tragedies such as the death of children from easily preventable diseases, their mass murder in war, child-trafficking, forced soldiering, forced marriage, forced labor, ritual mutilation and a myriad of other abuses are being exposed as never before.

While we may feel overwhelmed or even numbed by the persistent picturing of pain and death, showing such suffering is better than the alternative of keeping it hidden from public view. By exhibiting it, photography spotlights children's rights with a light that in turn shines on all societal wrongs -- an exposure that hopefully will contribute to their amelioration.

ARTICLE 1: ". . . A CHILD MEANS EVERY HUMAN BEING BELOW THE AGE OF EIGHTEEN YEARS . . ."

ARTICLE 2: ". . . SHALL RESPECT AND ENSURE THE RIGHTS . . . TO EACH CHILD . . . WITHOUT DISCRIMINATION OF ANY KIND . . ."

ARTICLE 3: "IN ALL ACTIONS CONCERNING CHILDREN . . . THE BEST INTERESTS OF THE CHILD SHALL BE A PRIMARY CONSIDERATION . . ."

ARTICLE 5: ". . . SHALL RESPECT THE RESPONSIBILITIES, RIGHTS AND DUTIES OF PARENTS OR . . . LEGAL GUARDIANS . . . IN A MANNER CONSISTENT WITH THE EVOLVING CAPACITIES OF THE CHILD . . ."

ARTICLE 8: ". . . THE RIGHT OF THE CHILD TO PRESERVE HIS OR HER IDENTITY, INCLUDING NATIONALITY, NAME AND FAMILY RELATIONS . . ."

ARTICLE 12: ". . . SHALL ASSURE TO THE CHILD WHO IS CAPABLE OF FORMING HIS OR HER OWN VIEWS THE RIGHT TO EXPRESS THOSE VIEWS FREELY IN ALL MATTERS AFFECTING THE CHILD . . ."

ARTICLE 16: "NO CHILD SHALL BE SUBJECTED TO ARBITRARY OR UNLAWFUL INTERFERENCE WITH HIS OR HER PRIVACY, FAMILY, HOME . . ."

ARTICLE 19: ". . . SHALL . . . PROTECT THE CHILD FROM ALL FORMS OF PHYSICAL OR MENTAL VIOLENCE, INJURY OR ABUSE, NEGLECT OR NEGLIGENT TREATMENT, MALTREATMENT OR EXPLOITATION . . ."

ARTICLE 39: ". . . SHALL TAKE ALL APPROPRIATE MEASURES TO PROMOTE THE PHYSICAL AND PSYCHOLOGICAL RECOVERY AND SOCIAL INTE-GRATION OF A CHILD VICTIM OF ANY FORM OF NEG-LECT, EXPLOITATION, OR ABUSE . . ."

Gilles Peress, children's drawings, Bosnia, 1994
Articles of the Rights of the Child superimposed by editor

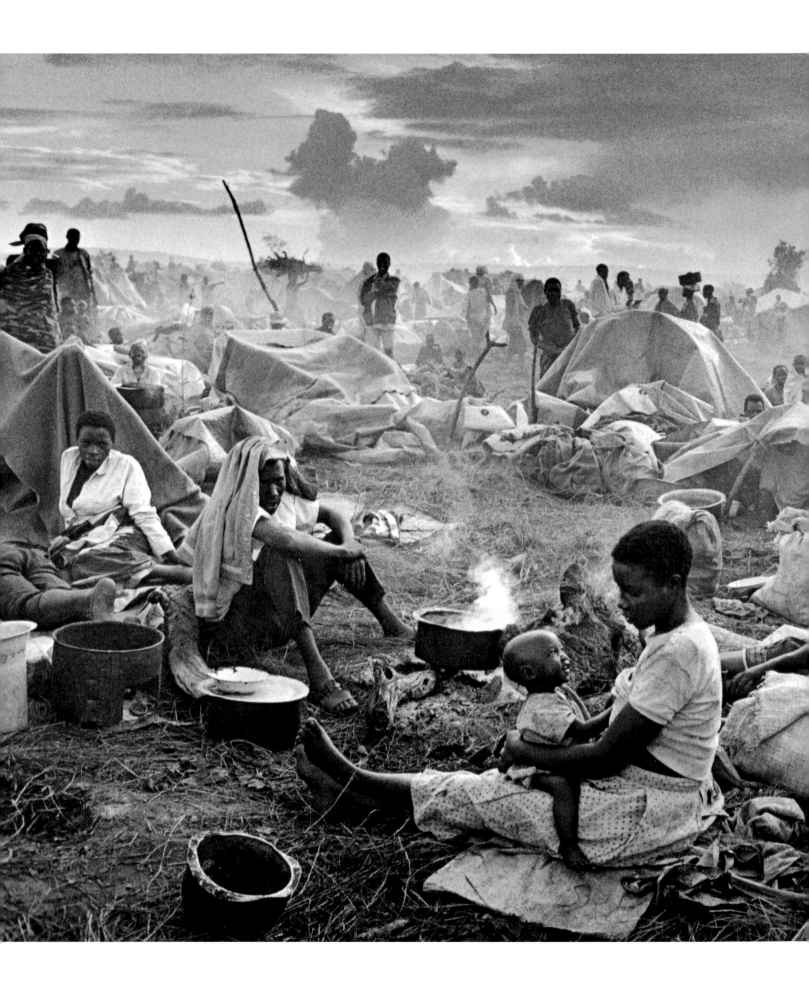

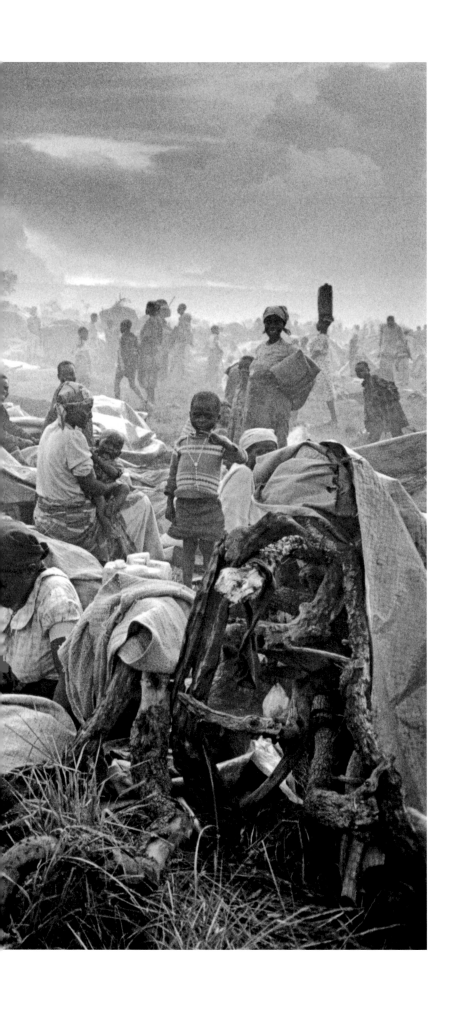

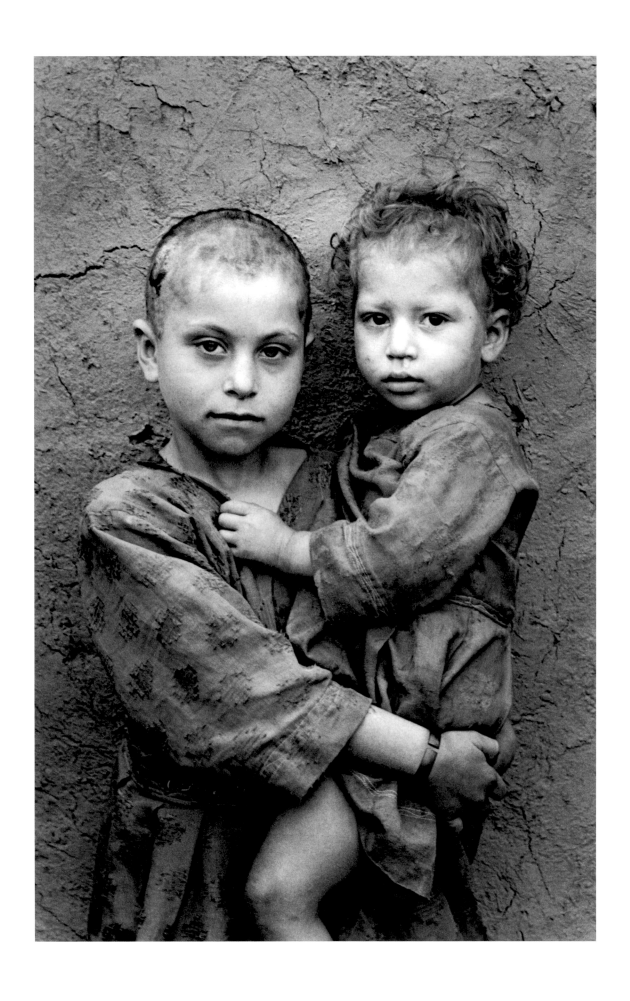

Sebastião Salgado,
Afghanistan, 1996

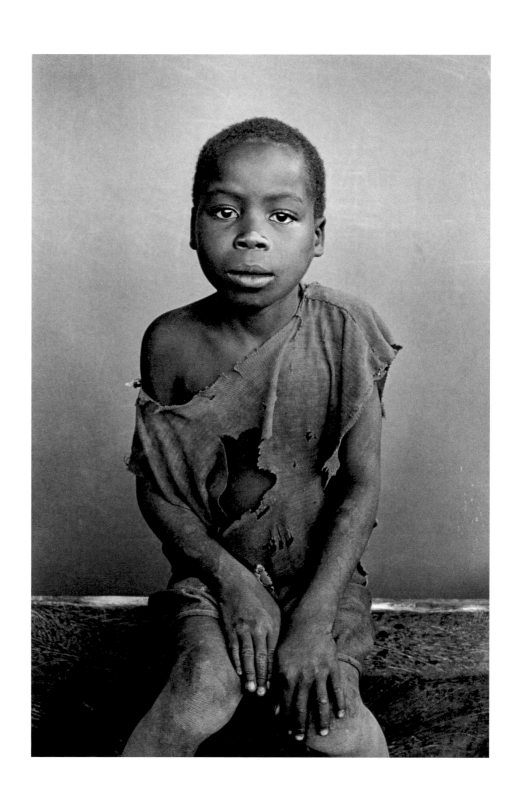

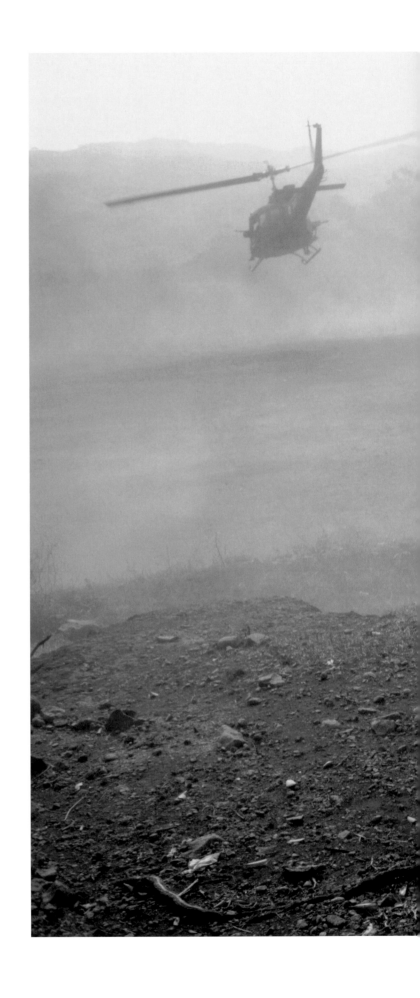

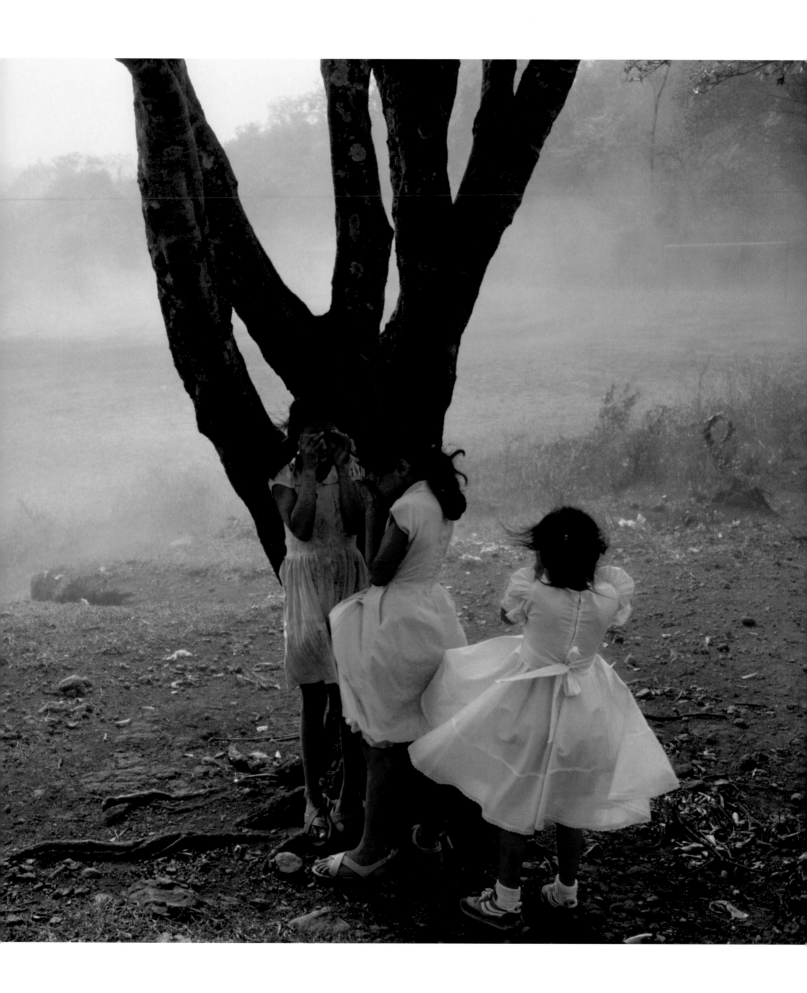

James Nachtwey,
El Salvador, 1984

365

HOW BRITTLE AND FUGITIVE IS ALL LIFE,

HOW MEAGERLY AND FEARFULLY

LIVING THINGS CARRY THEIR SPARK OF WARMTH

THROUGH THE ICY UNIVERSE.

HERMANN HESSE

Margaret, 15, was abducted by the Lord's Resistance Army (LRA). She is recovering at the UNICEF-supported recovering center in the northern town of Kitgum, Uganda. Like many other abductees, she was forced to walk long distances while carrying heavy loads. She witnessed girls being given to commanders as sex slaves and saw others being killed. She is still haunted and has nightmares about two children from her village who were accused of trying to escape and then killed in her presence. "If I get home, I need to pray a lot and go to school," she said.

By the end of 2004 in Uganda, up to 20,000 children in northern districts had been abducted from their homes and forcibly recruited into the rebel LRA as combatants, sex slaves and porters. Some 12,000 have been abducted since mid-2002, forcing over 44,000 children (and many adults) to become "night commuters" -- abandoning their homes and villages each night to seek shelter in relatively safe urban centers. The conflict has displaced 1.4 million people, more than eighty percent of whom are children and women.

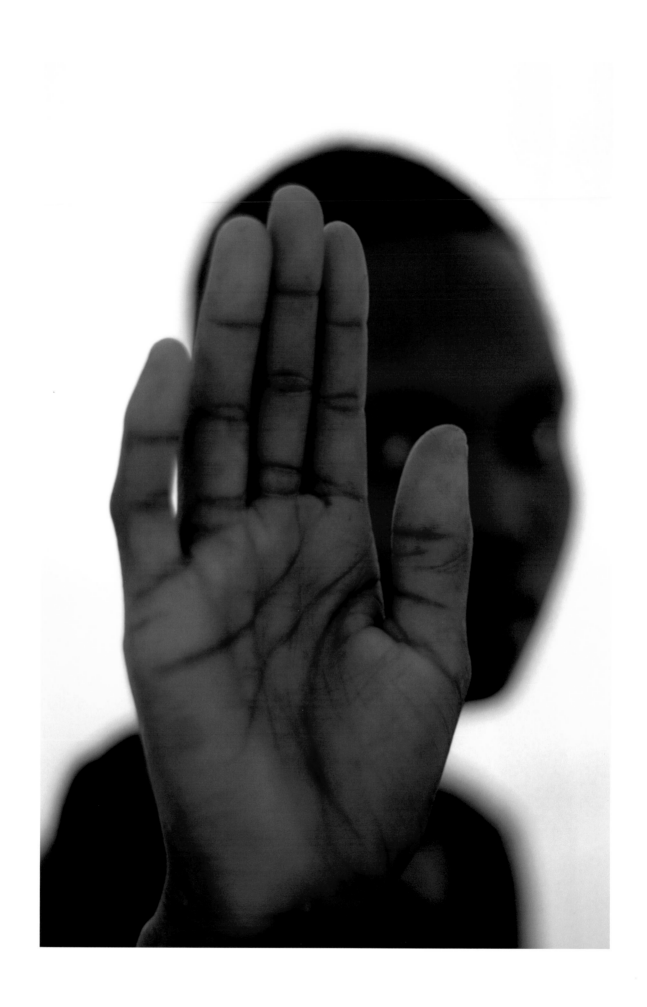

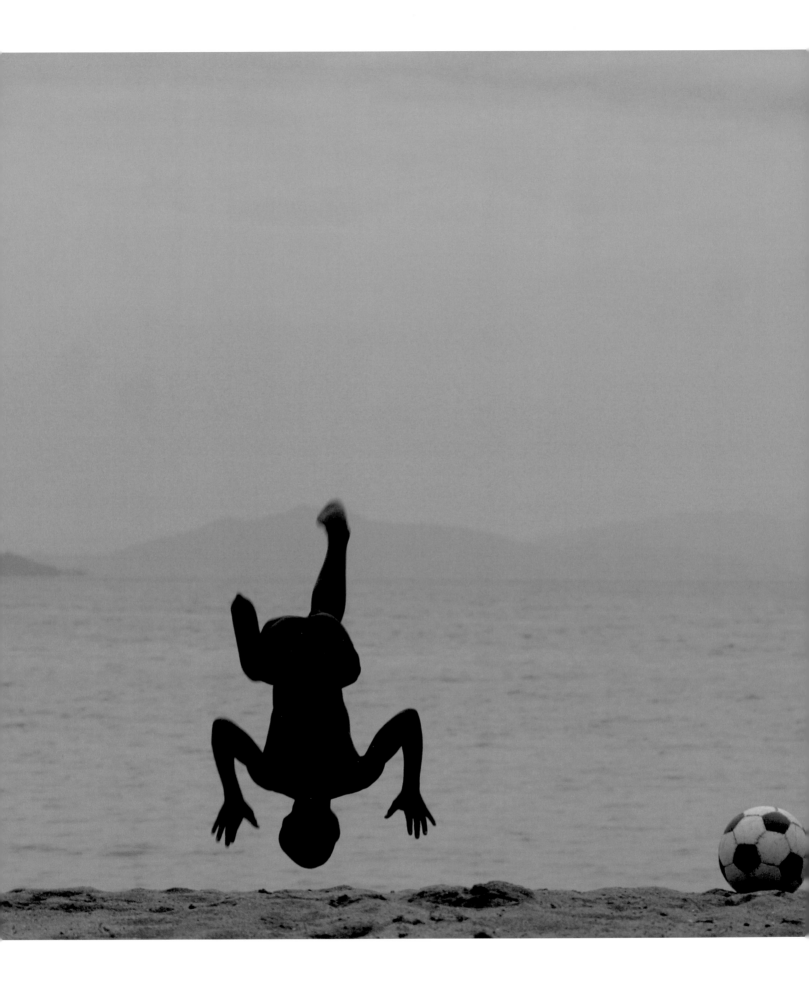

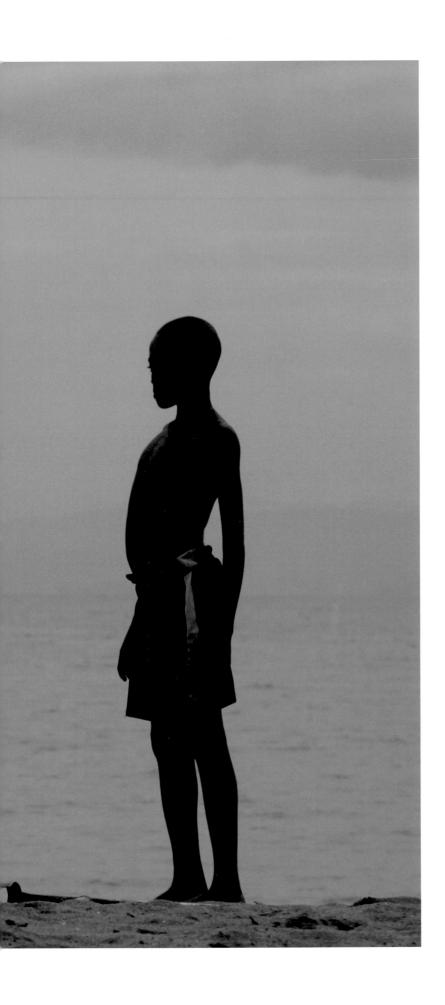

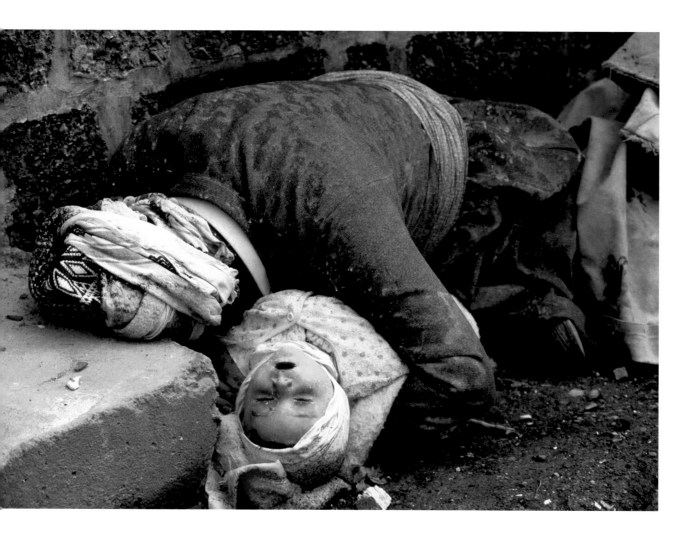

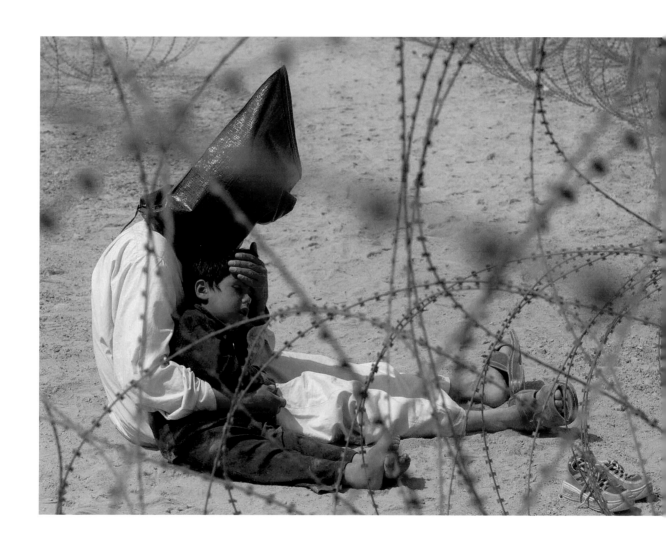

Jean-Marc Bouju, 2003
An Iraqi man comforts his four-year-old son in a holding center for prisoners of war.
The boy became terrified when his father was hooded and handcuffed. A U.S. soldier
later severed the plastic handcuffs to allow the father to embrace his son.

371

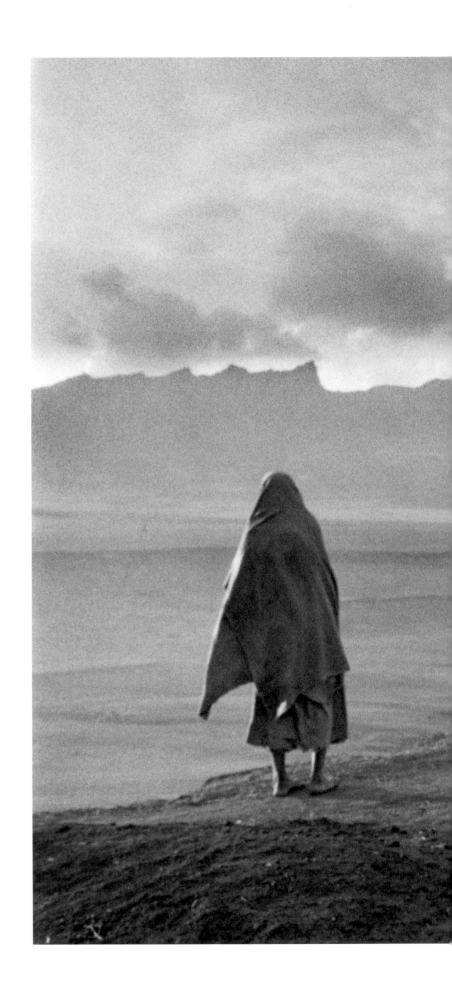

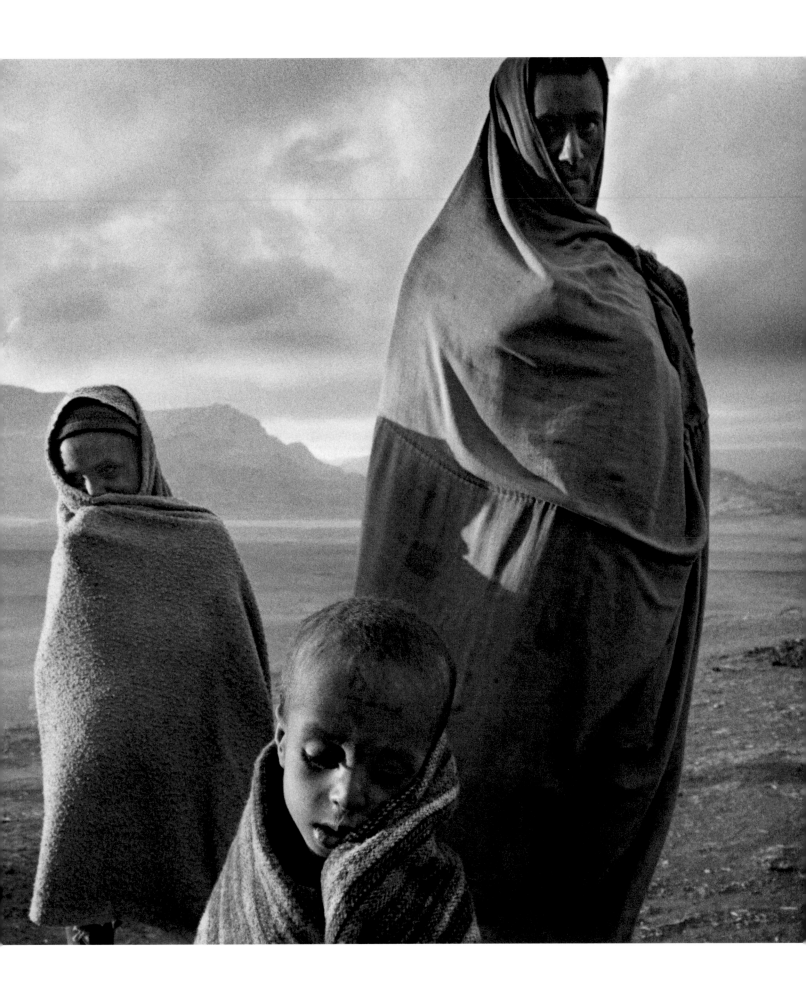

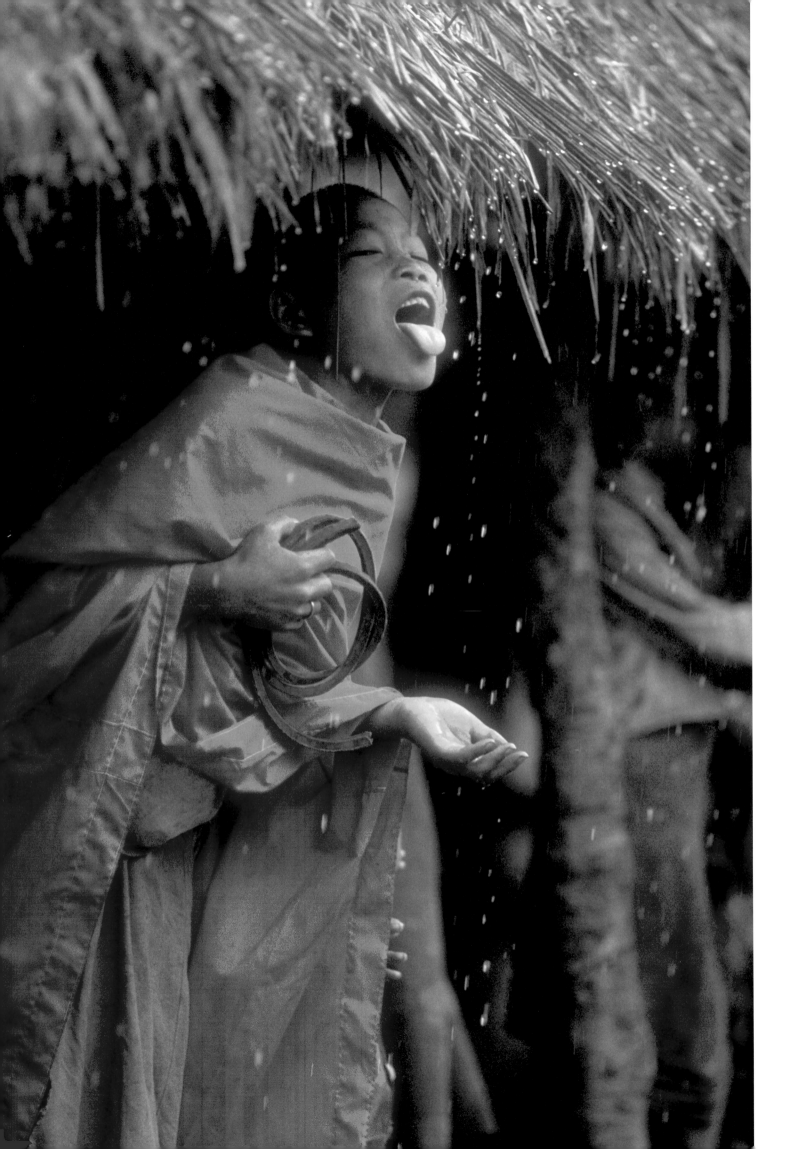

the child wondrous

IT IS HARDLY WORTH THE EFFORT
TO TRY TO GROW UP INTO -- AND
LIVE FULLY WITHIN -- A WORLD
THAT IS NOT FULL OF WONDER.

BRUNO BETTELHEIM

It is one of the premises of this book that the photography of children -- including those images deemed art, those taken for personal use and those viewed as documentary, whether depicting children close and familiar or faraway and unknown -- is better understood in the larger context of how children have been depicted since the camera's introduction. This is not only because the past informs the present, but also because images of the past are all around us, mixing with an expanding multimedia universe. It is now difficult to imagine that people living in any urban center in the world or within reach of a television or roadside billboard can spend more than a few hours without seeing an image of a child. Even in the most remote rural corners of the world, faded snapshots of children often cling to mud walls. The photographed child is everywhere.

Viewing a child's image encompasses both the immediate world of the viewer and the library of images each viewer maintains in his or her memory. That rich and varied archive contains much that testifies to the complexity of childhood. If there is one overarching quality running through the more than 165 years of photographic depictions of children, it is that elusive quality called grace. In the context of photojournalism, it is grace under stress -- the ability a child has to endure, forgive and forget. Our response to such images is often varied. We may be repelled by what we see and denounce the violations depicted.

We may seek to do something about those situations. We may proclaim and celebrate the victim's spirit or, not infrequently, we may sentimentalize the subject's innocence.

Grace, however, is not to be confused with innocence, and the theme of innocence is ripe for questioning. The romantic idea of children as sacred glyphs of innocence was not invented by photography nor is it confined to visual representations. It courses through all of Western art and thought. In Christianity, innocence has been symbolized for centuries by the image of the Christ Child, resplendent in his mother's arms. Rousseau was obsessed with childhood innocence and a similar obsession defined photography's first representations of children. In those early years, the camera also recorded the lives of children in need, including those who were destitute or forced to labor in the initial, brutal days of industrialization. It also accompanied explorers, missionaries and itinerate photographers, who provided the first visual evidence of childhood in other cultures. Yet these documentary and ethnographic studies, precursors of photojournalism, had little impact on the overriding ideal of the romantic child.

The next movement influencing how photographs represented children was amateur "snapshot" photography -- images made primarily by family members recording their offspring's growth from birth onward. Beginning with the Brownie in the early twentieth century, the camera played a central role in the life of the family. Family photographs, initially solemn tributes to patriarchal order, eventually edited out all traces of sorrow and sadness to accent the positive,

with the smile as their omnipresent motif. This motif did not take on its preemptive attributes by accident.

The smile, the most immediately expressive muscular contraction of which bodies are capable, is not the exclusive domain of the child, or for that matter of humankind. Something akin to it is often observed in the animal world, in dolphins, macaques and baboons. It is also found in the inscrutable Cheshire cat and, of course, in every dog. For most adults, however, its manifestation is often coded -- politically correct, polite, sardonic, lascivious and, on rare occasions, spontaneous. Yet for the child, a smile is usually without agenda. Babies' smiles are wondrously endogenous. For postinfancy children, the smile is a natural manifestation of joy, almost always genuine. As any photographer knows, a child's smile transforms every circumstance, no matter how terrible. Yet, it cannot be produced simply by the command: "Say cheese!" Its depiction reads "happy" and, in time, these "happy child" images became the ubiquitous counterpoint to images of the "suffering child."

In the 1970s, Susan Sontag observed that "taking photographs sets up a chronic voyeuristic relationship to the world which levels the meaning of all events." Her argument is that image saturation causes individual images to lose their specificity and become stereotypes. As a result, they do not allow for more than a generalized and diffused response, overwhelming us rather than moving us to action. This lament is both a truism and an exaggeration. For example, many photographs of children who are suffering due to disease, starvation or trauma continue to resonate with pathos, regardless of the context in which they are presented. Nevertheless, some maintain that the current proliferation of such images has made them suspect. They argue that the magnitude and intensity of the suffering conveyed has numbed viewers' sensibilities. Some critics also say that this proliferation of suffering child imagery is a form of voyeurism. Yet, if looking at images of unknown children in distress is so, then perhaps the same should be said about the viewing of representations of unknown happy children. In the market-place, where so much in life is objectified, images of children, detached from their context, are often intended primarily to satisfy viewer expectations, with little relationship to the feelings or circumstances of the child depicted.

In this way, these images become like photographs of the physically beautiful, clad or unclad, posing for the pleasure of the viewer, which are unrelated to the reality, or perhaps even the wishes, of the person on display. It may be hard to acknowledge that this kind of objectification extends to children, but it is also difficult to ignore. At the same time, the general sullying of documentary photography's representation of less privileged children with the accusation that such images are somehow exploitive unfairly paints all photographers with the same brush. Unfortunately, these philosophical debates, as interesting as they may be, often create roadblocks to the process of addressing the content of imagery of children. It is a telling tribute to the continuing enormous appeal of great photography and its magical ability to stop time that it so often rises above attempts to level or belittle the process.

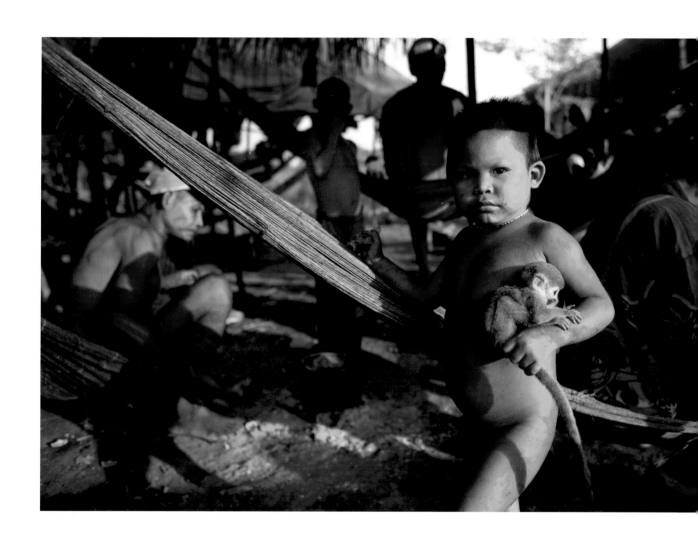

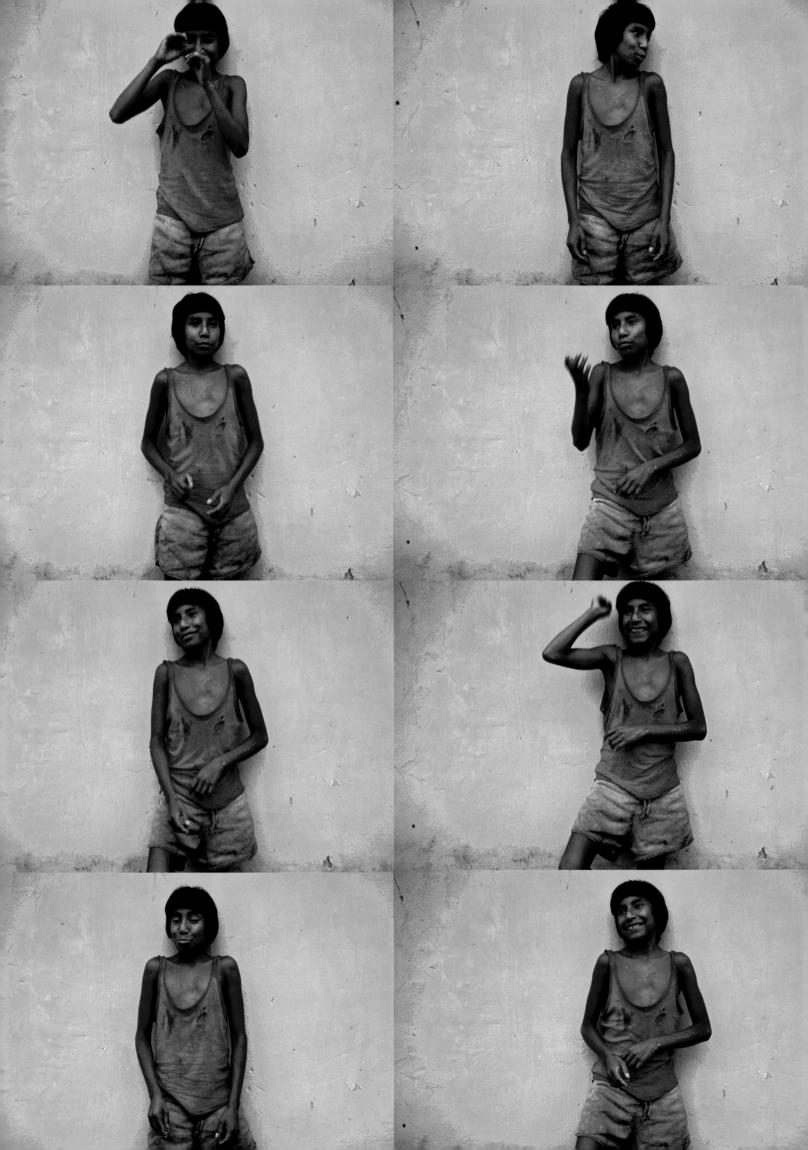

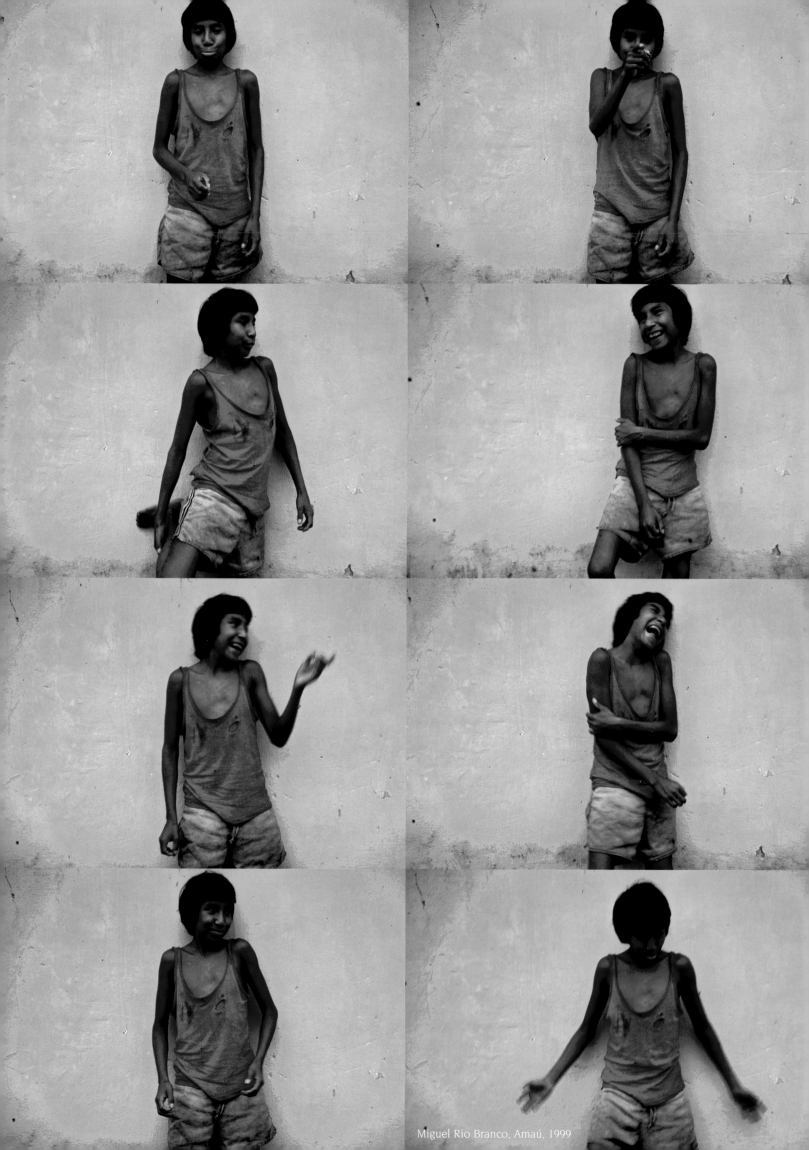

Miguel Rio Branco, Amaú, 1999

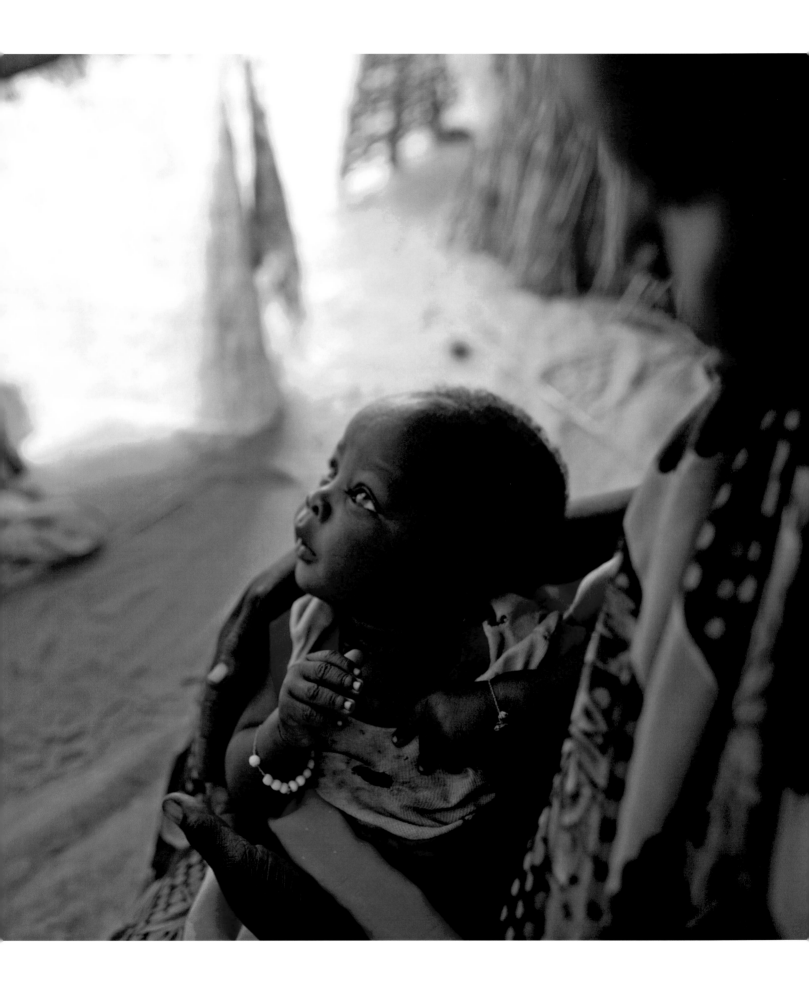

Michael Kamber, Faisal, 2005

There is no simple answer to explain what makes one image of a child stand out among the billions made every year. In some instances, it is the artistry of the photographer. Edward Weston's nude of his son Neil stands alone as a marble sculpture does. It is beauty captured and we need not look beyond its surface and form. Walker Evans combines formal brilliance with social concern, as his Depression images demonstrate. Henri Cartier-Bresson, Sally Mann and Sebastião Salgado have each bequeathed us a virtually new way of seeing the world.

Critiquing photographs is notoriously difficult, for soon after being rendered, they assume multiple, often inscrutable, other lives. They are both receptive, and simultaneously resistant, to our manipulation. An exercise used by photography teachers to make the latter point asks students to bring to class images of their children (or childhood pictures of themselves), then to cut the subjects' eyes out of the pictures. Many students are unable to do so and most gain a new respect for the photograph's innate power.

Images of children affect people differently -- they can please one's senses, jog one's memory, educate as well as elucidate, engage, enliven, sadden, anger or motivate. They have a social and psychological resonance all their own. In this section, there are three images that underscore this fact. Two-month-old Faisal, profiled in Michael Kamber's photograph, is already bejeweled and adorned with handmade amulets to ward off evil spirits. He was conceived during a rape eleven months earlier in Darfur, Sudan -- the scene of perhaps the most villainous abuse of human rights at the time of this writing. Faisal faces an uncertain future. His father is Janjaweed, one of the feared horsemen from an opposing tribe. Stigmatized by the manner of his conception, Faisal may well be rejected, even by family. But he does not know that yet. His world, for now, is one of pure wonderment. Strife, anxiety and a terrible knowledge enshroud his mother, but Faisal simply bathes in the light of his new world.

The collage on the previous spread is of a young South American Indian boy, Amaú. He was the photographer's guide and companion during an assignment in Gorotire, a small Brazilian village where communication is basically verbal and musical. Amaú is deaf and mute, yet his only real disability seems to be an inability to suppress a smile. The artist Manuel Rio Branco observed that Amaú "made my visit special just by the creativity of his expression."

The image on page 377, by Luca Zanetti, is also of a young boy. A member of an indigenous South American tribe, the Nukak, he had until very recently lived with his tribe in relative isolation in the Amazon basin, surviving on foraged berries and monkey meat. Members of the tribe were recently forced out of their natural habitat by the encroachment of a warring rebel faction and the disease brought by other outsiders, for having lived virtually alone for generations, the Nukak have not acquired immunity to the contagious illnesses of civilization. In the last several years, the common flu has proved fatal to many of their elders, also causing the loss of a large part of their oral history. The remaining children of the tribe will now know less about their heritage and will have

to seek knowledge from a different world. All these profound complexities reside in this seemingly straightforward image of this boy.

What is also striking about these images is how differently they are perceived at first impression. Viewed in their specific social and cultural contexts, they take on new and very profound meanings and we, the viewers, care more about the direction each subject's life's journey will take. Amaú, who relies on his sight and touch to comprehend the world, has come this far primarily because of his enormous zest for life. The Nukak child is embarking on a voyage into a newly discovered civilization. Faisal has all his senses, but a social and humanitarian crisis makes his future the most precarious. Yet, both despite and because of the astounding disadvantages these children face, viewers are all pulling for them, hoping that their innate grace and sense of wonder will help them overcome their obstacles.

According to Paul Strand, photography is "the symbol of all young and new desire." It is the photographer's ability to capture that desire that is so compelling. What these three images show, like those of Sally Mann and so many other great photographers, is neither an entirely innocent nor an entirely "knowing" child. Children were probably never innocent in the Victorian sense. That term applied more to the nostalgia of viewers than to the nature of the subject. Nor are children now more knowing. The mysteries of the world still elude them, notwithstanding greater and more accessible portals to knowledge. The state that best encapsulates the essence of childhood is grace, and images that are more about

nurturing and less about nostalgia hold this quality within their frames.

While reflecting on his mother's passing, Roland Barthes, who along with Susan Sontag, is considered by many to be one of photography's most respected seers, discussed the one possession that helped him tolerate his grief -- a photograph of her. This image, he reminisced, gave him "a sentiment as certain as remembrance. An unknown photographer had been the mediator of a truth, he had produced a supererogatory photograph which contained more than what the technical being of photography can reasonably offer . . . |an image that accorded| with both my mother's being and my grief at her death." It was an image of his mother at age five.

If this book's journey has a single goal, then it is the revelation that children are complex and multidimensional beings who also embody many of humankind's best qualities in their least corrupted form. Hopefully, this radiance is not irretrievably lost in adults. The French philosopher and poet Gaston Bachelard believed that "childhood remains alive and poetically useful within us" and that through that "permanent childhood" we maintain the poetry of our past. Whether one calls it poetry, wonder or grace, its essence is the same and it is not confined to any one culture. And when the company of children is not available, and words do not suffice, it is the images of children that return to us a glimmer of what William Butler Yeats called the "brightening glance," affirming and reaffirming their quintessential importance to all of us.

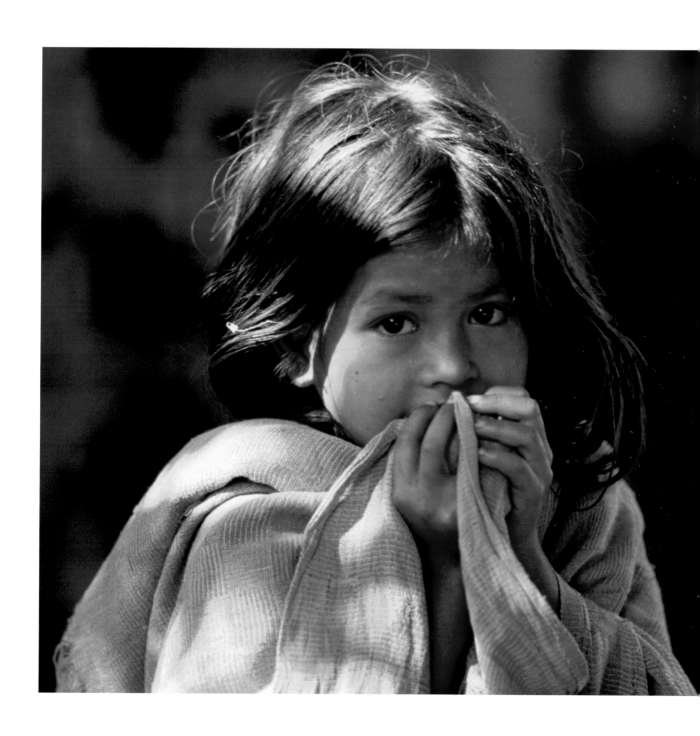

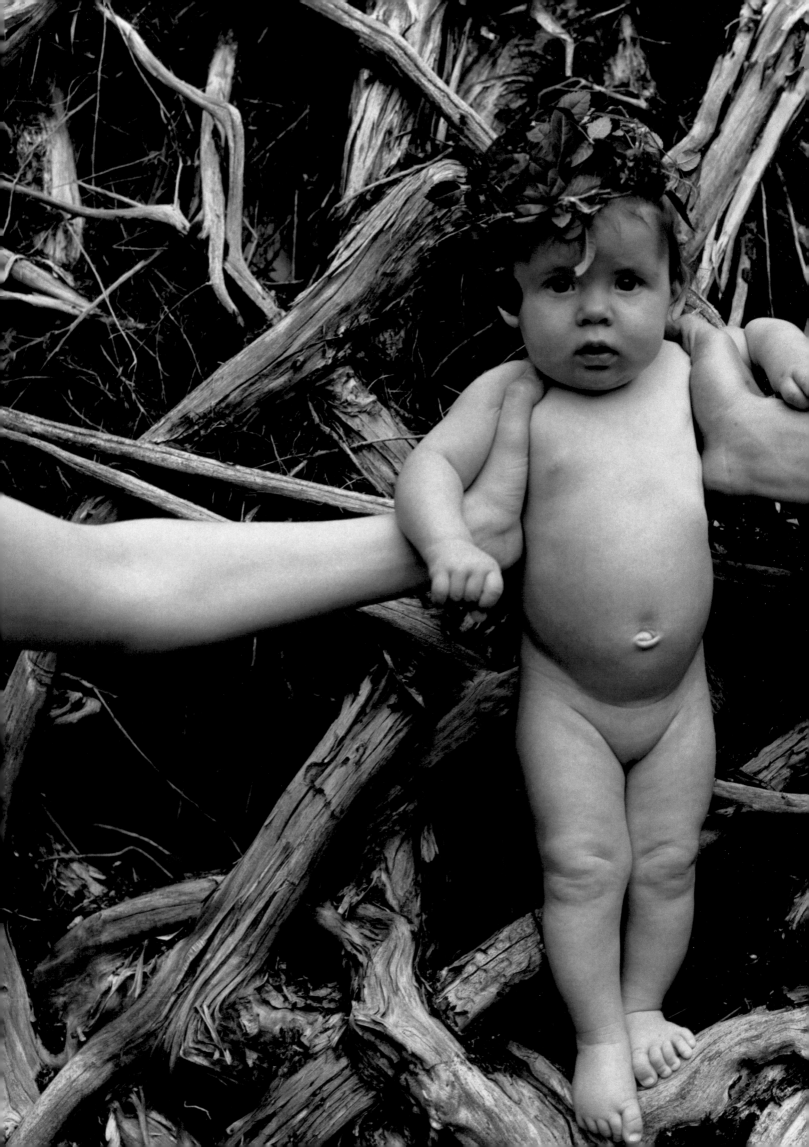

IN THE CONTEMPORARY IDIOM,
GRACE IS A HAPPENING RATHER
THAN AN ACHIEVEMENT,
A GIFT RATHER THAN A REWARD.

SAM KEEN

Pedro Isztin, 1999

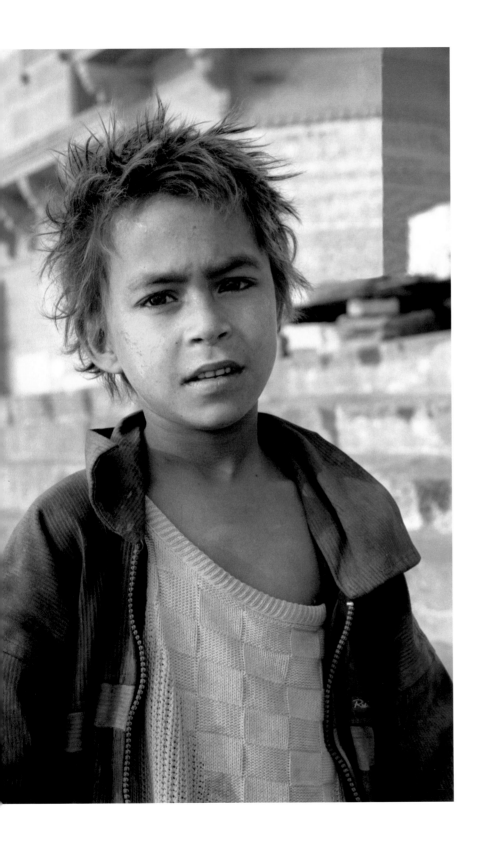

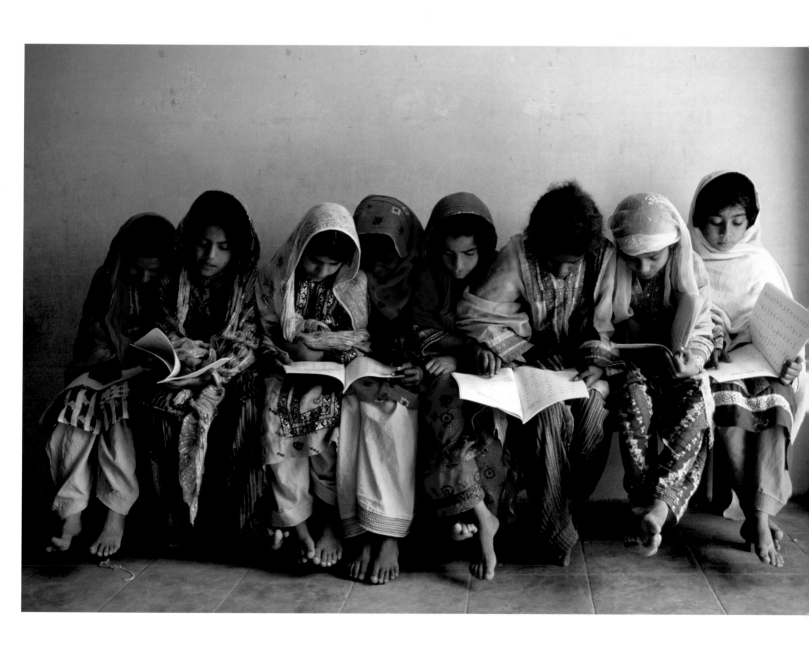

MONDAY'S CHILD IS FAIR OF FACE,
TUESDAY'S CHILD IS FULL OF GRACE,
WEDNESDAY'S CHILD IS FULL OF WOE,
THURSDAY'S CHILD HAS FAR TO GO,
FRIDAY'S CHILD IS LOVING AND GIVING,
SATURDAY'S CHILD HAS TO WORK FOR ITS LIVING,
BUT A CHILD THAT HAS BEEN BORN ON SUNDAY
IS FAIR AND WISE AND GOOD AND GAY.

NURSERY RHYME

Radhika Chalasani, Niger, 2005

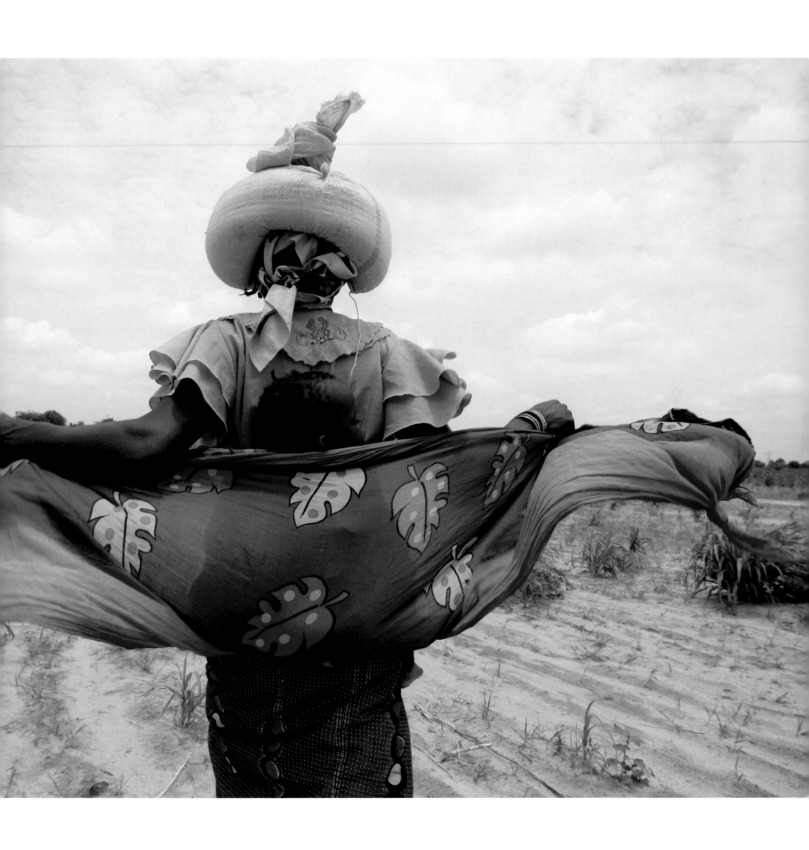

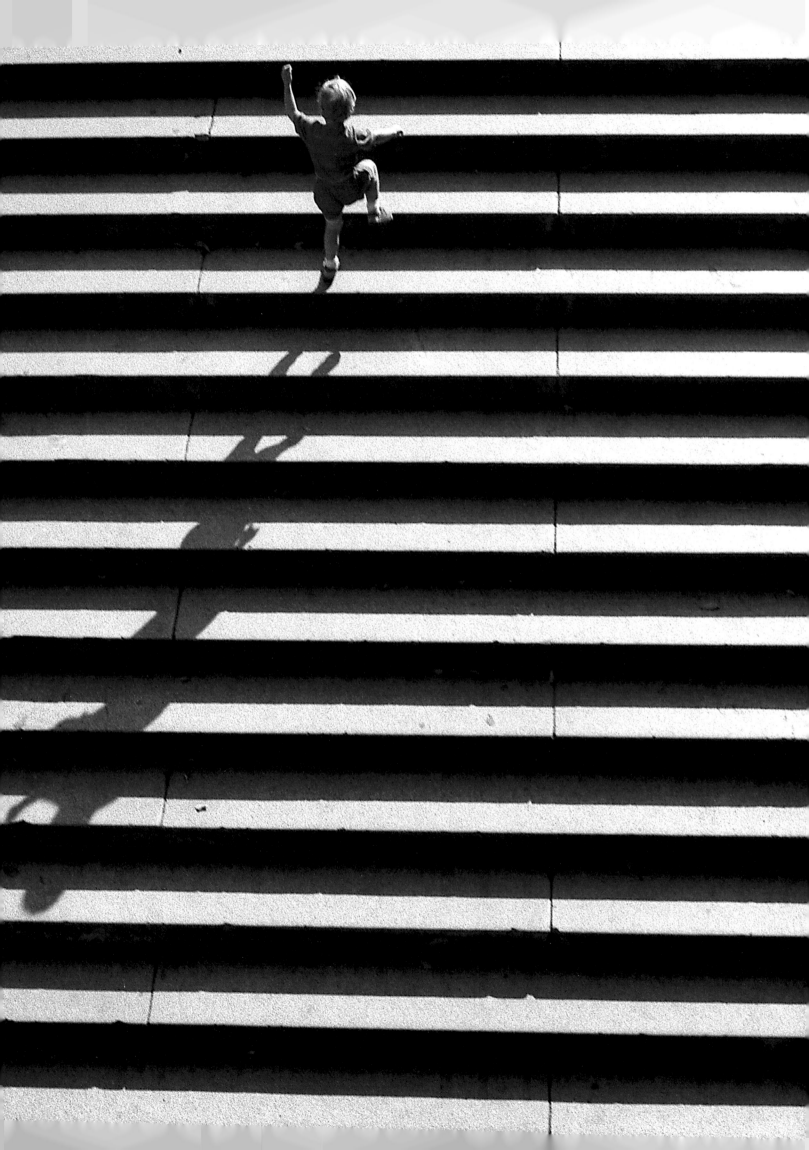

afterword

EVERY CHILD COMES WITH THE
MESSAGE THAT GOD IS
NOT YET DISCOURAGED OF MAN.

RABINDRANATH TAGORE

Our journey is over. It has taken us through over a century and a half of childhood -- a small period in the larger sense of time. Along the way, we have traversed the history of childhood as well as the growth and maturation of photography. Hopefully, like me, you've seen some new sights and remembered some that were forgotten, while recalling memories long ago stored away. At a minimum, this experience should make you venture into your attic and revisit those albums or shoeboxes of visual memories, for the "long history of most of humanity is found in a grainy dog-eared picture." That wry observation by Eduardo Galeano seems apt for this journey because those much-loved, dog-eared images are so often of children.

A photograph of a child is a unique and paradoxical object. Many taken by kith and kin have banality at their aesthetic core, in the sense that they lack spectacularity. Yet to dismiss these images would be a mistake, for their content often renders them more than spectacular. In that respect, family photos have an initial advantage over fine art photography, even if that advantage is only short-lived. The German photographer Gerhard Richter put it as follows: "Picturing things, taking a view, is what makes us human; art is making sense and giving shape to that sense." This is particularly true when it comes to fine art photography and the works of photojournalists. Their artistic and incisive vision gives shape to our view of a broader world and, in particular, to our view of the world's children.

Seventy years ago, László Moholy-Nagy astutely prophesied that in the future photography would be so important that the illiterates of the world would be those "ignorant of the use of the camera as well as the pen." Unfortunately, that time has yet to come, for the power of photography is still not fully understood by many. Photographic illiteracy may well still be the norm, rather than the exception. Some see photography merely as a potent tool for manipulation, yet the very best of images -- whether they be amateur or professional -- possess a power infinitely greater than that, for they have the capacity to enliven and ennoble our lives.

It is my belief that pictures of children should not be viewed primarily as symbols or icons, but more tellingly as visual reference points. Some serve as portals through which we recapture moments of past joy; others serve as peepholes through which we glance at the splendor, wonder and grace of the young. These images also act as mirrors, reflecting back to us our own childhood feelings, hopes, fears and dreams. Now, thanks to digital technology, they can also serve as pixie dust, taking us to places and people that exist only in the imagination. They are indeed powerful objects of engagement.

The good ones are those that are akin to poetry in their lyricism, poignancy and potency. That poetry ignites our emotions and removes our blinders, letting us see in new as well as old ways. Similar feelings are evoked by rereading the classics of children's literature. With those books, children (and adults) can reaffirm important societal values and priorities. All of us could profit from a dose of Harry Potter's steadiness, Max's spunk in taming the Wild Things, Horton's sensitivity and dedication to the downtrodden Whos and Charlotte's sense of self.

It is axiomatic that children are the future of our species, yet, on a personal level, they serve as the guardians of our aspirations, the keepers of our memories and, for most, the only realistic chance we have for a bit of immortality. As Mark Alice Durant observed, children "own nothing of the world, and as if to make up for this material poverty, the universe bestows |on them| all of its wonder." It is that endowment that makes children so innately and emotionally wealthy and wise. Many childhood experiences illustrate that wonder -- to ride a bike without holding on, to jump over puddles made by new rain, to chase squirrels and pigeons you never want to catch, to turn a tree into your own private domain, to keep a diary no one else will ever read and to bury a treasure no one but you will ever find. These moments are the wealth of the young. The signature attribute of images that capture those dream-like moments is grace, the essence of what takes children's imagery straight to the heart.

These sweet dreamers -- over two billion of them -- now dominate the world. Thankfully, many of them are physically healthier, emotionally wealthier and culturally wiser than ever before. Visual and verbal communications about children often express our noblest thoughts, yet there remains a puzzling reluctance on society's part to do what is necessary to create a world fit for all children. One in three children is malnourished. Eleven million die each year before their fifth birthday. Every minute of every hour a child under the age of fifteen dies of an AIDS-related illness. HIV alone may undo in ten years what the world community has spent fifty years trying to accomplish, for many of the gains realized in stemming child mortality and child morbidity while at the same time increasing access to education and health services for children could be wiped out in the coming decade. Sadly, in the worldwide AIDS crisis, the worst may be yet to come where children are concerned.

We are living in a new century that is clearly child-centric -- for reasons both noble and ignoble. We see the commodification of childhood increasing, traditional childhood precepts deconstructing, and children's durability tested as their vulnerability rises. The increasing weight of children's influence in the human equation is tilting that equation toward them. In the end, it is children who will develop new languages both to alleviate society's ills and to bring peace and tolerance to the world. Old men can make war, but it is children who will make history. We can contribute positively to that process if we make children our priority. Only in doing so can we share their dreams -- and then, just maybe, they will share with us a little of their grace.

Producing this book involved forming a nuclear family made of six principal members and scores of others. It is a great pleasure finally to thank them for their generosity and support. Carol Merritt served as head of household and endured the dislocation that a project of this magnitude requires. She shared our house with thousands of images of children, probably the largest private assemblage of children's pictures in history. She also served as the first and last reader of each essay. She is my biggest fan and my harshest critic. Her contribution helped shape this book and to her this book is dedicated.

Two others were adopted for the project. Caleb Cain Marcus, a gifted photographer young enough to be comfortable and proficient in the digital age, worked side by side with me, laying out the imagery and laying in the words. His vitality, imagination and talent helped make the book succeed. Marie Lillis, my assistant for thirty years, was called into service once again for the harrowing task of bringing order to the process. Without her the project would have never ended.

Added to that mix was a trio of editors who critiqued the book. Each brought his or her very special talents and a large dose of enthusiasm to the project. Virginia Heckert, Associate Director of the J. Paul Getty Museum, is an esteemed expert on art photography. Marvin Heiferman is a highly respected commentator on the visual arts. Ellen Tolmie, Photography Editor of the United Nations Children's Fund (UNICEF), is perhaps the most knowledgeable person in the world when it comes to the picturing of children. She is responsible for the procurement and selection of the more than one million images that constitute the UNICEF archives and is a devoted expert and advocate on issues of children's rights. Additionally, she co-wrote "the child violated" and "the child wondrous" texts with me. These three became project siblings and, like all siblings, worked together (sometimes critically) to ensure that the project remained faithful to its mission. They were generous with their time and knowledge, not only in editing the text, but in teaching me what they knew. For all they have done, I am truly indebted and appreciative.

Others made important contributions. Alexandra McNair, a superb researcher, provided the initial background information that helped in setting the textual template for the book. Lise Andersson Logan, Julia Balfour, Reed Seifer and Tanya Briganti assisted in the initial design and layout. The photographer Jill Mathis, along with Larimore Hampton, assisted Marie Lillis in the often daunting task of obtaining the images and the necessary permission for their use. A dedicated corps of proofreaders led by the invaluable Cathy McCandless, including Myra Stennett and Joan Cassidy, and a wonderful copy editor, Paula Glatzer, helped put the book in readable order. Without their enthusiastic help, this project may well have died in the crib.

Deep respect and appreciation must also be accorded to the many professionals who helped make this project possible, and the

Unknown Photographers, child portraits, Caleb, Virginia, Carol, Ellen and Marvin, n.d. (top to bottom)

artists and photographers who graciously and freely provided the images that this book celebrates. They all care very deeply about photography and their efforts attest to that. A special thanks to friends Ralph Gibson and Gilles Peress for lending their support, encouragement and artistry to this undertaking.

I wish to express thanks to Damiani Editore, particularly Andrea Albertini, Silvia Albertini and Marcella Manni, and powerHouse Books, especially Daniel Power and Craig Cohen, for their collective foresight in embracing a project of this scope and magnitude.

Furthermore, I appreciate the support of the Cygnet Foundation in making all of this possible. Through its involvement in projects like this, the foundation hopes to further its purpose of helping those who cannot help themselves -- children and animals in need. The net proceeds that the foundation and I receive will be contributed to UNICEF, the most effective charitable organization working with children today. I invite you to visit its website at www.unicefusa.org and to generously support its continuing efforts.

As stated previously, I am not an expert on childhood history, childhood development, children's literature or the history of photography. As a consequence, I had to rely on and appropriate the genius of others. Too numerous to list here, their names can be found on the foundation's website at www.cygnetfoundation.org under "Full of Grace Credits, Bibliography and References." There you will also find a more complete listing of the images used in the book and their appropriate credits and copyrights. Again, I thank the artists, dealers, photography agencies and collectors involved for their generosity. A few of these, however, need to be singled out: Matthew Butson and Getty Images; Dan Cheek of the Fraenkel Gallery; Robert Gurbo of the Kertész Estate; Howard Greenberg and his staff; Peter MacGill and his excellent and enthusiastic assistants; Yossi Milo, Ronald and Robert Pledge of Contact Press; and Michael Shulman of Magnum, as well as individual collectors and friends, Joe Baio, Henry Buhl and Joseph Cohen, who generously opened their impressive collections to me.

And lastly, thanks to the "children" -- those unknown and those known -- particularly our own, Ray and Kim and their progeny, Danny, Catherine, Caden, Reed and Brady. They all have served as constant reminders of the grace found so often in children. That is the true art we celebrate here.

ray merritt

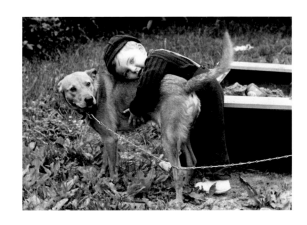

May Hanson, author
photographed at age six, 1944

credits

Greenberg Gallery. Pages 194, 195, Garry Winogrand, 1957. Courtesy, Fraenkel Gallery. © The Estate of Garry Winogrand. Page 196, Dan Weiner, c. 1956. Courtesy, Howard Greenberg Gallery. Page 197, Esther Bubbley, 1958. Courtesy Deborah Bell Photographs. © Jean Bubbley, 2006. Page 199, Bill Owens, 1956. Courtesy of the Artist and Howard Greenberg Gallery. Page 200, Wynn Bullock, 1958. Courtesy, Howard Greenberg Gallery. Page 202 (top), Ken Heyman, 1960. Courtesy, Howard Greenberg Gallery. Page 202 (bottom), Emmet Gowin, 1969. Courtesy of the Artist and Pace/MacGill Gallery. Page 203, Bruce Davidson, 1963. Courtesy, of the Artist and Magnum Photos. Page 204, Gordon Parks, 1950. Courtesy, Howard Greenberg Gallery. © Estate of Gordon Parks. Page 205, Elliott Erwitt, 1955. Courtesy of the Artist and Howard Greenberg Gallery. Page 206, Bruce Davidson, 1967. Courtesy of the Artist and Magnum Photos. Page 207, Duane Michals, 1975. Courtesy of the Artist and Pace/MacGill Gallery. Pages 208, 209, Garry Winogrand, 1977. Courtesy, Fraenkel Gallery. © The Estate of Garry Winogrand. Pages 210, 211, Peter Keetman, 1957. Courtesy, Peter Keetman. © F.C. Gundlach Foundation, Hamburg. Page 212, Arthur King, 1958. Courtesy of the Artist. Page 214, Maurice Sendak, 1963, illustration. Page 215, Unknown Photographer, c. 1960. Courtesy, Getty Images. Page 216, Dare Wright, 1957. © Brook Ashley. Page 217, Garth Williams, 1952, illustration. Page 218, Theodor S. Geisel, 1957, color illustration. © 1960. Dr. Seuss Enterprises, L. P. Page 219, Carol Bremer, 1956. Courtesy of the Artist. Page 220, André Kertész, c. 1960. Courtesy, Stephen Bulger Gallery. © Estate of André Kertész, 2006. Page 221, Ralph Eugene Meatyard, 1967. Courtesy, The Metropolitan Museum of Art, Gift of Steven and Phyllis Gross, 1988 (1198.470.7). Page 223, Kathryn Abbe, 1957. Courtesy of the Artist. Page 224, Robert Frank, 1955. Courtesy of the Artist. Page 226, Robert Frank, 1955. Courtesy of the Artist. Page 227, Robert Frank, 1962. Courtesy of the Artist. Page 229, Robert Frank, c. 1948. Courtesy of the Artist. Page 230, Ralph Eugene Meatyard, 1959. Courtesy, Fraenkel Gallery. © The Estate of Ralph Eugene Meatyard. Page 232 (top), Ralph Eugene Meatyard, 1955. Courtesy, Fraenkel Gallery. © The Estate of Ralph Eugene Meatyard. Page 232 (bottom), Ralph Eugene Meatyard, 1960. Courtesy, Fraenkel Gallery. © The Estate of Ralph Eugene Meatyard. Page 233, Ralph Eugene Meatyard, 1962. Courtesy, Fraenkel Gallery. © The Estate of Ralph Eugene Meatyard. Page 234, Larry Clark, 1971. Courtesy of the Artist and Luhring Augustine Gallery. Page 236, Larry Clark, 1971. Courtesy of the Artist and Luhring Augustine Gallery. Page 237, Larry Clark, 1971. Courtesy of the Artist and Luhring Augustine Gallery. Page 238, Bruce Davidson, 1960. Courtesy of the Artist and Magnum Photos. Page 239, Bruce Davidson, 1965. Courtesy of the Artist and Magnum Photos. Page 240, Bruce Davidson, 1965. Courtesy of the Artist and Magnum Photos. Page 241, Bruce Davidson, 1970. Courtesy of the Artist and Magnum Photos. Page 243, Ralph Gibson, 1961. Courtesy of the Artist. Page 244, W. Eugene Smith, 1955. © Collection, Center for Creative Photography, University of Arizona. Page 247, Philip Jones Griffiths, 1970. Courtesy, Magnum Photos. Page 248, Paul Fusco, 1968. Courtesy, Magnum Photos. Page 250, Don McCullin, 1970. Courtesy, Contact Press. Page 251, Henri Cartier-Bresson, 1972. Courtesy, Magnum Photos. Page 252, Gordon Parks, 1961. Courtesy, Howard Greenberg Gallery. © Estate of Gordon Parks. Page 253, Gordon Parks, 1961. Courtesy, Howard Greenberg Gallery. © Estate of Gordon Parks. Page 254, David Heath, 1955. Courtesy, Howard Greenberg Gallery. Page 255, Carl Iwasaki, 1954. Courtesy, Iwasaki/Time Life Pictures/Getty Images. Pages 256, 257, Don McCullin, 1971. Courtesy of the Artist and Contact Press. Pages 258, 259, Huynh Cong (Nick) Ut, 1972. Courtesy, Getty Images. Page 260, Unknown Photographers, 1975. Page 261, Unknown Photographer, 1974. Page 262, Peter Magubane, 1976. Courtesy of the Artist and UNICEF. Page 263, Jeanne Moutoussamy-Ashe, 1977. Courtesy of the Artist. Page 265, Larry Clark, 1971. Courtesy of the Artist and Luhring Augustine Gallery. CHAPTER 5. Pages 266, 277, Sally Mann, 1989. Courtesy of the Artist. Page 269, Fazal Sheikh, 1992. Courtesy of the Artist. Page 270, Alexander Tsiaris, 2002. Courtesy of the Artist. Page 273, Adam Fuss, 1992. Courtesy, Fraenkel Gallery. Page 274, Ralph Gibson, 2000. Courtesy of the Artist. Page 275, Angelika Krinzinger, 2002. Courtesy of the Artist. Page 277, Christopher Bucklow, 2000. Courtesy of the Artist and Paul Kasmin Gallery. Page 278, Jill Greenberg, 2005. Courtesy of the Artist. Page 279 (top), Caleb Cain Marcus, 2006. Courtesy of the Artist. Page 279 (bottom), Raymond Wm. Merritt, 2006. Courtesy of the Photographer. Page 280, Caleb Cain Marcus, 2006. Courtesy of the Artist. Page 281, Kimberly Quinn, 2006. Courtesy of the Photographer. Page 283, Nadav Kander, 2003. Courtesy, Yancey Richardson Gallery. Page 284, Brian Smale, 2000. Courtesy of the Artist and Raymond Merritt. Page 285, Jodie Vicenta Jacobson, 2003. Courtesy, Yancey Richardson Gallery. Page 286, David Graham, 1994. Courtesy of the Artist. Page 287, Marianne Courville, 2000-2001. Courtesy of the Artist. Page 288, Lindsay McCrum, 2006. Courtesy of the Artist. Page 289, Ruud van Empel, 2005. Courtesy, Stux Gallery. Page 290, Susan Paulsen, 1998. Courtesy of the Artist. Page 291, Keith Carter, 1992. Courtesy of the Artist. Page 293, Ingar Krauss, 2001. Courtesy of the Artist and Marvelli Gallery. Page 294, Bruce Weber, 1998. Courtesy of the Artist. © Bruce Weber. Page 295, Robert Mapplethorpe, 1985. Courtesy, Robert Mapplethorpe Foundation. Page 296, Jill Mathis, 2000. Courtesy of the Artist. Page 297, Sabine Vollmer-von Falken, 2004. Courtesy of the Artist. Pages 298, 299, Wang Quingsong, 2002. Courtesy of the Artist and Salon 94. Page 300, William Ropp, 1998. Courtesy of the Artist. Page 302, Sally Mann, 1985. Courtesy of the Artist. Page 303, Sally Mann, 1993. Courtesy of the Artist. Page 304, Sally Mann, 1992. Courtesy of the Artist. Page 307, Loretta Lux, 2003. Courtesy, Yossi Milo Gallery. Page 308, Anna Gaskell, 2001. Courtesy of the Artist and Casey Kaplan. Page 310, Wendy Ewald, 1994-1997. Courtesy of the Artist and Yossi Milo Gallery. Page 311, Wendy Ewald, 1994-1997. Courtesy of the Artist and Yossi Milo Gallery. Page 312, Thomas Allen, 2003. Courtesy of the Artist and Foley Gallery. Page 314, Sesame Street Workshop, 2006. © Sesame Street Workshop. Page 315, Ramon F. Bachs, 2006. Courtesy of the Artist. © Marvel Comics. Page 316, Hayao Miyazaki, 1996. Page 317, Osamu Tezuka, c. 1982. Page 318, Damian Ward, 2006, illustration. Courtesy of the Artist. Page 319, Alexandre Orion, 2002. Courtesy of the Artist and Foley Gallery. Pages 320, 321, Trent Parke, 2004. Courtesy, Norton Museum of Fine Art. Page 323, Nicholas Prior, 2004. Courtesy, Yossi Milo Gallery. Page 324, Caleb Cain Marcus, 2003. Courtesy of the Artist. Page 325, Loretta Lux, 2001-2002. Courtesy, Yossi Milo Gallery. Pages 326, 327, Sandy Skoglund, 1990. Courtesy of the Artist. Page 328, Anthony Goicolea, 2005. Courtesy of the Artist. Page 329, Simen Johan, 2001. Courtesy, Yossi Milo Gallery. Page 331, Lucien Clergue, 2004. Courtesy of the Artist. Pages 332, 333, Desiree Dolron, 2001-2005. Courtesy of the Artist and Michael Hoppen Gallery. Page 334, Adam Fuss, 1999. Courtesy, Brent Sikkema Gallery. Page 336 (top), Sally Mann, 1989. Courtesy of the Artist and Joseph M. Cohen. Page 336 (bottom), Edward Weston, 1923. © Collection, Center for Creative Photography, University of Arizona. Page 337, Jean-François Bauret, 1970. Courtesy of the Artist. Pages 338, 339, Tierney Gearon, 2000. Courtesy, Yossi Milo Gallery. Page 341, Shirin Neshat, 1996. Courtesy of the Artist and Gladstone Gallery. Page 342, Jocelyn Lee, 2005. Courtesy, Pace/MacGill Gallery. Pages 344, 345, Michael Meads, 1993. Courtesy of the Artist and ClampArt. Page 346, Larry Clark, 1995. Courtesy of the Artist and Luhring Augustine Gallery. Page 347, Helmut Newton, 2002. Courtesy, Raymond Wm. Merritt. © Estate of Helmut Newton. Page 349, Bradley McCullum and Jacquelin Tarry, 2005. Courtesy of the Artists. Page 350, Bradley McCullum and Jacquelin Tarry, 2005. Courtesy of the Artists. Page 351, Bradley McCullum and Jacquelin Tarry, 2005. Courtesy of the Artists. Page 352, Amy Vitale, 1995. Courtesy of the Artist and UNICEF. Page 355, Gilles Peress, 1999. Courtesy of the Artist. © Gilles Peress, 1999 and Magnum Photos. Page 356, Sebastião Salgado, 2001. Courtesy of the Artist and UNICEF. © Sabastião Salgado/Amazonas Images. Page 358, 359, Gilles Peress, 2002. Courtesy of the Artist. © Gilles Peress, 1999 and Magnum Photos. Page 360, 361, Sebastião Salgado, 1994. Courtesy of the Artist and UNICEF. © Sabastião Salgado/Amazonas Images. Page 362, Sebastião Salgado, 1996. Courtesy of the Artist and UNICEF. © Sabastião Salgado/Amazonas Images. Page 363, Sebastião Salgado, 1994. Courtesy of the Artist and UNICEF. © Sabastião Salgado/Amazonas Images. Pages 364, 365, James Nachtwey, 1982. Courtesy of the Artist and UNICEF. Page 367, Roger Lemoyne, 2004. Courtesy of the Artist. Pages 368, 369, Giacomo Pirozzi, 2004. Courtesy of the Artist and UNICEF. Page 370, Ramazan Ozturk, 1988. Courtesy of the Artist and Sipa Press. Page 371, Jean-Marc Bouju, 2003. Courtesy of the Artist and Getty Images. Pages 372, 373, Sebastião Salgado, 1984. Courtesy of the Artist and UNICEF. © Sabastião Salgado/Amazonas Images. Page 374, Roger Lemoyne, 1993. Courtesy of the Artist and UNICEF. Page 377, Luca Zanetti, 2006. Courtesy of the Artist. Pages 378, 379, Miguel Rio Branco, 1999. Courtesy of the Artist. Page 380, Michael Kamber, 2005. Courtesy of the Artist and UNICEF. Page 383, Shehzad Noorani, 1995. Courtesy of the Artist and UNICEF. Pages 384, 385, Pedro Isztin, 1999. Courtesy of the Artist. Page 386, Caleb Cain Marcus, 2004. Courtesy of the Artist. Page 387, John Isaac, 2001. Courtesy of the Artist and UNICEF. Pages 388, 389, Radhika Chalasani, 2005. Courtesy of the Artist and UNICEF. Page 390, Bill Perlmutter, 1998. Courtesy of the Artist. Pages 392, 393, Gilles Peress, 1993-1999. Courtesy of the Artist. © Gilles Peress, 1993 and Magnum Photos. Page 395, Ralph Gibson, 2000. Courtesy of the Artist. Page 396, Unknown Photographers, n.d. Page 397, May Hanson, 1944. Courtesy, Carol Ann Merritt. Page 400, Ellen Tolmie, 1990. Courtesy of the Artist. BACK COVER. Southworth & Hawes, c. 1836. Courtesy, The J. Paul Getty Museum.

Printed by:

Grafiche Damiani

via Zanardi 376

40131 Bologna, Italy

info@grafichedamiani.it

http://www.grafichedamiani.it

Distributed by:

powerHouse Books

37 Main Street

Brooklyn, NY 11201

info@powerhousebooks.com

htttp://www.powerhousebooks.com

Published by:

CYGNET FOUNDATION

870 UN Plaza (R. Merritt)

New York, NY 10017

rmerritt@willkie.com

http://www.cygnetfoundation.org

The net proceeds received by the Cygnet Foundation from the sale of this book are being donated to the U.S. Fund for UNICEF (www.unicefusa.org). UNICEF remains the most effective organization dealing with the welfare of children worldwide. We suggest that our readers consider it as a recipient of their generosity.

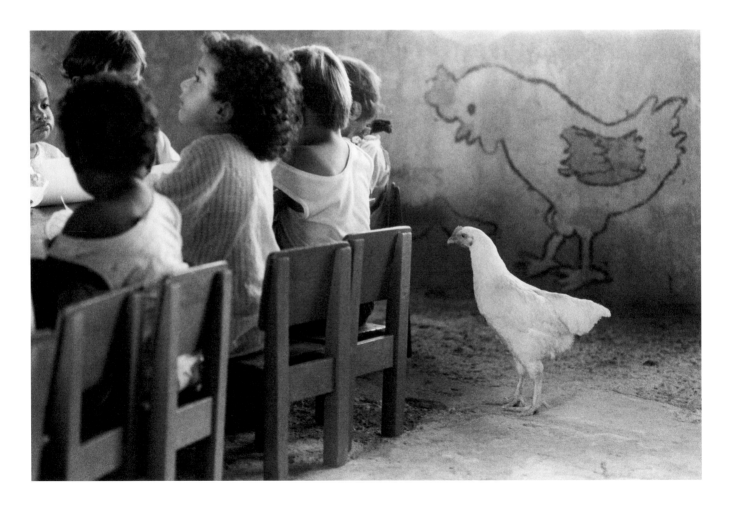

Photographer Ellen Tolmie is the Photography Editor of UNICEF. She served, along with Marvin Heiferman and Virginia Heckert, as a collaborator on this project and co-wrote "the child violated" and "the child wondrous" texts.

Ellen Tolmie, Colombia, 1990